DIGITAL NON-LINEAR
DESKTOP EDITING

DIGITAL NON-LINEAR DESKTOP EDITING

Sonja Schenk

CHARLES RIVER MEDIA, INC.
Hingham, Massachusetts

Publisher: Jenifer Niles
Production: Publishers' Design and Production Service
Printer: InterCity Press, Inc.
Cover Design: The Printed Image

CHARLES RIVER MEDIA, INC.
20 Downer Avenue, Suite 3
Hingham, Massachusetts 02043
781-740-0400
781-740-8816 (FAX)
info@charlesriver.com

www.charlesriver.com

This book is printed on acid-free paper.

Sonja Schenk. *Digital Non-Linear Desktop Editing*.
ISBN: 1-58450-016-6

dps Velocity images © copyright Leitch Technology Corp., 2001.

Adobe, After Effects, Photoshop, and Premiere are either registered trademarks or trademarks of Adobe Systems Incorporated in the United States and/or other countries.

Avid Technology, Inc. products were generously provided to the author by Avid Technology, Inc. for the writing of this book. Avid Technology, Inc. was not a contributor to or author of the book or its contents, and has no liability for any content or omissions of content. All Avid products mentions and images used in the book are reprinted with permission. All related images are copyright © 2001 Avid Technology, Inc.

All brand names and product names mentioned in this book are trademarks or service marks of their respective companies. Any omission or misuse (of any kind) of service marks or trademarks should not be regarded as intent to infringe on the property of others. The publisher recognizes and respects all marks used by companies, manufacturers, and developers as a means to distinguish their products.

Printed in the United States of America
01 02 7 6 5 4 3 2 First Edition

Library of Congress Cataloging-in-Publication Data

Schenk, Sonja, 1965-
 Digital non-linear desktop editing / Sonja Schenk.
 p. cm.
 ISBN 1-58450-016-6 (alk. paper)
 1. Motion pictures—Editing—Data processing. 2. Video tapes—Editing—Data processing. I. Title.
 TR899 .S33 2001
 778.5'235—dc21

2001002591

CHARLES RIVER MEDIA titles are available for site license or bulk purchase by institutions, user groups, corporations, etc. For additional information, please contact the Special Sales Department at 781-740-0400. Requests for replacement of a defective CD must be accompanied by the original disc, your mailing address, telephone number, date of purchase and purchase price. Please state the nature of the problem, and send the information to CHARLES RIVER MEDIA, INC., 20 Downer Avenue, Suite 3, Hingham, Massachusetts 02043. CRM's sole obligation to the purchaser is to replace the disc, based on defective materials or faulty workmanship, but not on the operation or functionality of the product.

Contents

Acknowledgments

I would like to thank the many vendors who generously contributed software, hardware, and technical support, especially Amy Phillips and Doug Hansel at Avid Technology, Inc., Jane Perratt, Mike Nann and Shari Beck at DPS, and Kristen Chan at Adobe. I would also like to thank Lauren Paskal of Moviola Digital for giving me great photos of classic editing equipment. The tutorials in this book exist thanks to the generosity of several filmmakers, including Gene Rosow of R&B Pictures for the *Knights* footage, Michael Breitenstein for the music video, Ben Long for the Tin Hat Trio footage, and Ralph Smith for the Venice Beach montage media. In addition, I'd like to thank the performers and others responsible for the creative talent in the tutorial footage: Ashley Adams, Rob Burger, Carla Kihlstedt, Ben Long, Kim Michalowski, Mark Orton, Regina Saisi, and Hans Wendel. Last, but not least, I wish to thank Ben Long and Ralph Smith, without whose generous help and support this book would not exist.

CHAPTER

1

Introduction

"A film is difficult to explain because it is easy to understand."
—Christian Metz

*B*razil, *The Exorcist, Blade Runner, The Abyss, Das Boot.* Anyone who's ever watched both the original and director's cut of a movie has seen what a difference editing can make in a story. The original release of *Blade Runner* features a voice-over, and a happy ending, while the director's cut has no voice-over, several extra scenes, and a darkly ambiguous ending. The re-release of *The Exorcist* offers several new scenes, including a scene that was lost and digitally reconstructed.

In many ways, editing a film is like doing a rewrite of the script, using footage that already exists. In addition to simple cuts, voice-over, music, special effects, titles, and transitions are all tools that editors use to tell a story, whether for a feature film, a music video, a commercial, or a documentary. Successful editing involves the manipulation of pacing, structure, rhythm, and mood, and it requires a great deal of technical knowledge—especially now that editing has moved off the film flatbed and onto the desktop workstation.

Modern digital non-linear computer-based editing is a hybrid of traditional film editing, analog linear video editing, and digital non-linear computer technology. Therefore, editing is both a creative process and a complex skilled and technical craft. This book endeavors to demystify both the technical and the traditional craft of editing.

THE LANGUAGE OF FILM

The quote at the beginning of this chapter can easily be applied to editing. Editing is often referred to as "the invisible art," and many editors swear that "if you notice it, the editing is bad." So, how do you study something that you aren't supposed to notice?

Think about the last movie or television show you saw that featured a dream sequence. As soon as you saw a long dissolve accompanied with a dreamlike soundtrack, you knew it was a dream sequence. The long dissolve and the dreamlike soundtrack are parts of the filmic language that you already understand. A handheld shot following a person as she walks can make you feel nervous, because you know that someone's stalking her; a close-up can draw you into the emotion of an actor's performance; and a fast zoom in a reality show can make you think something exciting must be happening simply because the cameraman is using the zoom.

The way that shots are composed and edited together add up to the language of film, a surprisingly sophisticated language that can convey all sorts of information without using a single word (Figure 1.1). If you grew up watching movies and television, you already know this language intuitively. Just as you know how to speak your native tongue, you don't need special instruction to understand the language of film; you just have to step back from enjoying movies as entertainment and watch them with an eye toward how the director, cinematographer, and editor use camera movement, composition, and timing to create more compelling stories.

 Learn by Watching

The best way to develop an understanding of editing, and film-making in general, is to watch movies, documentaries, television shows, or whatever it is that you want to create. Start with something you've already seen, and rather than simply enjoying the story, try to look at how it was put together.

You might be saying to yourself that this "filmic language" seems to depend more on how the film is shot than how it is edited—you're half right. Editing is a process of working within limitations; you're limited by the type of footage that was shot. To compare it to fine art, editing is more like making a collage rather than an oil painting. The choices the editor must make are innumerable: which performance to use, which camera angle, the order of the shots, and so on. These choices are ultimately responsible for the overall successful telling of the story.

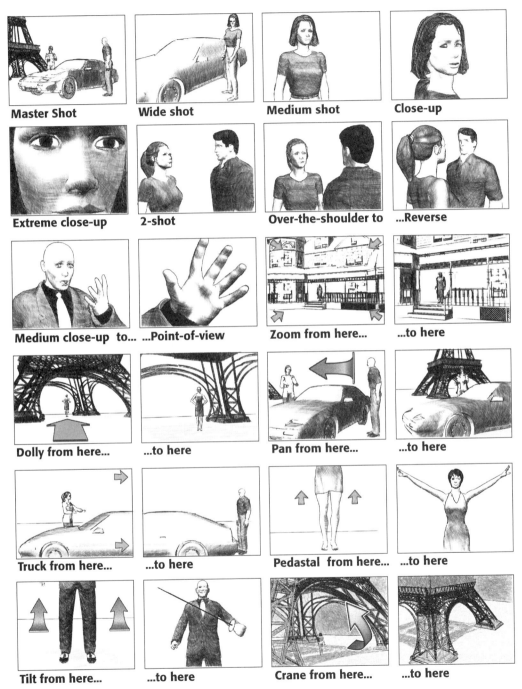

FIGURE *The shots illustrated here form the building blocks of filmmaking.*
1.1

WHO SHOULD USE THIS BOOK

This book is aimed at potential filmmakers, editors, and others new to the world of non-linear postproduction and filmmaking in general, and those who are serious students, hoping to apply their newfound knowledge to their own independent film and video projects or to a new career path.

ON THE CD/DVD

This book will provide necessary information about editing terms and equipment. Detailed tutorials will teach the reader about the every step of the editing process. The included CD-ROM and DVD-ROM contain unedited video footage and demo versions of popular editing applications so you can get started right away, even if you haven't yet purchased video equipment or editing software.

The tutorials presented show more than just how to use editing software. Using sample footage from a music video, a promo for a TV series, a documentary scene, and a dramatic scene, the tutorials will lead you through the entire process of editing—from digitizing, to structuring and refining your cut, to adding titles and compositing. In addition to popular non-linear editing software applications such as Avid Xpress DV, Apple Final Cut Pro, DPS Velocity, EditDV, and Adobe Premiere, this book also covers popular 2D effects applications like Adobe After Effects, and other specialty tools.

Chapter 2, "Cut to the Chase!," starts you off with an easy tutorial: editing a music montage. With this basic and fun editing experience under your belt, it's time to move on to Part One, "Getting Ready to Edit." Chapters 3, 4, 5, and 6 cover everything you need to know to set up your editing system—editing software, computer hardware, video hardware—and how to put it all together. Chapter 7, "Setting Up and Managing a Project," is about organization, including budgeting, scheduling, and managing complicated projects, and a short tutorial walks you through setting up a project and testing your system. Chapter 8, "Getting Media into Your Computer," covers logging, digitizing, and capturing. Part Two, "Editing," focuses on the art and craft of editing itself, from creating the first rough cut to polishing the final cut. In-depth tutorials feature tips and techniques for editing short format projects such as short films, music videos and commercials; long format projects such as documentaries and feature films; and how to build a rough working soundtrack. Most books on editing treat sound as a separate subject, but sound is such an integral part of editing that it's covered throughout Part Two. You'll learn how to capture good sound at the outset, so that you'll spend less time fixing it later, how to perform a basic sound mix as you edit the rough cut, synchronizing picture and sound, dialogue editing and adding effects, ambience, and fixing technical problems. In Chapter 11, "Polishing the Final Cut," a series of mini tutorials will help you put the finishing touches on your final cut—titles, fixing and enhancing the image, color correct-

ing, and bluescreen compositing. You'll learn about polishing the soundtrack and building tracks for a final sound mix. The last chapter covers the final step in postproduction: mixing the audio and outputting your project, whether to videotape, projected film, and or digital media optimized for the Web.

FROM FRAMES TO PIXELS: 100 YEARS OF FILMMAKING

The techniques and terminology of the modern editing room have resulted from a century of technical innovations. Filmmaking has come a long way since its invention in the late nineteenth century when pioneers like the Lumiére brothers experimented with shots of everyday events. Quickly, the potential for film as a storytelling medium was realized, and early filmmakers paved the way for the silent era by inventing all sorts of things we now take for granted, such as the dissolve, the close-up, the intercutting of parallel plot lines, jumping around from different points of view within a scene, the montage, and much more. By the 1930s, with the addition of synchronized sound, the modern feature-length film was born.

In Hollywood, a standard way of working in the editing room also developed. The 35mm film *negative* was processed at a laboratory, and a *work print*, a quick, low-quality print of the film, was created. The work print was then sent to the editing room where it was *synchronized* with the soundtrack and screened as *dailies* for the director and other key players. The synchronized work print was then literally cut into pieces with a razor by the editor and spliced back together with a special sort of tape to create the first rough cut of the movie. Tables with mounted rewinds, sync blocks, and viewers (Figure 1.2), upright Moviolas (Figure 1.3), and flatbeds (Figure 1.4) were used to view and edit the reels of film. As the editor worked, the pieces of film in a particular scene were temporarily stored in *trim bins*, metal carts on wheels with a rack of hooks from which the pieces of film were hung. A complicated filing system was developed to keep track of the thousands of feet of film found in a typical editing room, and the assistant editor was assigned the time-consuming task of keeping it all organized and in sync.

The final steps of the traditional film editing process are still a part of modern film editing—once the final cut is approved, the picture is *locked* and the sound editors go to work, building tracks until the sound is also locked. The edited work print and a *cut list* are then sent back to the lab, where the *negative cutter* conforms the negative, editing it to match the locked picture. The cut list contains all the edits in the film, identified by the *keycode numbers* on each frame where an edit is made. The negative is then used to strike an *answer print*. Finally, the *release prints*, complete with an *optical soundtrack*, are sent to the theaters.

FIGURE **1.2** *Early editing tools included a pair of rewinds, a viewer, a gang synchronizer, and a splicer.*

FIGURE **1.3** *The upright Moviola is responsible for editing some of the most important films in history. © Copyright Moviola, 2001.*

FIGURE *Flatbed editing systems, such as this Moviola, were the most popular way to edit*
1.4 *feature films as recently as 1989. © Copyright Moviola, 2001*

In the late 1980s, editing on film was replaced with editing on computers; however, before that could happen, another invention was needed: television. Early live television was transmitted directly from the camera to the airwaves, with no recording device in between. The recordings of live TV shows that you may have seen were made using a film camera shooting directly off the TV monitor (also known as *kinescoping*). The need for a recording medium resulted in the invention of videotape, and the first practical videotape recorder was invented in 1956 by the Ampex Corporation (Figure 1.5). Originally, videotape came on reels and was edited using splicers, just like film. This process was considerably more difficult than editing film, because you can't see a visible image on a piece of videotape the way that you can see a frame of film.

The invention of electronic video editing systems soon followed, and manual splicing was replaced with recording from the *source tape* onto a new piece of videotape known as the *master*. These systems consisted of a source, or *playback,* deck and monitor and a record, or *edit,* deck and monitor and an *edit controller* that took control of the decks and automated the process of accurately recording from the source deck to the record deck. (Figure 1.6). Nowadays, when a non-linear editing interface features two viewing screens (Figure 1.8), it is following the linear video editing model. The next big innovation

FIGURE *Ampex Corporation received an Emmy for the invention of the first practical*
1.5 *videotape recorder in the 1950s; shown here is a later model, the VR1100.*

FIGURE *JVC edit controller.*
1.6

occurred in the late 1960s: *timecode*. Timecode is simply an electronic signal that tells editors (and machines) where each frame of video starts. This *address* of each frame is displayed on the *videotape recorder* (or *VTR*, the professional version of VCR) in hours, minutes, seconds, and frames.

Linear vs. Non-linear
Linear *simply means that the medium—in this case, videotape— can only be accessed in a chronological manner. If you want to go to the end of a shot, you have to scroll through the entire shot until you arrive at the end.* Non-linear *means that you can jump to, or* randomly access, *any point at any given time. Video and audio tape formats are linear, regardless of whether they are analog or digital.*

The new technology of videotape resulted in new ways for TV editors to work. Originally, all video editing was done *online*, a somewhat confusing term that means the editors took the video from the camera-original source tapes and edited it directly onto the final master tape. This meant that they were editing with the best quality footage and using the best equipment available. However, sometimes this process backfired; each time a piece of analog videotape is recorded onto another tape, it loses a *generation*. With analog videotape, losing more than a few generations results in a visible loss of the image quality. Producers soon realized that they could save time and money and avoid generation loss by doing an *offline edit* on a cheaper editing system, often using *work tapes* instead of the camera-original tapes. Similar to the film editing process, once the final cut was approved, the final master would be conformed in an online session using a list of all the edits and their corresponding timecodes, also known as an *edit decision list*, or *EDL*.

Analog vs. Digital
Analog media consists of a continuous electronic signal, like the sound wave in Figure 1.7a. Digital media is sampled, *or broken down into small pieces, also known as* bits *(Figure 1.7b). A full-color image requires a* bit-depth *of 32 to accurately display enough color to look good to the human eye. Sound requires a bit-depth of 16 to sound good to the human ear.*

The advent of computer technology resulted in further innovation. Digital audio editing systems began to surface as early as the 1950s, but it would be many years before computers were sophisticated enough to handle enough data for the moving image. Early non-linear systems such as the Ediflex and the Edit-Droid used arrays of videotape players or video laser discs to create a non-linear

A. Analog sound wave

B. Digitally sampled sound

FIGURE *The analog sound wave in A is sampled, resulting in the digital sound file in B.*
1.7

environment. With the desktop publishing revolution in the 1980s, image compression technology became prevalent. Personal computers weren't powerful enough to handle full-resolution photographs, so image editing applications such as Adobe Photoshop used compression to make the image smaller. By the late 1980s, a type of compression for moving images—M-JPEG (Motion-JPEG)—was put to task, and the earliest non-linear video editing software began to appear on the market. Today, there are a number of different types of video compression in use (M-JPEG, MPEG, Sorenson, DV, etc.), and a number of different non-linear editing applications on the market (Figure 1.8). In the early 1990s, the professional non-linear editing market was quickly taken over by the line products developed by Avid Technology that cost upward of $100,000. Since then, the processing power of computers has increased and the prices have decreased, the result of which is an affordable, full-featured non-linear editing system.

Just as the invention of videotape changed the workflow in the editing room, the advent of non-linear, computer-based editing has again changed the way in which editors work as well. For projects shot on film, the negative is still processed at the lab, but instead of striking a work print, the image from the negative is transferred directly to videotape, a process known as *telecine*. The

FIGURE *Early digital audio editing systems led the way to the modern desktop non-linear*
1.8 *editing system, like this one featuring Matrox hardware and in:sync Speed Razor*
 software.

resulting work tape is taken to the non-linear editing system, and *logged* and *digitized*, usually by the assistant editor. The now-digital media is stored on the hard drives of the system and edited using non-linear editing software. When the cut is finished, a cut list or an EDL is generated by the NLE, depending on whether the project is destined for film or video, and the final master is conformed. The editor and assistant editors gain the biggest advantage from this process. The hours spent synchronizing and keeping track of the film are gone, and the time spent scrolling through tapes is minimized. Thanks to improved technology, the modern editor actually spends less time dealing with technology and more time editing.

New innovations such as digital video formats, high-definition television, digital "film," and digital projection are continuing to change the way in which editors work; we'll deal with these growing technologies later in this book.

WHAT TYPE OF EQUIPMENT DO I NEED?

This book assumes you will be using a Macintosh or Windows-compatible computer, that you are familiar with your computer and your operating system of choice, and that you have a CD-ROM or DVD-ROM drive. You also need either

ON THE CD/DVD

a pair of speakers or a set of headphones. That's all you need to get started with the first tutorial in Chapter 2. The CD-ROM and DVD-ROM that come with this book include demo versions of several non-linear editing applications. Although you may not be able to save your projects, you'll still be able to work through the tutorials in this book even if you haven't already purchased software. In addition, because all of the tutorial media is contained on the CD-ROM and DVD-ROM, you won't need a video deck, a video capture card, or any other peripheral video hardware—*yet*. So, turn the page and dive in!

ON THE CD/DVD

CHAPTER

Cut to the Chase!

IN THIS CHAPTER

- Installing the Demo Software
- Montage
- Tutorial: Music Montage

A. Sequencer window

B. Timeline

C. Track selectors

D. SkyView

Professional editors are spoiled; the fact is that they don't have to deal with the majority of the things covered in this book. Rather, a postproduction supervisor or producer figured out which system to buy, a technical support person set it up and will troubleshoot any hardware problems they have, an assistant editor logged and digitized the media, a sound editor will build the soundtracks, and an online editor or special effects editor will deal with the titles, compositing, and other special effects. However, a *good* editor knows how the entire process works, even if someone else takes care of it. A good editor acts as a consultant to the post-supervisor when the project is set up, offers intelligent suggestions to the technical support staff when there's a problem, helps the assistant editor do his or her job efficiently, and leaves behind a project that is organized and ready for the sound editors, special effects editors, online editor, and negative cutters. In a traditional film workflow, the editor is the head of the editorial department, and it is his or her job to know the entire process thoroughly.

That said, you're going to get a chance to be a spoiled, prima donna editor for a day or two. There's a project that's just waiting for you to start working on, so grab the CD or DVD (preferably the DVD), put it in your computer, and follow the instructions in the next section.

INSTALLING THE DEMO SOFTWARE

ON THE CD/DVD

If you already own software with which you wish to work, skip ahead to the tutorial; otherwise, grab the demo software you wish to work with from the CD/DVD included with this book and install it. Windows users can choose Adobe Premiere 6.0, in:sync Speed Razor 4.5, Digital Origin FreeDV, or Ulead Media Studio Pro 6.0. Mac users can choose Adobe Premiere 6.0 or Digital Origin EditDV Unplugged.

The tutorial in this chapter uses Digital Origin EditDV Unplugged, but you can use any of the applications on the CD/DVD. Drag the software you want to your hard drive and double-click on it to begin the installation process. You should restart your computer after you install the software.

ON THE CD/DVD

TIP

CD or DVD?

This book comes with a CD and a DVD. Both contain the media and other files needed for the tutorials. The footage on the CD was saved at a low resolution to save space. The footage on the DVD is high-quality full-screen footage. (See Appendix C.) If you have room on your hard drive and a DVD-ROM drive, the DVD is the best choice.

MONTAGE

Montage is one of the most basic concepts in editing. At the simplest level, *montage* means that by placing two shots next to each other, they combine to create a more complex meaning than each would have on its own. A classic example of montage is a close-up shot of a person reacting in surprise. If the second shot is a birthday cake, the meaning is very different than if the second shot is the barrel of a shotgun.

A montage sequence is a series of shots that add up to a narrative scene. For example, if you're editing a documentary and the subjects go to the country fair, it might be tedious to show every detail of their day. However, if you cut four or five shots of them doing different things at the fair, you can quickly convey what they did that day and how they felt about it without having to show the blow-by-blow details. Montage sequences can serve to collapse time, set a mood, and quickly set up a location or event. Probably the earliest film based entirely on montage is *Man with a Movie Camera* by Dziga Vertov. This cinema verité film features events and images of daily life in Moscow in the early twentieth century. Music, ambient sound, and the use of montage create a narrative build that sustains the film without the need for voice-over or dialogue.

A modern-day example of a montage is the typical music video. Music videos also rely on music and a variety of images to create a mood, and possibly a narrative without the need for dialogue or voice-over. Many feature films use a few carefully placed montage sequences to simplify a complicated event, such as the preparation for a big event (*The Full Monty*), a rehearsal for a performance (*Waiting for Guffman*), the introduction of the film itself (*The Big Chill*), and surreal experiences such as dreams and drug-induced hallucinations (*Trainspotting*, *American Beauty*).

TUTORIAL

ON THE CD/DVD

CREATING A MUSIC MONTAGE

Editing images to music can be a lot of fun. For this tutorial, you'll build a montage using footage of Venice Beach, California. You'll create a project, import media from the CD/DVD, import a song from an audio CD, and cut together a montage sequence with music tracks and video footage. You'll focus on using montage to create an interesting sequence of images and set a tone.

This tutorial covers:

- Importing media
- Creating a project
- Drag-and-drop editing

- Editing music
- Timeline editing
- Basic trimming

STEP 1: SET UP THE PROJECT

ON THE CD/DVD

Drag the *Venice montage tutorial* folder from the CD/DVD onto your hard drive. Then, launch the editing software you chose, and create a new project. You should be prompted to name the project and select settings when you launch the software. If not, go to the File menu and select New > Project. Call the project *Venice Montage*. Next, you'll need to choose project settings that are appropriate for the tutorial media. Appendix C contains specific instructions to help you choose the right settings for the media contained on the CD and the DVD for this and the other tutorials in this book. (Figure 2.1).

FIGURE *Project settings for media from the DVD.*
2.1

TIP

How'd It Get Here?

It's always a good idea to find out how the media you're editing was shot, transferred, and so forth. The information can help you troubleshoot any problems that might arise. In this tutorial, the footage originated on a JVC miniDV camcorder and has been compressed using Sorenson video compression.

STEP 2: IMPORT THE VIDEO FOOTAGE

From inside the editing application, select File > Import. Navigate to the *Venice montage tutorial* folder, and import everything inside the folder. Your project should now look something like Figure 2.2.

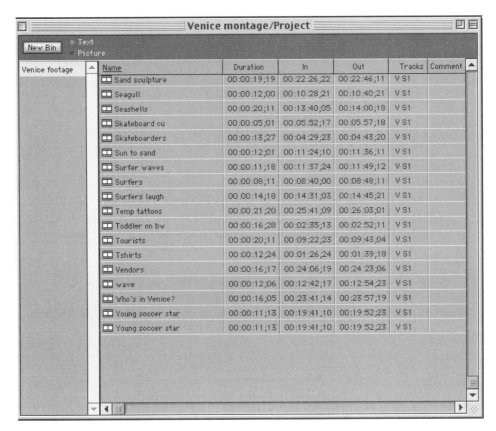

Venice montage/Project						
New Bin · Text · Picture						
Venice footage ▲	Name	Duration	In	Out	Tracks	Comment

Name	Duration	In	Out	Tracks	Comment
Sand sculpture	00:00:19;19	00:22:26;22	00:22:46;11	V S1	
Seagull	00:00:12;00	00:10:28;21	00:10:40;21	V S1	
Seashells	00:00:20;11	00:13:40;05	00:14:00;18	V S1	
Skateboard cu	00:00:05;01	00:05:52;17	00:05:57;18	V S1	
Skateboarders	00:00:13;27	00:04:29;23	00:04:43;20	V S1	
Sun to sand	00:00:12;01	00:11:24;10	00:11:36;11	V S1	
Surfer waves	00:00:11;18	00:11:37;24	00:11:49;12	V S1	
Surfers	00:00:08;11	00:08:40;00	00:08:48;11	V S1	
Surfers laugh	00:00:14;18	00:14:31;03	00:14:45;21	V S1	
Temp tattoos	00:00:21;20	00:25:41;09	00:26:03;01	V S1	
Toddler on bw	00:00:16;28	00:02:35;13	00:02:52;11	V S1	
Tourists	00:00:20;11	00:09:22;23	00:09:43;04	V S1	
Tshirts	00:00:12;24	00:01:26;24	00:01:39;18	V S1	
Vendors	00:00:16;17	00:24:06;19	00:24:23;06	V S1	
wave	00:00:12;06	00:12:42;17	00:12:54;23	V S1	
Who's in Venice?	00:00:16;05	00:23:41;14	00:23:57;19	V S1	
Young soccer star	00:00:11;13	00:19:41;10	00:19:52;23	V S1	
Young soccer star	00:00:11;13	00:19:41;10	00:19:52;23	V S1	

FIGURE *Files in the* Venice montage *project bin.*
2.2

STEP 3: IMPORT A SONG FROM AN AUDIO CD

Pick a favorite CD from your personal collection and choose a song to use for the montage. An up-tempo song with a strong beat is a good choice. Put the music CD into your computer CD drive. You'll need to use an application such as Windows Media Player or Apple QuickTime Pro that can decode MP3 files to prepare the song for importing into EditDV. (For more applications that can perform this conversion, see Chapter 8, "Getting Media into Your Computer.") Launch Windows Media Player or QuickTime Pro, and then open the CD file. You should see all the tracks on the CD displayed as separate files. Open the track you wish to use, and then use Export or Save As to save the file in the *Venice montage tutorial* folder as either a .WAV file (Windows) or an .AIFF file (Mac) (Figure 2.3). Quit that application, go back to the editing application, and import the audio track by selecting Import from the File menu.

FIGURE *QuickTime Pro is one of several applications that can convert the MP3 files on a*
2.3 *music CD to the WAV or AIFF format audio needed by most editing applications.*

STEP 4: WATCH THE FOOTAGE

Now it's time to look through the footage. You should have several video files
and a single audio file in the project. As you watch it, start to think about which

shots you like, and how you want to cut them together. Will you do a series of fast shots, or use the camera moves for a more rhythmic montage? This part is all up to you.

STEP 5: USE DRAG-AND-DROP EDITING TO CREATE A SEQUENCE

Next, you need to start building an edited sequence in the timeline. Drag-and-drop editing is one of the simplest ways to build a sequence. Make sure the A1 track selector (Figure 2.4c) is active in the sequencer (Figure 2.4a) by clicking on the red dot, and then drag the music clip from the Bin window into the timeline and drop it onto track A1. You should now see the CD track in the timeline (Figure 2.4c). This will be the basis for your edited sequence. Try playing the sequence and get a feel for navigating around in the timeline using the mouse. In EditDV, there's a small navigation bar, called the SkyView, that shows the entire sequence and lets you move easily from one point to another (Figure 2.4d). You can also use the + and - buttons in the upper-right corner of the sequencer to zoom in and out of the timeline.

A. Sequencer window

B. Timeline

C. Track selectors

D. SkyView

FIGURE *In EditDV, the Sequencer window (A) contains the timeline (B), where you can target different*
2.4 *tracks (C) and use the SkyView navigation bar (D) to move and view the entire edited sequence.*

STEP 6: SHORTEN THE SONG IN THE TIMELINE

Most pop songs are at least 3.5 minutes long—that's a long montage! Since you're going to be cutting the video to go with the music, start by cutting the song down to a more reasonable length, say 2 minutes.

Use the navigation bar in the upper-right corner of the sequencer to move to a point about 2 minutes into the music track. You're going to set an in-point and an out-point to tell EditDV which portion of the song you want to remove from the sequence. Click the Mark In button (Figure 2.5a) and note that the in-point icon appears in the sequence (Figure 2.5d).

Now move to the end of the song, select a point about 5 seconds from the end, and set an out-point (Figure 2.5b). A yellow bar appears in the upper area of the sequencer to highlight the area you've selected (Figure 2.5c).

Next, you want to extract this highlighted portion of the song and close the gap between the beginning and the end portions at the same time. Click the Eliminate button in the sequencer (Figure 2.6a), and your music track should look something like the sequence in Figure 2.6.

A. Mark In button B. Mark Out button D. In-point icon C. In to Out selection highlight bar

FIGURE *Use the Mark In button (A) and the Mark Out button (B) to select (C) the portion of*
2.5 *the music you wish to remove.*

A. Eliminate button

FIGURE *Use the Eliminate button in the sequencer (A) to remove the unwanted part of the*
2.6 *song and close the gap.*

Don't worry if the end of the song doesn't sound good; you'll fix that later in Step 10.

STEP 7: ADD VIDEO TRACKS WITH DRAG-AND-DROP EDITING

Now it's time to add some video to the sequence. In the timeline, select the V1 track and deselect any of the audio tracks. Shift-select the shots called *Who's in Venice?, Tshirts, Vendors,* and *Toddler on bw,* and drag them onto the V1 track in the timeline. Watch them, then set In and Out points, and use the Eliminate button, as described in Step 6, to get rid of the parts of the shots you don't want. Find a couple of shots you like in the bin, and add them to the end of the *Toddler on bw* clip.

STEP 8: ADVANCED DRAG-AND-DROP EDITING

By marking in- and out-points in a source clip, you can make a more refined drag-and-drop edit. Double-click on the clip called *Sun to Sand* to launch it in the Source viewer. Press the space bar to play the shot. When you get to the point where the camera pans down from the sun to the beach, back it up a little bit by dragging the cursor in the Source viewer, and click the Mark In button to set an in-point. (Figure 2.7a). Press Play and wait until the shot settles on the wide view of the beach for a couple of seconds. Press the space bar again to pause, and click the Mark Out button to set an out-point (Figure 2.7b). Now click in the middle of the Source viewer, drag the shot to the end of the last video click in the timeline, and release. Only the portion of the shot between the in- and out-points will appear in the timeline.

Continue to open other shots into the Source viewer, set in- and out-points, and drag them into the timeline until the video extends to the end of the music.

Mark In

Mark Out

FIGURE *Mark in- (A) and out-points (B) in the Source viewer, and then drag the shot from the Source*
2.7 *viewer into the timeline.*

STEP 9: DRAG-AND-DROP EDITING IN THE TIMELINE

Play the shots in the timeline by activating the Sequencer window and then
pressing the space bar. The edited sequence will play in the Program viewer.
Now that you've watched your edit, you might want to rearrange some of the
shots in the timeline. To do this, select a shot that you wish to move by clicking
on it in the timeline. A black outline appears to indicate that the shot is selected
(Figure 2.8a). From the Edit menu, select Copy. Move the cursor to the place in
the timeline where you wish to insert the shot. The cursor should snap to the
transitions between shots. Select Paste from the Edit menu. The shot will be in-
serted after the transition, and all the shots after the transition will move down
the timeline to accommodate the inserted shot (Figure 2.8b). Then, set in- and
out-points to mark the original shot, and click the Eliminate button to remove it
from the timeline (Figure 2.8c).

Continue to rearrange the shots until you are happy with the order in which
they appear.

A. Select shot and Copy

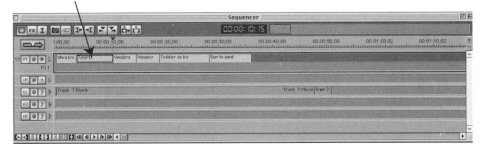

B. Position cursor and Paste

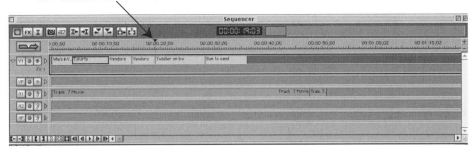

C. Mark in and out and Eliminate

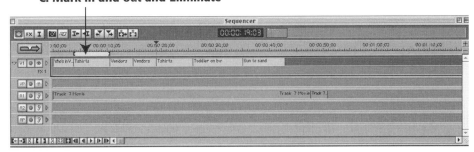

FIGURE *Select the shot you wish to move (A), copy and paste it at the desired transition in the*
2.8 *timeline (B), then set in- and out-points to select the original shot in the Fineline and*
 use the Eliminate button to remove it from your sequence (C).

STEP 10: USE TRIM MODE TO ADJUST THE MUSIC EDIT

Play the music track around the edit at the end of the sequence to hear how it
sounds. Unless you're very lucky, it probably won't sound very good. You need
to adjust the edit so that it falls at a place where it sounds seamless. To do this,
you'll use Trim Mode to refine the edit. Select the Trim button (Figure 2.9a) in
the sequencer, and then click on the transition between the two parts of the
music in the timeline. The Trim Both icon appears at the transition in the time-
line (Figure 2.9b), and the Trim Mode window opens (Figure 2.9c). Go to the

C. Trim Mode window **D. Trim mode transition**

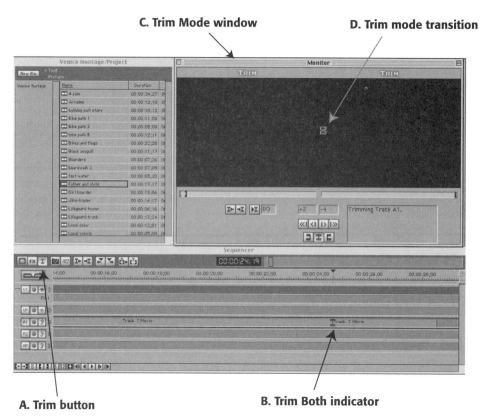

A. Trim button **B. Trim Both indicator**

FIGURE *Use the Trim Both button (A) to launch Trim Mode (B) the Trim Both icon set the*
2.9 *transition (C), and then drag in transition (D) in the Trim Mode window to adjust*
the music edit.

Trim Mode window and select the area in the middle with the mouse (Figure 2.9d). Now, drag left or right to adjust the edit—you'll see these changes reflected in the timeline when you release the mouse. Use the space bar to play just the transition in Trim Mode. You might want to read the user documentation for more information on Trim Mode.

Continue to adjust until you're happy with the way it sounds. If you've never done this before, it might take awhile, but making seamless music edits is a basic skill that every editor needs to possess. You can also use Trim Mode to refine some of the picture edits.

STEP 11: REVIEW YOUR WORK

EditDV Unplugged requires that you render to view a good quality version of your edit. Set an in-point at the beginning of your sequence and an out-point at the end. Select Update VP Track from the Program window to create a rendered

A. VP Track

**B. Track monitor indicators
(eye and ear icons)**

FIGURE *Click on the track monitor selector (eye icon) to view the rendered VP track.*
2.10

ON THE CD/DVD

preview of your sequence. Be sure the track selector is set to view the VP track in the timeline (Figure 2.10). To see one possible music montage, open the file called *Final Venice Montage.mov* from the *Final Movies* folder on the CD/DVD.

AND NOW FOR SOMETHING REALLY CHALLENGING . . .

Now that you've had a taste of what's fun about editing, it's time to go back to the more serious stuff. If you haven't already done so on your own, it's time to build your editing system, and the next four chapters are designed to help you do just that. Chapter 3 will help you decide on a software package, Chapters 4 and 5 will help you make sure you have all the computer and video hardware to round out your system, and Chapter 6 will walk you through putting it all together.

1

Getting Ready to Edit

CHAPTER

Editing Software

IN THIS CHAPTER

- Evaluating Editing Software Packages
- The Basic Editing Interface
- Editing Tools
- Capturing Media
- Audio Editing Tools
- Special Effects
- Outputs
- Other Software Products

Irst, the bad news: it's very hard to evaluate editing software without sitting down and actually working with it. Whatever the manufacturer claims, you'll never know how easy it is to work with five layers of effects or a feature-length sequence until you try it. The fact remains that every project comes with its own unique set of challenges, and every editor develops his or her own way of working. That said, this chapter will help you find the right editing software for your needs by explaining the components found in most editing applications, and why they're useful.

Now, for the good news: most people end up liking whatever they use regularly. Just as Windows and Mac users swear by their operating system (OS) of choice, so do experienced editors swear by the editing system they use. A couple years ago at NAB, the National Association of Radio and Television Broadcasters' annual convention, Avid announced that it was abandoning the Macintosh platform. Professional editors freaked out. These editors not only wanted to stick to the same software, they also wanted to stick to the same OS. They raised such a ruckus that Avid revised its decision and now continues to make products for both operating systems. Although it may sound like the editors were being fussy, there's a good reason for their concern: in editing, it's important to develop a rhythm when working. The idea is to forget about the manual steps you're taking and work by rote. When you drive, you don't think about how to use the brakes or where the stick shift is located, and when you edit, you don't want to think about where the key is that performs the edit or which monitor is showing your source footage. Rather, you want to focus on the feel of how the images and sounds are working together to tell your story.

That's why finding the software that's right for you *and* your project is fundamental. We suggest that you choose editing software first, and then choose the hardware to go with it. If you already own a computer that you wish to enhance with editing software and hardware, then you're in great shape—you've already narrowed down the options. However, whether you've got a specific platform in mind or not, be sure to choose carefully! Changing from one editing system to another can cost lots of time, effort, and money.

DEFINE YOUR NEEDS

Enough about you, what about your project? Before you buy anything, you should be able to answer these questions:

- **What is your final product?** Projected 35mm film? Broadcast television? Streaming media for the Web? Corporate VHS training video? DVD? Some editing applications are more suitable for certain types of projects than others.

- **What additional products will you be creating?** Trailers? Press kits? Work-in-progress VHS tapes? Streaming media? If you have more than one final delivery medium, you may need to do a little extra planning. You'll most likely need a product with support for SMPTE timecode and EDLs.
- **Do you already own equipment that you want to use with the software you buy?** If so, make sure it's compatible. Most editing software manufacturers provide a list of approved hardware (both video and computer) on their Web site.
- **Did you shoot your project on DV?** Some products, like Digital Origin's EditDV and Avid Xpress DV, are only set up to work with DV format footage. Others support the DV format, but use a different type of compression (M-JPEG), which nullifies many of the advantages of working with DV in the first place.
- **How much money do you plan to spend on hardware?** Some products, especially the DV/FireWire-based ones, do pretty well with very little hardware; others need lots of stuff to perform well. Be aware that *all* of them will require additional video hardware, especially storage drives.

If some of these questions are confusing to you, be sure to read this chapter and the next two chapters on hardware before you go shopping.

EDITING APPLICATIONS AND FEATURES

In the following section, we'll outline the basic components of a non-linear editing system. Later in this book, we'll go into how to use each component. Not all of the products on the market have all of the features listed here, so it's important to figure out which features you need and use that information to choose the software that's right for you.

THE BASIC INTERFACE

The editing interface provides an environment that allows you to manipulate and view your footage, as well as an organizational framework to manage media for both technical and creative reasons. Almost all editing applications share a similar interface that includes the following:

- **Project window**. Displays folders containing media and edited sequences. Some editing systems only allow one edited sequence per project. This means that every time you want to try a different version of a scene, you'll need to create another project. This could become tiresome if your project is very long and you want to break it up into scenes as you edit. Unless you only edit short pieces, a system with this limitation is not recommended (Figure 3.1).

Project
window

Source
viewer

Program
viewer

Timeline

FIGURE *The Edit DV interface includes a Project window, a Source viewer, a Program viewer, and a*
3.1 *Sequencer window that contains the timeline.*

- **Bins**. Also called folders, galleries, or libraries, bins contain video clips, audio clips, stills, graphic elements, and edited sequences. Usually, bins offer a thumbnail view and a text view, which can contain timecode information, source reel names, comments, and other organizational information.

- **Timeline**. The timeline is a chronological view of an edited sequence that displays video and audio tracks (or *layers*). Most systems offer an unlimited number of tracks; however, editing with more than eight audio tracks and four video tracks is fairly cumbersome, so don't be wowed by the ability of a package to support hundreds of tracks. There are two common types of timelines: A/B style timelines and single track timelines. A/B style timelines use two video tracks with a transition track in between. You'll have to checkerboard your video to work this way (Figure 3.2a). Single-track timelines combine video and transitions on one video track. (Just because a system offers a single-track timeline interface doesn't mean it can't support multiple video tracks.) A/B style timelines are unnecessarily complicated when compared with single-track timelines (Figure 3.2b).

A.

Video A
track

Transition
track

Video B
track

B.

Video
track

FIGURE *Adobe Premiere 6.0 lets you choose between an A/B timeline view (A) and a single-*
3.2 *track timeline view (B).*

Adobe Premiere 6.0

(Mac/Win) The new release of Adobe Premiere builds on the solid base of version 5.1 and has jumped on the streaming media bandwagon by adding all sorts of file format options, including streaming QuickTime, a modified version of RealVideo and EZ Cleaner, and a customized version of Terran's Cleaner 5. The interface is generally the same as in previous versions, although you can now choose between a single-track timeline and an A/B-style timeline (Figure 3.2).

Premiere 6.0 offers excellent support for keyboard editing and all of the features that professionals demand, including EDL and timecode support, batch capturing, and a 24-fps timebase option, which you would need for editing a project that's shot and finished on film. Premiere's capture interface leaves something to be desired, since it doesn't offer a software waveform monitor and vectorscope. Another potential drawback is that you can only have one sequence per project. That means you need to make a copy of your project every time you want to move in a new direction with an edit, but wish to keep track of your previous rough cuts. Version 6.0 also adds a new audio mixing interface (Figure 3.13).

On the plus side, Premiere is an excellent integrator; it's compatible with all the other Adobe products and is possibly the only editing application that lets you move an entire project from a Windows machine to a Mac, and vice versa, without any sort of conversion process in between. Premiere isn't too much of a system hog either, so if you have a decent amount of RAM, you can often have another application running at the same time. Perhaps the biggest advantage to Adobe Premiere is the sheer range of hardware choices available when it comes to video capture boards. If you're interested in more than FireWire-based DV editing, Premiere might be the most flexible product around (more about capture boards in Chapter 4, "Computer Hardware").

- **Viewers**. Most editing systems follow a video editing model and have two viewers built into the interface: a source (or playback) viewer on the left that plays source footage so that you can select in- and out-points, and a record (or edit or program) viewer on the right that plays your edited sequence. Other applications have only one viewer that switches between source footage and the edited sequence. This can help save some screen space, but may also be a little confusing.

- **Keyboard and mouse**. The keyboard and mouse (or other input device) play an important role in how the interface works, replacing the traditional *edit controller* (Figure 1.6).When evaluating a package, find out if you have to use the mouse for everything, or if can you use the keyboard for most functions. Many editors prefer the keyboard to the mouse because it's faster. Make sure a package provides good support for the input device you prefer. If you prefer the keyboard, find out if most functions are mapped to the keyboard, and if you can customize the keyboard.

- **Organizational tools**. You should be able to *sift*, *sort*, and *search* using the data visible in the text view of each folder. You should also be able to assign *keywords* to clips so that you can search by, say, the location or the name of a character (Figures 3.3 and 3.4).

FIGURE *DPS Velocity offers an A/B-style timeline and sophisticated organizational tools in the*
3.3 *Gallery (aka Bin) window.*

FIGURE *In Final Cut Pro 2.0, the Media Manager helps you organize QuickTime source files.*
3.4

- **Customizability**. Can you arrange the windows the way you want, or do you have to stick with the default? Can you customize the keyboard? Can you save settings for different users or for different projects? The more an application allows you to customize, the more likely you'll be comfortable with the interface.
- **Auto-save**. When you are editing, a lot can change in 10 or 15 minutes, and editing systems have to handle a lot of data and many hardware peripherals. This means that they are prone to crashes; because of this, auto-save is indispensable.
- **Auto-backup**. Also indispensable is an auto-backup function. Usually, this means that every time you save the project, the previously saved version is stored somewhere on your hard drive. Some systems let you decide how many backup versions are saved, and others decide for you. Backing up is boring and tedious, so there's no reason the computer shouldn't do it for you.
- **Undo**. Nowadays, most editing systems come with multiple levels of Undo. This is a very important feature, and you need at least 30 levels. Some editing apps also identify each action in the Undo menu with descriptive text, while others do not. Given the number of actions you might take in a mere 10 minutes of editing, it's hard to remember exactly what you did and in what order. Text identification of each available level of Undo can be a big asset.

Separating the Software from the Hardware

Although we deal with hardware in Chapters 4 and 5, you need to know a little about it in order to make an intelligent decision about software. Hardware is the key to high performance. If an editing application seems slow, it's probably due to lack of memory or a slow processor. If it needs to render a lot, it's probably due to the type of video card in the system. If the image quality isn't great, hardware is responsible. If you don't know much about computer hardware, you might want to skip ahead to Chapter 4 before you continue. Otherwise, here's a simplified list of what's responsible for what:

Hardware-related:
 Real-time playback
 Real-time effects
 Rendering speed
 Smooth playback
 Video resolution

Digital vs. analog I/O
Timecode* and deck control

Software-related:
Ease of use
Types of effects
Number of layers
Compatible file formats
Color correction
EDLs and cut lists
Codec

*The video deck and tape format must support timecode, but the software must also be able to read timecode.

EDITING TOOLS

There are several ways to make an edit in a typical non-linear editing application:

- **Drag and drop editing**. This is the most basic, least-refined way to edit. You drag selected clips from the folder into the timeline or record monitor, and then arrange them in order in the timeline. A variation of this is called *storyboard editing*; you arrange the thumbnails of your shots in order in a bin and then select all of them and drag them into the timeline or record monitor (Figure 3.5). The system then arranges them in the timeline in the order you selected. Almost every application comes with drag-and-drop editing. While it is useful for building a first cut of a project, it doesn't allow for the type of intuitive, rote functioning mentioned earlier—for that, you'll need *three-point editing*.
- **Snapping**. Snapping makes drag-and-drop editing easier by snapping to the beginning of each shot in the timeline.
- **Three-point editing** is a more refined way of making edits. You select an in-point (or start) and an out-point (or end) in your source footage, and an in- or out-point in the edited sequence. You then either insert or overwrite the selected footage into your edited sequence (Figure 3.6). Anyone who is used to three-point editing will go nuts using a system that doesn't offer it. For those new to editing, it may be less important at the outset, but it's certainly a function worth getting to know.

FIGURE *The Avid Xpress DV interface with thumbnails arranged for storyboard editing.*
3.5

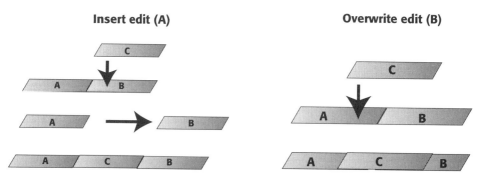

FIGURE *There are two variations of three-point editing:* Insert *edits allow you to add a shot*
3.6 *between two existing shots (A), while* Overwrite *edits allow you to easily add a*
cutaway (B).

Apple Final Cut Pro 2.0

(Mac) The arrival of Final Cut Pro on the market caused quite a stir, but why? There have been editing applications available in the same price range ($1,000 for software only) for quite some time. The main reason is that if you buy a new Macintosh computer, which comes with built-in FireWire, and a miniDV camcorder, you're pretty much ready to go. And, if you're like a lot of Final Cut users, you already own the Macintosh, so the cash outlay to get up and running will probably be less than $2,000.

However, most serious editors will have to spend a lot more than that to have a full-featured editing system. Aside from the capture boards, Final Cut Pro still needs all of the peripheral hardware any other system needs—accelerator cards, storage drives, extra monitors, video decks, and so on. (The peripheral hardware needed for every editing system is discussed in Chapters 4 and 5). You can add these items on an as-needed basis, which is nice if you're not sure which direction your editing needs are headed.

Another reason for all the fuss is that Final Cut has many professional editing features: EDL support, ability to handle film footage (with the help of film matchback software like FilmLogic), the ability to handle long format projects, support for HD format projects, including 24fps projects, and OMF file exports for sending audio to a ProTools, or other professional sound-editing systems. As a result, Final Cut Pro has carved out a niche in the low-budget professional film and television industry that was, until recently, completely dominated by Avid products.

Final Cut Pro is notoriously fussy about hardware and can be difficult to set up, but it's very solid once you get it going. It offers a nice set of editing tools and good keyboard support, although the key commands are not customizable. The new Easy Setup feature is a decided improvement over FCP 1.2.5. You can now create different sets of preferences for different types of projects. For example, if you have one project that's NTSC and another that's PAL, create a custom Easy Setup to choose the global settings when you launch FCP 2.0., Final Cut offers a matchframe command—a must for long format projects—and excellent capturing features. Audio tools are limited, as they are in most of the editing applications covered in this chapter, but the recently added export OMF file option facilitates the process of finishing the audio on a dedicated sound-editing system.

Final Cut Pro was designed to work with the DV format and offers real-time cuts-only playback for DV footage. Anything more complicated will require lots of rendering and the application is not a particularly fast renderer, although you can add third-party hardware like the Matrox RT Mac board for three layers of real-time effects. The way that Final Cut Pro treats renders is also a weak spot. When you render a filter, Final Cut creates a media file on your hard drive, but

does not create a new clip in your project window the way an Avid Media Composer does. Rather, the render is associated with the sequence, so if you change the rendered part of the sequence, you'll have to rerender. Even if you turn a track selector on and off, you'll lose the render (although you can usually Undo). Rendered material is therefore somewhat fragile and easily lost. If you have effects-heavy projects, Final Cut may not be the best choice for you.

- **Fit to fill**. Fit to fill lets you make an overwrite edit that automatically fills an empty space in your timeline.
- **Keyboard editing**. Some systems allow you to customize the keyboard or include preassigned functions to certain keys for you. Typically, the I key sets the in-point; the O key sets the out-point; and the J, K, and L keys rewind, pause, and play, acting as a *jog shuttle* (Figure 3.7). If you love to use the mouse, this won't be very important to you, but editing with the keyboard is often the fastest way to work. Some systems will list this feature as "JKL editing" support.
- **Trimming**. Most applications have a separate interface for trimming, or fine-tuning, an edit (Figure 3.8). A display shows the frame of the outgoing shot on the left, also known as the *a-side* of the edit, and the first frame of the incoming shot on the right, or the *b-side*. This interface allows you to easily make small adjustments to the edit and watch the results.
- **Ripple** and **Roll**. These functions let you fine-tune the position of an edit by moving the a-side of the edit, the b-side of the edit, or both (Figure 3.8).
- **Slip** and **Slide**. Slipping and sliding are also ways to fine-tune an existing edit. In your edited sequence, you can *slide* a shot backward or forward in

FIGURE *Keyboard, or JKL, editing provides a simple one-handed editing interface.*
3.7

FIGURE *This dialogue overlap was created using a rolling edit, shown here in the Avid Xpress*
3.8 *DV timeline and trim mode windows. The edit in the video track rolls left as the A-*
side of the edit is extended and the B-side is simultaneously shortened.

time—the surrounding shots will automatically fill the gaps (Figure 3.9).
Slip allows you to change the footage contained within a shot, starting it at
a different place, without affecting the duration of the shot or the shots sur-
rounding it.

• **Multi-camera groups and/or synchronized editing**. *Multi-camera edit-*
ing is a feature that's rarely found on cheaper editing systems. Designed
for typical broadcast television multi-camera shoots, multi-cam editing lets
you group two or more shots together based on the source timecode or se-
lected in-points. A special interface with the source monitor divided into
quadrants displaying the grouped shots lets you easily switch from one
camera angle to another as you edit the scene. *Synchronized editing* is a
less sophisticated version of multicam editing, where you define which
shots get linked together by timecode or selected in-points. This feature is
necessary if you're working on a project shot on film and will be synchro-
nizing your sound and picture together inside your editing application, as
opposed to having the film lab do it for you (Figure 3.10).

Three shot sequence (A)

Center shot slides to the right (B)

Center shot slides to the left (C)

FIGURE **3.9** *By using a* Slide *edit, you can move the center shot in A to the right (B) or to the left (C) without changing the length of your overall sequence.*

Grouped
clips in
Source
Monitor

Record
Monitor

Timeline

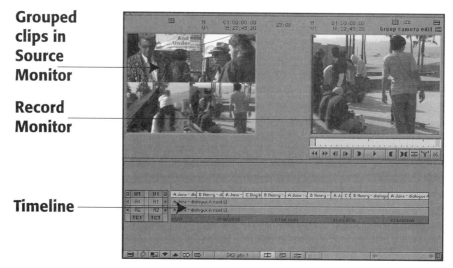

FIGURE **3.10** *Multi-camera editing with grouped clips in Avid Media Composer.*

Avid Products

(Mac/Win) **Avid Media Composer** is the professional editing system of choice. Because it's a turnkey system, Avid Media Composer includes a sophisticated set of hardware components, and there are several different bundles from which to choose. The interface is simple and completely customizable—you can even assign menu items to the keyboard. Currently, Avid Media Composer does not offer FireWire-based DV input or output, opting to stick with the high-end SDI format for digital video. Avid Media Composer may not be the ideal choice for a DV project, since it only offers M-JPEG-based compression, but if the project needs high-end features, there aren't any products on the market that offer it serious competition. It's the only system described in this chapter that offers sophisticated grouping of shots for editing material from a multi-cam shoot, and all the extra hardware adds performance that makes these systems ideal for long format projects. And don't forget that many of those features you're looking for were invented here—JKL editing, Slip, Slide, Ripple, Roll, Trim Mode, Matchframe, multiple Undos—the list goes on and on.

Avid Xpress is a scaled-down version of Avid Media Composer that uses basically the same software interface and similar hardware, including the Avid Meridien board set, and offers the same M-JPEG compression and lack of FireWire-based DV support. Xpress comes in three different bundles that start at around $13K for a basic system, but by the time you add storage, "Avid assurance" (Avid's support, warrantee, and upgrade package), and other extras, you'll be looking at around $20K. The fact is, however, that if you're looking for a "cheap" Avid, Xpress is a very good solution.

Avid Xpress DV is the latest addition to the Avid family, and is available as either a turnkey system (about $6K) that comes with the Canopus DV Raptor board, or as standalone software (approx. $1,700). Xpress DV is a DV-only system that is very limited in terms of input and output, but has the advantage of the Avid software interface. Look for more I/O options as additional third-party capture boards are approved. Like many products in its price range, Xpress DV was designed to facilitate media creation destined for the Web. If you're coming from a professional Avid editing background, Xpress DV might be the best choice for you. Xpress DV supports film projects with Avid's FilmScribe utility, along with EDLs and plug-ins (check out Figure 4.15 in Chapter 4).

All three of the systems have the advantage of support within the Avid family of products. You can take a project from Xpress DV and open it up in a high-end **Avid Symphony** for color correction and image enhancement. Avid also owns **Digidesign ProTools**, and they invented the OMF format that lets you export timelines, including audio level information, to send audio to a sound-editing workstation. All of the Avid products also benefit from having the largest user base of professional editors, and the learning curve between the three products is small.

- **Matchframe**. The bigger your project, the harder it will be to remember which bin contains the shot you're looking for. Pressing the matchframe button when you're parked on a frame in your timeline will load that shot into your source monitor. When you need to adjust a clip, this command can save you hours of looking through folders and shots for the right piece of video.
- **Lockable tracks**. You can avoid accidentally changing a finely cut sequence or losing sync by locking one or all of the tracks in your sequence.

TIP

Great Expectations

If you come from a linear video-editing background, or if you've worked on a high-end professional non-linear editing system, you might be surprised to find out that the things you take for granted aren't necessarily available on lower-end systems. Three-point editing, instant real-time playback, SMPTE timecode support, and control over the video levels when capturing video are just a few of the things an editing application might not offer, so be sure to do your homework before you buy a package.

CAPTURING MEDIA

Capturing needs vary greatly from project to project. Most people will be capturing the media that they'll eventually use to create their final master output, especially if the project is destined for nonbroadcast videotape or the Web. Those working with any of the DV formats probably fall into this category. However, those with projects destined for broadcast video or projected film may not need to capture high-quality footage. Instead, they'll capture low-quality footage, use their system to create an offline edit, and then take their EDL or cut list to another system and reconstruct their project with the best-quality media possible. Because they're dealing with low-res footage, they'll have lower storage requirements and, possibly, better playback performance. In other words, the higher the overall budget, the lower the level of image quality needed. Whatever your capturing needs, the following are the standard features you'll need when capturing media:

- **Logging**. The first step in any editing project is logging, the process of going through all of your footage and deciding which shots to capture. If you're working with film transferred via telecine to videotape, you might have a digital log delivered along with the telecine tape. In this case, you need to make sure your editing system is capable of importing shot logs. If you're logging from scratch, look for a system that supports SMPTE time-

FIGURE *The Final Cut Pro 2.0 capture interface.*
3.11

code and serial remote deck control within the editing application (Figure 3.11). As we mentioned earlier, timecode support and remote deck control are hardware-based features, but the software has to offer support for them as well. Only those who are producing short pieces with small amounts of source footage should consider systems without SMPTE timecode or deck control.

- **Batch capturing**. Once you have a shot log (whether imported from another application or created within your editing application), you can have the NLE capture all the shots you've logged automatically. This feature also requires hardware support for timecode and remote deck control.

- **Video resolution**. Available video resolutions vary from system to system. Video resolution is measured by the data rate (KB/sec), the size of each frame (1K, 2K, etc.), or by a compression ratio (1:1; 3:1, etc.). DV editing systems typically only offer one standard DV resolution—3.6 kb/sec—that is of high quality. Others offer a selection of low and high resolutions. Depending on your project, you either want a very high resolution, to create the best possible image quality for your final output, or *online*, or you want a medium-to-low resolution to conserve disk storage space while you create the *offline* edit of your project. Video resolution is intrinsically linked to your video capture hardware, which we'll discuss in greater detail

in Chapter 4, "Computer Hardware," but your choice of software may also be a limiting factor. Make sure that the software product you purchase supports the type of video-capture board you need.

- **Audio sampling rates**. Just as there are a number of different video resolutions, there are also different audio quality levels, also known as *audio sampling rates*. Audio sampling rates are measured in *kilohertz*, and range from 12kHz, 22kHz, 44.1kHz (CD quality), to 48kHz (DAT quality). 44.1kHz is sufficient for almost any project; anything less is not a good idea. Even if you're ultimately going for a Web format, you can compress the audio later in an application such as Terran Cleaner 5 or Macromedia Flash 5.

- **Waveform monitors and vectorscopes**. *Waveform monitors* and *vectorscopes* are used to display the video signal in different ways so that you can analyze it for quality in terms of brightness, black levels, and color saturation. Hardware waveform monitors and vectorscopes are the best way to look at the video signal, but it's also good to have an application that offers a software waveform monitor and vectorscope in the capture utility. This is the only way to ensure that the quality of the signal is "broadcast legal," something we'll cover in detail in Chapter 8, "Getting Media into Your Computer." If you're using your NLE to create an offline edit of your project, these monitors aren't as necessary (Figure 3.12).

- **Audio level controls and meters**. *Audio level controls* in your capture utility let you adjust the volume of the audio when you capture. Although you can usually adjust these levels using the hardware on your VTR, audio deck, or mixing board (see Chapter 5, "Video and Audio Hardware"), it's nice to be able to do it with software too. *Audio level meters* offer a visual display to show how loud the audio signal is, usually measured in *decibels* (dB). Audio level meters are necessary to ensure that the sound you're capturing isn't *peaking*, *clipping*, or too soft. Audio level meters that aren't measured in dB are somewhat useless.

- **Timecode support**. Timecode support is dependent on hardware and your videotape format, but ideally, you want an editing system that supports SMPTE timecode for North American NTSC video and EBU timecode for European PAL video. This will let you create EDLs that other non-linear and linear editing systems can read so that you can reconstruct your project at a later date or on another system either for more online editing or for taking segments of your project offline if you run out of disk space. It's also often important to be able to modify the timecode of a clip you've already captured.

- **Importing files**. A good non-linear editing application should be able to import the following file formats: shot logs, EDLs, standard still graphics formats like PICT or BMP (depending on whether you're using a Mac or

FIGURE *Software waveform monitor, vectorscope, and audio level meters in Avid Media*
3.12 *Composer.*

Windows machine, respectively), sequential PICTs, QuickTime, AVI (if
you're working on a Windows machine), WAV audio (IBM), and AIFF
audio (Mac).

- **Pixel aspect ratios**. Your system should let you choose between square
 and nonsquare pixel aspect ratios. Most analog video consists of square
 pixels, while most digital video consists of nonsquare pixels—although the
 actual shape can vary from one format to another (more about pixel aspect
 ratios in Chapter 7).

- **Widescreen (16:9) support**. If you plan on shooting widescreen, you
 need an editing system that can handle widescreen footage. Most non-linear

editing applications have added this functionality in the last year or so (more about working with widescreen in Chapter 5).

- **HDTV**. HDTV comes in a number of different flavors, and to work in a native HD environment you'll need software that can handle the various frame rates of HD and a lot of extra hardware to allow for the processing of high-resolution images. Research carefully before you buy.

NTSC AND PAL

NTSC, short for the National Television Standards Committee, is the standard for video that is broadcast in North America and Japan. (Japanese NTSC is slightly different, however (see Appendix B, "Video Standards," for more information). PAL (Phase Alternate by Line) is the broadcast standard for most of the rest of the world. For more about NTSC and PAL and other broadcast standards, like SECAM (Sequence Couleur a Memoire) and HDTV (High-definition Television), read Appendix B.

- **PAL/NTSC switchability**. Switching from NTSC to PAL is a challenge for linear video hardware but not for digital video hardware or digital video software. As a result, most non-linear editing applications support either PAL or NTSC projects. Most users know which standard they'll be working in and don't need support for anything else. However, if you're shooting PAL to facilitate a video-to-film transfer, or if you work on both American and international projects, you may need software that can handle both PAL and NTSC. You'll also need video hardware (monitors, VTRs) that support that format.

AUDIO EDITING

The audio capabilities in the average non-linear editing system are often weak at best. Serious sound editors will need an audio-specific editing application such as DigiDesign's ProTools. For the rest, here's a quick rundown of what to expect:

- **Audio tracks and playback**. While many applications offer an unlimited number of audio tracks in a sequence, what's more important is how many tracks you can listen to, or *monitor*. The ability to monitor eight tracks is great, four tracks is decent, and two will drive you crazy unless your audio needs are very minimal (e.g., music or voice-over only).
- **Mixing**. *Mixing* is simply a fancy word for adjusting the volume of the audio in an edited sequence. For example, in a 30-second commercial spot, you might want to start with some music, have it fade down as a voice-over comes in, and then up again for a flourish at the end. If you don't mix your audio, you'll have the music track and the voice-over playing at the same level throughout the spot. All non-linear editing systems

FIGURE *Audio EQ and mixing interface in Adobe Premiere 6.0.*
3.13

support mixing, but some have better mixing tools than others (Figure 3.13). At the low end of the spectrum, you can mix by dragging a level indicator in your timeline (Figure 3.14). Although simple and intuitive,

**Level
slider (dB)**

**Level
indicator**

**Waveform
display**

FIGURE *The Final Cut Pro 2.0 timeline showing an audio track in waveform display with a*
3.14 *level indicator line.*

FIGURE *The Avid Xpress DV mixing interface with level sliders.*
3.15

dragging can be cumbersome. A more sophisticated way to set your audio levels is with a mixing interface that resembles a mixing board, with sliders for each audio track (Figure 3.15). Some applications will even let you adjust these levels "on the fly" as your tracks play in real time, while others may require rendering.

- **Equalization (EQ)**. In addition to adjusting the volume (or level), you may also need to adjust the bass (or low frequencies) and treble (or high frequencies) of your audio, also known as *equalizing*. In addition to the standard low- and high-frequency adjustment that you can do on a typical home stereo, with a professional equalizer you can also adjust the midrange frequencies and often anything in between (Figure 3.16). Software support for equalization can be weak in a typical non-linear editing system, but you can often add a plug-in to improve the toolset at hand.

- **Audio effects and filters**. Just as you can apply filters to an image to create special effects, you can also filter your audio to create special sound effects, such as reverb, echo, pitch-shifting, and so forth. Some filters let you make a voice sound as if it's coming over the telephone, and others let you remove a high-pitched hiss in the background. As with video effects, many prebuilt audio effects are too specific for sophisticated editing needs.

- **Audio scrubbing**. Another tool to look for is the ability to *scrub* audio. Scrubbing means that as you scroll through your audio track, the audio

FIGURE *The DPS Velocity effects editor showing Luma keying and keyframes.*
3.16

plays at the rate that you are scrolling. This helps you find the start or end of a specific sound, a feature you'll need if you plan to do much dialogue or music editing.

- **Subframe editing**. Subframe editing allows you to make sound edits in increments smaller than a frame. Since audio isn't divided into frames, this feature can help you make more refined sound edits and avoid pops at sound cuts.

TIP

Third Party Plug-Ins
There are a growing number of companies that develop plug-ins for different software products. Most of these are for video effects, but there are tons of audio plug-ins as well. Be aware that just as there are different file formats, there are different plug-in formats, too. Most video effects will be either Adobe Premiere or Adobe After Effects compatible, while audio plug-ins will come in the TDM, Premiere, or AudioSuite formats. Check for compatibility with your software before you buy.

Digital Origin EditDV 2.0

(Mac/Win) EditDV is a small but solid editing application. What it lacks in features, it makes up for in ease of use and elegant interface design. Rather than giving the user the standard drag-and-drop editing tools found in most cheaper software packages, EditDV sticks to the professional toolset, offering three-point editing, trimming, and support for SMPTE timecode and EDLs. The interface is simple and the learning curve isn't too steep, simply because EditDV doesn't offer the myriad options found in other applications.

In keeping with the limited but functional software interface, EditDV is designed strictly for DV-only projects. You can enhance performance by adding a capture board, like MotoDV, but as long as you've got a FireWire interface, EditDv is ready to go. For short, FireWire-based DV projects, and for those new to the non-linear editing world, EditDV is a good first step.

SPECIAL EFFECTS EDITING

These days, you'd be hard-pressed to find an editing application that doesn't offer a palette of hundreds of special effects. The question is, what type of special effects do you actually need? As with audio, serious special effects editors will want to use a separate 2D application, such as Adobe After Effects, or 3D application, like Softimage, Maya, or 3D Studio Max, to create special effects. As for creating effects in a non-linear editing system, look for a package that offers the basics: real-time dissolves, basic color correction, internal titling, motion effects, and compositing.

- **Transitions**. Transition effects create a bridge from one shot to another. The most common transition effect is the dissolve. Others include wipes, pushes, page turns, white flashes, and so on.

TIP

Keyframes
Keyframes let you change the parameters of an effect over time. For example, a standard 30-frame dissolve starts at 100-percent transparency and ends at 0 percent 30 frames later. By setting keyframes, you can tell the dissolve to start slowly, speed up, and then slow down again. In other words, keyframes give you control over the way an effect plays out, whether the effect is a color effect, a transition, or a matte key. If you're serious about adding effects to your project, you need an application that allows for keyframing.

- **Filters**. Filters are effects that are applied to a whole shot, as opposed to the transition between two shots. There are myriad filters available, but be sure your application allows for control over brightness, hue, saturation, and contrast. These will allow for basic color correction and image enhancement (Figure 3.17).

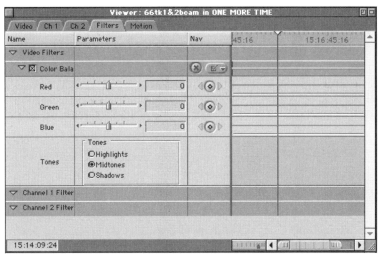

FIGURE **3.17** *Color correction in Final Cut Pro. If you're used to Adobe After Effects, you'll recognize the effects adjustment interface.*

- **Motion effects**. One of the most basic video effects is the ability to freeze, slow down, speed up, or reverse-motion a shot. Look for software that lets you set a variable frame rate from 0 percent (freeze frame) to 400 percent (the maximum most programs allow).
- **Compositing**. Compositing (or *keying*) simply means that two or more shots are somehow mixed together to create a single shot. The compositing tools offered by most editing applications (*luma keying*, *chroma keying*, and *matte keying*) are good enough for creating simple composites, but they usually lack the precision and control needed for serious blue-screen compositing work (Figure 3.16).
- **Titles**. Most editing applications have an internal titling tool, a separate interface where you can create and animate titles (Figure 3.18).
- **3D effects**. At best, the 3D effects offered by non-linear editing systems involve flipping or spinning the image. Any complex 3D animation must be created in a separate 3D animation application such as SoftImage, Maya, or 3D StudioMax (Figure 3.19).

FIGURE *The title tool in Adobe Premiere 6.0.*
3.18

FIGURE *3D effects editing in Avid Xpress DV.*
3.19

TIP

> ***Rendering vs. Real-Time Effects***
> *Most non-linear editing programs require that you render each effect before you can play it back in full motion. Many programs support special hardware that can render effects in real time. At the very least, look for a video card that supports one layer of real-time effects so that you don't have to render dissolves. If you know you'll be using lots of effects, invest in a video card with dual-stream processing.*

DPS Velocity

(Win) DPS Velocity 7.5 is available as both a turnkey system or as stand-alone software. The turnkey Velocity offers real-time, dual-stream playback and is capable of capturing and outputting uncompressed D1-quality video thanks to the DPS Reality board. The breakout box is one of the most desirable features, and includes just about every sort of input and output you can imagine, including digital audio in and out (check out the picture of it in Chapter 4, Figure 4.19).

The editing interface uses the cumbersome A/B-style timeline, but is otherwise elegant and responsive. Features include unlimited audio and video tracks, multiple levels of Undo, trim mode, and audio tools for mixing and equalizing that surpass most other editing applications on the market. Velocity's true strength lies in its effects capabilities, including real-time color correction with a waveform monitor and vectorscope. High-end features include solid EDL support, 24-fps time base option, subpixel rendering, and grouped clips.

The documentation that comes as part of the Velocity package offers a great set of learning tools and includes a VHS tape with footage for use in the tutorials.

OUTPUTS

Hopefully, you already know what kind of outputs you may need, whether they're high-quality broadcast masters, VHS tapes, or streaming media for the Web. Most of the features described here depend on having the right hardware in your system:

- **High-quality video resolutions**. If your goal is to create high-quality masters from your own editing system, you need a software/hardware package that offers high-quality video resolutions, preferably *uncom-*

pressed, or *D-1 quality*. Most FireWire-based DV editing systems only offer a single resolution, because you're actually capturing a clone of what's on tape (more about the idiosyncrasies of the DV format in Chapter 4).

- **Outputting to videotape**. If your project is fairly short, you shouldn't have too much trouble outputting to videotape with any of the non-linear editing products on the market. However, if you want a higher level of control, or if you want to output your project in pieces, you'll need software (and hardware) that supports frame accurate control of your video deck (more about deck control in Chapter 5, "Video and Audio Hardware"). Look for software that supports both *insert* and *assemble* edits when laying off your project to videotape (Figure 3.20).

- **EDLs**. Most of the editing products on the market support edit decision lists, or EDLs. There are several types of EDL formats, and these formats are based on the different hardware-based online editing systems that are found at professional postproduction facilities. CMX format EDLs are now the standard (Figure 3.21).

FIGURE *The print-to-tape interface in Apple Final Cut Pro.*
3.20

FIGURE *Exporting an EDL with Avid's EDL Manager.*
3.21

- **Cut lists**. Cut lists are the film equivalents of EDLs. They are given to a negative cutter, who will then conform the negative at the lab to match the locked edit of the film. Most of the editing applications described in this chapter do not support cut lists. Instead, you'll have to use a secondary software product such as Focal Point Systems' Film Logic.

- **OMF files**. Open Media Framework files are special media files that allow you to export an edited sequence, including the associated media files, timecode information and handles, if desired, as a single stand-alone file. This is especially useful when moving audio from the editing system to a digital audio workstation for sweetening.

- **Exporting media files**. Still images, audio, QuickTime, video for windows, other video formats, etc. Most applications support any format you may need.

OTHER CONSIDERATIONS

- **Technical support**. Some companies charge a service fee for technical support.
- **Training classes**. The more popular the application, the more likely you'll be able to take a class to learn to edit with it. (Hopefully, if you read this book you won't need a class, but . . .)
- **Tutorials**. A good tutorial can save you a lot of time and money spent on the aforementioned expensive workshops.
- **Free minor upgrades**. Some companies offer minor upgrades for free; other companies charge.
- **Documentation**. Do you need to buy a "third-party" manual? Some docs are great; others seem like a bad translation from another language (e.g., Fortran).
- **User base**. The more popular the editing system, the easier it will be for you to rent it, impress fussy clients, hire experienced editors and assistant editors, find competent technical support, and so on. The professional industry standard is the Avid Media Composer, but Apple Final Cut Pro has started to carve out a niche in the lower-budget cable TV (Oxygen Network, for example, uses Final Cut Pro editing workstations) and independent feature market. Industrial and institutional producers are less committed to any one system, as are streaming media producers.

TIP

Product Watch

If you're waiting for the latest gear, most manufacturers try to unveil big innovations at trade shows. Windows software is usually revealed at Siggraph and COMDEX, Mac software often appears at the MacWorld Expos, and professional video gear is usually unveiled at the NAB convention in April. It's also a good idea to read the trades so that you don't buy something that's about to get upgraded.

OTHER SOFTWARE YOU MAY NEED

Chances are you'll need to enhance your system with some additional applications:

- **Audio editing software**. Since most non-linear editing systems have somewhat limited sound-editing tools, you'll need a special sound-editing application if you're serious about sound. Sound editing applications let you make edits smaller than a frame, a necessity for cleaning up dialogue.

Pro Tools from DigiDesign is the software of choice for most professional sound editors, but to get it to perform at its best you'll need a lot of dedicated hardware. *Peak* and *Sound Forge* are two other popular sound-editing applications that don't need the professional hardware associated with Pro Tools.

- **2D effects**. If sophisticated 2D effects are important for your project, you may need to step outside your editing software application. *Adobe After Effects*, *Adobe Photoshop*, and *Commotion* are popular choices.

- **3D effects**. While offered with many non-linear editing applications, these aren't truly 3D; they're more like 2-1/2 D. If you really want to create a 3D environment or character, you'll need special 3D animation software such as *Discreet Studio Max*, *Maya*, or *Softimage*.

- **Logging software**. Not everyone can afford to log their tapes on a full-featured editing system; others want to log on a laptop or Palm Pilot on the set, and some producers want to log at home or in their office using their own computer or laptop. *The Executive Producer* (Imagine Products) for Windows and Mac, *Play Pocket Producer* software for the Palm Pilot, and *Pipeline Autolog*, although discontinued, are all good choices for logging. Also useful is *Avid's Media Log*, which comes free as part of the Media Composer and Xpress software packages.

- **Film matchback software**. Trakker Technologies' *Slingshot* and Focal Point Systems' *Film Logic* are two standalone software applications designed to help you generate an accurate cut list for a film project. Unless your editing application has built-in film matchback software, such as *Avid FilmScribe* for Xpress and Xpress DV, you'll need a separate application to help you out.

- **Web authoring software**. If your project is destined for the Web, *Terran Cleaner Pro 5* is pretty much a necessity. Cleaner will take your audio and video and optimize it for playback on the Web. RealSystems' *Real Player* and Apple *QuickTime Pro* will help you deliver streaming media in those formats. *Macromedia Flash*, *Adobe Live Motion*, *Macromedia Shockwave*, and *Macromedia Director* are all 2D animation programs that you can use to create more sophisticated, interactive outputs for the Web. Unique applications like *Wildform Flix* (Windows only) can turn your video into a Flash player file.

- **DVD authoring software**. The market is being flooded with DVD authoring software, and nowadays it may come bundled with your editing software. Look for a package that meets your specific needs. DVDs may soon replace VHS tapes as the medium of choice for viewing works-in-progress.

- **Utility software**. *Norton Utilities* and *Tech Tool* are great for keeping your computer in good working condition. Look for software that your editing application manufacturer recommends, but beware: some of these utilities

can actually make your system perform worse. For example, some Avid products purposely defragment storage drives for optimal performance, so Norton's Speed Disk is not a good idea.

TEST DRIVE

ON THE CD/DVD

Once you've purchased the necessary software and hardware, the price of a good editing system will rival that of a car ($5,000–$30,000)—and you wouldn't buy a car without driving it and checking it out first. As you may be aware, we've included as many demo applications as are available on the CD-ROM/DVD-ROM. You should consider working through some of the tutorials in this book using more than one editing application. Some companies do not offer demo versions of their software. If you are seriously interested in one of these products, we suggest you go to a vendor who has a system that you can spend a little time playing with. Attending a trade show can be a good way to see many systems in one place, but be aware that these systems will be backed up with top-of-the-line hardware. If it's a turnkey system, you might even consider renting one for a few days, preferably with similar hardware that you'll be purchasing. This might cost a few hundred dollars, but you'll save money and frustration in the end.

DESERT ISLAND PICKS

There are a few features no editor should have to live without: real-time playback for cuts-only edits, three-point keyboard editing, SMPTE timecode, remote device control, and EDL support are all crucial if you're planning to edit a project of any sort of complexity. All of these software features depend on having the right kind of hardware to back them up, which brings us to the next chapter.

CHAPTER

Computer Hardware

In This Chapter

- Choosing a Video Input Device
- Videotape Formats
- The Video Signal
- The Audio Signal
- The DV Format
- Compression and Codecs
- Computer Basics
- Storage Devices

External Storage Drives Video Input Device CPU Computer Monitor

For many people, dealing with editing hardware will be the most challenging part of the process of building an editing system. However, building your own editing system has a decided advantage over buying a pre-assembled or *turnkey system.* When you assemble a system yourself, you will cease to see your system as an object, and will begin to understand it as a series of interconnected parts. Even if you're buying a turnkey system and a service contract to go with it, you'll find it's worth knowing what goes on under the hood. You'll be able to help troubleshoot problems that arise in the future and solve simple problems on your own, instead of waiting for tech support to show up or answer the telephone.

The first step of the process is research. You've chosen a software application; now it's time to build a system that will work with that particular application. The list of minimum system requirements found on the outside of the software box is usually exactly that: the bare minimum. Non-linear editing requires a lot of computer processing power to work well, and most software manufacturers also have a list of suggested system requirements that are usually quite different from the minimum.

Next, look at the software manufacturer's list of supported hardware, usually available at their Web site. Typically, this is a list of video cards, FireWire devices (such as cameras and video decks), and storage drives that have been tested by the software manufacturer and are guaranteed to work with their software. There are a number of untested products that might very well work with your system, but that's generally an expensive risk to take.

Every editing system needs four basic computer components: the video input device, the computer itself, the computer monitor, and the external storage

External Storage Drives **Video Input Device** **CPU** **Computer Monitor**

FIGURE **4.1** *No matter what type of editing system you end up with, these are the basic computer hardware components you'll need for it to work properly.*

drives (Figure 4.1). You may be able to get away without purchasing external storage drives, but it's unlikely, given the large size of digital video files. The first section in this chapter covers video input devices, including a chart listing the features of many of the video capture boards and FireWire devices currently on the market. The second section covers computer basics: CPUs, RAM, monitors, and more. The last section covers storage devices, from drive arrays to media towers. Chapter 5, "Video and Audio Hardware," covers video and audio hardware; Chapter Six, "Setting Up an Editing System," walks you through putting it all together; and Chapter 7, "Setting Up and Managing a Project," helps you test your system and set up a first project.

A Rose Is a Rose . . .
FireWire, iLink, and 1394 are all different names for the same thing.

TIP

CHOOSING A VIDEO AND AUDIO INPUT DEVICE

After choosing editing software, choosing a video and audio input device is possibly the most important decision you'll make. The video input device determines the quality of the digital video you capture, what video formats you can capture, and what video formats you can send back out to videotape.

First, a quick word of clarification: Most video input devices are called video boards or capture boards, but if video is going into your computer via FireWire, it's not technically a video capture board. As you'll see in the sidebar, "More about the DV Format," later in this chapter, FireWire is the exception to many digital video rules. Therefore, "video input device" really means either a video board or a FireWire device.

Now, if you've done your homework, you should be armed with a list of video and audio input devices that are approved by your software manufacturer of choice, which will make it easier when you have to choose from the myriad products on the market. A notable exception is Adobe Premiere, for which there are many options. Links to these lists are available at *www.dvhandbook.com/ NLEcompatibility.*

Software/Hardware Bundles
Many editing software and video card manufacturers offer bundled packages. They guarantee compatibility between the video card and the editing application, often at a reduced price (Figure 4.2).

TIP

FIGURE *This hardware/software bundle from Matrox includes Adobe Premiere editing*
4.2 *software and other video applications along with the Matrox RT2000 board set.*

VIDEOTAPE FORMATS

The video format you decide to work with will help you decide which video input device works best for you.

There are many different videotape formats out there today, and that number is growing. Appendix A, "Videotape Formats," provides a detailed, technical description of each format that's still in practical use, but here's a cheat sheet for the most popular choices today, ranked from consumer ($) to professional ($$$$):

- **VHS**. Almost everyone has a VHS deck at home, and therein lies the usefulness of the low-quality VHS format. With a VHS deck attached to your editing system, you can make viewing copies of your project that anyone can take home and watch. On the other hand, video that was shot with a VHS camcorder or dubbed to VHS is too low quality for most serious producers.

- **Digital-8**. The digital cousin of Hi-8, Digital-8 is a decent-quality consumer format that, although FireWire compatible, has very little practical use in the editing room. Instead, go with the DV format and dub any Digital-8 source tapes to miniDV.

- **3/4-inch Umatic**. This old workhorse of the broadcast television industry is still around, and you might find that you have cheap or free access to 3/4-inch equipment. It's highly unlikely that your project will be shot on 3/4-inch; however, you might have 3/4-inch telecine tapes and/or work-tapes and you might make 3/4-inch outputs, although the latter is fairly unlikely unless you work for a studio or TV production company that still uses the format (and there are quite a few who still do). Three-quarter-inch tape was once the standard for "broadcast quality" in the United States.

Telecine

If your project was shot on film, the film negative must be transferred to videotape before you can edit using your non-linear editing system. This process is called a telecine. *The most common format for telecine tapes is Beta SP, although 3/4-inch telecines are often still available. DV format telecines, particularly DVCAM, are becoming increasingly common.*

NOTE

- **DV**. We've all heard about DV, and much of the hype is well deserved. DV offers high-quality video and, thanks to the FireWire interface, allows you to build an editing system with minimal computer and video hardware needs. Check out the sidebar later in this chapter for more about this occasionally idiosyncratic format. By the way, if you're wondering why DV is listed here, but not miniDV, it's because miniDV is simply the name for the small tape cartridges used in DV format camcorders. miniDV isn't a videotape format.

Bigger Is Better

When it comes to videotape cartridges, the bigger they are, the better. There's more room on the tape to record the signal, and larger tapes are sturdier than small cassettes. Editing can involve a lot of fast-forwarding, pausing, and rewinding; all of which can wreak havoc on a tape and result in dropouts. The bigger the cassette, the more it can withstand the strain of frequent use. For this reason, it's often advisable to transfer your tiny miniDV tapes to a bigger format such as DVCAM or DVCPro for editing.

TIP

- **DVCAM and DVCPro**. DVCAM and DVCPro are the next step up from DV. The actual technical specifications aren't that different, but the associated hardware, such as cameras and video decks, is of higher quality. The other big difference is that DVCAM and DVCPro tapes come in the larger size, and are therefore more stable and reliable for use in an editing environment. Of the three DV-based formats, DVCAM is probably the most popular

for use in broadcast postproduction. DVCPro offers slightly higher quality than DVCAM, but the practical differences between the two formats are negligible, and all three DV-based formats are somewhat compatible with each other. For example, both DVCAM and DVCPro decks can play miniDV tapes, although an adapter may be required. (See Table 5.1 for more on video deck compatibility.)

- **Betacam SP**. Beta SP is has been the professional industry standard since its inception in the early 1980s, but this niche is being carved away from below by DVCAM and DVCPro and from above by Digital Betacam and the HD formats. Nevertheless, it's accepted almost everywhere as both a shooting format and a mastering format, and just about every sort of professional service provider—from film labs to postproduction facilities—works with this format.

- **Digital Betacam**. Nowadays, Digital Betacam is the high-end shooting and mastering format of choice, but it comes at a price. If you want to do an online edit on your own system, Digital Betacam is a good choice, and you can rent a deck for a day for about $900—a worthwhile investment if you're serious about quality.

- **D1**. Today, D1 video is synonymous with the best. Video cards taunt their "D1-quality" inputs and outputs (more on this in the section titled "Compression" later in this chapter). For all practical purposes, D1 is strictly a mastering format. You probably won't encounter D1 equipment outside of a postproduction facility—at upwards of $200K for a video deck, the gear is simply too expensive for anyone except a company dedicated to mastering in this format on a regular basis.

- **HD formats**. High-Definition video, or HD, has gotten a lot of press lately. HD image quality rivals that of film, and the widescreen format makes it a great, although expensive, format for feature films shot on video. In addition to the extra investment for cameras and video decks, you'll also need an editing application, an external video monitor, and a video capture card that supports the 16:9 screen ratio. All three major video equipment manufacturers—Sony, JVC, and Panasonic—have their own HD format. These are discussed in depth in Appendix A.

THE VIDEO SIGNAL

Next, you need to find a video input device that can handle the videotape formats with which you'll be working. The connectors, or *video signal interface*(s), on your video input device must match those on your video deck (Figure 4.3). There are, to simplify a bit, five types of video signal interfaces, and each is identified by the type and configuration of connectors it requires:

FIGURE *The connectors on your video device must match those on your video deck or*
4.3 *camcorder in order to cable them together.*

- SDI digital video
- Analog component video
- FireWire-based digital video
- S-video, aka analog Y/C video
- Analog composite video

Digital vs. Analog?

Just because something's digital, doesn't necessarily mean it's of better quality. It's arguable whether a FireWire-based digital video interface is better quality than an analog component video interface. Rather, video (and audio) signal quality has more to do with the video decks that support these interface types and how they were recorded. Generally, video decks that come with analog component outputs, such as DVCAM, DVCPro, and Betacam SP, are of better quality than DV decks.

TIP

Analog component video consists of three separate cables, each of which carries a different part of the color video signal, resulting in the highest quality analog video signal. All Beta SP decks and most professional digital video decks offer analog component video.

If your editing work falls into the professional realm, but not the extremely high end of it, you'll probably need a video card with analog component inputs. If you want to online from your editing system to Betacam SP, you'll probably need a video card with analog component outputs.

Analog component video uses three BNC connectors (Figure 4.4).

FIGURE *BNC connector.*
4.4

Acronyms

TIP

Don't be intimidated by all the acronyms floating around the digital video world; they simply make a mouthful of techno terms more manageable. I/O stands for Input/Output; A/V stands for Audio/Video; D/A stands for Digital/Analog; and OS stands for Operating System.

Analog composite video consists of one cable that contains a single RGB video signal. This is the lowest-quality video signal around. Consumer VHS decks are usually analog composite. The cheapest cards on the market will offer analog composite video I/O, but this doesn't necessarily mean they're bad if they suit your needs.

Analog composite video uses one *RCA connector* (Figure 4.5), or one BNC connector (Figure 4.4), or, more rarely, one mini connector (Figure 4.9).

S-video (aka analog Y/C video) consists of two separate parts of the video signal contained in a single cable. Although not as high quality as component video, S-video is significantly higher in quality than composite video. S-video connectors are found on better VHS decks, and almost all digital video decks have analog S-video I/O.

S-video uses one *S-video connector* (Figure 4.6).

FIGURE *RCA connector.*
4.5

FIGURE *S-video connector.*
4.6

Staying Digital

If you send your digital video or audio signal through an analog cable, you've just turned it into an analog signal. This process is also known as a D/A CONVERSION. *This is fine if that's what you intended to do, but if you're committed to working with a digital video signal, be sure that the signal stays digital throughout your equipment chain.*

FireWire-based digital video is a unique entry in this list. That's because "FireWire" isn't a type of video signal interface; instead, it is what's known as an *I/O protocol.* In plain English, that means that FireWire is simply a way of getting data in and out of your computer—any type of data, whether it's video, Microsoft Excel spreadsheets, or saved games of Diablo II. The speed at which FireWire moves things around, aka the data transfer rate, is fast enough to move the digital video files of the DV format and play them in real time. The DV format is the only format that uses FireWire, because the DV format only needs a sustained data transfer rate of 3.6 kilobytes per second. The other digital video formats, such as Digital Betacam, would require a much faster data transfer rate.

If you are only using FireWire-based digital video, you don't need a video card; you simply need a FireWire interface. If you have a new Macintosh, you already have one or two built into your system. If you have a Windows machine, you may need to add a FireWire interface card. The advantage of buying a FireWire-based video card—Pinnacle Systems' DV500, Canopus' DVRexRT or Matrox' RT2000 (Figure 4.2) or RT Mac—is that you can get other I/O options, such as S-video or composite video, as well as playback of two or more layers of video and/or graphics in real time.

FireWire-based digital video uses either a 4-pin FireWire connector (Figure 4.7) or a 6-pin FireWire connector (Figure 4.8).

FIGURE *A 4-pin FireWire connector.*
4.7

FIGURE *A 6-pin FireWire connector.*
4.8

SDI-based digital video is similar to FireWire, except it offers the huge data transfer rate—270 MB/second to be exact—needed for the high-end uncompressed digital video formats. Even the professional DVCAM and DVCPro decks eschew FireWire in favor of SDI. SDI has many advantages for the professional editing environment. Moreover, the prices of SDI video boards have gotten so low that they can cost about the same as component analog boards, making it a viable option outside the professional postproduction facility. Unfortunately, the minimum system requirements are also much greater—most SDI-based video boards require 64-bit PCI interface for uncompressed video and extremely fast SCSI storage drives—and the associated video hardware will cost quite a bit of money.

THE AUDIO SIGNAL

Audio doesn't get the same amount of attention as video when it comes to capturing, but it's important in its own right. You can use the audio I/O on your video capture board, or spring for an additional audio card if your video board doesn't offer the sort of audio connectors you need. Just as with video signals, audio signals also have different types of interfaces.

Analog audio can be connected with several different types of connectors. Low-end consumer products often have only one mono mini (Figure 4.9) or RCA (Figure 4.5) connector. Better consumer equipment offers two channels of stereo audio with RCA connectors. Many kinds of professional audio equipment use *phono connectors*, also known as *1/4" connectors* (Figure 4.10), and the best analog audio signal interface is a pair of *balanced XLR connectors* (Figure 4.11). You can use adapters to make different types of analog audio cables compatible with each other, but you must be careful to maintain the integrity of the audio. Switching from balanced to unbalanced connectors can introduce hums in the audio signal.

FIGURE *Mini connector.*
4.9

FIGURE *Phono connector.*
4.10

FIGURE *XLR connector.*
4.11

Balanced Audio

Balanced audio connectors have a special wiring scheme that reduces the amount of noise or hum introduced into the audio signal by the cable itself. Most XLR connectors are balanced, but not always. Phono connectors can also be balanced. Remember, balanced cables won't result in balanced audio if your capture board doesn't support it.

Digital audio offers the best quality and comes in two flavors, AES/EBU digital audio and SP/DIF audio. If you want to work with digital audio, you'll have to make sure your capture board supports the format you need. Digital audio uses XLR, BNC, or RCA connectors.

Audio and FireWire

FireWire cables carry the audio part of the signal embedded in the data stream that also contains the video signal and other information such as timecode.

THE BOTTOM LINE

Now that you've considered the various videotape formats and signal interfaces, you need to answer the following questions: What videotape formats will you use for source tapes, and what videotape formats will you use for masters? Will you have DV source tapes but a Digital Betacam final master, or will you stick with DV the entire way?

Breakout Box

Breakout boxes, when available, are an extension of the video board that connect to the board with a data cable and offer all the input and output connectors you'd typically find on the board itself. Because they have connectors on the front and are somewhat mobile, they make it much easier to change the cables in your system (Figure 4.12).

Most likely, you will have more than one type of source tape—say, DV and Betacam SP—and more than one type of mastering (or output) format—say, VHS, Betacam SP and Digital Betacam. Be aware that the video deck itself determines the type of video signal interface, and most professional video decks have more than one type of video signal output. Similarly, most higher-end video cards have more than one type of video signal input, so you may have some choices if you're purchasing equipment in the higher end of the spectrum (Figure 4.12).

FIGURE *This breakout box from DPS may look daunting, but it offers the I/O flexibility that's*
4.12 *ideal for any editing system.*

More about the DV Format

It's impossible to mention "independent film" without mentioning the DV format in the same sentence. But what, exactly, is DV, and why is it such a big deal?

First, you need to understand what's meant by the phrase "FireWire-based DV." FireWire-based DV means DV format video that is transferred from one FireWire device—a video deck, for example—to another FireWire device—your computer—with a FireWire cable. Depending on your video deck and your video input device, you could also transfer footage from a DV video deck to your computer using a different video signal interface, such as analog component cables. There's nothing necessarily wrong with this, but using FireWire to transfer DV format video has definite advantages. The biggest one is that the video playing on your camcorder is already digital, and by transferring it with FireWire, you are essentially copying digital files off the videotape onto a storage drive. That means that nothing is lost in the process.

For all of you who are familiar with non-linear video editing, FireWire-based DV editing works in a unique way: the compression and decompression is performed by external DV hardware, not your computer. As a result, the hardware in a FireWire-based DV editing system is set up differently from other editing systems (Figures 4.13 and 4.14). Because the hardware in your video deck or camcorder performs the decompression, you absolutely must have an external video monitor hooked up to the video deck or camcorder. Without an external video monitor, you won't be able to see full-resolution playback of your DV footage as you edit, unless you have a special video board installed in your system.

With an editing system that doesn't rely on FireWire, such as the one illustrated in Figure 4.14, it's not necessary to always have a video deck and video monitor attached to your system. After capturing the video, you could, for ex-

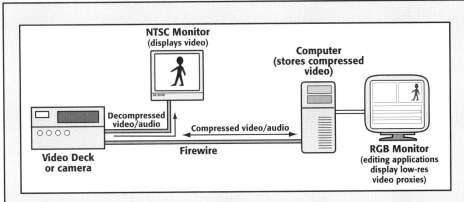

FIGURE *DV workstation diagram.*
4.13

FIGURE *Non-DV workstation diagram.*
4.14

ample, remove the deck and even the video monitor from the system and con-
tinue to work. (Editing with a video monitor attached is always recommended;
for more on this, read the section on monitors in Chapter 5.) However, with a
system that relies on FireWire, you must have these components attached to
your system to be able to edit properly.

You're probably wondering why DV is supposed to be so cheap if you need
all this equipment. There are a couple reasons: First, if your computer has a
built-in FireWire port, you don't need to purchase a special video capture
board unless you also want to capture other types of video directly or playback
special effects without rendering them first. Second, DV format video decks
are very cheap compared to other professional format video decks, and you
can also use a DV camcorder as a deck. Finally, DV is a cheap acquisition for-
mat—cameras are cheaper and tapes are cheaper.

The upshot is that if you already own a computer with built-in FireWire, a DV camcorder, and a decent TV set, you can have your editing system up and running today. You may eventually want to swap out the camcorder for a video deck to save wear and tear on the camera, and you may want to invest in a better monitor and return the TV set to your living room, but for all intents and purposes, you're ready to go. And that, along with the relatively high quality versus cost, is the reason why so many people are excited about DV.

FIGURE **4.15** *This Xpress DV turnkey system from Avid Technology features the Xpress DV software and a FireWire-based Canopus DV Raptor board inside a 500 MHz IBM Intellistation M Pro.*

CODECS

All digital video, as we know it, starts out as an analog electronic signal and gets turned into a digital signal; that is, it gets digitized somewhere along the way. Digital video formats—DV, Digital-8, and Digital Betacam—are digitized in the camera. Analog video formats are digitized by the video card in a computer. No matter where the digitization happens, a codec is used to create the resulting digital media. Codecs, short for *co*mpressor/*dec*ompressors, are complicated formulas that are able to take a continuous analog video signal and break it down into digital pieces.

Codecs can be either *lossy* or *lossless*; that is, they either degrade the image quality, or leave it unaffected. Many codecs take longer to compress than they do to decompress (these are called *asymmetrical*). Most of the codecs that ship with QuickTime are asymmetrical. For example, although it may take hours to compress a QuickTime movie using Cinepak or MPEG, the computer can decompress it and play it back in real time.

There are many different types of codecs, and many ways your video signal can be compressed and decompressed. High-compression/low-quality codecs are used for Web or CD-ROM delivery, and low-compression/high-quality codecs are used for higher-quality playback. Depending on your equipment, you'll either be working with a *hardware codec* or *software codec*. Hardware codecs are a part of the chipset in your video card or DV camera. If you have a video board installed in your computer, you'll probably be using its hardware codec to play back video in your NLE. Software codecs add video playback functionality to a computer and compress video when you export it from your editing software to another application or back to videotape. By adding the appropriate system extension to the operating system, software codecs let you play video digitized by a Media100, an Avid, or most other editing applications even if you don't have the proper hardware installed (Figure 4.16).

The native codec for your editing system will fall into one of these three categories:

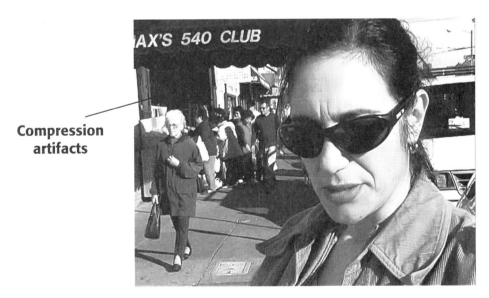

Compression artifacts

FIGURE *Compression artifacts in a frame of QuickTime video using Sorenson compression.*
4.16

- **DV-based**. Editing applications and video boards designed to work with FireWire-based DV video (whether it's Digital8, DV, DVCAM, or DVCPro) use the hardware DV codec in the camera or video deck to compress and decompress the video on a DV videotape. After you transfer that media to your storage drive and use it in an editing application, the software DV codec is decompressing the video for playback and compressing it to send it back out to record onto videotape in your VTR or camera. Some applications such as Digital Origin's Edit DV also offer additional software DV codecs, like Digital Origin's SoftDV, that offer more control and extra features than the stock DV codec used by your OS.
- **M-JPEG**, or **Motion-JPEG**. M-JPEG is a codec with several quality levels available, ranging from very lossy to not too noticeably compressed. Most better-quality video boards that offer digital and analog component I/O, such as Avid Meridien, DPS Reality (Figure 4.17), and Matrox DigiSuite LE, use M-JPEG codecs.
- **MPEG-2**. MPEG-2 is a codec that was originally developed for full-frame broadcast-quality video. DV video boards that offer analog composite I/O (e.g., Pinnacle Systems' DV500, Canopus' DVRexRT or Matrox' RT2000) usually use MPEG2 to compress and decompress analog video. MPEG-2 is also used for DVDs and to broadcast certain types of Digital Television (DTV) (see Appendix B, "Video Standards" for more on DTV).

QUICKTIME AND AVI

QuickTime and AVI (video for Windows) are two types of video architectures used by the operating system and the non-linear editing application in your computer. They determine how your system compresses, plays, and stores video. Codecs are components of the video architecture, and special codecs such as SoftDV and Sorenson work like plug-ins to customize your system for your editing application and improve the way your system handles video.

Uncompressed digital video doesn't, technically, require compression or decompression, but you really can't escape it altogether. When you send uncompressed video from your computer back to NTSC videotape, you'll have to deal with the fact that the YUV color space of NTSC video is much smaller than the RGB color space used by your computer. The uncompressed video will eventually be compressed to fit the NTSC color space and this is where problems occur with uncompressed video. Areas of fine color gradations, like the sky, can show *banding*. Instead of a smooth gradation, you'll see contoured areas of distinct colors (Figure 4.17). Uncompressed video with 8-bit sampling is notorious for exhibiting banding, while 10-bit sampling eases the transition to NTSC, thanks to more color and luminance information in the digital video signal.

Banding

FIGURE *Banding is a common problem for 8-bit uncompressed digital video.*
4.17

Other codecs such as RealSystems and MPEG are common export formats for the Web, but aren't native to any of the non-linear editing systems discussed in this book. They're covered in Chapter 12, "Outputs."

Avoid Recompression

If your digital video was compressed by the DV codec in your camcorder or the M-JPEG codec in your video card, you must be careful to avoid recompressing it using a different codec, such as Sorenson video. If you export your DV video to lossy QuickTime codec, such as Cinepak, for use in a QuickTime-based application, such as Adobe After Effects, you'll be compressing the video a second time, which can lead to visible compression artifacts. You can always use a lossless QuickTime codec such as Animation, but you'll need more storage for the resulting large file.

TIP

Color Sampling Ratio

Quality varies greatly from one codec to the next, and one way to determine the quality is to look at the color sampling ratio. A component video signal consists of three signals bundled together: luminance (or brightness), chrominance minus red, and chrominance minus blue. These three signals are often abbreviated as Y:Cb:Cr. An uncompressed video format has four samples of each per pixel, so uncompressed video is notated as 4:4:4.

Since the human eye is more sensitive to luminance, or brightness and darkness, than to color, it's possible to remove half of the color information without a visible loss of image quality. This compression ratio is notated as 4:2:2. You've probably also heard 4:2:2 referred to as D1-quality, 601, or "uncompressed."

DV formats use 4:1:1 color sampling, which has half the amount of color information as 4:2:2. This is an amount of color reduction that is considered visible to the viewer. Because PAL video handles color differently, a color sampling ratio of 4:2:0 in PAL is equivalent to 4:1:1 in NTSC.

Sometimes, you'll see the color sampling ratio notated as 4:2:2:4 or 4:1:1:4. This extra component is the *alpha channel*, or transparency information. For reasons not worth going into, this component always has four samples per pixel.

VIDEO CARDS AND PERFORMANCE

Video cards are responsible for a lot more than simply getting video and audio in and out of your computer. A good video card is also the key to editing system performance and, as mentioned in Chapter 3, offers some features that you might not want to go without:

- **Playback and rendering**. Some video cards require that you render before you can play back full-screen video in real time; others support real-time cuts-only playback; and still others support real-time playback of two layers—usually a layer of video with a transition effects like dissolves, a layer of video with a filter, such as color correction, or a layer of video with a superimposed effect, like titles. At the top of the line, you get real-time playback of video and several layers of effects, including 3D effects. No matter how good your card is, some rendering is inevitable, and the speed at which your computer renders is also dependent on your video card, the codec it uses, and the speed of your storage drives.

- **Audio I/O**. Not all video cards come with audio I/O. Make sure your card offers audio I/O, and if it doesn't, be aware that you'll need to add an audio card to your computer as well.
- **Breakout box**. Some video cards come with an external breakout box that has all the connections offered by the card itself. Breakout boxes allow for easier access to the inputs and outputs, so that you don't have to crawl behind your computer to change a cable.
- **NTSC and PAL switchability**. If you want to be able to go from NTSC projects to PAL projects, make sure your video card supports both standards.
- **Pixel shape**. Your computer screen—as well as many video formats—uses square pixels. This means that a screen with a resolution of 640 × 480 pixels will have an aspect ratio of 4:3. DV, DVCAM, DVCPRO, and D1 (sometimes incorrectly referred to as CCIR-601) all use rectangular pixels and require pixel dimensions of 720 × 486 pixels to achieve the same 4:3 aspect ratio. But wait, it gets worse: NTSC D1 formats use vertically oriented rectangular pixels, while PAL D1 formats use horizontally oriented rectangular pixels. Make sure your video card supports all the pixel shapes you'll be using.

2D and 3D Graphics Cards

If you'll be doing a lot of graphics or special effects, your system may benefit from the addition of a 2D or 3D graphics accelerator card. These cards offers additional real-time layers, faster rendering, and often includes special plug-in software that adds special effects to your editing application. Some graphics cards are designed to accompany a specific video capture card, while others stand alone. Be sure to refer to your software and video card manufacturers' recommendations before you buy.

TIP

Pedal to the Metal

Some things, such as long edited sequences and many layers of effects, are very hard for non-linear editing systems to handle. They're the equivalent of flooring it in your car, but are you driving a Porsche or a Ford Escort? The video card equivalent of a race car is dual-stream processing. To get dual-stream processing, you must have two video cards, either a primary PCI video card with a daughter board piggy-backed onto it, like the Avid Meridien 3D

> board set, or a pair of PCI cards that connect with a special bus, like the DPS Velocity 3D board set. By having two pieces of hardware dedicated to processing media, your computer can handle two video signal streams at a time. Usually this means that you can play back more layers of video and effects at the same time, without rendering. But be aware, you must also be using a software application that's optimized for dual-stream processing.

COMPUTER HARDWARE

Processing power, flexibility, and the ability to upgrade are the keys to a good computer for non-linear editing. Because you may start out making home movies and end up with your own independent feature film, you need a system that can grow with your needs

The key to this growth is the room for expansion, whether that means adding a SCSI accelerator card for fast external storage drives, a pair of capture cards for dual-stream processing, a 3D effects card, or a second monitor. The more ins and outs on your computer, the better—PCI slots, serial connectors, FireWire connectors, secondary monitor connectors, RCA audio connectors, S-video connectors, headphone and speaker jacks, and so on.

WHAT'S IN A TURNKEY?

If all this computer talk isn't for you, you might benefit by purchasing a turnkey system (Figure 4.18 and Figure 4.15). You'll get a CPU, the necessary amount of RAM, a video capture card or FireWire interface, cables, operating system software, and editing software. You probably won't get a computer monitor (or two) or any of the necessary video and audio hardware (see Chapter 5) you'll need for a complete editing system, although some manufacturers and third-party packagers will include these items for a price. You'll also have to purchase some sort of service agreement, or else you'll have to put it together yourself. However, some of the best systems around are turnkey systems, and you'll have the security of knowing that it will work flawlessly.

Another option is a stand-alone hardware-based video editor, such as the DraCo Casablanca, that provides full DV editing with storage, editing software, and digital I/O in a single, plug-and-play video appliance. Such systems are great for the user who absolutely does not want to deal with a computer.

On the downside, choosing a turnkey system or a stand-alone editor may lock you into a proprietary environment for which you may have few expansion and

support options. If you want flexibility, look for a turnkey system from a company that sells stand-alone software and hardware, like the DPS Velocity system in Figure 4.17 and the AVID Xpress DV system in Figure 4.15. These companies sell turnkey packages, but have also approved other CPUs and video capture boards for use with their software. With these systems, you'll be to able upgrade parts of the system as you need to, rather than upgrading the entire turnkey. However, be careful as you upgrade so as not to void the warranty.

CPU

The CPU, or central processing unit, is the brain of your system. For video editing, you want the fastest machine you can afford. Editing can take a long time even if you aren't sitting around waiting for your edited sequence to start playing! For IBM users, this means a 300mHz Pentium III or better (Figure 4.18); for Macintosh users, this means a 300mHz G3 or better (Figure 4.19). If you have an older system, you can upgrade by replacing your motherboard or adding accelerator cards and special co-processors.

FIGURE *DPS Velocity turnkey editing system on IBM Intellistation with CRT monitor, optional*
4.18 *breakout box, and Ultra-wide SCSI storage.*

FIGURE *300 MHz Macintosh G3 with Final Cut Pro and Canon GL1 FireWire-based DV*
4.19 *camcorder.*

It's also important to make sure you have enough PCI slots available. A PCI slot is simply an empty space inside the CPU that gives you room to customize your computer. Each CPU comes with a set of input and output connections, or ports that let you attach peripheral hardware to your CPUs. If your computer doesn't have all the ports you need, you're going to have to add them yourself by inserting PCI cards into the empty slots. For example, if your computer comes with a built-in FireWire port, as do all new Macs, you won't need a PCI slot for a FireWire interface card. However, if you want to add a second monitor and your computer doesn't come with a built-in second monitor interface, you'll have to add one with a PCI card.

Most new Windows machines have six PCI slots, most new Macs have four or five PCI slots, and laptop computers have none. As long as you don't have any other PCI cards in your system, three slots will probably suffice, because you'll use one slot for the video capture card or FireWire interface card, one slot for the storage drive interface card, and a slot for either a secondary video capture card for dual-stream processing and/or 3D effects or for a secondary monitor card .We've already discussed video PCI cards, and we'll talk more about these other specific types of PCI cards throughout the chapter.

Special Hardware for Apple PowerBooks
*Magma makes PC cards that can add up to six PCI slots to the
Macintosh G3 PowerBooks (Wallstreet and Pismo models). They've
been approved by DigiDesign ProTools and Media100, while other
cards such as Digital Voodoo (Figure 4.20) have yet to be tested.
Prices range from $700–$2,000. Ratoc makes SCSI and ultra-wide
SCSI PC card adapters ($130–260) and Xcarét makes 6–32gb ATA
expansion bay drives acceptable for FireWire-based DV editing.*

FIGURE *This Digital Voodoo D1 Desktop 64 A/V card has one 10-bit uncompressed*
4.20 *component SDI digital video input (BNC), two SDI outputs (BNC), and six
channels of AES/EBU digital audio.*

RAM

You'll need at least 128 megabytes of RAM to work comfortably in most non-lin-
ear editing applications. You'll need even more if you want to be able to work
in Adobe Photoshop or Adobe After Effects comfortably. No one ever regrets
buying "too much" RAM, so get what you can afford.

IBM OR MACINTOSH?

Most computer users already have a platform of choice; for the rest, here are
some factors to consider:

- Is the software you prefer limited to a particular platform? in:sync Speed Razor, DPS Velocity, and the stand-alone version of Avid Xpress DV only operate on the IBM platform, and Final Cut Pro only operates on the Macintosh platform—everything else is cross-platform.
- Will you need to interface with others using a particular platform? If your work is graphics heavy and your special effects or motion graphics artists work on Macs, you might prefer having a Mac yourself. However, the issues of cross-platform compatibility of file formats have decreased, so you shouldn't have too much trouble going back and forth across platforms these days.
- Are you going to be editing with FireWire DV-based video? If so, the Macintosh OS combined with QuickTime provides solid support for FireWire-based DV I/O and device control. In addition, new Macs come with FireWire I/O, so you don't have to buy additional cards to get started.
- Are you working with lots of 3D animation? These days, the best 3D applications, such as StudioMax and SoftImage, are Windows based. However, competition on the Macintosh front should increase with the new Unix-based OSX, and formerly Window-only 3D apps such as Maya are already available for the Mac.
- Are you planning on Webcasting? The Windows platform has better support for Webcasting software and other Internet needs.

OPERATING SYSTEM

Check your software manufacturer's specifications to make sure you're running the suggested version of Windows or the Mac OS. Sometimes, the most up-to-date OS isn't the right choice. If you'll be working with QuickTime video or Video for Windows, make sure you have the correct version of that as well.

COMPUTER MONITORS

Editing software will expand to fill the space available, no matter how big it is, and two 20″ (or bigger) computer monitors, aka CRT monitors, are the standard for high-end professional editing systems. For Macs and new Windows machines that can support two monitors, you'll need to add a second PCI card with a monitor interface. If your budget is tight, it is *much* more important, possibly essential, to have a good external video monitor, which is covered in Chapter 5.

　　If you're only going to have one computer monitor, try to get a moderately high-resolution monitor that's 17″ or larger. Monitor prices exponentiate as the screen sizes and resolutions increase, with the best monitors costing upward of

$2,000. These top-of-the-line monitors are designed for print graphics professionals, and will be an asset if you'll be doing lots of high-resolution special effects for film or high-definition television (HDTV). If you'll just be doing normal titles and effects for video or Web delivery, the resolution of NTSC video and streaming media for the Web is comparable to 72 dpi, so a very high-quality monitor is probably overkill.

VGA to Video

If you have a graphics card that supports two VGA monitors, such as the Matrox G450 Millenium card, you can purchase a VGA-to-composite video adapter and connect an NTSC video monitor directly to your computer, without the need for an intermediary device, such as a video deck. (Note to FireWire-based DV editors: This won't work for you.)

STORAGE DEVICES

Most editing systems require that you capture media to secondary storage drives, or media drives, not to the primary internal hard drive where your application and OS reside. Having your media on secondary drives gives some extra processing ability to your system, allowing for better playback and faster performance. Check your manufacturer's recommendations for what works best with their product, but whatever their opinion, you'll probably need some extra space when dealing with the mammoth file sizes that come with the non-linear editing territory.

These days there are many options for storage, and the bottom is falling out on prices. Having enough storage space isn't the big issue it was a few years ago, now that you can get 30-gigabyte drives for a couple of hundred dollars.

How Much Storage Do You Need?

For FireWire-based DV, you need 1 gigabyte for every 4.5 minutes of video. For 3:1 M-JPEG, you need about 9 gigabytes for each hour of video; for uncompressed video, you need between 1–1.5 gigs for each minute.

SCSI DRIVES

The fastest drives around connect via the SCSI (Small Computer Systems Interface) interface and can transfer data at speeds up to 160MB/sec. There are several

different types of SCSI drives: SCSI 2, Fast and Wide SCSI, Ultra-wide SCSI, and Ultra 2/LVD. For editing systems, Ultra-wide SCSI or Ultra-2/LVD drives, with a spin rate of at least 7200 RPMs and a resulting data transfer rate of up to 160MB/sec, are the best choice for video editing. You can have up to 15 Ultra-wide or Ultra-2 SCSI devices chained together, but you'll need to add an interface card to one of the PCI slots in your computer. If you are using only FireWire-based DV footage, SCSI drives may be overkill. However, if you need to move media around from one system to another, and interface with applications such as ProTools, external SCSI drives are the way to go. Although you'll need to add a PCI host adapter card, SCSI drives are compatible with just about everything (Figure 4.21).

Rendering and Storage Drives

Rendering speed is primarily related to the type of video cards and other accelerator cards installed in your system. It's also related to the speed of the drives you're rendering onto. Using faster storage drives will speed up rendering times, even if you're using a format like FireWire-based DV that doesn't need fast storage drives for playback.

FIGURE *This Seagate Cheetah SCSI drive offers 36GB of storage with a spin rate of 10,000*
4.21 *rpms.*

RAIDs

RAIDs (Redundant Array of Independent Disks), also called *arrays*, consist of two drives that have been formatted together, or *striped*. The CPU treats them as a single drive, and can use both drives at the same time for extra speed. Some editing systems save video information to one drive and audio information to the other drive. Most get their speed by *interleaving*, accessing consecutive bytes on alternate drives. With this mechanism, one drive can be reading or writing while the other drive is preparing. Others use a different method of dividing media between the two drives. Either way, the result is faster performance from your video editing system. For very high-quality digital video, such as uncompressed D-1 quality, SCSI RAID storage, like the Medea VideoRaid RT in Figures 4.22 and 4.23, is required.

FIGURE *The Medea VideoRaid RT has up to 450GB of storage per module and*
4.22 *a sustained data transfer rate of 65MB/second, which is fast enough to handle uncompressed D1-quality digital video.*

FIGURE *This Medea VideoRaid RackRT fits securely into a standard video equipment rack.*
4.23

Spin Rate

The key to finding the right external drives for your editing system lies in the spin rate of the drives, measured in rotations per minute (rpms). Drives with a spin rate of 4200 RPM are considered acceptable for FireWire-based DV editing, although a spin rate of 5400 RPM is usually recommended. A spin rate of at least 7200 rpms is needed for most M-JPEG-based editing systems. Uncompressed video needs a spin rate of at least 10,000 rpms. Check the manufacturer's specifications on your video capture card and editing application before you buy.

TIP

ATA, UltraATA, EIDE, IDE, DMA, and UltraDMA Drives

These drives are all variations of the same specification and offer up to 5400 rpms and data transfer rates as high as 66MB/sec—more than fast enough for FireWire-based DV editing. You can have two of these drives chained to each built-in or PCI card interface on your CPU. If you have a Windows machine, you may be able to chain storage drives off your internal hard drive. With the right interface, these drives can also be configured into a RAID for faster performance.

Data Rate
The speed at which a computer device can transfer information is also known as the data-rate, which is measured in megabytes per second (MB/sec). To transfer digital video in real-time, a certain minimum data rate is required: for FireWire-based DV, the data rate is 3.6 MB/sec; for SDI digital video, the data rate is 270 MB/sec. The speed of storage drives are often described by their data rate, which can help you determine whether the drive is fast enough for your needs.

FIREWIRE DRIVES

FireWire drives, start at 4200 rpms, but can go as high as 7200 rpms, which is fast enough for most editing systems. At present, they can be somewhat pricey compared with ATA-type drives, but they are hot-swappable, and you can have up to 63 FireWire devices in one daisy chain. Cable length limitations make this somewhat impractical, but nonetheless, there's plenty of room for expansion. A word of warning: don't plan on chaining your FireWire drives to your FireWire camcorder or video deck. You might have problems transferring data fast enough for both devices (Figure 4.24).

FIGURE *LaCie 36GB FireWire drive.*
4.24

Moreover, not all vendors adequately follow the rules of the FireWire spec. Some cheaper drives may not be hot-swappable or offer very good performance. Do a little research into a particular model before you buy; make sure the drives are up to your software manufacturer's specs and that the vendor provides a good return policy.

Internal or External?
The best bargain for projects that don't require a RAID are internal ATA/EIDE drives. However, if you're planning to move media from one workstation to another, external SCSI or FireWire drives may be a better choice.

REMOVABLE MEDIA DRIVES

Removable drives aren't fast enough to use as storage for video editing, and for the most part, they aren't large enough either. There are basically two uses for removable media when it comes to editing: backups, and transferring files from one workstation to another. With the growing number of removable media storage devices on the market, the choice comes down to what's most popular (and therefore most compatible with other workstations), and what holds enough media to be useful.

- **Zip, Jaz, etc**. If you're going to be moving media around, a Zip is big enough for still images and audio files, but won't cut it for video files. Go for the biggest Jaz (or similar) format you can afford.
- **CD-RW and DVD-RW**. CD-RW and DVD-RW drives are great options, because CDs are cheap and they're a very stable storage medium. In addition, almost everyone has a CD-ROM drive these days, so it's a good choice if you'll be delivering files to many different workstations. DVDs offer a lot of room for big digital video files.
- **Tape drives—DLT**, **DV**, **DAT**, **etc**. DLT tape drives are useful for editors because they can hold so much data—up to 100GB. They can be used to back up an entire project, including all the video and audio, but aren't as common as the other storage media. At around $80 for each tape cartridge, they can be very cost efficient. Digital Audio Tape (DAT) drives and DV tape drives don't hold quite as much data for the money, but offer the added convenience of using media you may already have available; i.e., miniDV and DAT tapes (Figure 4.25).

FIGURE *LaCie DLT drive and cartridge.*
4.25

FIRST, THE GOOD NEWS . . .

If you have your editing software and all the computer hardware, you're more than halfway to having a complete system. However, before you put it all together (Chapter 6), you'll need some video and audio hardware. No editing system is complete without speakers, video monitors, video decks, and audio decks—so, turn the page and read on.

Video and Audio Hardware

In This Chapter

- Video Decks
- Video Monitors
- Working with Widescreen Footage
- Audio Hardware
- The Editing Room

T he last step in building a non-linear editing workstation is adding the external audio and video hardware. Without it, your system is a locked box, with no way to get information in or out. At the very least, you'll need a *video deck* to play your source videotapes as you capture media into your system, and to record outputs of your final edit back onto videotape. You'll also need an *external video monitor*, especially if you're editing with FireWire-based DV media (see the sidebar, "More about the DV Format" in Chapter 4 for more on this), and you'll need a pair of speakers or headphones (Figure 5.1).

FIGURE *The hardware used in a simple non-linear editing system.*
5.1

You may need more than one type of video deck, say, a DV deck and a VHS deck for making viewing copies, and you may need a special *audio deck*, like a DAT (Digital Audio Tape) player. If you have several decks (audio and/or video), you might want to add an *audio mixing board* and a *video router*. These components help you repatch your system without actually moving the cables around. (Once you configure a system for the first time, you'll better understand the benefits of a router.)

For those concerned with online quality outputs, an external *waveform monitor* and *vectorscope* is a necessity, and high-end professional video decks may need a *black burst generator* (Figure 5.2).

This chapter explains in detail all of the aforementioned equipment so that you can make intelligent decisions about the sort of audio and video hardware you need to make your non-linear editing system complete.

At this point, you should already know what sort of video format(s) you'll be working with, and what kind of inputs and outputs are available on your video capture device (Chapter 4). Most video card manufacturers include VTRs and camcorders on their list of compatible hardware—especially manufacturers of FireWire-based DV software and hardware.

FIGURE *The hardware used in a professional non-linear editing system.*

5.2

VIDEO HARDWARE

Chapter 4 explained the different videotape formats that are popular today, as well as the different types of video signal interfaces (FireWire, analog component, analog composite, S-video, and SDI). This information is crucial to finding the right deck for your system. When you're looking at video decks, look at the back of the machine. This is usually where you'll find all the inputs and outputs. You need to make sure that the VTR has a selection of inputs and outputs that are compatible with the video capture device on your computer. In other words, if you're using a FireWire-based system, you need a VTR with FireWire I/O. If you're using an analog component video capture card, you need a video deck with analog component I/O, and so on (Figure 5.3).

Higher-quality VTRs will have more than one type of video signal interface. A good DV deck might have both FireWire and S-video I/O. A Betacam SP deck will have analog component and analog composite I/O. A high-end DVCAM deck will have SDI, analog component, and analog composite I/O. However, be careful: unless you have a breakout box, your video card may only have one choice of video I/O.

FIGURE *Standard video and audio cables.*
5.3

Adapters

TIP

You can sometimes use adapters to make a cable compatible with a different type of connector. Usually this is limited by the video or audio signal interface. You can adapt a 4-pin FireWire cable to a 6-pin FireWire cable, but not to an analog BNC cable. You can adapt an analog composite RCA cable to an analog composite BNC cable, but not to an analog component BNC cable. Doing the latter would involve changing the type of video signal itself, and requires a special device, known as a transcoder. *More about transcoding later in this chapter.*

WHAT'S IN A VTR?

Not all VTRs are alike, but the section that follows describes the standard features of a good professional VTR. You may not be in the market for a VTR of this caliber, but you may find that some of these features are available on cheaper VTRs as well, so it's a good idea to get acquainted with them.

- **Tape transport controls** such as *play, pause, rewind, fast-forward,* and *stop* buttons are found on all VTRs. Be wary of consumer decks that only offer these controls on a remote. Lose the remote, and you'll be unable to control the deck, and you might even be stuck with a VTR that continuously displays the date and time onscreen. But who'd ever lose their remote, right (Figure 5.4)?

Audio level controls

Remote control switch

Timecode display

Edit controls

Tape transport controls

Jog shuttle

FIGURE *Front of a professional VTR.*
5.4

- **The jog shuttle** is a knob that lets you scroll through a tape at variable speeds, which is very useful for logging tapes. High-end VTRs (Figure 5.4) feature jog shuttles on the front of the machine; others (Figure 5.9) feature jog shuttles on a remote control device.
- **Audio level controls** let you adjust the volume of audio as it comes into the VTR (Figure 5.5).
- **Audio level meters** show the volume, or *level,* of the audio as the deck plays or records. You can quickly see if the audio is too loud or too soft (Figure 5.5). Look for either digital or mechanical meters that have markings in decibels (dB).
- **The audio limiter** tells the VTR to *not* play—i.e., *clip*—any audio that's too loud.
- **The video level meter and control** lets you view and adjust the strength, or *level,* of the analog video signal.

FIGURE *Audio level controls and meters on a professional VTR.*
5.5

• **The tracking adjustment** lets you correct rolling or flickering video play-back that happens when an analog videotape is out of alignment.

• **The remote/local selector** is a switch that lets you choose between the local tape transport controls on the front of the VTR or the remote tape transport controls in your non-linear editing application or other remote device (Figure 5.4).

Remote Control and Frame Accuracy

Almost every editing system should have some sort of *remote deck control*, sometimes called *device control*. By remote control, we're not talking about the handheld device you use with your VCR at home, although these are handy, too. Rather, we're talking about the ability for another machine, like your computer, to control the VTR.

Device control is the key to convenient tape logging—you simply use the software-based tape transport controls inside your NLE rather than the ones on the VTR itself. Device control is also a prerequisite for batch capturing, where your editing software takes a list of logged shots and automatically captures them for you. This type of control is necessary for frame accurate outputs to videotape (although you'll need a frame accurate deck, too).

There are currently six types of remote interfaces:

• **RS-422** is the professional standard for deck control, developed by Sony and available on all professional VTRs.

- **RS-232** looks very similar to RS-422, but is found on more inexpensive equipment.
- **LANC or Control-L** is another serial control protocol developed by Sony for their "pro-sumer" level VTRs.
- **FireWire** is capable of remote device control, although it technically isn't a device control protocol.
- **Control-S** is yet another "pro-sumer"-level serial device control protocol.
- **VISCA** is a relatively uncommon "pro-sumer"-level serial device control protocol developed by Sony for use with Hi8 equipment.

Unlike the remotes you're used to at home, they connect from a serial port on your computer to a serial port on your VTR via a special cable (Figure 5.3). If your computer has a USB connection, you'll need to add a USB to serial adapter in order to connect your computer to your deck. Even if your computer does have a serial connection, you may need an adapter such as an RS-232 to RS-422 adapter. The exception, as usual, being FireWire-based deck control, which contains the deck control signal in the same cable that transfers your audio and video.

Frame accurate simply means that when your editing software tells the VTR to play or record at a specific frame, it starts at exactly that frame—not the frame before or after. There are several prerequisites for frame accuracy: you must have an RS-422 connection, you must have a VTR that uses SMPTE or EBU timecode, and you must have a VTR that's capable of frame accuracy. (For more about SMPTE and EBU timecode, see the section on timecode in Chapter 8, "Getting Media into Your Computer.") If a VTR is considered frame accurate, it usually has all of these features.

Most VTRs are rated for frame accuracy by their manufacturers. FireWire-based DV format VTRs are usually rated at +/- 5 frames, meaning they could miss their mark by five frames in either direction. If you'll be doing lots of precise online edits onto videotape, this may be a problem for you. For simple capturing and outputting offline edits onto tape, the lack of frame accuracy shouldn't be too much of a problem.

- **On-board edit controls** on the front of the VTR itself let you set in-points, out-points, and perform a frame-accurate assemble edit or insert edit (Figure 5.6). If you're buying a high-end VTR with on-board edit controls, you're paying for that capability, so make sure it's something you'll use. Some lower-end VTRs, like the Sony GVD-900 miniDV Walkman (Figure 5.8) and the Sony DSR-11, have more limited on-board edit controls (more about assemble and insert edits in Chapter 12, "Outputs.")

VTR edit controls

FIGURE *VTR edit controls.*
5.6

- **The timecode display** shows the position of the tape in hours, minutes, seconds, and frames (Figure 5.4). Better consumer equipment only shows hours, minutes, and seconds; and poor consumer equipment uses a "counter" that has no reference to time. The timecode display can also indicate whether a tape was recorded with drop frame or non-drop frame timecode.
- **The timecode selector** on some VTRs can switch between normal, or *address track*, timecode, *control track timecode* and *U-bits* (see Chapter 8 for more on timecode).

TIP

Drop Frame Timecode

NTSC video plays at a strange speed: 29.97 frames per second. This awkward number is difficult to use when calculating time, so SMPTE devised two ways to display time values by rounding off the fractional frames to whole numbers. The frame rate remains 29.97, but the counter displays 30 frames per second. To compensate for this .03 frame discrepancy, one frame is occasionally dropped out of the count (the frame itself isn't dropped, just the number in the counter). Drop frame timecode is usually indicated with semicolons between the hours, minutes, seconds, and frames (01;00;00;00), and non-drop frame timecode is indicated with colons (01:00:00:00).

- **Timecode preset** lets you choose the start time of the timecode you wish to record onto a tape. Others start at one hour or zero by default.
- **Drop frame/non-drop frame** lets you choose between drop-frame and non-drop frame timecode on professional VTRs, usually through a menu setting or button. Drop frame is the standard for NTSC television, so if a VTR doesn't offer a choice, it's probably recording drop frame.
- **Tape speed selectors** are available on lower-end VTRs, like DV and VHS decks, and let you choose between a fast tape speed, which gives better quality video, or a slower tape speed, which lets you record more footage on the tape. For most serious productions, you'll never use the slower tape speeds—save them for recording your favorite TV shows. High-end VTRs only have one tape speed.
- **Audio and video I/O** are usually located on the back of the machine. Professional VTRs usually have at least two types of video and audio input and output. These vary from deck to deck.
- **The input selector** chooses between the different video inputs: composite, component, S-video, SDI, and DV on most pro VTRs; and Line 1, Line 2, or TV on most consumer VTRs.
- **Reference video input** on professional VTRs is a reference video signal to calibrate the video signal as they play and record. Usually, this is a pure black signal sent from a black burst generator into the VTR through the reference video input connector.
- **Monitor output** on top-of-the-line VTRs helps you avoid wasting a video output on your external video monitor. Instead, they offer an analog composite BNC video output for monitoring. Others have a UHF connector, such as those found on the back of older TV sets, that includes the audio signal as well.
- **The onscreen character/title display** is primarily used to display timecode information on the video monitor. Some VTRs have a special video output that includes this information in the video signal. This lets you record timecode information onto a viewing copy, like a VHS tape.

- **Menu display**, when available, allows you to view any additional controls and features.
- **An A/C power supply** input is found on all VTRs sold in the United States, and some also have a D/C power supply input, for battery-run operation. If you're using a PAL VTR in the United States, or an NTSC VTR in Europe, you'll need a transformer to convert the power signal.
- **Remote control interface** is discussed in the sidebar, "Remote Control and Frame Accuracy" earlier in the chapter.
- **The time base corrector**, (or TBC) helps the VTR to play the videotape at exactly the right speed all the time. The clocks we use to tell time use a base of 60 seconds per minute. In video and motion pictures, the time base is broken into even smaller increments—frames per second. NTSC video has a time base of 29.97 fps; PAL is 25 fps; and film is 24 fps. Just to make matters more confusing, VTRs can often run at slightly different or varying speeds. Consumer VTRs don't have a TBC, and often play tapes at irregular speeds. Older professional VTRs need external TBCs, and new professional VTRs come with internal TBCs so that you don't have to worry about it.
- **Transcoding** allows you to change video information from one type of signal, say analog composite, to another, like DV or analog component.. Many VTRs have internal transcoding capabilities, which is why you can send a composite video signal from a VHS deck into a DV deck, for example, and send it back out to your computer through the FireWire cable— the hardware inside the DV deck transcoded the signal from analog to digital. Some VTRs simply pass the transcoded information through, a function called *E-E mode*, while others require you to record the incoming signal to tape before you can send it out as a different type of signal.
- **NTSC/PAL switchability** is available on most high-end digital video VTRs. Recently, Sony has offered a low-end DVCAM VTR, the DSR-11, that plays and records both PAL and NTSC format DVCAM and miniDV tapes.

TIP

Video Routers

If you have several video sources—for example, a Beta SP deck, a VHS deck, the video output from your computer, and a black burst generator—a video router can help you route the video signal from one device to another without having to physically move any cables. Most video routers have four channels, which means they can have four sources of video. A number of different manufacturers make video routers. Look for one that has the inputs and outputs you need. Remember that if you send your digital video through a router that has analog I/O, you will no longer have digital video coming out of the router.

VTR Maintenance

A typical VTR works by running the videotape past a *play head* for playback and a *record head* when recording. Over time, these heads get dirty due to dust and other debris that gets inside the tape cartridge and the VTR itself, and from bits of tape emulsion that are scraped off the tape during playback. These tiny particles can cause dropouts and other image problems. Small tape formats are particularly susceptible to problems caused by dirty heads, simply because the dust particles are bigger in relation to the size of the tape.

Most VTR manufacturers make head-cleaning products specifically designed for their VTRs. Usually, these are special video cassettes that have an abrasive material inside instead of videotape. They work by running the abrasive material across the heads and thereby remove any dust or dirt. Because they are slightly abrasive, overuse of head-cleaning cassettes can result in unnecessary wear and tear on the heads. The standard rule is to clean the heads of your VTR after every 50 hours of use. Be sure to follow the manufacturer's instructions to avoid any damage. Also, never reuse a head-cleaning cassette once it reaches its end.

VIDEO DECKS

The type of hardware available is unique to each videotape format. Here's a quick list of things to be aware of:

- **VHS**. VHS is a consumer format, but is commonly used for creating work-in-progress viewing copies. The garden-variety VHS deck has analog composite I/O using RCA connectors for both audio and video. If you can afford it, look for a higher-quality four-head VHS deck that has a jog shuttle, frame-by-frame slow-motion, a *time-based* counter, and S-video I/O. Most good consumer VHS decks will have these options (Figure 5.7).

FIGURE *A good VHS player, like this S-VHS deck from JVC, is a useful addition to any editing*
5.7 *workstation.*

"Professional" VHS decks that cost upwards of $1,000 aren't a good investment for most editing systems. It's better to spend that money on a higher-quality format VTR such as DVCAM.

• **DV**. Most of the DV video decks on the market are consumer products. For portability, the GVD-900 Walkman by Sony is a good choice (Figure 5.8); the dual-format VTR by Panasonic in Figure 5.9 conveniently plays both VHS tapes and miniDV tapes; and the JVC DV-BR600U (Figure 5.12) has many professional features. However, since DVCAM and DVCPro VTRs can play DV tapes (Table 5.1), it's better to invest in a low-end professional DVCAM or DVCPro VTR, like the Sony DSR30 in Figure 5.10. These decks have more durable tape transport mechanisms, will stand up better to the rigors of editing, and will usually perform their transport functions more quickly than a lower-end DV deck. If you're not ready to invest in a good VTR, consider the Sony DVMC-MS1 DV decompressor box in Figure 5.11. For about $300, it contains the DV hardware architecture needed for full-motion playback on an external video monitor.

LCD screen

Display modes

LANC device control

I/O ports (inside door)

Speaker

Tape transport controls

Headphones jack

FIGURE **5.8** *This Sony GVD-900 DV format Walkman plays only miniDV-sized cassette cartridges, but has many features and a built-in LCD monitor and speaker.*

FIGURE *The Panasonic dual S-VHS and DV VTR.*
5.9

FIGURE *This Sony DSR30 DVCAM VTR is a better investment than a consumer-*
5.10 *grade miniDV VTR.*

Table 5.1 VTR compatibility chart. Many digital video decks can play (but not record usually) multiple tape formats. Be sure to check each manufacturer's specifications if you need a VTR that plays back multiple formats.

Tape format:	Can also play:
Digital-8	Hi8
Sony DV	DVCAM
Panasonic DVCPro	DV* and DVCAM
Sony DVCAM	DV*
JVC Digital-S	S-VHS
Digital Betacam	Beta SP
Betacam SX	Beta SP
DVCPro50	DV, DVCAM and DVCPro
DV	DVCAM**
D5	D3
D9 –HD	Digital-S

* DV tapes must be recorded in SP mode to play back on DVCAM and DVCPro equipment.

** Except the Sony VX700 and VX1000.

DVMC-DA1 **DVMC-DA2**

FIGURE *The Sony DVMC-DA1 and DA2 digital/analog converters can take the place of a*
5.11 *FireWire-based DV VTR or camcorder.*

FIGURE *JVC DV-BR600U VTR.*
5.12

DV Decoder Box

If you don't want to invest in a DV deck, and you want to save
TIP
wear and tear on your DV camcorder, you can buy the DVMC-
MS1 from Sony (Figure 5.11). For about $300, this little device
provides hardware DV decompression, so that you can have full-
resolution playback on an external video monitor without the
need for a VTR or camcorder.

- **DVCAM and DVCPro**. At the bottom end of the DVCAM and DVCPro
 spectrum, VTRs in these formats offer FireWire and analog composite I/O.
 In the midrange, they often have analog component and analog composite
 I/O with an option to add FireWire I/O or SDI I/O. Top-of-the-line models
 have SDI, analog component and analog composite I/O, but no FireWire.
 In other words, if you're buying one of these decks to integrate into your
 FireWire-based system, make sure it has FireWire I/O—this isn't a given. If
 you need frame-accurate deck control, remember that FireWire isn't up to
 the task, so you'll need to look for a VTR with an RS-422 interface.
- **3/4-inch**. If you're editing with 3/4-inch material, it's probably because
 you either already own a 3/4-inch deck, or you're getting access to a 3/4
 deck for free. Many post facilities still have 3/4-inch equipment, and these
 can be a good choice for work tapes, such as telecine tapes from a film-to-
 tape transfer. These decks are very stable and reliable, and offer most of
 the features you'll need for professional offline editing: remote control via
 RS-422, address track timecode, and frame accuracy. As companies switch
 to other formats, you can get used 3/4-inch VTRs at reasonable prices, but
 stick to the more recent models such as the Sony VO-9850 in Figure 5.13.

FIGURE *Sony VO-9850 3/4-inch VTR.*
5.13

- **Betacam SP**. Beta SP VTRs have everything you need for professional offline, and sometimes even online, editing. These VTRs are strictly analog and offer high-quality analog component and composite I/O. Prices range from about $12,000 for a bottom-of-the-line *play-only* Sony UVW model—a deck that has no record head and is useful for digitizing only—to $35,000 for the top-of-the-line Sony PVW 2800 in Figure 5.14 that includes edit controls on the front panel. The price tag may prohibit purchase, but you can rent a Beta SP deck for around $400/day, depending on the model. If you're renting just to digitize, a play-only model saves $100–$200 a day. If you use a Beta SP VTR, you should also get a *black burst generator* to go with it (Figure 5.15). See the following definition for more on black burst generators.

FIGURE *Sony PVW 2800 Betacam SP VTR.*
5.14

FIGURE *Black burst generator.*
5.15

Black Burst Generator

Black burst generators are very simple pieces of equipment that generate a pure black video signal, sometime called "reference black." Just as you can adjust the color and brightness on a video monitor, the color and brightness on a high-end VTR is adjustable. The black signal helps high-end video decks define what's black in order to calibrate the VTR and stabilize the video signal. The black signal is also used to "black" a videotape; i.e., lay down a pure black image on the tape (Figure 5.15).

- **Digital Betacam**. Digital Betacam VTRs are even more expensive than Beta SP, but you'll get high-quality SDI digital video along with all the other top-of-the-line features described in the "What's in a VTR" section earlier in this chapter. Rentals run around $900/day, so if you plan your capturing and mastering schedule carefully, these decks can be somewhat affordable.
- **D1**. Better than Digital Betacam, D1 is the best choice for mastering if quality is of utmost importance. You can't usually rent these, and at upwards of $200,000, you probably won't buy one either. Mastering to D1 is done at a professional postproduction facility and starts at around $500/hour, depending on the type of equipment and operators you need along with it.
- **HD formats**. Last but not least are the HD, or *high-definition*, formats. These offer ultra-high quality images in a wide-screen format (Figure 5.16). As with D1, price generally prohibits individual ownership and even rental, so mastering at a post-facility is a must.

FIGURE *JVC D9 HD VTR.*
5.16

Working with Widescreen Footage

Until recently, widescreen footage was solely the domain of film editors. Now, however, with the advent of HDTV and videotape-to-film transfers, widescreen footage is starting to look like the wave of the future. Many filmmakers prefer widescreen footage because it looks more "cinematic" and less like television. This TV vs. film rivalry goes all the way back to the early days of television in the 1950s. Movies started to lose their audience to television, and in order to win them back, they raised the bar by offering the combined grand spectacle of Technicolor and Cinemascope. Today, movies use the same techniques to draw their audiences out of their homes and into theaters—surround sound, special effects, and high production values just aren't the same when viewed on the family VCR.

Now, as more and more feature films are shot on videotape and later transferred to 35mm film, shooting widescreen video has become very popular. Working with widescreen footage is relatively simple if you make sure that your NLE, your VTR, and your video monitor all support widescreen footage. In addition, these days, most editing applications support widescreen footage. As for the VTR, it usually has more to do with how the camera recorded the widescreen footage than the VTR itself. If it was shot with a high-end camera that has true 16:9 support, like the Sony DSR-500, then a memory chip embedded in the tape itself tells the VTR that the footage is widescreen. The VTR will automatically "unsqueeze" the image as it plays the tape. The most expensive part of the equation is finding a video monitor that supports 16:9 footage. Most newer professional video monitors do, but they can be pricey.

MONITORS

In the professional world, the term *monitor* refers to any way of viewing or listening to a video or audio signal. This includes anything from a TV set to a pair of headphones.

VIDEO MONITORS

No matter what sort of editing system you end up with, you'll need an external video monitor to see what your final project will look like once it goes back to videotape. By now, you should know that FireWire-based DV editing systems *must* have an external video monitor to view full-screen, full-motion playback. If you're not using FireWire-based DV, you should still have a monitor to see a more color-accurate, *interlaced* version of your project. In addition, video mon-

itors are simply larger than the software-based viewers in your non linear edit-ing application are—you'll be more likely to see a dropout or problem on a larger screen. The only time you might not need a video monitor is if you are creating output for delivery over the Web. In this case, assuming you're not using FireWire-based DV, your software viewers will suffice.

NTSC/PAL MONITORS

Professional video monitors are often called NTSC/PAL monitors because they can switch between the two video standards (Figure 5.17). At the nonprofes-sional level, you can simply use a television set, although you might have some difficulty patching it into your system if it only offers a *UHF connector*. If you can, get a TV set with analog composite RCA or S-video I/O.

As with all other editing equipment, professional monitors offer a lot more than your standard TV set. Just like professional VTRs and video cards, these monitors provide SDI, analog component, S-video, and analog composite I/O. In other words, if you're editing with SDI video and using SDI cables to send video into your monitor, what you see is pretty much what you get. If you send it to a TV set via analog composite RCA cables, you're not really seeing your final video, but instead a scaled-down version of it. (It's arguable that, since this scaled-down analog composite version is what most viewers at home will see, this is just fine.)

Professional monitors also have a higher resolution than TV monitors do. They're also often smaller, so don't be fooled by the fact that the pro monitor is 13" and your TV is 30". Many pro monitors can switch between the standard 4:3

FIGURE *JVC 13" high-resolution NTSC/PAL monitor.*
5.17

FIGURE 4:3 (left) and 16:9 (right) aspect ratios.
5.18

aspect ratio of regular video, and the 16:9 widescreen aspect ratio needed for projects shot with an anamorphic lens or destined for HDTV (Figure 5.18). Be aware that an HD image will be letterboxed unless you buy a special HD monitor, like the one in Figure 5.19.

In addition, professional monitors usually support more than one input source. In a typical editing system, the "A" input would be video coming out from your computer, and the "B" input would be video coming out of your primary VTR. When you output your project to tape, you can compare the image your computer is sending out with the image that's being recorded onto tape by simply pushing a button. For a FireWire-based DV editing system, this feature is not that useful, since all video will be coming out of one source: your DV video deck or camcorder.

FIGURE *JVC HD monitor.*
5.19

Finally, professional monitors offer advanced monitoring choices that let you analyze and troubleshoot the video signal if you're having problems. *Underscan* mode displays the entire video signal, including the *control track* area between the fields that normally isn't visible. *Horizontal delay* and *vertical delay* display an offset video signal that lets you see the areas of the video signal that contain the *horizontal and vertical sync pulses.* You can't use these features to fix a problem with a videotape, but you can determine how serious the problem is and determine a solution, if one exists. More about troubleshooting video problems in Chapter 8.

NTSC COLOR

There's another important reason for using an external video monitor if your final project is destined for videotape. NTSC is notorious for its poor ability to handle saturated colors. On the other hand, computers are notorious for their excellent ability to handle colors. Therefore, what looks great on your computer monitor—a brilliant red, for example—can bleed, flicker, and look horrible on an NTSC monitor. PAL is slightly better when it comes to handling color, but still doesn't come close to the color capabilities of your computer.

Just as video and graphics destined for the Web use a "Web safe" palette, you need to make sure that graphics and video destined for video are "NTSC safe." Some editing and motion graphics applications offer a limited, NTSC safe, palette; however, the best way to be sure is to look at it yourself on an external NTSC monitor.

WAVEFORM MONITORS AND VECTORSCOPES

Waveform monitors and vectorscopes (sometimes both referred to as *scopes*) are used to set the proper video levels when capturing and mastering video. Waveform monitors display the brightness, or *luminance*, in a video signal, and vectorscopes display the color information, or *chrominance*, in a video signal. If you're concerned with image quality, you should always use hardware scopes when capturing and outputting to tape (Figures 5.20 and 5.21). Many editing applications come with software-based waveform monitors and vectorscopes, which suffice for most projects that aren't quite as concerned with image quality. Even professional editing systems often skimp on the scopes, but it's worth renting a set for a day or two if you're going to online a project yourself. Chapter 8 includes a tutorial on using waveform monitors and vectorscopes.

FIGURE **5.20** *Tektronix 657 dual monitor in waveform monitor mode.*

FIGURE **5.21** *Leader LV5100 dual monitor in vectorscope mode.*

AUDIO MONITORS

Audio is monitored through speakers or headphones. As you probably already know from purchasing home audio equipment, the price of speakers can range from next to nothing to several paychecks. A decent set of self-powered A/V speakers will suffice for the most part, but if you're going to do some serious sound editing, you should invest in something better. For the budget conscious, a good set of headphones is the way to go. You can get a lot of quality for about

$200, and they'll provide the added bonus of blocking out unwanted environmental noise and sparing the ears of your office and housemates. Some sound editors like to have a set of high-quality speakers, and a cheap, tinny, TV-like speaker. This way, they can create their mix listening to the good speakers, and then use the cheap speakers to hear what their mix will sound like in the worst-case scenario.

AUDIO HARDWARE

It's a rare project that consists strictly of video-based media. However, sometimes it seems as if audio is the neglected cousin of video when it comes to talking about editing. That shouldn't be the case, since audio plays an incredibly significant role in the success of any project. However, much of the audio used in editing is part and parcel of the video hardware, since it comes in the form of production audio that's been recorded on videotape—the exception being projects shot on film where the audio was recorded separately, usually on a DAT machine. Nowadays, that audio comes via videotape as well, since it is usually laid down onto videotape and synchronized with the picture in the telecine process. (Special concerns for audio in regard to film editing are covered in Chapter 8.) That said, you'll probably be using audio-only decks for the icing on the cake: sound effects, music, and voice-over.

AUDIO DECKS

Most likely, you'll have some source of recorded audio, such as audio CD, DAT, or MiniDisc. Since most computers come with an internal CD-ROM or DVD-ROM drive, it's unlikely that you'll need a CD player. If your production audio was recorded separately on DAT or MiniDisc, you'll need a corresponding deck when capturing audio. As with VTRs, just because DAT and MiniDisc are digital audio formats doesn't mean that all DAT and MiniDisc players have digital audio I/O—many of them don't. There are several types of DAT, so be sure your DAT player matches the format with which the DAT was recorded. For film production audio, a timecode DAT recorder, like the one in Figure 5.22, is generally necessary.

The Tascam DA series is another family of digital audio decks that can be very useful in an editing system if you'll be building lots of tracks and creating lots of different split-track mixes. They record eight tracks of digital audio with SMPTE timecode onto high-quality 8mm videotape. The DA88 (Figure 5.23) has analog phono I/O, and the DA98 features all digital I/O.

FIGURE *Tascam DA60MKII timecode DAT recorder.*
5.22

FIGURE *Tascam DA88 digital audio tape recorder.*
5.23

AUDIO MIXING BOARDS

Even if you don't intend to add any audio decks to your system, a mixing board can be a great asset to any editing system. By sending all the different audio sources you have, including those coming from video decks, into a mixer, you can control the level and quality of each sound source *before* you capture it. If you capture the best-sounding audio possible, you'll have to do less work tweaking it in your editing application. This saves a lot of time and is especially valuable if your editing application is weak in sound editing, which is often the case. Also, while it's common to redigitize the video for your project at a higher

resolution, there's no good reason to redigitize audio if you can avoid it. There-fore, whatever you capture the first time around is often what ends up in your final tracks.

Mixing boards let you adjust the *equalization, gain, balance,* and levels (Fig-ure 5.24). They also help you send audio from one machine to another, and let you control the volume and quality of the sound as you send it out from your editing application onto videotape. (Actual use of mixers is covered in Chapters 8 and 12.)

FIGURE *Close-up of EQ, gain, and level controls*
5.24 *on a Mackie mixer.*

To simplify, audio mixing boards are categorized by two things: the number of *channels*, and the type of audio signal they support. You need a separate channel for each audio signal that you send in and out of the mixer, so the more equipment you have, the more channels you'll need (Figure 5.25). Professional sound editors and musicians can put lots of channels to use, but the average video editor will be satisfied with 6 to 14 channels. As with video, if you send

FIGURE *Close-up of inputs and outputs on a Mackie mixer.*
5.25

your digital audio through an analog mixer, you'll no longer have digital audio. You won't necessarily ruin your audio by doing this, but you should be aware of it. Six-to-eight channel analog mixers like the Tascam M-08 in Figure 5.26 range from $200–$500; the digital equivalent, like the Tascam TCM-D1000 in Figure 5.27, will cost upwards of $1,000.

FIGURE *The Tascam M-08 analog 8-channel mixer.*
5.26

FIGURE *The Tascam TCM-D1000 digital 8-channel mixer.*
5.27

MICROPHONES

Normally, microphones are associated with production sound, but they can be a useful tool in the editing room as well, particularly if you want to record voice-over on the spot. How good a mic you need depends on whether you're recording a placeholder or the final audio. Generally, a moderate-quality *directional microphone* should suffice.

THE EDITING ROOM

One of the most overlooked aspects of setting up an editing system is the editing room itself. Be sure the room is well ventilated and adequately cool. All that equipment can generate a lot of heat, and heat is bad for computer equipment and can lead to frequent crashes. Invest in an air conditioner if necessary. Choose a location where the noise from the editing room won't disturb others in your office or building. Repetitive trimming might not bother you but it will bother everyone else. Be sure that the room has enough power to handle all the equipment you'll be using. Brown-outs can damage equipment and cause you to lose valuable unsaved work. A battery backup unit can be a worthwhile

investment. These units have enough juice to let you save your work and shut down properly in the case of a black-out. Finally, dusty or smoky environments are bad for sensitive equipment and can lead to dropouts on videotape.

By now, you should have a room full of boxes. It's time to unpack them and move on to the tutorials in Chapter 6, "Setting Up an Editing System."

CHAPTER

6

Setting Up an Editing System

IN THIS CHAPTER

- Putting It All Together
- Tutorial: Setting Up the Computer
- Tutorial: Setting Up Video and Audio Hardware

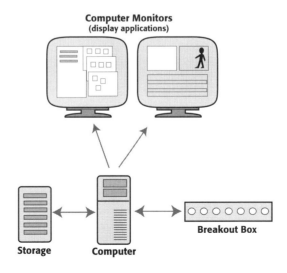

Computer Monitors
(display applications)

Breakout Box

Storage **Computer**

If you've never set up a non-linear editing system, you might find it daunting at first. Don't let that stop you—it's really not that bad. The key is to work through it step by step, which is exactly what this chapter is designed to help you do. The first tutorial covers setting up your computer, whether it's a Windows machine or a Mac, installing the video card(s), extra RAM, and a SCSI accelerator card. If you've already done this, skip ahead to the second tutorial. If you bought a turnkey system, you'll still have to put it together, although it will most likely come with the internal parts (RAM, video card, etc.) already installed. However, you'll still need to connect all the peripheral hardware yourself. The second tutorial walks you through the process of doing just that: connecting video decks, monitors, speakers, audio mixers, and other peripheral hardware to complete your editing system.

WHAT YOU NEED

If you've purchased software and hardware based on the information in the preceding chapters, you're ready to go. Typically, you'll find that you're missing a cable or two during the setup process, so be prepared for a quick run to the electronics store. Before we start, you can assume that any trouble you'll have will be a result of using hardware that hasn't been recommended by the software manufacturer. That said, clear off your work area and gather the items in the following checklist—it's time to get started.

SETUP CHECKLIST

- Editing software package and documentation
- CPU, extra RAM, operating system software, documentation, and power supply
- Keyboard, mouse, etc.
- Computer monitor(s), cable, and power supply
- Video monitor, cable, and power supply
- Speakers or headphones
- Media drives, SCSI accelerator card (if needed), cables, power supplies
- Video capture card (unless your computer has built-in FireWire)
- Assorted video and audio cables and connectors
- Video deck or camcorder, other media sources (DAT player, CD-ROM drive, etc.)
- Optional: Battery CPU backup system, external waveform monitor and vectorscope, audio mixing board, power strips, etc.

- Small Phillips head screwdriver
- Flashlight

Cables and Connectors

Before you get started, make sure you have all the cables and connectors you'll need. If your system is FireWire based, you've got it easy. You'll simply need to see whether you need a 4-pin FireWire cable, a 6-pin FireWire cable, or a 4-pin-to-6-pin cable. Otherwise, look at the backs of your video capture card and your decks. Your capture card will need BNC or RCA cables for video, and BNC, RCA, or XLR cables for audio. If the connections coming out of your decks don't match, you'll need some adapters.

SETTING UP YOUR COMPUTER

This tutorial walks you through the steps necessary to get your computer ready to use as an editing system. However, first read all of the manufacturer's instructions that came with your computer. This tutorial is not intended to replace the manufacturer's recommendations. Rather, this section aims to give you a workflow, especially if you're new to setting up computers.

If your computer isn't brand new, you might consider reformatting the hard drive and reinstalling the operating system for a fresh start. If not, skip ahead to Step 3.

This tutorial covers:

- Partitioning hard drives
- Installing PCI cards
- Connecting SCSI drives
- Setting SCSI IDS
- Starting up the system
- IRQ conflicts
- Striping hard drives

STEP 1: CONNECT THE BASIC COMPUTER HARDWARE

Connect the basic hardware components of your computer: the CPU, the primary monitor, the keyboard, and the mouse. Power up the CPU and the monitor, and then start the computer. If you have a Windows workstation, a setup application will walk you through the setup process. If you have a Macintosh, you'll have to run a setup application from the CD-ROM drive. It's also possible

that your new computer will arrive with the hard drive already formatted and the OS software preinstalled.

Partitioning

Hard drive partitions tell your computer to treat a single drive as if it were two or more separate drives. A good way to partition the primary hard drive for an editing system is to designate 1–2 gigabytes for the operating system, 3–5 gigabytes for applications, and the remainder for other data. This configuration lets you easily reinstall system software without endangering media files or applications. It also improves performance, makes recovering from crashes easier, and can simplify the backup process.

STEP 2: PARTITION YOUR HARD DRIVE

Next, you need to create partitions on your hard drive. Partitioning your hard drive isn't an absolute necessity, but it is usually recommended by editing software manufacturers. Check your software documentation for details. If your hard drive is smaller than 2 gigabytes, partitioning is not recommended.

Most new Windows workstations come with a 2-gigabyte partition for the Windows operating system, and the rest of the hard drive unformatted. From the Access IBM menu, select Startup > Partition Hard Drive, or refer to the manufacturer's instructions. We suggest creating a 3–5 gigabyte partition for applications, and whatever's left for data.

Macs usually come with the hard drive formatted as a single partition. Mac users will need to reformat the hard drive in order to create additional partitions and reinstall the system software. To do this, insert the system CD-ROM disk and restart the computer while holding the C key. This will force the computer to boot from the CD-ROM drive. To partition your drive, you'll need to run the Drive Setup program included on your system CD-ROM. This program allows you to create and format a scrics of partitions, and its Help system includes detailed instructions.

System Diagnostics

If you're working with a computer you've had for a while, run system diagnostics to make sure that your computer is operating at its maximum potential. If you're working on a Windows machine, you can look at the System Event Viewer to see if there are any recent errors or warnings (Figure 6.1). If you find any existing problems, be sure to correct them before you move on to Step 3.

FIGURE *The System Event Viewer displays recent errors and warnings on a Windows*
6.1 *machine.*

STEP 3: SHUT DOWN

The next several steps walk you through the process of installing extra components into your CPU such as RAM, video capture cards, and SCSI interface cards. To begin, shut down and unplug the computer. Next, open the chassis, following your manufacturer's instructions (Figure 6.2).

Stay Grounded

. . . electrically grounded, that is. Disperse static electricity from your body by touching a piece of conductive metal while you install RAM and PCI cards. Static electricity charges from your body can destroy the delicate components inside the computer. You can buy special bracelets that clip on to a piece of metal and allow for hands-free grounding.

FIGURE *Newer computers, like this Macintosh G3, are often designed for easy access to the*
6.2 *internal components.*

STEP 4: INSTALL EXTRA RAM

Install additional RAM, if applicable. This varies greatly from CPU to CPU, so fol-
low your manufacturer's instructions.

STEP 5: INSTALL VIDEO RAM

If you have a high-resolution computer monitor and/or a second computer
monitor, you might need to add some video memory, often called SGRAM or
VRAM. The type of video memory you'll need depends on your computer, and
whether you need more depends on your monitor. Check the specifications on
your computer to see how much video memory you have. Then check the mon-
itor manufacturer's specifications to see how much video memory you need.
Follow the computer manufacturer's instructions to install it. As a point of clari-
fication, video memory has nothing to do with video editing or video monitors;
it's simply a different type of memory used by your computer to run a high-
resolution computer monitor.

STEP 6: INSTALL PCI CARDS

Next, install any PCI cards you have—video capture card and daughter board (if applicable), SCSI interface card, FireWire interface card (for Windows users), 3D or graphics accelerator card(s), and secondary computer monitor interface card—into the long PCI slots.

Thin Blue Line

TIP

Installing PCI cards can be a bit challenging: you may need to apply quite a bit of pressure to seat them properly, yet you must be extra careful not to force them in and risk damaging them.

PCI cards can only fit in a slot one way, so whatever you do, don't try to force them in. If you're not sure which way the card fits, refer to the card manufacturer's instructions. Be sure that each card is seated properly and securely. Typically, small screws will be provided to fasten the end of the card to the back of your computer chassis (Figure 6.3). When you're done, close the CPU chassis and secure it. The cards that have connectors on the back—the video capture card, the monitor card, and the SCSI card—should feel secure and stable when you *gently* try to wiggle them.

Rear view

Firewire ports

USB ports

Audio connectors

Graphics accelerator PCI board

Video/Audio capture board

SCSI interface PCI board

FIGURE *Diagram of the back of a computer that has a video card and a SCSI card installed.*
6.3

STEP 7: CONNECT EXTERNAL STORAGE DRIVES

Now it's time to attach any external storage drives.

If you have FireWire drives, connect the first drive to the FireWire input on the back of your computer with a FireWire cable. If you have additional

FireWire drives, you can daisy chain up to 64 of them; but beware, the total length of the cables between the drives shouldn't exceed four feet.

SCSI drives require two extra steps: After attaching the first SCSI drive to the CPU and daisy chaining any additional drives, you must terminate the last device in the SCSI chain. Some SCSI devices come with an electronic terminator switch that you can simply set to "on." Others need a special terminator cap that fits over the SCSI interface (Figure 6.4). Be sure that you have no more than six SCSI drives for each SCSI interface on the back of your CPU, and that the total length of the SCSI cables doesn't exceed 15 feet. Next, you need to set the SCSI IDs on each drive. Each device must have a different number from 0 to 6. Avoid using 0 and 1, which are the default SCSI IDs for your CPU.

FIGURE *An Ultra2/LVD dual-channel SCSI connector.*
6.4

STEP 8: ATTACH A SECONDARY MONITOR (OPTIONAL)

Attach the cable from your secondary computer monitor to the back of the CPU.

STEP 9: POWER UP THE SYSTEM

Now you should have everything in place. Start by powering up the external drives. You should hear them spin up, often accompanied by a slight clicking sound when they've reached the appropriate spin rate. Most external drives also have some sort of indicator light to let you know when they're spun up. Refer to your drive manufacturer's instructions. Next, power up any other peripheral hardware, including the monitors. Now you can start up your computer. If you're using SCSI drives, it's very important to follow this method of starting up every time you use your editing system. FireWire drives can be turned on or off at any time.

STEP 10: CHECK AVAILABLE RAM

Now it's time to make sure the computer recognizes the RAM you installed:

Windows: Control Panels > System > General tab (Figure 6.5)
Mac: Finder > Apple menu > About this computer (Figure 6.6)

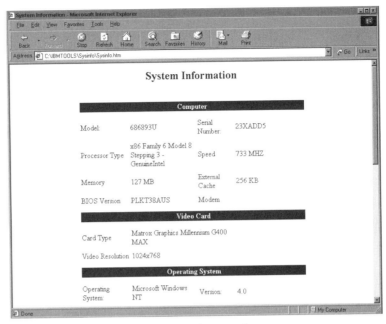

FIGURE *Checking the RAM on a Windows machine.*
6.5

FIGURE *Checking the RAM on a Macintosh.*
6.6

If the amount of RAM shown doesn't reflect the new RAM you installed, refer to the manufacturer's instructions. You may need to open up the computer and reseat the RAM chip(s).

STEP 11: INSTALL DEVICE DRIVERS

Install drivers for the PCI cards you installed. Each card probably came with some installation software. Refer to the manufacturer's instructions.

STEP 12: CHECK YOUR MONITOR'S SETTINGS

Check your monitor's control panel. Make sure your monitor is set to the right resolution and reflects the second monitor, if applicable.

Striped Drives

Some editing applications work best with striped storage drives, pair(s) of external hard drives that have been formatted together. The computer treats the pair of drives as a single, high-speed drive. When you capture media to the striped pair, the editing application will send some media to one drive and some media to the other drive, which results in faster performance, and as a result, better playback. A pair of striped drives is usually referred to as a drive array or a RAID (Redundant Array of Independent Disks).

STEP 13: FORMAT THE EXTERNAL STORAGE DRIVES

Determine whether your editing application and video capture card work better with striped drives (refer to the software and video card documentation). If so, follow the manufacturer's instructions to format and stripe your external drives. Remember that striped drives should consist of two drives of equal size. If your software doesn't recommend striped drives, format them as single, separate drives. Striping drives uses up some of the storage space on the drive, so don't stripe unless you need to.

As with the primary internal hard drive, you can also partition striped or single external drives. Designating smaller partitions on large media drives can make media housekeeping more manageable and help with drive performance. Again, check with your editing software and video card manufacturer's recommendations.

Once you've formatted the external drives, restart and make sure that all the drives appear properly on your desktop (Macintosh) or in the My Computer window (Windows).

Mind Your IRQs

Windows users need to make sure there aren't any hardware con-flicts by checking System Information > Hardware Resources > IRQs (Figure 6.7).

FIGURE *IRQ information window.*
6.7

STEP 14: RUN SYSTEM DIAGNOSTICS

Run system diagnostics software, such as Disk First Aid or Norton Utilities. You should get a clean bill of health! If not, check to make sure all the equipment you installed is working. The most common culprit is problems with SCSI dri-ves—confirm that all the cable connections, the SCSI Ids, and the terminator are set properly, and then shut down and restart following the instructions in Step 8. If you're still having problems, refer to the troubleshooting section in Chapter 7, and the various manufacturers' documentation for each component in your system.

Flaky SCSI

Note that SCSI chains can sometimes behave strangely. If your SCSI chain isn't working properly and you've double-checked all your termination and IDs, then take the chain apart and reassemble it in a different order. Sometimes you can even take it apart and put it back in the same *order and it will work. Although this tip may sound like voodoo, voodoo is often what it takes to get a complex SCSI chain working.*

SETTING UP THE PERIPHERAL HARDWARE

Now that the inner workings of your computer and operating system are set up, it's time to move on to the external stuff. Setting up peripheral hardware doesn't require the delicacy of installing internal hardware, but it's more likely to get confusing due to the mass of cables and connectors involved—and the more equipment you have, the more complicated it gets. Work through the steps in this tutorial methodically, dealing with each piece of equipment one at a time. You'll be less likely to get confused or make a mistake.

This tutorial covers:

- Connecting video decks
- Connecting audio decks
- Connecting video routers
- Connecting audio mixers
- Connecting video monitors
- Special instructions for FireWire-based DV systems

STEP 1: CONNECT THE BREAKOUT BOX OR CABLE (OPTIONAL)

Connect the breakout box or cable, if applicable (Figure 6.8).

Label Your Cables

The back side of an editing system can look like a tangled spider web when you're done setting it up. Use paper tape to create hand-made labels for each cable, such as "VTR video out to video monitor input B," or "VHS audio ch.1 out to mixer ch. 10 in." That way, if a cable gets accidentally disconnected, you'll know where it belongs.

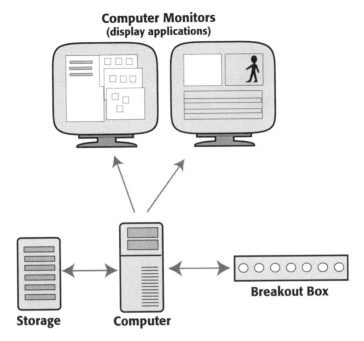

Computer Monitors
(display applications)

Breakout Box

Storage Computer

FIGURE *Attach the breakout box, if available, to the computer.*
6.8

STEP 2: CONNECT THE VIDEO FROM YOUR PRIMARY VIDEO DECK TO THE COMPUTER

Connect the deck you'll use for digitizing and higher-quality outputs (Figure 6.9).

- For a VTR with SDI video I/O you'll need BNC cables.
- For a VTR with component video I/O (Betacam SP, professional DVCAM and DVCPro), you'll need three BNC cables.
- For a VTR with composite video I/O (VHS, 3/4" Umatic), you'll need one BNC cable or one RCA cable.
- For a VTR with S-video I/O (VHS, Super VHS, etc.), you'll need one S-video cable.
- For a VTR with FireWire I/O (DV, DVCAM, DVCPro), you'll need one 6-pin FireWire cable.
- If you're using a DV camcorder instead of a DV deck, you'll need a 6-pin to 4-pin FireWire cable or adapter. The FireWire cable also contains the two audio signals and the DV timecode signal used for deck control. And it gets better: FireWire cables are two-way communicators, so the one cable sends video, audio, and timecode signals to your computer, and also receives those signals from the computer. Skip ahead to Step 9 unless you have other decks you need to add to the system.

FIGURE *Send the video signal from the primary VTR to the breakout box or video card.*
6.9

Abbreviations
TIP
V *stands for video,* A1 *stands for audio channel 1, and* A2 *stands for audio channel 2, etc.*

Special Instructions: External waveform monitor and vectorscope
NOTE
If you have an external waveform monitor and vectorscope, it should be added to the chain of equipment in the following way: the video output signal from the breakout box or video card should go through the scopes on the way in to the primary VTR. The video output signal from the primary VTR should pass through the scopes on the way in to the computer (Figure 6.10).

FIGURE *Attach the external waveform monitor and vectorscope.*
6.10

NOTE

Special instructions: Video Routers

If you have a four-channel video router, the extra time you spend setting it up will pay off later. The video output from the router should connect directly to your CPU or breakout box. Then, send all video cables from the decks into the router (Figure 6.11). Be aware that you'll need twice as many cables to do this.

STEP 3: CONNECT THE AUDIO FROM YOUR PRIMARY DECK TO YOUR COMPUTER

Most video decks have two audio channels: left, aka channel one or A1; and right, aka channel 2 or A2. Unfortunately, how these channels are labeled varies from deck to deck. Be sure that you connect left/channel one to the channel-one input on your CPU/breakout box and right/channel two to the channel-two input. If your deck only has one audio channel, typically if it's a

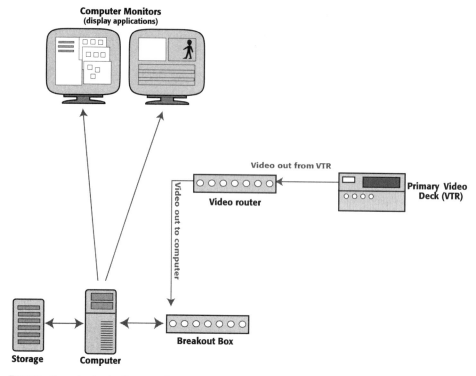

FIGURE *If you're including a video router in your editing system, send all video signals*
6.11 *through the router.*

low-end consumer VHS deck, connect that channel to the channel-one input
(Figure 6.12).

Special instructions: Audio Mixers

*If you have an audio mixing board, it should connect directly to
your CPU or breakout box. Then send all the audio cables, in-
cluding those from the video decks, through the mixer (Figure
6.13). Be aware that you'll need twice as many cables to do this.
Refer to the mixing board manufacturer's instructions for more
details.*

STEP 4: CONNECT ADDITIONAL VIDEO DECKS

Repeat Steps 2 and 3 with any additional video decks you have (Figure 6.14).
Repeat Step 3 with any other audio decks, such as a DAT player (Figure 6.15). If
your capture card has only one set of video and audio inputs, you might need
to patch any other decks through your primary VTR. *Patching through* is the

FIGURE *Send the audio from your primary VTR to the breakout box/capture card.*
6.12

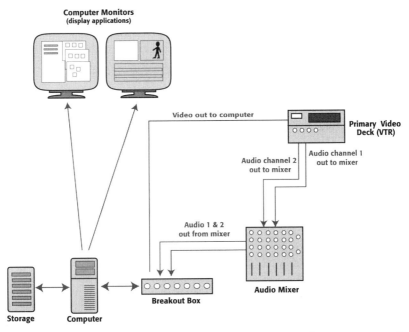

FIGURE *If you're including an audio mixing board in your editing system, send all audio*
6.13 *signals through the mixing board.*

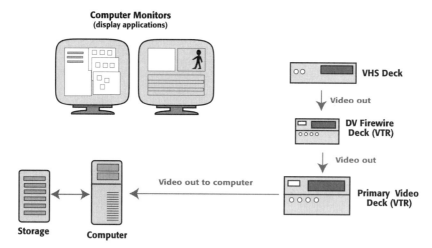

FIGURE **6.14** *The video signal from the VHS deck is patched through a daisy chain of other video devices. This way, the signal video input on the capture card is getting video signals from all three VTRs.*

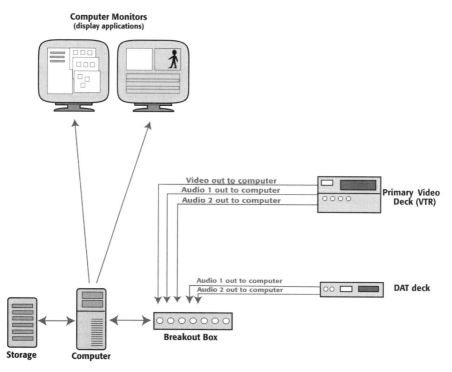

FIGURE **6.15** *Send the signal from any audio decks to the breakout box/capture card.*

video and audio version of a daisy chain; you're simply sending the same video or audio signal through an extra device, not changing it in any way.

Chances Are . . .

It's probable that your video card and/or breakout box will have either XLR audio I/O or RCA audio I/O, but probably not both. If so, you may need to buy some adapters to make the cables coming out of your deck compatible with your card.

STEP 5: CONNECT THE DECK CONTROL CABLE

If your primary VTR allows for deck control, connect the RS-422 cable (Figure 6.16) from the back of the VTR to the RS-422 connector on your video card or breakout box. Some systems use RS-232, so you'll need to use an adapter. If you are capturing from a FireWire-based DV deck, you can skip this step if you want the deck control handled by the FireWire cable.

FIGURE *Attach the deck control cable.*
6.16

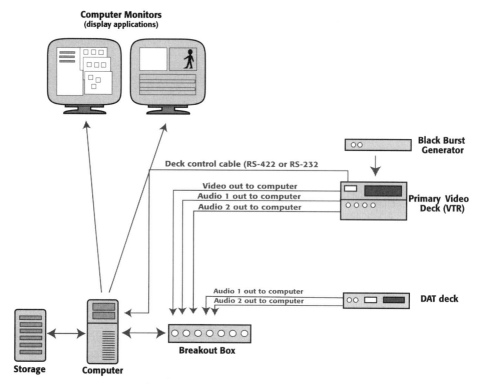

FIGURE *Attach the black burst generator, and send the black signal into the primary VTR*
6.17 *(optional).*

STEP 6: CONNECT THE BLACK BURST GENERATOR

Attach the black burst generator to feed a black signal into your primary VTR. Many consumer-level VTRs do not have an input for a black burst generator. If that sounds like your VTR, skip ahead to the next step. Otherwise, send the black signal from the black burst generator into the Reference Video input on your primary VTR with a BNC cable (Figure 6.17).

If you have a four-channel video router, send the black signal to one of the inputs on the router instead. You can then use the router to send black to your VTR when needed.

STEP 7: REVERSE THE PROCESS

You should now have all your equipment sending signals into your computer, for capturing. Now you want to send the signals from your computer back out to your decks, to create videotape outputs.

FIGURE *Send video and audio back out from the computer and into the primary VTR.*
6.18

Start by sending the video signal out from the computer to the primary deck (Figure 6.18). The types of cables you will need should be the same as those in Step 2.

STEP 8: SEND AUDIO OUT FROM THE COMPUTER TO THE PRIMARY DECK

This will probably be the same cable configuration as in Step 3. It's unlikely that you'll need to send audio from your computer to an audio deck, such as a DAT player, but if so, go ahead and attach those cables as well. If there's only one audio output on your capture card, you'll need to patch them through your primary VTR.

STEP 9: ATTACH THE PRIMARY AND SECONDARY VIDEO DECKS TO EACH OTHER

Most editing systems have a high-quality primary deck (Betacam, DVCAM, DVCPro, DV, etc.) and secondary VHS deck for making viewing copies of works

FIGURE *Send video and audio from the primary VTR to the VHS deck.*
6.19

in progress. It's best to connect this deck through your primary VTR (Figure 6.19). This way, you can easily make a high-quality output and a viewing copy at the same time. Attach a cable from the composite video out on the primary deck (most likely BNC or S-video) to the video input on the VHS deck. If your VHS deck has an RCA video input, you may need an adapter. Repeat this process with audio channels one and two.

If you're using a FireWire-based DV camcorder, you won't have the necessary output connections to patch a VHS deck directly from the camcorder. Instead, you need to send the video output signal, via FireWire, to your video monitor (see Step 10), and then send the analog video and audio signals out of the monitor to the VHS deck.

STEP 10: CONNECT THE NTSC/PAL VIDEO MONITOR

If you have a FireWire-based DV system, connect the analog video output from the DV deck or camcorder to the video monitor (Figure 6.21). If you have any

Video is captured by
special hardware in
the computer

Video deck (VTR)

CPU

Video monitor Computer monitor

FIGURE *In most editing systems, video is sent to the computer, where it is captured for editing.*
6.20 *The computer sends the video signal to the VTR for recording to tape, and sends it to*
the NTSC/PAL monitor for playback.

other sort of system, ideally, you'll have a professional monitor that allows for at
least two input sources. Connect the composite video output from your video
card/breakout box to video input A on the monitor. Then connect the compos-
ite video output from the VTR to video input B on the monitor. This way, you
can switch from viewing directly from tape to viewing the computer output. If
you only have one input choice on the video monitor, send the signal from the
computer to the monitor (Figure 6.20).

A/B Switchers
You can buy cheap switch boxes that let you send video from two
sources into one monitor. These are available at most electronics
TIP *stores and cost around $25.*

STEP 11: CONNECT THE SPEAKERS OR HEADPHONES
Depending on how you configure your system, the speakers will attach to the
back of the CPU, the breakout box, or the audio mixer. Your final configuration
should resemble Figure 6.22, or, if it's FireWire based, Figure 6.23.

FIGURE **6.21** *In a FireWire-based DV editing system, video is digitized by the camera or deck, and the resulting digital file is sent to the computer. When editing, the computer transmits a compressed digital signal back to the camera, where it is decoded for playback on a video monitor.*

FIGURE **6.22** *If your system is FireWire based, it will look something like this when you're done setting it up.*

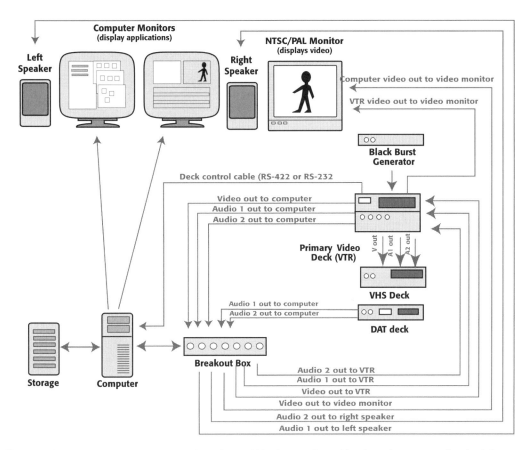

FIGURE *If your system is not FireWire based, it will look something like this when you've finished this*
6.23 *tutorial.*

DRUM ROLL, PLEASE . . .

By now the suspense is probably killing you—will it work? The only way to find
out is to install the software, set it up to suit your particular hardware configura-
tion, and do some test capturing and outputting to videotape—and that's exactly
what the next chapter is all about.

CHAPTER

7

Setting Up and Managing a Project

IN THIS CHAPTER

- Software and Settings
- Tutorial: Setting Up a Project and Testing Your System
- Troubleshooting
- Scheduling and Budgeting Postproduction
- Jobs in Postproduction
- Networked Editing Systems

Odd fields + Even fields = Complete image

The value of planning in advance when it comes to postproduction cannot be underestimated, whether it's simply making sure your system works properly or creating a realistic budget and schedule.

The first part of this chapter offers tips for setting up your OS and installing your editing software. The tutorial in the next section will help you create a first project and test your newly configured system to make sure it's working properly. This chapter can't possibly address every situation, but it should point you in the right direction for your own specific needs.

The second half of this chapter is about project management: scheduling, budgeting, and a description of the traditional jobs in postproduction. It should help you make intelligent decisions that pave the way when planning future jobs and projects.

The final section covers networked editing systems, including different types of networking hardware, and the pros and cons of setting up a network of editing workstations.

SOFTWARE AND SETTINGS

Once you've configured the hardware in your editing system, there are only three remaining steps to this process: prepare your computer operating system, install the software, and configure the settings inside the editing application. The specifics of each step will be different depending on your CPU, the operating system you're using, and the editing application you've chosen.

- For the Windows OS, use the Add/Remove Programs Control Panel to uninstall any other video applications on your system. You can always reinstall them later if you want (Figure 7.1).
- For the Macintosh OS, use the Extensions Manager in the Control Panels to turn off unnecessary extensions and also to turn off codecs from other applications that might conflict with your editing software (Figure 7.2).

TIP

Codec Conflicts
If you installed demo software in Chapter 2, you'll need to turn off the preferences, drivers, and control panels for that software before you install or launch a different editing application. Otherwise, you may face conflicts that cause errors with your new editing software. You can always reinstall the demo application if you need it later.

FIGURE *Use the* Add/Remove Programs Control Panel *to uninstall demo applications from a*
7.1 *Windows system.*

FIGURE *Use the Macintosh Extensions Manager to turn off extensions and preferences*
7.2 *associated with hardware and software you're not using.*

INSTALLING THE SOFTWARE

Most software packages will walk you through the installation process, but here are a few quick tips:

- Always quit all other applications before performing an installation.
- Turn off any background applications such as screen savers and network connections.
- After performing the installation, always restart your system,
- Make sure the software drivers are running. Check the Control Panels and make sure they are set properly. Refer to your software manufacturer's instructions.
- Launch the editing application, and make sure it is functioning.

Macs and RAM

If you're working on a Macintosh, you'll need to designate the amount of RAM used by your editing application. From the Finder level, select the icon for your editing software, and then press Command + I. The Info dialog box will appear. Select Memory from the Show pop-up menu, and type in the minimum and maximum amounts of RAM you want dedicated to the application in the fields at the bottom. Follow your software manufacturer's recommendation on how much RAM your application needs (Figure 7.3).

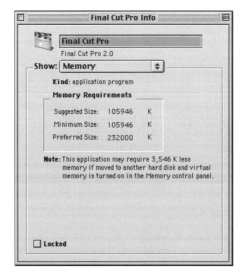

FIGURE *Configuring the RAM on a Macintosh.*
7.3

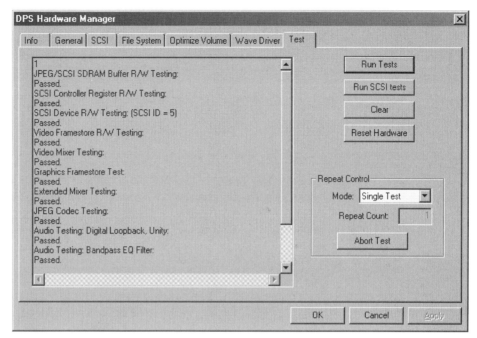

FIGURE *The DPS Hardware Manager.*
7.4

Your editing software may include special hardware diagnostic software. If so, this is a good time to make sure your hardware passes the tests. DPS Velocity comes with the DPS Hardware Manager utility (Figure 7.4). If your software package includes special utilities for optimizing drives (Figure 7.5) and other hardware management, always use them rather than third-party utilities such as Norton Utilities.

FIGURE *If your software comes with special dedicated hard drive management utilities, like*
7.5 *the one from DPS shown here, use them to optimize your drives rather than third-party software.*

SETTING UP YOUR FIRST PROJECT AND TESTING YOUR SYSTEM

TUTORIAL

Now that you have it all together in one place, it's important to make sure the system functions properly. Editing systems are tricky to set up, but are usually very stable once they're up and running. By setting up a new project and testing all the basic functions of the editing application now, you can discover and correct any problems up front, instead of finding out about them in the middle of an important project.

WHAT YOU NEED

For this tutorial, you'll need, in addition to your editing system, a videotape to capture from and a blank videotape on which to record. The idea is to test every feature of your system, so if you have other hardware, such as a DAT player or a secondary video deck, it's also a good idea to have some media for capturing

and a blank cassette in those formats as well. You'll also need to have a still graphics file available on your computer, such as a PICT or BMP file.

Important
If you have problems with any step of the process, refer to the troubleshooting section later in this chapter.

STEP 1: CREATE A PROJECT FOLDER

Start with your system shut down. Then, turn on your system as explained in Chapter 6: turn on the storage drives and let them spin up, turn on all other peripherals and let them warm up, and then turn on your computer.

Some editing applications, like Avid Media Composer, create their own files and folders to contain the project and its associated media. If this is the case for you, skip ahead to Step 2. However, most other editing applications leave the file organization up to you. Typically, you should go to the Windows or Finder level and create a folder for your project and, for this tutorial, call it Test Project Folder. If you'll be capturing media to an external storage drive, create a folder on the external drive and call it Test Project Media. Otherwise, create a Test Project Media folder on your internal hard drive. In general, you should keep your project folder and your media folder on different drives. Some applications can be fussy about where they store files, so refer to your software manufacturer's documentation for specifics. Keeping track of your project and media files at the Finder/Windows level is a good habit to develop.

Crash Logs
If you get an error message when working or during a crash, be sure to write down what it says, and take note of what you were doing when the error or crash occurred. This can be useful information for you or a technical support person when troubleshooting the problem. If the crash isn't too severe, you can make a screen grab of the error message by using the Print Screen key on a Windows machine, or typing Command+shift+3 on a Mac.

STEP 2: CREATE A PROJECT

Launch your editing software. When prompted, choose to create a new project, call it Test Project, and save it in the Test Project Folder you created on your hard drive. Some applications will open directly into a tutorial project. Working through the manufacturer's tutorial is a great idea, but first it's best to make sure the software is working properly by following the rest of the steps in this tutorial.

TIP

Where's the Rosetta Stone?

Unfortunately, many software manufacturers feel the need to put a unique stamp on their product by giving each feature a unique name. Project Settings might also be called Preferences or Presets. Poke around the menus in your editing application to get a feel for what's available.

What's Under the Hood?

When you're working in an editing application, the software is acting as a link between you and the hard drive(s) where your media is stored. Exactly how does the computer handle the massive amount of data that is being processed when you edit?

Each project that you create is stored in a folder on the Finder or Windows level of your computer, usually on the main hard drive. Some applications create a special folder for all the projects they create, while others let you decide where to store the project folder. Inside the project folder are all the files that make up your project—some applications, like Final Cut Pro 2.0, store a master project file that includes just about everything. Others, like Avid Media Composer, store a master project file, a file for each edited sequence, a file for each bin, and a settings file for each project and each user.

What you won't find in this folder is the actual media for your project—the video and audio files that make up your source clips. How the NLE stores this data differs from application to application, and results in variances and limitations that you'll experience as the user of the software. Here's a quick peek under the hood of the editing applications covered in this chapter:

- **Adobe Premiere**. Stores media to a folder that you designate. Each clip consists of one QuickTime movie file that contains the video and audio tracks together.
- **Apple Final Cut Pro**. Stores media to a folder that you designate in the Preferences settings, in subfolders that it creates called Capture Scratch and Render Files. Each clip consists of one QuickTime movie file that contains the video and audio tracks together. Final Cut is notorious for leaving Capture Scratch and Render Files folders scattered across your drives.
- **Avid Media Composer**. Media files are stored on peripheral hard drives in folders called Media or OMFI. Each clip has three files associated with it—one video and two audio files (assuming you captured two tracks of sync audio with the video)—and each Media or OMFI folder contains a media database file that keeps track of what's in the folder. Since each media file has a name that consists of a zillion characters, it's almost impossible to tell what's what on the Windows/Finder level. Avid provides a

special folder inside the Media Composer application, called the Media Tool, that allows access to the media files and the files for rendered effects, called *precomputes*.

- **Avid Xpress DV**. Avid Xpress DV stores files in a manner similar to Avid Media Composer.
- **DPS Velocity**. You can choose the default and let Velocity store media in folders designated by the application, with each folder representing a different type of file (AVI, BMP, WAV, etc.), or you can designate custom folders in the General Settings (Figure 7.9).
- **EditDV**. Stores media to a folder that you designate in the Media Drive preferences dialog box. Media files consist of one QuickTime movie file that contains the video and audio tracks together.

STEP 3: CONFIGURE THE GENERAL PROJECT SETTINGS

The general projects settings tell the application how you want the interface to behave. Usually, you can set the number of levels of Undo, the length of pre-roll and post-roll when Trimming, how often to Auto-save, and more. The location of these settings varies from application to application, so refer to your software documentation for details. If you haven't the slightest idea what you want, stick with the default settings until you're more familiar with your personal editing preferences. You can always go in and change these settings later (Figures 7.6 and 7.7).

FIGURE *General project settings in Apple Final Cut Pro.*

7.6

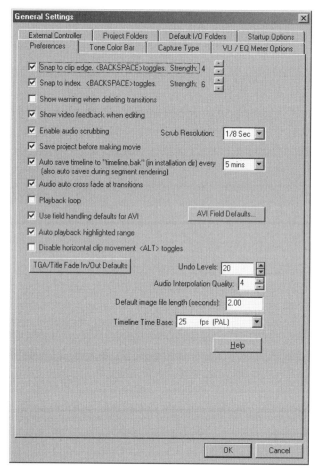

FIGURE *General project and playback settings in DPS Velocity.*
7.7

STEP 4: CONFIGURE THE PLAYBACK SETTINGS

The playback settings tell the application how to play video and audio in your project. Sometimes these settings are in the same window as the general project settings (Figure 7.7). You'll select a time base: 29.97 fps for NTSC and 25 fps for PAL. You'll also choose which field is dominant. This depends on how your tapes were recorded, but general DV footage is lower, or even-field dominant, and most other footage is upper, or odd-field dominant. You can also decide what timecode you wish the sequence to start at, and whether the timecode is dropframe or non-dropframe. Starting a project precisely at 01;00;00;00 with dropframe timecode is the standard in professional editing, so for now, leave it at that. You should tell your software how many tracks of audio you wish to monitor in your sequence—the maximum is usually eight (Figures 7.8).

FIGURE *Playback settings in Avid Xpress DV.*
7.8

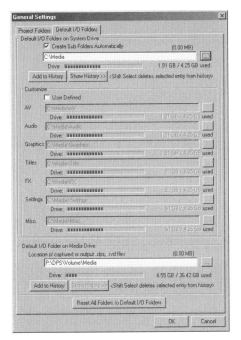

FIGURE *This tab in the General Settings for DPS Velocity lets you choose where to save*
7.9 *different types of files associated with a project.*

Field Dominance

NTSC/PAL video is comprised of hours, minutes, seconds, frames, and fields. Each frame of video consists of two fields, so that NTSC has about 60 fields per second, and PAL has 50 fields per second. One of the fields contains the odd-numbered scan lines and is called the odd, or upper, field. The other field contains the even-numbered, or lower field. If the upper field plays first, the video is considered upper-field dominant; if the lower field plays first, it's considered lower-field dominant. DV footage is lower-field dominant, and most other video is upper-field dominant (Figure 7.10). Just to make this more confusing, the odd/upper field may also be referred to as the A field or field 1, and the even/lower field, correspondingly, B field or field 2.

| Odd fields | Even fields | Complete image |

FIGURE *Interlaced fields of video.*
7.10

STEP 5: CONFIGURE THE CAPTURE SETTINGS

The capture settings allow you to tell the application what type of video you'll be capturing (DV, component analog, S-video, composite, or SDI); whether your video is NTSC or PAL; which type of timecode you'll be using (DV for FireWire-based DV footage, SMPTE for most others); and whether you have a remote device control set up between your computer and your VTR. You may have to tell your application if your device control interface is FireWire, RS-422, RS-232, or LANC (Figure 7.11).

You'll also have some options as to *pre-roll, post-roll* and *handles*. The pre-roll setting tells the VTR to cue up at a certain point and play from there *before* it starts capturing. This guarantees that the tape will get up to full speed by the time capture starts. The ideal setting for pre-roll on a VTR is six seconds. Post-roll is less important, and you can leave this at the default setting. The *handles* option, if available, in the capture settings can cause problems if there are *timecode breaks* in your source tapes. This is explained further in the troubleshooting

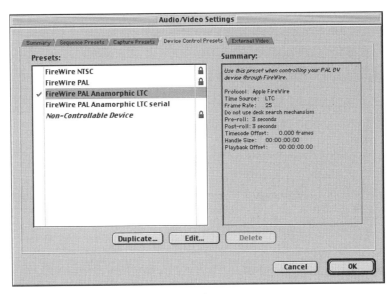

FIGURE *Device control settings in Final Cut Pro.*
7.11

section later in this chapter, but for now, set the handles to zero seconds (Figure 7.12).

The capture settings will let you select the video and audio quality. Some applications offer special video quality presets, with names like *online capture*,

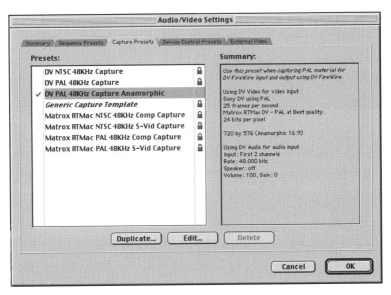

FIGURE *Capture settings in Final Cut Pro.*
7.12

high-resolution, or *offline quality.* Your software manual should explain what these presets mean.

Some applications give you a choice of *capture resolutions* for video. Usually, these are described as a ratio—1:1, 2:1, 3:1, and so on. You will be limited by the hardware in your system, so choose the best capture resolution that your system can handle—hopefully 1:1—unless you're capturing a large amount of media (refer to the information that came with your capture card). If your project is FireWire-based DV, there is usually only a single 1:1 resolution available, and you won't be offered a choice in the Capture Settings (Figure 7.13).

Next, select the *frame resolution,* also known as *pixel dimensions.* If your footage is DV, this means 720 × 480-pixel resolution. If your footage is analog component video, this means 720 × 540. If it's analog composite, 640 × 480 will do, and if it's component digital SDI video, it should be set to 720 × 486 (Figure 7.14).

Next, you'll set the audio quality by selecting a sampling rate. Select 48 kHz if you have digital audio from DAT or digital videotape, or select 44.1 kHz if your audio is analog or coming from CD. If you have a combination of both, select 48 kHz (Figure 7.15).

FIGURE *Capture settings in Avid Xpress DV.*
7.13

Pixel Aspect Ratio

Pixel Aspect Ratio:	Square Pixels (1.0)
	✓ D1/DV NTSC (0.9)
	D1/DV NTSC Widescreen 16:9 (1.2)
	D1/DV PAL (1.067)
	D1/DV PAL Widescreen 16:9 (1.422)
	Anamorphic 2:1 (2.0)
	D4/D16 Standard (0.948)
	D4/D16 Anamorphic 8:3 (1.896)

FIGURE *Selecting pixel dimensions.*
7.14

FIGURE *Audio capture settings in DPS*
7.15 *Velocity.*

FIGURE *Quick Capture mode in*
7.16 *DPS Velocity.*

STEP 6: PERFORM A TEST CAPTURE

Go into *capture mode* or *record mode*, as described in your software manual. If you have more than one VTR, you may have to choose which one you'll be capturing from. Next, insert the tape in the VTR. Hopefully, you'll be prompted to enter a tape name or number; if not, enter this information manually. You can call this particular tape anything you want for now; we'll talk about tape names and numbers more in the next chapter (Figure 7.16).

Start with the tape transport controls in your Capture window. You should be able to use them to control the tape in your VTR. If your system doesn't have device control, you'll have to use the transport controls on your VTR instead.

The first thing to test is digitizing *on-the-fly*. Select a portion of the videotape that has video and audio, and press Play. Next, press the Record button in the Capture window. The red light next to it, or the button itself, should start blinking, which indicates that capturing is in process. After a couple of minutes, stop the capture by pressing the Record button again. You should now see a clip in either the Capture window or the clip bin (Figure 7.17). Double-click on the clip to display it, and press Play. You should be able to see and hear the clip you just captured. If you're capturing timecode from your source tape, make sure that the timecode on the captured clip matches the timecode on the tape (Figure 7.17).

FIGURE *The Log and Capture window in Final Cut Pro, 2.0.*
7.17

If you have other media sources, such as a DAT player or another VTR, go ahead and capture some clips from those machines too, to make sure everything works. If you don't have remote device control, capture another clip or two, and then skip ahead to Step 6.

Next, try logging a shot. Use the tape transport controls to find the start of a shot you like, and then set the in-point in the Capture window. Usually, you can type the letter "I" on the keyboard to do this. Next, find the end of the shot, or the out-point, and select it by typing an "O." A clip should now appear in the capture interface. Select it, and then select Capture. The software should control the VTR and capture the clip. Log a few more shots, select them, and choose Batch Capture (Figure 7.18). When they're captured, close the capture interface and move on to the next step.

STEP 7: IMPORT SOME GRAPHICS

Many editing applications offer separate settings for imported graphics, such as PICT or BMP files. It's common to import graphics at an uncompressed resolution, even though video was captured at a lower resolution. (FireWire-based DV systems probably won't offer this option, so skip ahead to the next step.) If you

Bin: 11

Name	Duration	In	Out	Media Start	Media End	Tracks	Good	Log Note
14-1	00:00:45:23	Not Set	Not Set	00:40:41:01	00:41:26:23	1V, 2A		
14-2	00:00:34:09	Not Set	Not Set	00:41:26:23	00:42:01:06	1V, 2A		
14-3	00:00:36:05	Not Set	Not Set	00:42:01:06	00:42:37:10	1V, 2A		
14-4	00:00:34:13	Not Set	Not Set	00:42:37:10	00:43:11:22	1V, 2A		
14-5	00:00:31:18	Not Set	Not Set	00:43:11:22	00:43:43:14	1V, 2A		
14-6	00:02:00:21	Not Set	Not Set	00:43:43:14	00:45:44:09	1V, 2A		SERIES-DUDE
14-7	00:01:31:07	Not Set	Not Set	00:45:44:09	00:47:15:15	1V, 2A		SERIES-DIANE
15A-1	00:00:28:15	Not Set	Not Set	00:48:35:15	00:49:04:04	1V, 2A		
15A-2	00:00:43:09	Not Set	Not Set	00:49:04:04	00:49:47:12	1V, 2A		
15A-3	00:00:48:24	Not Set	Not Set	00:49:47:12	00:50:36:10	1V, 2A		
15A-4	00:00:32:13	Not Set	Not Set	00:50:36:10	00:51:08:22	1V, 2A		
15A-5	00:00:43:06	Not Set	Not Set	00:51:08:22	00:51:52:02	1V, 2A		
15A-6	00:00:38:02	Not Set	Not Set	00:51:52:02	00:52:30:03	1V, 2A		
15B-1	00:00:21:04	Not Set	Not Set	00:52:30:03	00:52:51:06	1V, 2A		
15B-2	00:00:39:11	Not Set	Not Set	00:52:51:06	00:53:30:16	1V, 2A		
15B-3	00:00:15:09	Not Set	Not Set	00:53:30:16	00:53:45:24	1V, 2A		SECOND STICKS
15B-4	00:00:51:15	Not Set	Not Set	00:53:45:24	00:54:37:13	1V, 2A		TAIL SLATE
15C-1	00:00:44:23	Not Set	Not Set	00:54:39:11	00:55:24:08	1V, 2A		
15C-2	00:00:41:10	Not Set	Not Set	00:55:24:08	00:56:05:17	1V, 2A		
15C-3	00:00:47:11	Not Set	Not Set	00:56:05:17	00:56:53:02	1V, 2A		
15C-4	00:00:51:24	Not Set	Not Set	00:56:53:02	00:57:45:00	1V, 2A		
15C-5	00:00:38:24	Not Set	Not Set	00:57:45:00	00:58:23:23	1V, 2A		
15D-1	00:00:34:02	Not Set	Not Set	00:58:23:23	00:58:57:24	1V, 2A		
15D-2	00:00:22:06	Not Set	Not Set	00:58:57:24	00:59:20:04	1V, 2A		
17-1	00:01:08:05	Not Set	Not Set	00:59:22:24	01:00:31:03	1V, 2A		SLATE OFF
17-2	00:01:42:05	Not Set	Not Set	01:01:41:10	01:03:23:14	1V, 2A		
17A-1	00:00:37:02	Not Set	Not Set	01:03:23:14	01:04:00:15	1V, 2A		
21M-3	00:03:02:00	Not Set	Not Set	00:00:14:00	00:03:15:24	1V, 2A		
21M-4	00:02:38:23	Not Set	Not Set	00:03:15:24	00:05:54:21	1V, 2A		
21M-5	00:03:50:11	Not Set	Not Set	00:05:54:21	00:09:45:06	1V, 2A		NO SLATE
21N-1	00:04:05:16	Not Set	Not Set	00:09:45:06	00:13:50:21	1V, 2A		SERIES
97-1	00:01:27:05	Not Set	Not Set	00:13:50:21	00:15:18:00	1V, 2A		

FIGURE *A bin with logged shots ready for batch capture.*

7.18

have the option, choose an uncompressed setting, or the same setting you selected for video in the capture settings (Figure 7.19).

If you've never created graphics files for use in a video, be sure to prep the graphics file before you import. The image resolution should be 72 dpi, and the dimensions should match the pixel dimensions of the video format with which you are working.

Next, refer to your software manual for instruction on importing a graphics file. Usually, the Import command is located in the File menu. Once the file is imported, you'll see a new clip in your bin that acts just like a video clip. Check to see if it plays back properly, and look at the image quality. Does the image quality seem to reflect the import settings you selected? When judging image quality, always look at your external video monitor, rather than your computer monitor. Remember that video has a very low resolution compared to a graphics file destined for print publication. If you're used to looking at 300 dpi

FIGURE **7.19** *Graphics import settings in Avid Xpress DV.*

images, you might not think the image looks very good, even though it was imported as uncompressed—this is normal.

STEP 8: CREATE A SEQUENCE, AND TEST PLAYBACK

You should now have several captured video clips and a couple of imported graphics clips (Figure 7.20). Select them all and drag them into the timeline. Set your cursor in the timeline, and press Play. The string of clips should play back without any jerkiness or other errors. Listen to the audio, too; it should sound just like the audio that was on your videotape. If the graphics files don't play properly, your system may need to render them first. Move on to the next step.

FIGURE **7.20** *Bin with clips and timeline in Final Cut Pro.*

STEP 9: CONFIGURE THE RENDER, EXPORT, AND OUTPUT SETTINGS

Next, you need to configure the *render, export,* and *output settings.* The render settings tell the computer how to process graphics and other media that it's not able to play back in real time. You'll need to render before you export a file or output to videotape (Figure 7.21). Refer to your software manual for the location of the render settings. You should be able to choose between a draft render preset (a low-quality fast render for viewing purposes only) and a high-resolution render preset (for high-quality outputs and exports). Select the high-resolution render for this test. The frame rate should be 100%, or 29.97 fps for NTSC and 25 fps for PAL. The resolution should also be 100%, or match the pixel dimensions of your video, as described in Step 5. If available, you should select field rendering, motion blur, and frame blending.

Next, configure the export settings. These settings tell the computer what type of media you wish to send out to a file will be, such as a QuickTime or AVI movie. (Figures 7.22 and 7.23). These settings will vary depending on the type of file you wish to export. For the sake of this tutorial, select either QuickTime or AVI. Choose full resolution, full frame rate, and select the Animation compressor for the best quality final export.

Finally, configure the output settings. These settings tell your computer what sort of media you want to send out of your system and back onto videotape (Figure 7.24). Refer to your software manual for the location of these settings. Here you'll find a similar list of options as you did in the capture settings. For this tutorial, select the same quality as you did for capturing (refer to Step 5).

FIGURE **7.21** *Render settings in Final Cut Pro 2.0.*

FIGURE **7.22** *Export settings for QuickTime.*

FIGURE *Export settings for AVI.*
7.23

FIGURE *Video output settings in DPS*
7.24 *Velocity.*

STEP 10: TEST RENDER AND EXPORT YOUR SEQUENCE

Now that all your settings are configured, select the edited sequence you created in Step 8, and render it (refer to your software documentation for details). This might take awhile. Once it's done, play it back to make sure it plays properly.

Now try to export the sequence as a QuickTime or AVI movie. After the export is completed, go to the Finder or Windows level, and play the exported file to make sure it looks good and plays properly.

STEP 11: OUTPUT YOUR SEQUENCE TO VIDEOTAPE

Finally, send your edited sequence back out to videotape. Some applications call this *printing to tape*; others call it a *digital cut*. This process can vary from one application to the next, so refer to your manual for details. If you don't have deck control, you'll have to press record on your VTR and let it get up to speed before you send the sequence out from the computer. If you do have deck control, the editing system should perform this for you automatically. If you have a choice between *assemble* and *insert* edit, select assemble edit. Assemble edits and insert edits are discussed in Chapter 12.

STEP 12: REVIEW THE VIDEOTAPE OUTPUT

Finally, watch the output to make sure everything came out okay, including the audio.

Congratulations—if you made it through this entire tutorial, you have a fully functional editing system. You can feel confident that your system is up to any task you put before it. You've also been introduced to a lot of editing basics.

TROUBLESHOOTING THE SYSTEM

Problems with editing systems can be mystifying; after all, with so many components, it's hard to guess what might have gone wrong. Nevertheless, the problems you'll run into are somewhat predictable. Here are a few suggestions to get you up and running again:

- **Check your software settings**. Make sure all preferences are set properly. Relaunch. Refer to your software documentation.
- **Check your computer**. Is there enough RAM dedicated to your editing software? Are other applications running? Are your drives full or fragmented? Mac users should try rebuilding the desktop, zapping the PRAM, and restarting the computer. Remember, when you shut down your computer, count to 10 before restarting.
- **Check your cables**. With your computer shut down, check all of your cables, connections, and routers (if you have any), and make sure everything is secure. Check that cable lengths are within the approved limits. If you're using SCSI drives, check your SCSI IDs and termination.
- **Check your hardware**. Check all the settings on your VTR and other peripheral hardware. Refer to your equipment documentation. If you're unable to record to tape, check for *record inhibit* tabs on your videotapes. Check the menu functions to make sure the video deck is set to play the right video standard (NTSC, PAL, etc.), the right audio sampling rate, the right aspect ratio, the right tape speed, and the right videotape format. Make sure all your components are receiving power.

PROBLEMS AND SOLUTIONS

Most technical problems can be solved by thoroughly working your way through the preceding list, but that can take a while. Here's a list of common problems and likely solutions:

- **Dropped frames**. Frame dropping is often due to a hardware compatibility problem. Make sure all your hardware conforms to your software manufacturers' specs and recommendations. Dropped frames can also stem from performance bottlenecks: fragmented disk drives, an overtaxed processor, or lack of RAM. If your software manufacturer provides a hardware utility

FIGURE **7.25** *Using a proprietary hardware utility program, like the DPS Hardware Manager that comes with the Velocity software, can confirm that your SCSI drives and other hardware components are performing well.*

program, like the one in Figure 7.25, make sure that your system passes all the tests. Also, check for system conflicts, especially codecs from different editing applications.

- **No video coming in**. This is either due to a settings problem in your software, or a cabling problem. Check your software settings and preferences, especially the capture settings for the video format and device control. Finally, check your NTSC/PAL monitor to make sure video is playing from your VTR—it may be that you are looking at a black portion of the tape. Try another videotape that you know has an image on it to make sure the problem isn't the videotape itself.

- **No audio coming in**. Look at the audio level meters on your VTR, audio deck, and in your software to determine where the audio signal might be stopping. If there are no levels on your deck, make sure that you haven't accidentally muted the deck or changed other audio settings. Try another tape that you know has audio on it to make sure the problem isn't the tape itself. Make sure your audio sampling rate in your software setting matches the audio sampling rate you recorded if your software is fussy about sampling rates.

- **Audio is distorted**. Compare the levels on your deck to the levels in your software—are they both overmodulating? If so, the problem is on the deck or the tape itself. If your deck has level controls, try to lower them so that they aren't peaking. Use a pair of headphones, or set your mixer to monitor the deck only. If the audio still sounds distorted, it was probably recorded that way, so there's little you can do. If the audio is fine on your deck but overmodulating in your software, check the level controls in your software—are they up too high? Does turning down the gain remove the distortion? If not, check the path your audio signal follows from the deck to the computer—is it getting amped more than once? Is there something wrong with your settings on your mixer? Are you using cables of the wrong impedance level? Is there a power source near the audio cables that's generating a hum?

- **Inaccurate timecode**. If the timecode on your deck does not match the timecode in your software, you're going to have some serious problems. Check your capture settings, device control settings, and your device control cabling. Make sure the timecode from your deck is compatible with your software. Some software does not recognize SMPTE timecode, and some software doesn't recognize DV timecode. See your documentation for workarounds, or consider having your tapes *striped* with the compatible form of timecode.

- **Your software refuses to batch digitize a previously logged shot.** This is almost always due to timecode breaks in your source footage. Sometimes when the camera switches from one shot to another, a break occurs in the timecode. This means that for a few frames in between shots, there is no timecode on the tape. When the editing system tries to pre-roll and finds a hole in the timecode, it gets confused and stops. Relog the shot, making sure that the in-point you set is six seconds after the very beginning of the shot, and that the out-point is set before the very end of the shot.

- **Audio and video are out of sync.** This is usually a playback problem. Older versions of Adobe Premiere are known to be unable to maintain sync in longer edits. Also, low-resolution codecs, like the one offered in ProMax' DVToolkit, often aren't capable of maintaining true sync. Final Cut Pro offers the Sync Audio Manager to compensate for sync issues with older Canon cameras. If your answer is "none of the above," pick a frame in your clip or sequence that appears out of sync, and check the timecode of the video and the audio—it may be that your tracks in your timeline have accidentally gotten out of sync.

- **Video glitches and dropouts**. Check your camera original tape—is the glitch on your tape as well? If the dropout is only on your captured clip and not the tape itself, simply delete the damaged media and recapture the

clip. If you've been using your VTR a lot, it could need cleaning—refer to the section on VTR maintenance in Chapter 5 and then recapture the clip. If the problem is on your tape and you're using a digital video format, there are a couple of ways to try to fix digital dropouts. If it's a small dropout, try to fix it using the effects tools in your editing software—more about this in Chapter 11, "Polishing the Final Cut." If it's a big dropout—one that lasts for several frames—try cloning the tape. If this doesn't work, try dubbing the tape. If this doesn't work, try dubbing the tape while feeding the record deck an audio signal from another source—a CD player or other VCR. You can then record the audio separately and resync manually in your NLE. All of these processes can help create a more stable video signal and possibly remove the dropout. If it still won't go away, you're probably stuck with it.

- **Video looks bad on the computer screen**. Remember, if you're capturing DV through a FireWire interface, your video *will* look lousy on your computer monitor, but should look okay on your video monitor (see Chapter 4, "Computer Hardware," for details on why). Check your software settings, and make sure that your NLE is echoing your video clips to your FireWire port. This will allow you to see full-quality video on an NTSC monitor attached to your deck.

PROJECT MANAGEMENT

Starting postproduction work on any sort of project always benefits from advance planning, and most of the problems with editing have to do with unrealistic schedules or understaffing. Editing can be an expensive and time-consuming process, but cutting corners can exacerbate these problems.

SCHEDULING

Scheduling for postproduction depends on the sort of project you're trying to schedule. Is it an unscripted documentary? A feature film with lots of footage? A special effects-laden short? Here are some things to consider before you try to set up a schedule:

- **How many hours of footage are there?** The more footage there is, the longer the initial stage of editing—logging and capturing—will take. Someone, probably the editor or assistant editor, will have to wade through it all, possibly in real time. For an unscripted project, there's no easy way out—plan on a factor of two for logging; for example, two hours of footage will take four hours to log. In addition, having lots of footage re-

quires more storage drives. For a scripted project, having a shot list with circled takes can really speed up the logging process.

- **Does the project have a script?** Having a script speeds up the editing process. Most narrative projects have some sort of script, but if you have a wanna-be John Cassavetes, or just a regular documentary, chances are there won't be a script. Without a script, the story is "written" in the editing room, a process that can take a long time.

- **Does the project have lots of special effects and graphic elements?** Complicated special effects and graphics take a long time to edit, and add rendering time to the schedule. A factor of 8 to 1 is a good estimate for rendering on a fast system; for example, an hour-long project will take eight hours to render. If your system isn't built for speed, plan on even more time, and be sure to build this into the schedule. Consider adding a render station to your equipment list—another computer that can do the rendering without tying up the editing workstation. Plan on extra storage space as well.

- **How many people need to approve the project?** A feature film or network television show goes through a lot of different screenings and approvals before the project is considered complete. After each screening, the director and editor often walk away with a huge list of changes and tweaks. Build approval screenings (and time to make the resulting changes) into the schedule.

TYPICAL WORKFLOWS

In Hollywood, traditional workflows were developed in the editing room. Chapter 1, "Introduction," covered this in terms of technological innovation, but here's a brief description of how the pros schedule postproduction:

- **Feature film** postproduction begins during the shoot. The editorial staff screens dailies, deals with telecine transfers, and the editor starts creating rough cuts of scenes as they are shot. After the shoot is finished, the editorial team works to create a first cut and subsequent cuts based on screenings with the director and/or producer. Once they are happy with the film, the edit, known as the *director's cut*, is screened for people outside the production—executive producers, studio execs, etc. Changes are made, and after everyone is, for the most part, satisfied, the film is often screened for a preview audience. If the preview audience doesn't react well to the film, it is often recut, and sometimes entire scenes are added. Finally, the picture is locked and the sound-editing team takes over. The editing process can take anywhere from three to six months. The sound-editing process usually takes less time, about six to eight weeks. You've no doubt

heard stories of big-money movies that spend a year in the editing room—usually this is due to trouble in the approval process or trouble with the story (or both). However, it's also true that once big money is involved, the rules change.

- **Dramatic television** shows have a process that is similar to feature films, but is somewhat regulated by all the unions involved. Generally, the editor gets to cut scenes as they arrive from the shoot, and then has about a week to deliver the *editor's cut*. The cut is screened, and then another week is spent doing the *director's cut*. It's screened again, and then another week or so is spent doing the *producer's cut*, which usually become the *final cut*.

- **Documentaries** can vary greatly from project to project. Generally, there are two types of documentary: the documentary that starts out with an outline or script and seeks to shoot or acquire the footage necessary to create an edit based on that outline; and the documentary that goes out and shoots, and then constructs a script or outline based on the footage shot. An example of the former is a show like *A&E Biography*. A writer creates a script based on research, and the producing staff shoots interviews and finds footage to support that script. The editor then puts it all together in a process that takes about eight weeks for an hour-long project. The film *American Movie* is an example of the latter—the producers knew they had an interesting subject and probably had some idea of what would be worth shooting, but the actual story was constructed after the film was shot. It's difficult to know how long it will take to edit a film of this sort, but it's usually more like a feature film schedule—three to six months.

- **Daily shows** are a common sight on television, and you might be wondering how a show, like *Oprah* or the news, gets done so quickly. Most of these shows are shot in a studio with three or more cameras. The "editing" is done as they shoot by a technical director, and the resulting edit is known as a *line cut*. The line cut is then polished by an offline editor, and the graphic elements are added, usually by an online editor. Some daily shows rely on a combination of three camera studio shoots and *segments*. The news, most of the shows on *E!*, and magazine shows follow this format. In this case, the technical director is responsible for the line cut, while the offline editors cut the segments, and an online editor builds the final show, including the graphic elements. The sound is often edited and mixed by the offline and online editors, rather than by special sound editors.

BUDGETING

Once you have an estimate of how long it will take to edit your project, you can start to create a budget. Here are some things to consider when budgeting for postproduction:

- **Staff**. Many productions try to save money by not hiring an assistant editor. However, editor hours are more expensive, so why pay an editor to do assistant editor work? The following "Editing Jobs" sidebar lists many of the other types of postproduction positions. Consider carefully your project's needs, and the schedule. For example, if you want to do an hour-long show in four weeks, rather than the standard eight, you'll probably need two editors.
- **Equipment**. These days, it costs about $6,500 a week to run a professional offline editing room—$2,000 for a top-of-the-line Avid system including VTR and other A/V hardware, $2,000 for the editor, $1,200 for a simplified assistant's workstation, and $1,200 for a good assistant editor. Throw in another $100 for videotapes and other expendables. The going rate for renting a lower-end workstation, like an Apple Final Cut Pro system with a DV deck, is about $1,000 a week. Most producers who want to edit on that sort of system find it's more economical to buy rather than rent. Be sure to include other special equipment needs your project might have—a render station, a graphics and special effects workstation, an online editing session, professional sound mix, and so on.
- **Expendables**. Editors can burn a lot of videotape, and even if they only cost $15 each, the costs can quickly add up. Also, dubs and transfers can eat up a lot of time if you have someone on your staff do it, but cost quite a bit to send out to a tape dubbing facility.

Editing Jobs

The are many different staff positions in postproduction, and knowing who does what can help you budget and schedule for your own postproduction needs—even if you'll be wearing all those hats yourself.

- **Editor**. The editor is the person who builds the project. He or she is responsible for maintaining or creating (in the case of some documentaries) the narrative structure, the rhythm and pacing, and the overall flow from one scene to the next in a project. For some projects, editors work directly from a script; for others, they act as a writer and create the story from whatever materials are available. If the project will be onlined by another editor, the person who fills this position may be also called the *offline editor*. In the case of feature films, this person may be called the *picture editor*.
- **Assistant editor**. The assistant editor is in charge of media management and other technical concerns. His or her job is to make sure that the editor has everything he or she needs to do the job—all the necessary

media is available on the system, the editing system is well-maintained and working, and the project schedule is on track. The assistant editor is also usually responsible for logging and organizing tapes. In feature films, the lead assistant editor manages the other assistant editors.

- **Digitizer**. Some projects can't afford an experienced assistant editor. Instead, they'll hire someone to log and digitize tapes, but isn't responsible for all the other things an assistant editor handles.

- **Sound editor**. Once the offline or picture edit is complete, a sound editor steps in and fine-tunes the soundtrack, adding special effects, cleaning up dialog, building a music score, and trying to fix any technical problems. A picture editor will typically build four to eight tracks of sound; the sound editor may add upwards of 20. Most professional sound editors work with special sound-editing software, such as DigiDesign's Pro-Tools. In feature films, the sound editor is assisted by a dialog editor and others.

- **Visual effects editor**. Projects that have complicated special effects often hire a visual effects editor. The duties of this person can vary. If the special effects are being created by another company, the visual effects editor will build temporary visual effects sequences using the tools at hand, so that rough cut screening have some indication of what certain scenes will be like when they have the final effects edited in. As the effects are delivered, they will then edit them into the cut. In other cases, the visual effects editor is the person who builds the actual visual effects sequences, usually in Adobe After Effects or in a high-end system such as Discreet Logic's Flame or Quantel's Harry.

- **Online editor**. In a project destined for TV broadcast, after the offline edit is completed the project is reconstructed on a high-end system using the best quality video possible. Nowadays, the online editor may work on a linear editing system, like a GVG or a CMX; on a non-linear system, like an Avid Symphony or a Quantel Edit Box; or, if the budget is low, on a non-linear editing system like the ones discussed in this book by recapturing the footage at the highest resolution possible.

- **Negative cutter**. Once a feature film has a final cut, or is locked, the *cut list* is sent to the lab, where a negative cutter takes the original camera film negative and conforms it to match the locked final cut. The cut negative is then used to create prints of the films.

- **Post-production supervisor**. The more editorial staff associated with a project, the more need there is for a manager. The post-production supervisor hires (and fires) staff, negotiates pay rates, helps the producer create the budget and schedule for postproduction, and sees to the equipment needs of the project.

- **Tape operator**. Sometimes, a project needs lots of tape duplication, or dubbing. Tape operators simply manage the video decks and make copies of videotapes. All post-production facilities have tape operators, and so do most TV series.
- **Tape librarian**. The more tapes there are, the more organization is needed for storing them. Production companies with lots of tape resources usually have a library-like system where tapes are cataloged and "checked out" by different producers or editors. All incoming tapes, whether from a shoot or from another production company, go straight to the tape librarian, who numbers them, often with bar coding, catalogs them into a computer database, and then stores them in the vault.

NETWORKED EDITING SYSTEMS

If you're working on a project or in an environment where there is more than one editing system, connecting them with a local area network (LAN) can make things easier. There are basically two reasons to connect editing workstations via a network: you want to *transfer media* from one workstation to another, or you want to *actively share media* on two or more workstations.

Using a LAN to transfer media can simplify the editing process when there's more than one workstation, and eliminate the need for large removable storage drives. You can use the network to send media to a render station, tape logs from an assistant station to an editor station and offline edits to an online suite. Setting up a server with shared media—an online music library, sound effects, graphic elements, and titles—can be a boon if you tend to reuse these elements. For this sort of networking, having a fast connection is nice, but not a necessity.

Actively sharing media, on the other hand, is a resource-intensive, complex task that requires an extremely fast network connection, sophisticated editing software that supports file sharing, multiple users, and advanced project management. Unless you're configuring equipment for a postproduction facility, daily TV show, or high-end special effects-oriented feature, you probably don't need this type of network. If you do, make sure that all the components of your system—the editing application, OS, storage drives and networking software—support the high data rates needed for real-time video file sharing. FireWire-based DV needs a much smaller data rate than other types of video files (3.6 MB/sec), which makes it much easier to share video files in real time across local area networks. Look for better low-end support for actively sharing media in the near future.

The following LAN technologies are useful in the postproduction environment:

- **Fibre Channel** is the networking solution of choice for active real-time file sharing at high data transfer rates. High-end Avid systems use Fibre Channel for file sharing.
- **FireWire** was designed to carry multimedia files and can work as either a file transfer network or an active file-sharing network for FireWire-based DV editing systems. Any FireWire device can be a part of the network, including camcorders and video decks.
- **Ethernet** Many new computers come with a plug-and-play 10-BaseT Ethernet connection built in, making Ethernet one of the easiest network technologies to implement. At present, Ethernet isn't fast enough to support real-time transfer of video files.

Networks and Editing Software

Sharing media across a network can be tricky, and high-end software, such as Avid Media Composer, has a lot of support for this sort of complex project management. Lower-end applications rarely offer any sort of media sharing tools. You'll have to coordinate things yourself to avoid potential disasters, such as someone accidentally copying over a project on which someone else is working.

MOVING ON

You should now have a fully-functional editing system and, if you have a specific project in mind, a good idea of how to plan for it. Part Two of this book is about the editing process itself, from logging to polishing the final cut. The next chapter covers the first step in the editing process: getting media into your computer.

2

Editing

Upper test pattern

White (75%) — Yellow — Cyan — Green — Magenta — Red — Blue

Middle test pattern

75% White

Lower test pattern

100% White

0 IRE Black
7.5 IRE Black
10 IRE Black

Color Plate 1 SMPTE color bars.

Color Plate 2 Blue check bars.

Color Plate 3 The red in this image isn't NTSC legal.

A. Centered **B. Left justified**

Color Plate 4. *Watch the Preview to see if your title looks good. The title placed to the left (B) is easier to read than the title placed in the center (A).*

Color Plate 5 *This blue screen background will be somewhat difficult to key well. Notice how dark the blue areas are toward the top of the image.*

Color Plate 6 *(A) Dragging the Color Tolerance slider too far will cause areas that aren't part of the bluescreen, such as the actor's costume and eyes, to become transparent. (B) shows about as much as you can get from these particular settings.*

Color Plate 7 *Add a second Color Key effect to key out the darker blue areas.*

A. Foreground image

B. Background image

Color Plate 8 *The foreground image (A) and background image (B) are shown in 9–11 as superimposed, luma keyed, chroma keyed, and matte keyed using a black and white matte.*

A. Superimposed

B. Luma keyed

Color Plate 9 *The same two images (A) superimposed and (B) luma keyed.*

A. Chroma keyed

B. Matte

Color Plate 10 *The same two images (A) chroma keyed and (B) matte.*

A. Partial matte keyed

B. Full matte keyed

Color Plate 11 *The same two images (A) partial matte keyed and (B) full matte keyed.*

Original image

Brightness and contrast adjusted

Color balance adjusted

Slightly desaturated

Black levels adjusted

Color Plate 12 The color correction process from the Chapter 11 tutorial.

8 Getting Media into Your Computer

IN THIS CHAPTER

- Capture Resolution
- Timecode
- Audio Levels and EQ
- Video-to-Film Transfers
- Video Levels
- Tutorial: Capturing Video
- Working with Footage Shot on Film
- Calibrating Your Monitors
- Importing Digital Files

There are many types of media and many ways to get media into your computer. The most complicated type of media is videotape media, because it usually consists of three elements: timecode, audio, and video. This chapter covers each of these elements in detail, so that you'll understand how to preserve the quality of the media as you capture it. A tutorial covers logging, basic organization, setting audio and video levels, batch capturing, the unique issues involving projects shot on film, and details about importing different types of files.

QUALITY CONTROL

The first question to ask yourself before you start to capture media is, "How good does it need to look?" If you're editing together home videos for fun, the answer might be "not very," but if you're editing a feature film that was shot on miniDV and you hope to transfer it to 35mm film for projection, the answer is, "as good as possible." Only *you* know the answer to this question, and it will vary from project to project. This chapter explains all the things you need to know to maintain high image quality when getting media *into* your computer. You'll need to exert the same care when you send it back out, which is covered at the end of this book, but the fact is that when it comes to quality and non-linear editing, capturing media correctly at the outset is very important.

OFFLINE AND ONLINE EDITING

The concept of offline editing developed in the early days of television. Editing a rough cut with lower-quality work tapes saved the camera-original masters from wear and tear due to heavy use, and avoided the generation loss to which analog videotape is prone. A typical project was shot on a high-quality tape format, and then transferred with matching timecode to a lower-quality format, and edited. Once picture was locked, the project was then reconstructed using a very expensive online editing system and the camera-original tapes (Figure 8.1a).

Today in the non linear environment, the offline/online workflow still exists, but the distinction is now usually made in regard to capture resolutions. *Offline-quality resolutions* are the digital media equivalent of work tapes. They trade image quality for smaller file sizes, which in turn require less storage space. At the end of the editing process, the media is recaptured at a better, *online-quality resolution* and sent back out to tape. Sometimes this recapturing process is done on the same editing system that was used to create the offline edit;

FIGURE *Offline/online workflow diagram.*
8.1

sometimes it's done on an expensive system at a professional postproduction facility. Because the media is only captured twice, the risk of wear and tear on the tapes is relatively small, so even if the original tapes are analog, there's rarely a need for work tapes (Figure 8.1a).

Projects that originate on one of the DV-based formats are captured via FireWire at a lossless, online quality resolution and are not recaptured later on (Figure 8.1b).

There is, however, a modern-day throwback to film and analog video editing: video-to-film transfers. If you're editing a project shot on video that will eventually get transferred to film, it's generally considered advisable to avoid using the original tapes more than necessary. In order to save wear and tear on the tapes, video-to-film projects usually create a set of clones of the camera-original masters. The clones are used for viewing and logging, whereas the original tapes are used for online capture. (Figure 8.1c). See the sidebar on video-to-film transfers later in this chapter for more information.

TIP

Online-Quality Resolution
Uncompressed video, with a capture resolution of 1:1, is ideal when capturing online-quality media for a final master. However, resolutions as low as 3:1 are considered acceptable for non-dramatic television, and streaming media exhibits such low quality that the capture resolution is hardly an issue. Just make sure it's at least 15 fps if you want to have decent-looking motion.

PLANNED OBSOLESCENCE

As the price of storage drives continues to drop, the offline/online workflow is becoming obsolete. Why spend the time recapturing media if you can fit everything you need on your drives at the beginning of the process? This is a great advantage to editors and producers, and simplifies the process and lowers costs.

However, with all the changes in technology, there are new things to watch out for as well. If you start out editing with an online-quality resolution, you won't be recapturing your media later. In other words, the stuff you digitize at the outset of the project, perhaps carelessly, will end up in the final master. If you're in a hurry and rush through the capture process, you may end up with video that doesn't look as good as it could. This applies to anyone from D-1 editors to FireWire-based DV editors. You may find that you have to recapture it again after all.

This issue is even more important when it comes to audio, because audio is rarely recaptured. Even in an online/offline workflow, the audio is usually kept intact and only the video is recaptured. The reason for this is that the audio resolution, or sampling rate, is independent of the video resolution. Since audio files are much smaller, there's simply no good reason to capture low-quality audio and recapture it later. Even more importantly, the editor spent a lot of time setting the audio levels during the editing process, resulting in a preliminary mix. To start from scratch would mean remixing the entire project from ground zero—a very time-consuming process.

The next few sections of this chapter are designed to help you understand how to capture the best possible media for your project. You might not need to be this careful at this stage in the game if you're just starting out, but knowing how to maintain the best possible audio and video signals is an important part of being an editor in today's world. Whether you like it or not, the technological advances of the last two decades are throwing many of the tasks of postproduction professionals into the lap of the average editor. The luxury of simply being a "picture" editor no longer exists, except at the very high-end of the industry: well-funded features films, dramatic television series, and commercials.

TIMECODE

Digital non-linear editing offers one huge advantage to editors: random and instant access to any piece of media at any time. Videotape, on the other hand, is still prone to the challenges that plagued editors in the past. Because videotape is linear (whether or not it's digital), you'll have to scroll through the tape to find a particular shot. If you've ever searched through a standard audio cassette looking for a particular song, you know what this means—sometimes you can't find the song at all.

Instead of relying on a counter that gets reset every time you insert a new tape, like the one on an audio cassette player, video editors rely on a counter that's embedded in the tape itself. If you remove the tape and reinsert it, the counter will display the same time at the same moment in the tape no matter what. This special counting method is called *timecode*.

Timecode displays the position of each frame on the videotape in hours, minutes, seconds, and frames. For example, the first frame 20 minutes into the tape would be displayed as 00:20:00:00, and the frame after that would be 00:20:00:01.

Timecode, in and of itself, doesn't change the quality of the footage on a videotape, or affect the quality of the final master. It does, however, play an important role in the mastering process, and if quality is a big concern, you'll need videotapes with timecode.

WHY IS TIMECODE IMPORTANT?

Computers see the information they handle as a series of numbers. Timecode effectively assigns a number to each frame of video. When combined with a tape name or number, this means that every frame of video captured by your non-linear editing system has a unique number that refers back to a specific frame on a specific videotape source. The non-linear editing system can take an edited sequence and distill it down to a list of tape numbers and timecode, also known as an *edit decision list*, or EDL. Other editing systems can then take this EDL and reconstruct your final edit in an online session. Timecode, and by extension, EDLs, grant you the freedom to rebuild your project on any editing system that understands the type of timecode on your source tapes. If you want to offline your project on an Apple Final Cut Pro DV system, and then online it with a high-end Digital Betacam edit suite, you'll be able to do that somewhat easily. If you get an Avid Media Composer to edit on for free for two months, but then lose access to it and must move your project to a cheaper Avid Xpress system, timecode is part of what makes that possible. Moreover, if you want to archive your project without keeping all the captured media intact, a timecode-based EDL will let you save it as a tiny text file that fits on a standard floppy disk.

Imagine that you just spent a month editing a music video on your brand new system. It took you a long time because you haven't quit your day job yet. What if a drive crashes and you lose all the media on your project? If your tapes have timecode, you can reconstruct the project with a minimum of hassle. Yes, you may spend a few hours recapturing, but that's all. However, if you don't have tapes with timecode, you'll have to reconstruct the entire edit by eyeballing the last videotape output, or worse yet, from memory. However, by using video-tape sources with timecode and saving an EDL on a floppy disk, you have a safe and efficient way to restore your edit in a worst-case scenario.

In short, timecode is such a basic element of videotape editing that no one who's ever worked with it would want to work without it.

HOW TIMECODE WORKS

All videotape consists of magnetic material suspended in a glue-like medium attached to a strip of tape. By activating the magnetic particles, the record heads on a VTR lay down tracks that contain different types of information: one video track, two audio tracks, and a control track (Figure 8.2). The *control track* is the

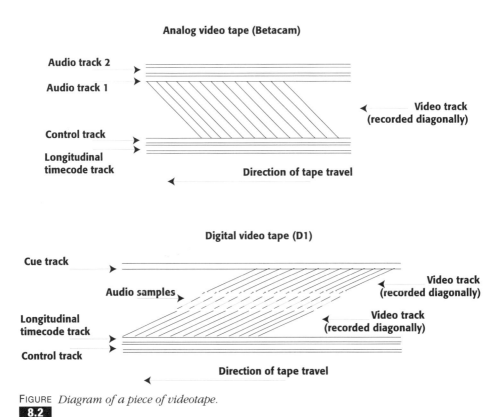

FIGURE *Diagram of a piece of videotape.*
8.2

most basic part of the videotape. The control track defines where each frame (and field) of video starts and ends using a series of sync pulses. In other words, the control tracks tells the video deck how to play the videotape. Video that doesn't have a control track displays the snow, or *noise*, that you sometimes see on a television set.

Using the information generated by these sync pulses in the control track, timecode numbers are chronologically assigned to each frame. The timecode information can be stored in three different places on the video tape: on a special address track, on one of the audio tracks, or as a part of the video track. Address track timecode is known as *vertical interleave timecode* (VITC), because the timecode information is stored in the *vertical blanking interval* on the tape—the part you don't see on a standard video monitor. Address track timecode is the best of the bunch, because it doesn't take up space needed for audio or video, and is displayed on the timecode window on your VTR. The next best choice is *longitudinal timecode* (LTC), or audio track timecode, which requires that you give up one of the audio tracks on your tape for storing timecode information. Audio track timecode consists of an electronic sound that some editing equipment can decode. *Burn-in timecode* (BITC), also known as visible timecode, is stored in the video track and is displayed along with the video information as part of the picture signal. Although film original projects often use BITC timecode, it's best avoided since it is married to the video track and can't be removed (Figure 8.3) (see the sidebar later in this chapter for more on BITC and film projects).

FIGURE *Burn-in timecode is a part of the video signal and can't be removed.*
8.3

TIMECODE STANDARDS

There are, at present, four different standards for timecode in use:

- **SMPTE timecode**, developed by the Society of Motion Picture and Television Engineers, is the standard for professional postproduction in the NTSC format. If you plan to interface with equipment in the professional world, you need SMPTE timecode.
- **EBU timecode**, developed by the European Broadcasters Union, is the standard for professional postproduction in the PAL format. If your project was shot in PAL and you plan to interface with professional equipment, you need EBU timecode.
- **DV timecode** is a part of the DV signal and is functional if your project will stay in a DV-only environment.
- **RC timecode** is a proprietary timecode format developed by Sony for their pro-sumer level products. As with DV timecode, it's best avoided unless your project will stay within an RC timecode-only environment.

TIP

Striping DV Tapes

If you need SMPTE timecode, but your DV camcorder doesn't support it, you can use tapes that have been prestriped with SMPTE timecode on one of the audio tracks. You'll only be able to record onto one audio channel during production, but later, you'll be able to interface smoothly with professional equipment. You can also stripe audio track timecode after you shoot, but you risk accidentally recording over your camera original tape.

BLACK-AND-CODING

A brand new videotape is a blank slate—it doesn't have a control track, timecode, a video track, or any audio tracks until something is recorded onto it. It is standard procedure in the editing room to record a signal onto each new videotape before using it, a process known as *black-and-coding*. Black-and-coding simply means that a black video signal and timecode are recorded onto each piece of new videotape stock. That way, the tape will display black when you play it, rather than noise, and it will have a continuous track of timecode that will later be used when you edit. To black-and-code a tape, simply send a black signal from a black burst generator into the VTR, then use the controls on the VTR to set the desired hour you wish the timecode to start at, and press Record (refer to your VTR manufacturer's instructions). This is a real-time process, and it will take an hour to stripe an hour-long tape, and so on. If you don't have a black burst generator, you can sometimes send a black signal out from your non-linear editing system.

TIMECODE CONVENTIONS

A few conventions have developed in the entertainment industry regarding timecode.

For a final master, the first frame of the project itself should start at *hour one*, or 1:00:00:00. Since the first minute or two on a videotape is prone to damage, you should make it a habit to black-and-code master tapes with the timecode starting at 00:58:30:00. This allows a minute and a half for color bars and informational slates. Then, the actual edited piece will start at 1:00:00:00.

For field tapes, it is common to use *time-of-day* timecode. The timecode generator on the camera will record timecode based on the current time. This is very useful for news gathering, since it offers information about when the recorded events occurred. However, for situations where this information isn't useful, time-of-day timecode is best avoided, since it causes serious difficulties in the editing room. Because the timecode is based on real time, there will be a *timecode break* between every shot. Discontinuous timecode can be a nightmare for logging, since VTRs can't pre-roll across timecode breaks. It's also a nightmare for creating digital clones, because most VTRs will stop when they encounter a timecode break. A better choice is to prestripe the tape with a different hour on each tape. That way, for a large project, you'll end up with, say, four tapes that start at each successive hour, rather than 80 tapes that all start at hour one. If there's some confusion later on as to which tape the footage came from, you'll at least be able to narrow it down to the four tapes that start at, say, hour six. In a perfect world, no footage is ever logged with the wrong tape number or gets "lost," but if you're dealing with a large project, you may have to deal with some lost footage at some point.

Timecode and QuickTime

QuickTime can store timecode information in a separate timecode track, but you'll need an application that can read QuickTime timecode to make use of it, such as Adobe Premiere 6.0 or Apple Final Cut Pro 2.0. Otherwise, all QuickTime clips will default to a starting timecode of 00:00:00:00.

AUDIO LEVELS

The perception of audio is very subjective, and what sounds loud to one person may not sound loud to another. The loudness of audio is measured in decibels (dB), and decibels represent a subjective scale: an audible increase in loudness means that the volume of the audio has increased 1 dB. Software and hardware

A. **B.**

FIGURE *The analog audio level meter on a Beta SP VTR (A), and the digital audio level meter*
8.4 *in Adobe Premiere 6.0 (B).*

manufacturers put decibel increments on the audio level meters that are a part
of their equipment (Figure 8.4), but 1 dB on your video deck may sound louder
than 1 dB in your software application. This fact is a good introduction to the
ambiguities you'll encounter when working with audio. Despite attempts to de-
fine it, sound is very subjective, and you'll have to learn to rely on your "ear" to
decide what sounds good.

Analog audio level meters, like the one in Figure 8.4a, place 0 dB in the mid-
dle of the scale. In other words, even though the dB scale measures loudness, 0
dB on an analog meter doesn't mean total silence. Rather, it indicates the mid-
point in the range of loudness and softness that the audio equipment can han-
dle. Digital audio level meters place 0dB at the top of the scale (Figure 8.4b),
and the midpoint is placed around –14 dB (this varies from one piece of digital
equipment to the next, so refer to your manufacturer's documentation). Because
it can vary from one piece of equipment to another, this midpoint is also re-
ferred to as *unity*. The sounds louder and softer than unity may vary from one
piece of equipment to another, but the sounds that fall exactly at unity should
sound exactly the same on any piece of hardware or software.

NOTE

Hertz
Always refill the gas tank before returning a rental car. Actually,
Hertz is a unit of measurement used to measure audio. Analog
sound travels in waves, and the number of waves per second—the
frequency of the waves—is also known as Hertz, or Hz. Audio
reference tone is always 60 Hz.

So, how does that work? It works because you, the editor, will tell the equipment what, exactly, is unity, and to do that, you'll use 60 Hz *audio reference tone*. When you play a videotape with bars and tone at the head, you'll see the audio levels in your capture software indicate where the tone falls in the dB scale (Figure 8.5). Adjust the level sliders until the tone rests at 0 dB if you're using analog equipment, or –14 dB if you're using digital equipment. If you're using a mixing board, you can also use the sliders on the mixing board to adjust the level. Now your editing application knows what unity is in regards to that particular videotape. You'll have to adjust the levels every time you change tapes or input devices.

Once you get used to it, setting the audio signal to match the audio reference tone should become second nature. But what if there's no reference tone on the tape? You'll have to rely on your ear and your eyes—by playing a portion of the tape and watching where the levels fall on the audio meters. You should see a *dynamic range* that varies across the scale. If the range hovers below unity, the levels are too soft; if they go into the red portion at the top of the scale, they're too loud. The dynamic range that's considered ideal varies depending on what you're mixing for. A dynamic range of 12 dB is fairly standard, although for broadcast television a dynamic range of 6 dB is the ideal. Make a habit of watching the audio levels occasionally as you play your soundtracks—you'll train yourself to recognize what good audio levels look like (Figure 8.6).

Digital dB scale Analog dB scale

FIGURE *The audio level meters and sliders in Avid Xpress DV.*
8.5

Red peak
indicator lights ►

FIGURE *(A) too soft; (B) too loud; (C) just right.*
8.6

You might be wondering what that red area is on the audio level meter. To simplify, it shows sounds that are very loud. Digital and analog audio levels differ when it comes to this portion of the dynamic range. It's perfectly natural that very loud sounds—a door slamming, for example—go to the top of the scale, or *peak*. In analog audio, as long as only a few extremely loud noises go into the red, it's okay. If the sound goes beyond what your equipment or speakers can handle, you'll hear *distortion*. If this is the case, you should adjust the levels appropriately. With digital audio, however, the red area should be avoided at all costs. That's because digital audio that's too loud gets *clipped*. Instead of distortion, the loud parts of the audio signal will simply be cut off. If, for example, the sound of a man yelling peaks, the high frequencies will get clipped, but the lower frequencies that aren't as loud will remain. The result will be a very strange-sounding yell (Figure 8.7).

TIP

Riding the Levels

Sometimes, the best solution to problems with audio levels is to adjust the levels on the fly as you capture, or ride the levels. If the levels are set perfectly except for one very loud sound five seconds into the clip, you can try to lower the levels for that sound and increase them again once it's over. The level sliders on an audio mixing board are designed to facilitate this process, but be aware that it requires a gentle and conservative touch. If you ride the levels too aggressively, you'll hear it in your soundtrack, and correcting it in an editing application will be a nightmare.

Digital audio that goes above the peak level gets clipped...

Analog audio gets distorted - the signal remains intact but it surpasses the capability of the speakers

FIGURE *Clipping and distortion.*
8.7

So, what if you set the tone to unity and you still have sounds that go into the red and are clipped? That means the audio wasn't recorded properly. Even though the sound recordist or camera operator added tone to the head of the tape, the audio itself was recorded with levels that were too high. You'll have to adjust the levels on your equipment accordingly.

EQUALIZATION

Adjusting the levels is the first crucial step in making sure you capture high-quality audio. However, there's a second step you can take: *equalization*. The sound of audio reference tone is a very simple sound—it only contains one 60-Hz frequency. However, most sounds in the natural world are complex and contain a range of frequencies. Think of them as a chord, in music, rather than a single note. Equalizers let you control these different frequencies—boosting some and diminishing others (Figure 8.8).

When capturing audio, you probably don't want to do much to the signal in terms of equalization. The goal is to capture the strongest audio signal possible, by adjusting the levels, and then to manipulate the equalization later in the "mix." For that reason, equalization is discussed in greater detail in Chapter 11, "Polishing the Final Cut." However, there are two cases where you should perform the equalization as you capture: globally enhancing a specific type of audio that you'll be using extensively in your project, and correcting problem sound.

If you're capturing a type of sound that you'll be using throughout your project, like a voice-over recording, it may be beneficial to determine the sort of equalization that sounds best now, and adjust the EQ on input. It's much easier to make a global adjustment of the EQ settings when you capture than to go through your entire edited project later and adjust each piece individually.

High frequencies

High-mid range frequencies

Low-mid range frequencies

Low frequencies

FIGURE *EQ adjustments on a mixing board.*
8.8

Moreover, if you have a mixing board, it's much easier to play with the EQ knobs on the board until it sounds good, rather than the controls in the average non-linear editing application. Your editing application may require that you render after adjusting the EQ, and it may only offer some standard EQ presets (Figure 8.9) The mixing board, on the other hand, will give a full range of possibilities in real time (Figure 8.8). If you're not comfortable making the sort of delicate aesthetic judgments required for good equalization, save it for later when you are ready to do your final mix. By then, you'll have spent some time working with the audio and you'll have a better idea of how it should sound. Also, if you'll be doing a *split-track output*, you can always use the mixing board on the way out as well. Chapters 11 and 12 cover EQ, mixing, and outputs in detail.

TIP

Where's That Hum Coming From?
If you hear a hum when you play audio, it might have been recorded onto the source tape you're capturing from, but it might be coming from your system itself. Faulty cables, loose connections, and power supply problems can all add a hum to your audio signal. Before you try to correct a hum with EQ, make sure your system isn't the culprit.

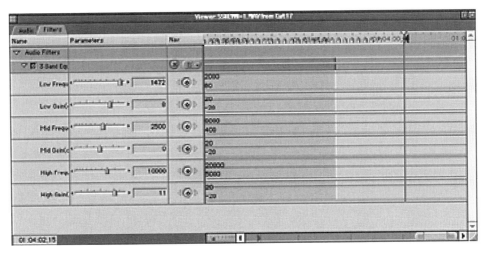

FIGURE *EQ adjustments in Final Cut Pro 2.0.*
8.9

You can also use equalization to correct global audio problems such as hums and hisses. If the audio was recorded too low and you have to boost the levels to get a good signal, you'll probably hear *tape hiss,* too—the sound of the tape running across the play heads. Diminishing the high frequency can alleviate this. Similarly, if the audio was recorded in a room with a refrigerator or air-conditioner running, you might have a low hum in the background. A faulty audio cable may also result in a hum. You can try adjusting the low frequencies to minimize these hums.

There's one big caveat: *be very careful.* By diminishing a part of the audio signal, whether it's low or high, you may also diminish the good audio that you want to capture. Most of the audio you'll be concerned with will involve the human voice, and you must be careful not to diminish the frequencies that contain voices. Human voices reside primarily in the middle frequencies, but may also dip into the low and high frequencies. Particularly when it comes to hums in the audio track, you may not be able to get rid of the hum without damaging the voices. There's no magic fix when the problem part of the audio shares the same frequencies as the voices in the soundtrack.

TIP

Bars and Tone
The accompanying CD/DVD contains sample audio files of 60-Hz tone and still-image files of different video test patterns. You can import these files into your editing software and put them at the start of your sequence, so that your final tape output can be calibrated when played on another editing system or VTR.

Preserving Quality for Video-to-Film Transfers

If you're planning to eventually transfer your final master to 35mm film for theatrical projection, you'll need to take extra care to avoid damaging your camera-original masters. Each time you play through a tape is considered a *pass*. Common wisdom asserts that the fewer passes on the tape, the less likely the tape will be damaged due to stretching, dust, and so forth. So, how do you avoid passes on your masters?

The first step, if you shot on a digital format, is to create a set of clones of your camera original tapes. These duplicates are, technically speaking, identical to the camera originals, and must have matching timecode. If you shot on an analog format, you should make a duplicate set using a digital format that's considered equal, or better, in quality to your camera originals.

The process that will add the most wear and tear to your tapes is logging. That's because you end up shuttling around the tape, rewinding, fast-forwarding, and pausing, as you set the in- and out-points. Now that you have two sets of masters, you can either use the camera originals, which have already had one pass on them, or you can use the clones, which are untouched. The best solution is to use the camera originals for logging, and save the clones as the new master sources. Some people have a hard time accepting that a digital clone is *exactly the same* as the camera-original master, but unless there was a problem with the cloning process, there is no difference between the two. If you have analog camera originals, use them to log, and save the new digital duplicates as your new master sources.

The next choice depends on your workflow. If you're editing with offline footage, you should capture from the same tapes that you used to log. Later, you'll have to replace this footage with the real thing, from the new set of cloned masters. If you're editing with online footage, use the more pristine set of clone tapes to capture from. Although the tape shuttling done during capture is potentially as destructive as logging, the back and forth movement of the tapes will be confined to the areas between the shots. It's unlikely that you'll cause any real damage to your masters during capture.

If you follow this process, your final master footage will come from a set of tapes that have only been used once.

VIDEO LEVELS

Setting the video levels is more complicated than setting the audio levels, because the video signal has more things to adjust. Luckily, there are several tools of the trade to help you set the video levels properly. *Waveform monitors*

Waveform monitor (A) **Vectorscope (B)**

FIGURE *Waveform and vectorscope displaying SMPTE color bars.*
8.10

display the brightness of the video signal. By looking at the waveform display, you can set the black level and the white level. Normally, everything else will fall into place once you have these two key variables in place (Figure 8.10).

Vectorscopes display the color information, or hue, in the video signal. After setting the black and white levels, you can use the vectorscope to make sure the color information is set correctly. You can use either a hardware- or software-based waveform monitor and vectorscope to check the video levels. Be aware that waveform monitors and vectorscopes do not do anything to the video signal—they simply display it, just like regular video monitors (Figure 8.10). To adjust the video signal levels, you'll have to use controls on your VTR (if available), or controls in the capture window of your non-linear editing application (Figure 8.11).

FIGURE *Video levels sliders in Apple Final Cut Pro.*
8.11

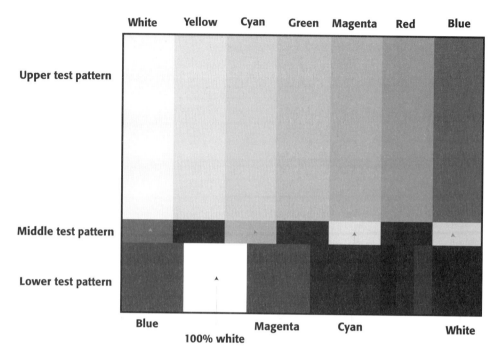

FIGURE *SMPTE color bars with callouts (see also Color Plate 1).*
8.12

So, how do you know what these levels should be? The video equivalent of 60-Hz audio reference tone is the *SMPTE color bars* test pattern (Color Plate 1 and Figure 8.12). There are slightly different video test patterns for PAL and other video standards. The SMPTE color bars image actually contains three separate test patterns. This allows you to double-check the video level settings.

Horizontal Scan Lines

TIP *Your waveform monitor should offer a choice between composite mode and line mode (Figure 8.13). Composite mode displays a waveform of the entire video image, while line mode displays a single horizontal scan line. Waveforms in line mode are simpler, and therefore easier to read. To check the brightness and hue of the upper SMPTE color bars test pattern, you need to make sure you have a line between 16 and 179 selected.*

The first step in setting up the video levels is to set the black level. Sometimes, the black level is also called the *set up*, because everything else is calibrated accordingly. It is also referred to as the *pedestal*. The brightness of an image is described in percentages, and 0% brightness is considered true black,

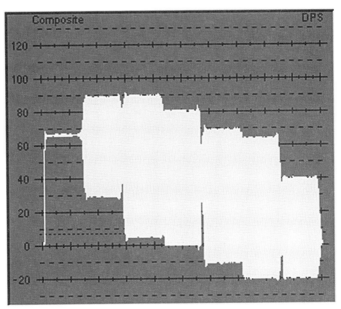

FIGURE *Waveform with a composite view of standard SMPTE*
8.13 *color bars.*

while 100% is pure white. In video, these percentages correspond to the values in the IRE scale: 0 IRE is pure black, and 100 IRE is pure white. Just to make things slightly more complicated, the value of pure black in North American NTSC video isn't 0 IRE, but 7.5 IRE. The difference between 0% black and 7.5% black is not distinguishable to the human eye. (For Japanese NTSC video and PAL video, black is set at 0 IRE.)

The black bar is located at the far right of the lower test pattern (Figure 8.12). This bar corresponds to the lowest step in the stair-like pattern of the SMPTE color bars waveform (Figure 8.15). The black input slider in your non-linear editing application's capture window should be adjusted until the top of this "step" is aligned with the 7.5 IRE mark.

Next, the white level is set using the white bar at the far left of the upper test pattern. There are two types of color bars: bars with 100% white in the upper test pattern (Figure 8.14), and bars with 75% white in the upper test pattern (Figure 8.10). The ideal is 75% bars, if you have a choice, and the test patterns provided on the CD/DVD are 75% bars Adjust the white level input slider until that bar rests at 75 IRE (or 100 IRE if you're using 100% bars).

Next, select a line in the lowest test pattern (Figure 8.15). The white bar here is always 100%. Make sure it hits the 100 IRE mark. If the white level goes above 100 IRE, it's too *hot*—the video equivalent of peaking (Figure 8.15a). The whites will be clipped, the same way that digital audio sounds that go into the red are

FIGURE *Waveform of 100% bars.*
8.14

clipped. If the white level is below 100 IRE, the image will appear dark and underexposed (Figure 8.15 b). Figure 8.15c shows how it should look.

Now, the colored bars in between white and black should fall in equal increments across the IRE scale in the waveform monitor. Be aware that although these bars are colored, the waveform isn't measuring the color, but rather the brightness. The yellow bar has a brightness of 50%, the cyan bar has a brightness of 40%, and so on.

Once the waveform resembles the image in Figure 8.10a, it's time to check out the color signal information. Each color bar in the upper test pattern should fall on a particular vector in the circular pattern of the vectorscope. Most vectorscopes have squares that indicate the ideal place for each color to fall (Figure 8.10b). Colors that radiate beyond these markings run the risk of not

A.

B.

C.

FIGURE *Waveform of the bottom test pattern: (A) too hot; (B) too dark; (C) just right.*
8.15

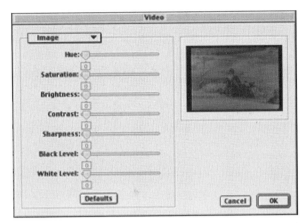

FIGURE *Chrominance adjustment sliders in EditDV.*
8.16

being "NTSC legal." They may bleed, flicker, and distort when played back on videotape.

If the white and black levels have been set properly, the hue information should naturally fall into place. If not, you may need to adjust the hue input sliders in your editing application's capture utility, if available (Figure 8.16). The middle test pattern (Figure 8.12 and Color Plate 1) has a blue bar, a magenta bar, a cyan bar, and a 75% white bar, with 7.5 IRE black bars in between. This test pattern is primarily for checking color information, and the corresponding vectorscope image should look like the one in Figure 8.17.

Just like audio reference tone, you'll need to check the color bars and adjust the input sliders every time you change tapes or input devices. Sometimes, you'll find that you've adjusted the bars perfectly, but the video still looks hot or

FIGURE *Vectorscope of center test*
8.17 *pattern.*

underexposed. This means that the color bars weren't recorded properly. In order for color bars to be effective, they must be recorded by the same device that records the video image, and with the same white and black balance settings. If a cameraperson uses a tape that's been prestriped on a VTR with timecode and color bars, these bars will not be relevant to what he or she records later at the shoot. Rather, the bars must be recorded by the camera itself.

Professional cameras have internal color bar generators, but most consumer cameras do not. Popular miniDV cameras, like the Canon XL1, do not generate color bars. If this is the case, you'll have to adjust the video levels by eye. The only way to do this is to watch the tape on a waveform monitor and make sure that none of the whites go above 100 IRE (Figure 8.18), and that none of the blacks go below 7.5 IRE (Figure 8.19). You should try to make sure that the brightest whites get as close to 100 IRE without peaking, and the darkest blacks get as close to 7.5 video black as possible. This ensures that you're

FIGURE *The waveform of this image shows that it's too hot.*
8.18

FIGURE *The waveform of this image shows that it's too dark.*
8.19

FIGURE *The vectorscope of this image show that the red is not NTSC legal (see also Color*
8.20 *Plate 3).*

getting the best video signal possible. Once you're satisfied with the brightness, watch the same section of the tape on the vectorscope. Look for any lines that go outside the circular boundary; these colors are too hot (Figure 8.20).

CALIBRATING YOUR MONITORS

By using color bars to set your video levels, you can rest assured that your video looks its best, no matter what your monitors display. However, why not display the best video possible on your computer and video monitors as well? If your monitors are off, you might make adjustments to the video signal that actually make the final product look worse, not better (relying on a waveform monitor and vectorscope, rather than eyeballing it, will help prevent this).

CALIBRATING A VIDEO MONITOR

To start, send color bars from your computer to the video monitor. Adjust the Chroma knob until the displayed image is *monochrome* (the professional term for black and white). Next, set the black level by adjusting the *pluge bars*. If you look at the bottom color bars test pattern, next to the black bar in the lower right-hand corner are three small gray bars. These are the pluge bars (or Picture Lineup Generating Equipment bars), and are used to set the black level. Adjust the brightness until the pluge bar on the right is barely visible and there is no visible difference between the left bar and the middle bar and the large black bar to the left of them. You have now set the proper black level.

Next, set the white level by turning the contrast on the monitor all the way up. The 100% white bar in the bottom color bars test pattern will flare. Reduce the contrast until the flaring disappears and a sharp edge is visible.

Next, adjust the Chroma control until the color bars look normal. Make sure that the yellow bar is truly yellow, with no green or orange tones, and the magenta bar is pure magenta with no shifts toward red or purple.

Professional video monitors come with a special setting called *blue check* that helps you calibrate the monitor. Turn on the blue check switch and you should see an image of alternating bars of equal luminance, like the images in Figure 8.21 and Color Plate 2. The blue bar on the far left of the top test pattern should be indistinguishable from the blue bar in the lower test pattern. The black bar second from the right should be indistinguishable from the bar below it (Figure 8.21). If the bars don't look right, adjust the color settings.

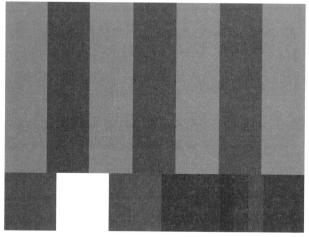

FIGURE *Color bars displayed as monochrome pluge bars (see also Color Plate 2).*
8.21

CALIBRATING A COMPUTER MONITOR

Unless you have a very high-quality computer monitor, you won't have too many choices when it comes to calibrating your computer monitor. Top-of-the-line monitors come with specialized calibration tools, so refer to your manufacturer's instructions if you own one of these. For lower-end monitors, brightness and contrast are about all you'll be able to adjust. To get the best adjustment possible, send color bars to both the video monitor and the computer monitor(s). After you've adjusted the video monitor, as described earlier, look at the color bars on the video monitor and compare them to the ones on the computer monitor. Adjust the brightness and contrast on the computer monitor until it matches the video monitor as closely as possible. The less ambient light in your workspace when you do this, the better.

Storing Your Media
Remember, most digital media is magnetic, and as such, it should be treated with care. Keep it away from monitors, CPUs, carpeting, and video decks. Store your tapes in the plastic boxes they came in, not uncovered on top of the tape deck or other electrically charged devices.

TIP

LOGGING AND CAPTURING FROM VIDEOTAPE

TUTORIAL

Once you have your editing system set up, the hardest part about logging is making intelligent, creative decisions about the shots you need for your project. Logging is the first step in editing a project. If the project is under a tight deadline, it's possible that footage that doesn't get logged won't end up in the project, no matter how beautiful or brilliant it is. With that warning in mind, this tutorial will walk you through the process of setting the video and audio levels, logging shots, and batch capturing.

This tutorial covers:

- Setting audio levels
- Setting the video levels
- Logging shots
- Handles
- Batch capturing

WHAT YOU NEED
In addition to your editing system, you'll need a videotape, preferably with DV or SMPTE timecode, that has footage on it that you wish to log and capture.

STEP 1: SET UP A NEW PROJECT
Power up your editing system and launch the software. Create a new project, and be sure the settings are correct for the type of media you'll be capturing.

Drive Space
Make sure you have enough drive space before you start capturing. Some programs calculate how much media you'll be able to capture; others do not.

TIP

STEP 2: OPEN THE CAPTURE UTILITY
Open the capture utility and insert the tape you wish to log in your VTR (Figure 8.22 and 8.24).

FIGURE *Capture mode and tape transport controls in Avid Xpress DV.*
8.22

STEP 3: FIND THE BARS AND TONE

Use the tape transport controls in the capture utility to scroll through the tape. The tape transport controls are a set of buttons that look just like those on a VCR: play, pause, record, fast forward, and rewind (Figure 8.22). Rewind to the beginning of the tape, and press Play. You should see the bars and tone described at the beginning of this chapter. Pause the tape.

STEP 4: SET THE AUDIO LEVELS

Open the audio levels meter in the capture utility (Figure 8.23). Now press Play on the VTR and watch the audio levels. Adjust the audio levels by moving the volume slider on your mixing board or capture window. The 60-Hz reference tone should fall exactly at 0 dB on an analog level meter, or −20 dB on a digital level meter (see your software documentation for specifics).

STEP 5: CHECK THE VIDEO LEVELS USING THE WAVEFORM MONITOR

If you don't have a hardware waveform monitor, open the software waveform that's a part of your capture utility Play the color bars and use the black

FIGURE
8.23
Capture mode and audio level meter in Apple Final Cut Pro.

FIGURE
8.24
Capture mode in DPS Velocity.

input adjustment to set the black level at 7.5 IRE. Next, set the white level to 75 IRE (Read the section on video levels earlier in this chapter for more information).

STEP 6: CHECK THE VIDEO LEVELS USING THE VECTORSCOPE

Now look at the vectorscope as the color bars play. Be sure the diagram for the bars looks something like the one in Figure 8.12. If not, adjust the input sliders accordingly.

TIP

Hot-Swappable Headaches

If you're working with storage drives that are hot-swappable, be careful not to remove drives while you have your editing application up and running. You might cause it to lose track of media, lose renders, or crash.

STEP 7: SET IN- AND OUT-POINTS

Find the *in-point* of your shot. The in-point is the first frame you want to capture. Set the in-point using your software's controls. Most NLEs let you press "I" on your keyboard to set an in-point. You should see the timecode from your tape appear in the window next to the "In." Compare this timecode to the timecode reading on your deck or camera to ensure they match. Be sure to allow a few seconds of *handles* if possible. You also need to be careful to leave enough *pre-roll* for your video deck. Now, find the out-point and set it by typing "O" or clicking the "Out" button on your interface. Again, check your timecode. Don't forget to leave a couple of seconds of handles at the tail.

TIP

Set Up a Numbering System

As you import files into your project—or capture or digitize video—your NLE will ask you for a label corresponding to the tape, disk, or drive on which the file is stored. If you ever need to recapture or link to that media, the NLE will be able to ask for the specific tape or disk by name. Therefore, you should label all your media with a unique ID number. It's best to use tape numbers of six characters or less, since there's a good chance that some software down the line will cut off part of the name, or change the spaces into underscores. Write that number on the tape itself if it's not already there.

STEP 8: LOG THE SHOT

Now you need to enter a name for your shot. Most NLEs also allow you to add other information: the shot number, the take number, whether the take is good

FIGURE *Logging controls in Digital Origin EditDV.*
8.25

(g) or not good (ng), and comments. If you have keywords for your project, you can also add them here. Click the button that says "log" to log the clip and add it to the bin (Figure 8.25). Note, however, that the clip has *not* been digitized. It is an *offline* clip, but the computer knows exactly where it is located if it needs to be captured.

STEP 9: LOG THE REST OF THE TAPE
Repeat this process until you've logged all of the desired shots on this tape. As you go through the tape, make a note of any quality changes or problems: drastic changes in lighting, changes in audio levels, and so forth. You may need to capture those shots separately so that you can adjust their audio and video levels independently.

Label Your Media
Label and number every piece of media that comes into your project—whether it's a miniDV tape, an audio CD, or a still photograph—before you start working with it. Write the ID number on the tape, CD, or disk itself, not just on the box.

STEP 10: SET THE CAPTURE RESOLUTION AND THE SAMPLING RATE

Once you get to the end of the tape, you can tell the software to "batch digitize." It will then work its way through your log and capture each clip. If you're using an editing system that offers more than one capture resolution, you'll need to specify the resolution at which you want to capture. For analog or digital captures, you need to pick an audio sampling rate—48 kHz is ideal for most projects. Whatever you choose, make sure you stick with it throughout your project. Many NLEs let you save these preferences.

Making Space
Be sure you have enough space on your storage drives before you start a batch capture session.

TIP

STEP 11: BATCH CAPTURE THE LOGGED SHOTS

Before you press the Capture button, you should quit any background applications, and turn off any networking functions. Once you start capturing, you can take a break while your machines work. It's a good idea to stay close by, however—NLEs tend to be fussy about capturing, and you may find an error message upon your return, instead of a bin full of media. Read the troubleshooting section in Chapter 7 if you have any problems with this tutorial.

Setting Up Timecode in Final Cut Pro
If you're using Apple's Final Cut Pro, you'll need to "calibrate" your timecode before you start logging, and every time you change to a different video deck. Refer to your user manual for more information.

TIP

Three Ways to Log Footage

There are three approaches you can take when logging tapes. Which one will work best for you depends on the sort of footage you're logging.

1. **Log every shot.** This method is the best for footage from a scripted, single camera shoot. Log every shot, and name it according to scene number and take number. Then, only capture the good, or circled, takes. You'll have a list of all the shots, but you won't clog your system with unnecessary footage. However, if you need to go back and get all the takes of a particular scene, you can quickly batch capture it. Similarly, if you

have a question-and-answer style interview, log each Q&A as a shot, and name it according to the question asked. Again, you don't necessarily need to capture every Q&A, but you'll be able to easily batch capture media later.

2. **Log dialogue and coverage.** Documentary shoots are notorious for long amorphous shots that never really start or end. Log the best dialogue in each scene with generous handles, and then round it out by logging the *coverage*—establishing shots, cutaways, reactions, etc.

3. **Log entire scenes and subclip.** If your project doesn't have a lot of footage, you can log each scene, or even each tape, as a single clip. Later, you can use *subclips* to break the scenes up into individual shots. The advantage to this is that you have all the footage available; the disadvantage is that you'll need a lot of storage space, and if your drives get filled up, you won't be able to delete unnecessary shots.

WORKING WITH FOOTAGE SHOT ON FILM

Projects that originate on film have some special concerns and require some extra effort if you're eventually going back to film to create a final release print.

TIMECODE FOR FILM

If you're editing with film footage that's been transferred to video, you'll have two different timecodes associated with your footage. The videotape transfers will have their own SMPTE timecode that the editing system uses, and you'll also have special film timecode that refers back to the original camera negative.

Keycode is a number on each frame of the film itself that was put there by the manufacturer of the film stocks. Keycode is used to generate a cut list for the negative cutter, the film equivalent of an EDL. When the film is transferred to videotape via telecine, you can have the keycode numbers burned into your videotape. Since these numbers are superimposed over the video itself, this is only a good choice if you're eventually going back to film, or if your footage is letterboxed and there's space to put the burn-in timecode in the black area outside the image.

Aaton timecode is an electronic form of timecode for film developed by the camera manufacturer Aaton. Electronic pulses are stored on the film itself and can be added to telecine transfers as window burn. Just as with keycode, the only reason you need to keep track of Aaton timecode is if you plan to later go back to film and have the negative cut.

3:2 PULLDOWN

When film is transferred to video, a process also known as a *telecine*, the difference between the 24-fps frame rate of film and the (approximately) 30-fps frame rate of NTSC video must be accounted for. In order to add the six additional frames, a process called *3:2 pulldown* is used. Remember that NTSC video consists of approximately 30 frames, or 60 fields. For 3:2 pulldown, the first frame of film is recorded onto the first two fields of video. Then, the second frame of film is recorded onto the next three fields of video (Figure 8.26). Unfortunately, as a result, the only place to make a clean edit, one where the cut exists between both a frame of video and a frame of film, is on every fifth video frame. Film-editing software, like Avid Film Composer, helps editors avoid making an edit on the wrong frame using a reverse telecine process. High-end products, like those by Quantel, do some serious calculation to get rid of this limitation. If you're editing with software that doesn't offer any film matchback tools, beware: you'll have to impose the every-fifth-frame limitation yourself—and that's a very easy way to make a costly mistake.

A side effect of 3:2 pulldown is that in order to reach the 29.97 frame rate of NTSC video, the footage is also slowed down by .1%. If your film footage has synchronized audio that was transferred with the picture during telecine, there won't be any problems. However, if you're planning to synchronize the picture and audio yourself in an NLE, you'll need to slow the audio down by .1% to have it sync up with the picture.

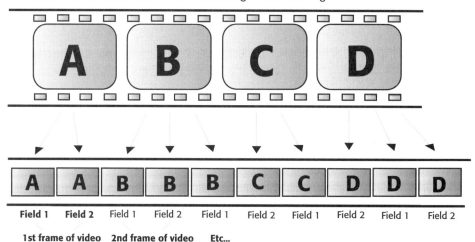

FIGURE *Illustration of 3:2 pulldown.*
8.26

High-end film editing systems, like Avid Film Composer, come with a switch on the audio board that lets you choose between different speeds to accommodate audio for film transfers.

TAKE THE "A" FRAME

A big advantage of having film transferred via telecine to videotape is that a digital log file is generated during the process. You can import these logs into your non-linear editing system and use them to batch capture the media. Be sure to check for any compatibility issues between your non-linear editing software and the file format of the telecine log. You may have to tell your non-linear editing application which frame is the start of the pulldown sequence, also known as the "A" frame. Telecine transfers and log files should come with a paper log that gives information about the pulldown sequence.

IMPORTING DIGITAL FILES

Importing digital files is probably the easiest way to get media into your project. Compatibility issues aside, the main thing you want to avoid is accidentally lowering the image or audio quality.

QuickTime and AVI files. Make sure you have the right codecs installed. For example, if you have QuickTime media that was created on a Media100 or Avid Media Composer, you'll need the Media100 Transcoder or the Avid Codec, respectively, in order to play those QuickTime movies on a different system. Another thing to be very careful about is recompression. If you have a QuickTime or AVI movie, it's already been compressed. If you import it into editing software that uses a different codec, you'll compress it again, which could seriously degrade the image quality. To avoid this, compress all QuickTime and AVI movies with lossless codecs, such as the QuickTime Animation compressor.

WAV, AIFF, and other Audio files. For optimal quality, the audio files you import into your editing system should have been saved with the same sampling rate as the one you're editing with, preferably 44.1 kHz or 48 kHz.

Keep a Database of Digital Files

If you're relying on lots of imported audio and graphics, you can easily lose track of those files. Use database software such as Extensis Portfolio or FileMaker Pro to keep track of your media.

TIP

Digital stills: TIFF, PICT, JPEG, BMP, etc. Some editing applications will let you import images of any size; others require that they fit the resolution

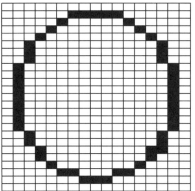

a. This circle originated with rectangular pixels . . .

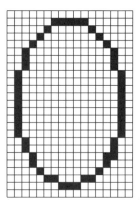

b. . . . results in an oval when converted to square pixels.

c. Similarly, this image shot with a rectangular pixel camera . . .

d. . . . will look distorted when displayed on a square pixel computer monitor.

FIGURE **8.27** *Image distortion due to pixel shape changes.*

and aspect ratio that you've set for the project. The standard resolution for video is 72 dpi, and the aspect ratio varies, depending on what type of video you're working with (see Chapter 7). The most important thing is to make sure the pixel shape of the still image matches that of the video. Otherwise, the still image may be distorted on import (Figure 8.27).

GETTING AUDIO FROM A CD

Chances are, a lot of the audio you'll be using for your project will come from an audio CD. To import this audio directly into your non-linear editing system,

you'll need some encoding software; that is, software that will take a track from a CD and encode it into the format that's compatible with your editing system. Apple's new iTunes will do the job for those of you running Mac OS 9 or later; Audion, SoundJam, or N2MP3 will work for users of Apple's older operating systems. Windows users will need something like MusicMatch, CD Copy, RealJuke-Box, or the latest version of Windows Media Player. A favorite tool for this job is QuickTime Pro, the professional version of the Apple QuickTime 5 utility (Figure 8.28). The QuickTime Player lets you open tracks from an audio CD, save them to your hard drive as QuickTime audio-only movies, and export them into any format you wish—.WAV, .AIFF, and so forth. Because the audio files are digital, you won't lose any sound quality when you do these conversions, as long as you stick with the CD-quality, 44.1 kHz sampling rate.

FIGURE *The QuickTime Player.*
8.28

Place the audio CD into your CD-ROM drive, and view the disc's contents through the software you chose. Next, you'll need to convert this file to the AIFF format if you're a Macintosh user, or to the WAV format if you're a Windows user. Some editing applications will import MP3 format audio files as well. This is great if you're planning to download all your music from the Web, but MP3 audio is already compressed—if quality is one of your concerns, it's best to stick with uncompressed AIFF or WAV files.

DECISIONS, DECISIONS

By going through the process of getting media into your computer, you've completed the first step of editing—you've made preliminary decisions about content and, hopefully, provided material of quality to edit. The next three chapters are all about the art and craft of editing. Chapter 9, "Editing Basics," will start you off with the basics.

CHAPTER

Editing Basics

IN THIS CHAPTER

- Rhythm and Pacing
- Hard and Soft Cuts
- Short Format Projects
- Tutorial: Editing a Promo
- Basic Sound Mixing
- Synchronization
- Tutorial: Editing a Music Video
- How to Become a Fast Editor

A. Time counter B. Target tracks C. Overlay edit

215

S torytelling, visual impact, mood, and structure: these are all elements that a good editor can manipulate to enhance a project. And there's no better way to learn about editing than by doing it yourself. This chapter, along with the next two chapters, will use a series of tutorials to guide you through several projects that will help you add these skills to your editing repertoire.

In this chapter, you'll edit a short promotional piece for a TV series, and a music video shot on 16mm film. You'll learn about rhythm and pacing and how different types of cuts affect them, then you'll expand on that, adding technical skills such as synchronizing audio and video. You'll also learn how to create structure in a short format piece that doesn't necessarily tell a story.

Whatever you do, don't skip the maintenance tips at the end of the chapter.

PACING AND RHYTHM

Concepts such as pacing and rhythm might sound ephemeral at first—after all, they're usually used to talk about music, not movies. And there's a good reason for this: sometimes, creating a scene with energy and style involves little more than finding the right piece of music and cutting to the beat, as you might have noticed doing the tutorial in Chapter 2, "Cut to the Chase!" This is particularly true for promos and commercials. Music is a powerful tool—it can set the mood, pick up or slow down the pace, add to the emotional power of the scene, and provide closure.

Another element that helps create rhythm and pacing is the story itself. A "story" doesn't necessarily mean a piece of fiction. All good films have a narrative, whether it's a documentary about the fall of Roman civilization, or a fictionalized story about the life of a gladiator, and this narrative often guides the pacing and rhythm used by the editor.

On a shot-by-shot level, pacing and rhythm are accomplished by the types of edits used and the length of each shot. In this way, the editor can manipulate a scene to make it better serve the story being told. Deliberately slow pacing can make a scene from a horror movie scarier and more intense; short fast cuts can add energy to an action scene.

SHOT LENGTHS

The length of a shot should be determined by the content of the scene. A touching emotional moment could be destroyed by too many fast cuts. An energetic chase could be ruined by staying too long on one camera angle. And when it comes to rhythm, variety is the spice of life. Too many long shots may seem dull; too many short shots may seem *cutty*, or distractingly disjointed. The most

effective use of pacing involves a variety of fast and slow cuts, as in the famous shower scene in Alfred Hitchcock's *Psycho* that starts out with a long slow shot and ends with a series of very short, fast cuts.

HARD AND SOFT CUTS

Every image in a film contains a variety of visual elements:

- **Camera angle**. Wide, tight, overhead, etc.
- **Screen position**. Is the subject on the left, right, or center of the frame (Figure 9.1)?
- **Color**. Is the overall color cast of the shot warm or cool? Does a strong color dominate?
- **Movement and action**. Is the shot moving or static, are the elements within the frame moving or static?
- **Narrative content**. Is the shot from the same scene, the same part of the story?

Cutting from one shot to another shot that has a lot of these elements in common is called a *soft cut*—it's smooth and seems motivated and natural. It's also known as a *seamless* edit. The effect of soft cuts is that the scene plays smoothly. The most extreme sort of soft cut is a *dissolve*. Dissolves can add a mysterious, dreamlike or moody feeling to a scene.

Cutting from one shot to another that differs greatly is called a *hard cut*. It feels somewhat jarring and shocking. Hard cuts add energy and intensity to a scene. The most extreme type of hard cut is a jump cut. Adding a sound effect to a hard cut can intensify it (Table 9.1).

In the two tutorials that follow, you can experiment with hard cuts and soft cuts to change the mood, rhythm, and pacing of the promo and the music video.

In a perfect world, style and substance are not mutually exclusive. A good editor should be able to employ the hard-cutting style without sacrificing the emotional content of a scene. In fact, the style should actually enhance each scene. A good example of a film with a strong sense of editing style that enhances the story is *El Mariachi*. Each shot is incredibly short, which gives the story a sense of energy and freshness that might be lost if longer shots were used. However, try to imagine a similar style used for a Merchant-Ivory production. For these films, longer shots that let the viewer linger on the beautiful production design and cinematography are more appropriate. Each project you edit will need a unique style, depending on the content. And even if your goal is to break the rules, you'll need to break them successfully. Learning to create style that adds to the story, rather than distracts from it, confusing the viewer or overwhelming the narrative, is an important skill for every editor.

A. Matching screen position

c. Matching movement within the frame

Dolly out

Dolly out

B. Matching camera movement

FIGURE *Matching screen position (A), camera movement (B), and movement within the*
9.1 *frame (C).*

Table 9.1 Shot Contents and Perceived Intensity

More Intense	Less Intense
Short shots	Long shots
Jump cuts	Dissolves
Hard cuts	Soft cuts
Varying camera angles	Matching camera angles
Changes in color cast	Similar color cast
Cutting from one scene to another	Cutting within the same scene
Change screen position	Matching screen position
Jumps in time	Natural progression in time
Varying movement within the frame	Matching movement within the frame

SHORT-FORMAT PROJECTS

Short-format projects span a huge gamut—from independent short films to big-budget commercials. Because they do not need to sustain interest for a long time, short projects have an inherent freedom and can be more experimental and less narrative driven. They may tell a story, but they may also simply convey a mood or an idea.

- **Commercials** are usually 30 or 60 seconds in length. They use brevity and sometimes complicated special effects to send a message with impact.
- **Music videos** are about 2–4 minutes in length, and generally feature intercutting between the performer(s) and footage that either tells a short story or evokes a mood.
- **Short films** are typically less than 10 minutes long, and tell a simple dramatic or documentary story. They rely heavily on three-act structure and are very similar to feature films in everything but length. (Three-act structure is covered in the next chapter.)
- **Trailers and promos** run anywhere from 30 seconds to 5 minutes. They usually manipulate mood and intensity to create visual impact and intrigue the viewer.

Because they are less resource intensive, short projects are often of very high quality technically. Producers who can only afford to shoot a feature film in miniDV may be able to afford to shoot a short on 35mm film. They can also hire a more experienced D.P. and use better equipment. Moreover, for the editor, it takes less time to view the footage and to review the edited sequence. The editor can focus on refining each edit, rather than simply getting through all the material in the allotted timeframe.

About the Editing Tutorials

The next four tutorials are specifically about editing. They move quickly, taking you from the technical basics to sophisticated decision making.

The first tutorial covers the basic elements of working within a non-linear editing environment, using the technology to create a short promotional piece. The second focuses on technical issues that aren't specific to non-linear editing, primarily synchronization. The third tutorial, in Chapter 10, moves away from technical instruction to focus on the storytelling skills needed for successful editing, particularly creating structure in an unscripted project. The last of the editing tutorials, in Chapter 10, takes storytelling a step further, focusing on the action and emotion within a scene.

TUTORIAL

EDITING A PROMO

The tutorial in Chapter 2 provided an introduction with the simple task of editing a montage to the beat of a song. This tutorial takes it a step further, with the introduction of some real information to convey to the viewer. The goal of a promo is to convince the viewer that whatever is being promoted is going to be very interesting. For this tutorial, you'll use selected material from a TV series called *Knights* and edit those shots into a 30-second promo that will be delivered as streaming media for a Web site.

This tutorial covers:

- Working with PAL video
- Using markers, timecode, and key commands to navigate
- JKL editing
- Three-point editing
- Building a voice-over track
- Overwrite edits
- Working with pre-edited material
- Adding dissolves
- Adding and mixing background sounds
- Exporting a QuickTime movie

WHAT YOU NEED

ON THE CD/DVD

You need non-linear editing software installed on a computer with a CD or DVD-ROM drive, and the companion CD/DVD from this book. See Appendix C for the specifics regarding the materials for this tutorial. You also need headphones or speakers. If you don't have an external NTSC/PAL monitor (or simply a PAL monitor), you won't be able to play the video from this tutorial on your external monitor. If so, don't worry—it's only going to be 30 seconds long and it's meant for the Web, so you can simply export it and watch it as a QuickTime movie.

ON THE CD/DVD

This tutorial will be edited using Adobe Premiere 6.0. You can either install the demo software on the CD/DVD or use your own editing application. If you're using a different application you may want to keep the user manual ready for quick reference.

TIP

Very Important

The footage for this tutorial was compressed using either the MJPEG-A Codec (for the media on the DVD) or the Sorenson video codec (for the media on the CD). Most editing applications will require that you render these compressed video files before you can play them back in real time. For tips on rendering, working with rendered media, and the media used in other tutorials in this book, please read the file called Render.rtf on the CD/DVD.

STEP 1: PREPARE THE MEDIA

ON THE CD/DVD

At the Windows or Finder level, drag the *Knights* Promo Tutorial folder from the CD or DVD onto your hard drive.

STEP 2: SET UP THE PROJECT

Launch Adobe Premiere 6.0 and create a new project. A project settings dialog box will appear. The footage you will be using for this project is PAL and has a 25 fps frame rate and a rectangular pixel aspect ratio and a frame size of 720 × 576. The DVD media uses 221 JPEG-A compression and an audio sampling rate of 48 kHz. The CD media uses Sorenson compression and a sampling rate of 22 kHz (Figure 9.2). If this is the first time you've launched Premiere, a dialog box will appear that gives you the choice between A/B editing or single-track editing. Select single-track editing. Next, from the Adobe Premiere File menu, select Import > Folder. Choose the *Knights Promo Tutorial* folder that you copied onto your hard drive. The media for the project will appear in a folder called *Knights Promo Tutorial* in the bin window (Figure 9.3). Save the project as *Knights Promo* on your hard drive.

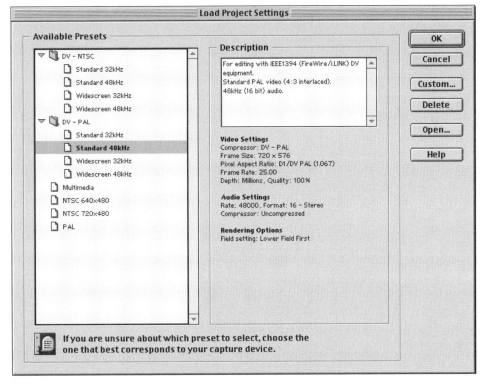

FIGURE Knights *tutorial project settings for Adobe Premiere 6.0.*
9.2

Bin	10 it..	Name	Media Type	Duration	Timecode	Video Info	Audio Info
▽ 🔵 Bin 1	💾	Show5.mov	Movie	00:01:33:17		720 × 576 (1.067)	
📁 Knights	💾	Show4.mov	Movie	00:01:01:07		720 × 576 (1.067)	
	💾	Show3.mov	Movie	00:00:26:20		720 × 576 (1.067)	
	🔊	Music3.mov	Movie	00:00:48:00			48000 Hz – 16 bit – Stereo
	🔊	Music2.mov	Movie	00:01:07:01			48000 Hz – 16 bit – Stereo
	🔊	Music1.mov	Movie	00:00:40:19			48000 Hz – 16 bit – Stereo
	💾	KTitle.mov	Movie	00:00:18:14		720 × 576 (1.067)	
	🔊	KnightsVO2.mov	Movie	00:00:30:20	00;04;17;04		48000 Hz – 16 bit – Stereo
	🔊	KnightsVO1.mov	Movie	00:00:49:15	00;00;48;08		48000 Hz – 16 bit – Stereo
	🔊	Intro.mov	Movie	00:02:39:07			48000 Hz – 16 bit – Stereo

Project: Knights promo 030701pm

FIGURE 9.3 *The bin window displays the imported tutorial media.*

How'd It Get Here?
TIP

This footage has been through a lot—it's gone from Los Angeles to Paris to London and back a couple of times. It originated mostly on 16mm film that was transferred to PAL Beta SP, or PAL D1 video that was treated with a film look. It was mastered onto PAL Digital Betacam, and PAL Beta SP dubs were made. The media from these dubs were sent via component analog inputs to an Avid Media Composer and captured uncompressed. The media was then exported to QuickTime files using an Avid codec and recompressed with either the Sorenson video compressor (CD) or MJPEG-A (DVD). Audio was maintained at a 48-kHz sampling rate (DVD) or 22 kHz sampling rate throughout these conversions.

STEP 3: CHECK OUT THE SCRIPT

Now it's time to look at the script—it's in the *Knights promo tutorial* folder and is called *Knights.txt*. You can open it in any text-editing software, such as Windows Notepad or SimpleText. It's also provided here in Figure 9.4.

You may have noticed that it's a very simple script. That means, as the editor, you will be responsible for filling it out with the visual content. Since the promo is only going to be 30 seconds long, that shouldn't be too hard.

```
Knights promo voice-over

For 500 years they were

the most feared warriors on earth.

Today they live on in our imaginations.

Join us for KNIGHTS the television series

which tells the true stories of real knights
```

FIGURE *The Knights promo script.*
9.4

STEP 4: IDENTIFY THE DIFFERENT VOICE-OVER TAKES

The first step in building this promo is editing the voice-over track. There are two versions of the voice-over, and each features a different style. *KnightsVO1* is comedic and intentionally over the top; *KnightsVO2* is more straightforward and serious. Listen to them both, choose the performance you like, and drag it into the Source viewer.

You may have noticed that there are two versions of the script in each of the three voice-over takes. That's because the script was changed after the voice-over was recorded. To build the voice-over track, you're going to take the opening line from the second take, the second line from the first take, and the last line from the second take.

To make this easier, you'll set markers in the clip to indicate the start of each line. Go to the Source viewer, and press Play using the mouse or the spacebar. When you find the start of the first line, "Knights, for 500 years they were the most feared warriors on earth," go to the Clip menu and select Set Marker > 1. Now go back to the Source viewer and continue playing until you find the start of the second line, "Today they live on in our imaginations." From the Clip menu, select Set Marker > 2. Continue to set markers for each of the remaining lines. You should have six markers when you're done.

Now, you can use the markers to navigate from line to line. Mac users press Command 1 to go to marker 1; Windows users press Control 1. You can also go to the Clip menu and select Go To Marker > 1.

STEP 5: BUILD A VOICE-OVER TRACK

Next, you'll use the JKL keys to navigate through the clip, and three-point editing to build the voice-over track. The first line of the voice-over is located at

marker #4. Navigate to that marker, and play the voice-over clip by pressing L on your keyboard. Press K to pause. Now press J to play it backward. Use the J-K-L keys to move around in the clip until you get to the point right before the first line of the voice-over. Now press the I key to set an in-point. Next, play the clip until you get to the end of the line, and press the O key to set an out-point.

You've just set two of the three points needed to make a three-point edit. Now, go to the Program viewer to set the third point. Use the mouse to navigate to a point about five seconds into the timeline. Look at the time counter in the lower-left corner of the Program viewer to see when your cursor is around the five-second mark (Figure 9.5a). Press the I key to set an in-point.

Now you're going to perform an overwrite, or as Adobe calls it, *overlay edit*. First, you need to identify which tracks you want to edit. In this case, you simply want to send the audio on track 1 in the Source viewer over to track 1 in the timeline. Go to the bottom of the Program viewer. There are two pop-up menus following the word *Target* (Figure 9.5b). The first pop-up menu identifies the video track you want to target—select None. The second pop-up menu identifies the audio track you wish to target—select A1. Now, perform the overwrite edit by clicking on the overlay icon with your mouse (Figure 9.5c).

Use the same process to add the second line of voice-over, identified by marker 2, at about 11 seconds into the timeline; and the third line of voice-over, at marker 3, 24 seconds into the timeline. For the third line, cut out the last part of the line so that it reads "Join us for Knights, the television series that tells the true stories of real knights."

Your timeline should now look like the one in Figure 9.6.

A. Time counter B. Target tracks C. Overlay edit

FIGURE *The Source and Program viewers both display a time counter (A), let you target*
9.5 *tracks (B), and perform an overlay edit (C).*

FIGURE *The timeline with a voice-over track.*
9.6

STEP 6: ADD VIDEO

Now you're going to cover the sequence with picture.

First, place a marker in the timeline at exactly 30 seconds. Go to the Program viewer and click on the time counter so that it's highlighted a bright green. Type in "3000" and press Return. The timecode counter and the cursor in the timeline will move to the 30-second mark. This is a very precise way to navigate in both the Source and Program viewers. Now, go to the Timeline menu and select Set Timeline Marker > 0. This gives you an easy visual reference for the length of the project. Make sure the scale of the timeline is set to 2 seconds using the pop-up menu in the bottom-left corner of the timeline (Figure 9.7). This lets you see the entire 30-second sequence in the timeline.

Now go to the Project window and double-click on the file called *Show5.mov.* This is a prebuilt element from the introduction of the TV series. Watch it in the Source viewer, and then set an in-point in the middle of the P.O.V. shot of the ground. This is approximately 44 seconds into the clip. Next, set an out-point at the end of the shot where a man is hit by a flaming arrow and falls, about 52 seconds into the clip. This pre-edited footage has many dissolves built into it, so be careful to choose a fairly clean frame (Figure 9.7). Set an in-point on the Program viewer at 00:00:00:00 and perform an overwrite edit. Be sure to target only the Video 1 (V1) track.

Next, set a new in-point in the middle of the shot with the large army of stampeding horses in the *Show5.mov* clip, at about 33 seconds in. You can make precise moves within a clip or sequence by typing the + or – (minus sign) and the amount of time you wish to advance or rewind. For this shot, set the out-point so that the duration of the shot is 7 seconds and 20 frames. To do this, highlight the timecode counter in the Source viewer, type "+720," press Return, and set the out-point. Next, activate the Program window, and from the Clip menu, select Go to > Video Out. Use the right arrow key to advance one frame and set an in-point, and then perform an overlay edit on the video track. The right and left arrow keys let you move backward and forward frame by frame. If you hold them down, they'll *scrub* video and audio.

Scale

FIGURE *The new sequence in the timeline with picture added. Note that the frame of the in-*
9.7 *point, on the left, and the out-point, on the right, are clean—they don't include*
partial dissolves.

Next, load the *Show4.mov* clip into the Source monitor, and pick a part of the
footage you like. Set in- and out-points for a clip with a duration of about 3 sec
onds, and edit into the timeline after the shot you just added. You can see the
duration of the selection you've made in the lower-right time counter in both
viewers (Figure 9.8). Do the same for the *Show3.mov* clip.

The *Show1.mov* clip is a little different because it has sync sound. Load it into
the Source viewer and set in- and out-points for a 3-second clip. On the Pro-
gram viewer, target the V1 track and the A3 track, and then perform an over-
write edit.

Finally, load the *KTitle.mov* clip in the Source viewer and set an out-point
about 13 seconds and 20 frames from the start. This is the last frame before the
cover of the book starts to move. Now go to the Program side and set an out-
point at the end marker. Remember, you can navigate there by pressing Com-
mand 0 (Mac) or Control 0 (Windows). Set an in-point at the end of the last

Source duration **Program duration**

FIGURE *The sequence is completely "covered" with picture.*

9.8

video clip in the timeline. Now you have two out-points set, and one in-point set—the other way to set up a three-point edit. Perform an overwrite edit and your sequence should look something like the timeline in Figure 9.8.

STEP 7: ADD BACKGROUND AUDIO

Now it's time to fill out the audio tracks. Load the *Intro.mov* clip and target A2 on the Program viewer (set the video track target to "None"). At about 1 minute and 15 seconds into the clip, or 00:01:15:00, the narrator recites a poem from the Middle Ages about the virtues of war. We're going to use this evocative audio to create a "bed" of background sound for the promo. Set an in-point right before the start of the poem. Set an out-point at the end of the line around 1 minutes and 30 seconds into the clip: "Horses of the dead and wounded moving around at random." Edit this selection into the timeline with an in-point at 00:00:00:00.

Now use go back to the Source viewer and navigate the out-point you set for the last clip by typing "W." You can also navigate to an in-point by typing "Q." From the out-point, press Play (L) and set an in-point right after the words "And when battle is joined." Set the out-point after the end of the phrase, "It is better to die than to be vanquished and live." Now set an in-point on the timeline right after the end of the second voice-over clip. Your sequence should now look something like Figure 9.9.

FIGURE
9.9
The timeline with the background sound on Audio track 2.

Avoid the First and Last Frames

It's always a good idea to avoid using the first and last frames of any shot, especially if you're working with pre-edited material. The video and audio signals may be unstable. If you're working with a single-field resolution, you may end up with an invisible frame from the next (or previous) shot that shows up as a flash frame in your final master, or the frame might include a partial dissolve.

STEP 8: FILL ANY SOUND HOLES

Now take some time to watch the cut. It's probably pretty distracting to hear both the voice-over and the poem at the same time, but don't worry—you'll fix that in the mix. For now, you want to fill the holes in the background sound-track so that it doesn't sound so choppy.

Turn off the audio playback on A1 by clicking the speaker icon on the left so that it disappears. Now you can listen to the background tracks, A2 and A3, without the voice-over. The hole happens at about 13 seconds into the sequence.

Load the *Intro.mov* clip into the Source viewer and go to the beginning of the clip. Here is a large section of pre-edited ambient sound with crows cawing and wind howling. Set in- and out-points for a duration of about 3 seconds, and drag

it onto Audio 3 in the timeline. This will act as a sort of audio Band-Aid to cover the hole in the background track. Play the track again and see if it sounds better. If you don't like it, try another area of the clip.

The next hole is at the end after the *Show1.mov* shot. You can extend the sync sound on Audio 3 by clicking on the end of the sound clip in the timeline and dragging it, but first you'll have to deselect Sync Selection from the Timeline menu. You can also extend the beginning of the sound clip. The picture and sound will remain in sync, but the sound will start before the picture and end after. Be careful not to drag too far, or you'll get the voice-over from *Show1.mov*.

Now the only remaining background hole is the very end. For this area, we're going to fill it with music from the show's title sequence, rather than ambient sound. First, add more audio tracks by selecting Add Audio Track from the Timeline pull-down menu. Load one of the three music clips into the Source viewer, and pick a section for the end. The edit shown in Figure 9.10 has two pieces of music layered together—the acappella chorus from *Music3.mov*, and the low tone and wind chimes at the end of that same track.

Choppy Playback

TIP

If you're hearing choppy-sounding audio, you may improve playback performance by turning off the video tracks temporarily. Usually, choppy playback indicates that your sequence has media that needs to be rendered. Be careful, though: if you've already rendered parts of your sequence, you might lose the render if you turn the tracks on and off. If this happens, you can always Undo.

FIGURE *The timeline with background sounds added.*
9.10

STEP 9: ADD AND RENDER DISSOLVES

When you're working with pre-edited material, you often have no choice but to edit in the same style. For this promo, you need to soften up the cuts in the picture track to match the pre-edited material by adding dissolves. From the

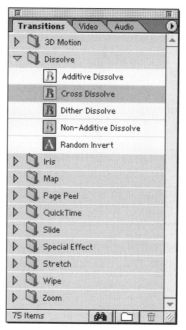

Window menu, select Show Transitions. Then, click on the triangle icon to open the Dissolves folder (Figure 9.11). For this promo, we'll stick to a standard dissolve, also known as a *cross dissolve*.

Click on the cross-dissolve text in the Transitions window, drag it to the timeline, and drop it on the transition between the first two shots in Video track 1. The transition icon appears between the two shots. The red line between the tracks and the yellow selection bar indicates media that needs to be rendered. You'll need to render a preview movie of this dissolve before you can watch it. Before you do that, however, drag cross dissolves onto all of the edits in the timeline so that it looks like Figure 9.12a.

From the Timeline menu, select Preview to render the dissolves. This might take a while. The red bars about the tracks turn green to indicate that they are rendered. Now watch your cut and decide if the dissolves are working for you. They may need some adjustment. You can move the transition itself by selecting the transition icon in the timeline and dragging it left or right. You'll also change the in- and out-points of the clips surrounding the transition. You can make the dissolves longer or short by clicking on the start or end of the transition icon and dragging. A red bar appears near the cursor to indicate that you are extending or shortening the shot. Try lengthening the dissolves to make

A. Cross dissolve

B. **Open audio track**

C. **Rubberband audio levels adjustment**

FIGURE *The timeline with cross dissolves added to the shots in Video1 track (A), and an open*
9.12 *audio track (B) with rubber band audio levels adjustment (C).*

them look more like the footage from *Show5.mov*. You'll have to re-render any changes you make. Make sure you have all the audio and video tracks you want to view turned on before you render.

STEP 10: PERFORM A BASIC SOUND MIX

Last, but not least, you need to mix the audio, lowering the levels of the background sound when the voice-over plays, and adding dissolves to smooth audible sound edits. Go to the Audio 2 track in the timeline and open it by clicking on the triangle icon (Figure 9.12b). A waveform of the sound is displayed, along with a red line called a *rubberband* that indicates the level, or volume, of the audio. Now do the same thing with the Audio 1 track. You may want to zoom in on the timeline to get a better view. By looking at the waveform of the voice-over in Audio 1, you can easily see where it stops and starts (Figure 9.12c).

Click on the red rubberband to create a keyframe, or *handle*, as Adobe calls it. You can drag this keyframe down to lower the volume, and up to increase it. Fade the ambient soundtracks down when the voice-over starts, and up again at the end of the voice-over to create a mix. For more about mixing, see the "Basic Sound Mixing" sidebar later in this chapter.

TIP

Advanced JKL Editing
If you're using an application that features JKL editing, tapping the L key more than once will play in fast motion, and tapping the J more than once will play backward in fast motion. Depending on the application, sometimes holding the Shift key or another key will let you use JKL to view the media in slow motion.

STEP 11: EXPORT A QUICKTIME MOVIE AND REVIEW YOUR WORK

If you want to view the movie at full resolution, choose Timeline Export from the File menu, and the settings should default to the ones shown in Figure 9.13.

Watch your cut. Do you like it? Does it make the show look interesting? If not, you might want to try to rearrange some of the shots, try different images, or tighten things up. Look at the file called *Knights.mov* in the *Final Movies* folder to see what one possible final version of the promo looks like. There's also a copy of the final Premiere 6.0 project file used to create the final movie. You may have to help Premiere locate the tutorial files on your hard drive when you open this file.

FIGURE *Export the file to a QuickTime format for full-res playback.*
9.13

You can find links to the real version of this and other promos for the *Knights* series at www.dvhandbook.com/nlebook/links.

BASIC SOUND MIXING

All editors take the time to do a basic sound mix as they create a rough cut, for a very simple reason: it makes the cut easier to watch. Screening rough cuts is an important part of the editing process, whether it's to get casual and friendly

feedback, or to get approval from an executive producer. A cut that has audio problems will distract the viewers from things you really want them to pay attention to: the story. If the voice-over is very loud but all the interview audio is low, viewers may miss some important information. Similarly, if there is a discrepancy between the audio of two actors, it may make one or both of the performances look bad—or it may make the editor look bad.

Everyone's heard the phrase "Fix it in the mix." That mistakenly implies that mixing is a one-time event that happens at the very end. While it's true that every project should receive the benefit of a final mix, mixing is an ongoing process that starts when audio is captured and continues throughout the editing schedule.

That said, here are some tips for creating a basic sound mix:

- **Set the level for the main source of audio first.** For a feature film, this usually means the dialogue; for a doc, this means the voice-over, interviews, and sound bites. This is the audio that needs to be heard at all times, and everything else should defer to it. The level should be strong but not peaking, averaging somewhere in the middle between 0 dB and the top of the yellow area on your audio level meter. It should never go into the red (Figure 9.14).
- **Set the levels for the secondary audio sources.** This usually means other sorts of dialogue—production sound, ambient noise, etc. This audio should provide a background for the primary audio, but it should never compete with it. In the case of a documentary, you should bring these levels up at times where there is no voice-over, and then dip it back down when the voice-over starts again. Raising the production sound like this is

FIGURE *Healthy levels for dialogue or voice-over fall into the range shown in A; levels for*
9.14 *background sound should look more like B.*

often called a "sound up." The documentary tutorial in Chapter 10 has several "sound ups."

• **Set the levels for the music.** If your scene has music, adjust the levels to defer to the dialogue/voice-over. Usually, the music will start out fairly loud, and then dip down once the primary audio starts. Be wary of creating too great a difference between the loud part of the music and the soft part—this will cause the fades to stand out. The idea is to sneak the music levels down so as not to call attention to them.

• **Add key sound effects if needed.** A basic mix doesn't need a full track of sound effects, but if there is a key moment—say, a knock on the door or a gun firing—that really calls out for a sound effect, it's a good idea to take the time and put it in.

SYNCHRONIZATION

Back when films were cut on film, synchronizing was a huge, time-consuming task. During production, the picture and the sound were recorded on separate devices—a film camera and a reel-to-reel tape recorder. A slate was used to identify each shot and also by the editor to synchronize the picture and the sound at the precise frame where the slate was clapped shut.

Today, the need for synchronizing media still exists any time picture and sound are recorded separately, which is always the case for projects shot on film, and often the case for multiple-camera shoots. These days, an electronic slate is used to display the timecode generated by the audio recorder, such as a timecode DAT machine. The timecode from the audio tape is matched up with the frame visually displaying that timecode on the slate, and the result is synchronized footage. For film projects with a decent budget, the sound and the negative are synched by the film laboratory that does the negative processing and telecine transfer to videotape. For lower-budget film projects, the synchronization is done by the editor after capturing the media in a non-linear editing application. The music video tutorial later in this chapter walks you through this type of synchronization.

For professional multicamera video shoots, there is usually one camera or video deck on the set that can generate timecode. All of the cameras are fed a timecode signal from that VTR or camera, a process known as *jam synching*. The result is several videotapes with matching timecode that can be synched, or grouped together, in a non-linear editing application. Lower-end cameras aren't always capable of jam synching. In this case, the tapes are prestriped with matching LTC timecode, or electronically slated the same way that film is slated. For the lowest-budget production, an old-fashioned film slate or hand clap is better than nothing at all (Figure 9.15).

Slate clap

FIGURE *The clap on the sound recording (A) is matched up with the visual clap (B), and the*
9.15 *result is synchronized sound and picture.*

Final masters also have a sync point, often called the *two pop*. All professional final masters have a leader that precedes the film and includes a 10-second *countdown*. The first frame of the project always starts right after the last frame of the 10-second countdown. To ensure sync, a single frame of 60-Hz audio reference tone is cut into the countdown at the exact frame where the count reaches the number 2. This way, anyone watching can easily see if picture and sound are in sync.

TUTORIAL

EDITING A MUSIC VIDEO

Editing a music video can be as difficult as you want it to be. The ones shown on TV often have multiple layers of effects and complex composites. However, no matter how many special effects they end up with, a music video always starts out as a very simple thing: a song and some footage to go with it.

ON THE CD/DVD

For this tutorial, you'll create a project, import media from the CD/DVD, and build a sequence with music tracks and video footage for a song called *Sweet Sound* by singer-songwriter Kim Petrowski. You'll focus on rhythm, pacing, and synchronizing video and audio. You'll also build upon the set of editing tools you've acquired in the last two tutorials. At this point, you should be comfortable creating a project, adding tracks to a sequence, drag-and-drop editing, three-point editing, and navigating around an editing application.

The tutorial will walk you through the steps to create a rough cut of the music video—a process that could take a day or two. After you complete the tutorial, you can spend more time on it working with the material and refining the cut.

This tutorial covers:

* Using electronic slates
* Synchronizing with timecode
* Synching by eye
* Building a master edit
* Hard cuts
* Staying in sync
* Cheating sync

WHAT YOU NEED

ON THE CD/DVD

You need non-linear editing software installed on a computer with a CD or DVD-ROM drive, and the companion CD/DVD from this book. See Appendix C for specific information about installing the tutorial media. You also need an external video monitor and headphones or speakers. This tutorial will be edited using Apple Final Cut Pro 2.0. At press time, there was no demo version of this product available, but it's included as a tutorial anyway because of its popularity. If you're using a different application, you may want to keep the user manual ready for quick reference.

TIP

Get Rid of Software Conflicts

If you are working with the demos on the CD/DVD that come with this book, you might find that they install system extensions and codecs that conflict with each other. Be sure to remove the extensions, or uninstall when switching from one editing application to another. The RadDV codec that you may have installed along with EditDV for the Chapter 2 tutorial does conflict with Final Cut Pro. Any problems you might have with dropped frames may be due to this.

ON THE CD/DVD

STEP 1: SET UP THE PROJECT

From the CD or DVD, go to the Tutorials folder, copy the folder called *Music Video tutorial* to your hard drive, and then launch Apple Final Cut Pro. From the Edit menu, check the Preferences. The video should be set to NTSC DV, and the audio should be set to 48 kHz. Beware that the default audio setting for NTSC DV footage is 48 kHz (Figure 9.16). Create a new project and call it *Sweet Sound*, the name of the song; then, from the File menu, select Import > Folder and import the media in the *Music Video tutorial* folder. Your project window should look something like Figure 9.17. Final Cut Pro automatically created a new sequence for you when you created the new project. Change the name from *Sequence 1* to *Sync sequence*.

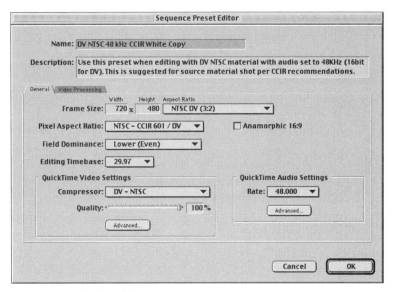

FIGURE *Project settings for Final Cut Pro.*
9.16

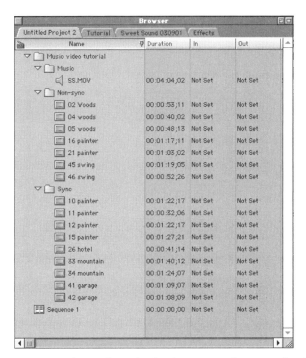

FIGURE *Project window with media for the music video tutorial in bins.*
9.17

TIP

How'd It Get Here?

The media for this tutorial was shot on 16mm film at 30 fps, transferred to NTSC Digital Betacam video, and from there, dubbed down to NTSC miniDV. It was then captured in Final Cut Pro as uncompressed NTSC DV footage and recompressed with the Sorenson video codec. Since no sound was recorded during the shoot, the only audio is from the CD track that has an audio sampling rate of 48 kHz.

STEP 2: BUILD A SEQUENCE WITH A SYNCHED MUSIC TRACK

Notice that there are three subfolders: *Sync*, *Non-sync*, and *Music*. This particular tutorial involves a fair amount of preparation, because all of the shots in the Sync folder need to be synched to the song in the Music folder. The material in the Non-sync folder is icing on the cake, so forget about it for now.

The source timecode for the song, *SS.mov*, should start at 00:00:43;08. Check this by double-clicking on the Music.mov clip to launch it into the Source Viewer. The source timecode is displayed in the box in the upper-right corner of the viewer (Figure 9.18). Be sure that your cursor is at the first frame of the music clip. If it doesn't match, go to the Modify menu and select Timecode, then Starting Frame from the pop-up menu. Enter 00:00:43;08 and make sure the Drop Frame box is selected. (Figure 9.19a).

Total run time of source clip (TRT)

Source timecode

FIGURE *The Final Cut Pro Source viewer.*
9.18

FIGURE *Modifying source timecode in Final Cut Pro.*
9.19

It will be easier for you to sync the audio and video together if sequence timecode matches the source audio timecode. Since the default starting time-code for a sequence created in Final Cut Pro is 00:00:00:00 and the music source track timecode starts at 00:00:43:08, next you'll edit the music so that it starts 43 seconds and 8 frames into the sequence. Double-click on the sequence, and then select Settings from the Sequence menu. Go to the second tab, Timeline Options, change the Starting Timecode to 00:00:00:00, and make sure the Drop Frame box is selected. (Figure 9.19b).

Next, activate the Canvas viewer (aka, Record viewer, Program viewer, etc.—everyone has a different name for it), type in "4308" and press Return to navigate to 00:00:43;08 in the timeline. Set an in-point here. Next, go to the *SS.mov* clip in the Source viewer and set an in-point on the first frame of the clip. Press F10 to perform an overwrite edit. The stereo song is now on the A1 and A2 tracks in the timeline. Click on the padlock icon to the left of the audio tracks (Figure 9.20a) to lock the tracks so that you don't accidentally move the music out of sync. Hatch marks will appear on the tracks to indicate that they're locked and can't be changed.

Now you know that the timecode of the music matches the sequence timecode. This will make it much easier to match the timecode from the film to the music.

STEP 3: USE THE ELECTRONIC SLATE TO SYNC THE VIDEO WITH THE MUSIC

Next, you need to go through all the shots in the Sync folder and sync them up with the music. This footage was shot on film, transferred to Digital Betacam, and then transferred to miniDV. The timecode on the miniDV tapes does not match the timecode on the slates. This is a common phenomenon when working with miniDV, because these miniDV tapes have DV timecode, as opposed to the SMPTE timecode on the slates and the Digital Betacam masters. Luckily, the electronics slate will make this job easy.

B. Viewer

A. Locked music tracks

FIGURE *The music tracks are locked (A), and the first picture shot, shown in the viewer (B),*
9.20 *has a clear view of the slate and the timecode numbers displayed on it.*

Load the first clip, called *10 painter* in the Sync folder, into the Source viewer and play until you reach a frame where the electronic slate is visible, at the very beginning of the clip. Use the arrow keys to move forward and backward frame by frame until you're on a clean image of the timecode counter in the slate (Figure 9.20b). Set an in-point there, and then go to the Canvas viewer. Type in the timecode number from the slate, and press Return and then I to set an in-point. Target the V1 track by clicking on the frame icon next to the track, and perform an overwrite edit.

Play that portion of the sequence. Picture and sound should be in sync. Lock that video track and continue this process for all of the clips in the Sync folder except the shot called *12 painter*. (This shot doesn't have a slate. You'll learn to sync it by eye in the next step.) Put each sync shot on its own video track, and lock it. You'll need to add more video tracks as you go by selecting Insert Tracks from the Sequence menu. When you're done, the Sync sequence should look something like Figure 9.21.

FIGURE *The Sync sequence containing all the sync shots on separate video tracks.*
9.21

STEP 4: SYNC A SHOT BY EYE

Go back to the shot called *12 painter*. The slate was probably cut off during the shoot or during capture—you'll have to sync it by eye. This isn't as hard as it might sound, especially since Kim has done a great job of singing along with her CD track (you don't always get this lucky). Look for a hard, distinct sound to use as a sync point. The start of the word *breath* in the third line of the song works well. Make sure Audio Scrubbing is turned on in the Preferences, and scrub frame by frame using the arrow keys until you find the first frame of the word *breath*.

Find the corresponding point in the picture and set an in-point there. You'll have to do some lip reading in order to find this in-point. Once you think you're on that frame, perform an edit, and then play the sequence to see if it syncs up. You might have to move it a couple frames forward or backward. To do this, zoom into the timeline by dragging the scale at the bottom-left corner. Then, click on the clip in the timeline and drag it slowly. A small window appears that tells you how many frames you're moving (Figure 9.22). Try moving one or two frames, and then test the sync. If you can't move in small enough frame increments, zoom in even further on the timeline.

When you're satisfied with the sync, select the beginning, or *head*, of the *12 woods* clip and drag it back toward the beginning of the song, to extend the picture back to the start of the shot (Figure 9.22).

Duration of position change

Frame counter Scale

FIGURE *Dragging the shot in the timeline.*
9.22

If you're having trouble synching this shot, try setting the in-point for *12 woods* at 00:21:25;20, and the in-point for the sequence at 00:01:22;25, and then perform an edit. Once you're satisfied, lock the track for safety.

STEP 5: CUT DOWN THE SYNC SEQUENCE

Now it's time to do some editing. Select the Sync sequence in the Browser window, copy it (Command C), and paste it (Command V). Rename the copy *Rough Cut 1* and load it into the Canvas viewer. Now you can unlock the tracks and start editing the synched material. If you lose sync, you can always go back to the Sync sequence and get your bearings. It's also a good idea to use the Sync sequence when you're looking for footage—since the audio is attached, you'll know what part of the song it goes with.

The first step is to look at the shots that cover the bigger portions of the song. The "painter" shots cover the first verse and chorus; the "garage" shots cover the second verse and chorus; and the "mountain" shots cover the last two choruses. Watch these shots and pick the performances you like best. This will create the spine of the rough cut. Whenever you have nothing else to show, you'll show one of these shots. Things to look for at this point include a performance that matches the music and interesting camerawork. Sometimes you won't have many choices in this regard, and you'll have to cover up the flaws later. Another word of advice at this point: think in broad strokes; you can fine-tune the details later on. Don't worry too much about the beat of the music either—you'll do that when you add the non-sync material.

For the "painter" shots, try the start of *11 painter*, even though it's not a complete take, and *10 painter* for the rest of the scene.

To cut them down, unlock the tracks containing the shots you want, and select the Razor tool from the Tool palette (Figure 9.23). Find the point where you want the first shot to end, and click on that frame in the timeline with the Razor. Now get the Arrow tool from the Tool palette, click on the end of the shot to highlight it, and then press Delete. Use the Razor again to splice the second shot and delete the unwanted portion. Now, collapse those two shots onto V1 by selecting the clip on V2 and hold the Shift key as you drag down to V1. This will help you drag the clip without shifting it by a frame or two and losing sync (Figure 9.24). Proceed this way through the remaining garage and mountain shots.

Razor tool

FIGURE *Use the Razor tool to splice a shot.*
9.23

FIGURE *Hold the Shift key to drag a shot from one track to another without losing sync.*
9.24

You should end up with a V1 track that's covered with sync, except for the opening and the musical interludes. Lock this track, save a copy of this sequence, and call it *Rough Cut 2*.

Save Lots of Sequences

Every time you reach a significant point in your edit, save a copy of the sequence so that you leave a trail of edited sequences behind as you work. This way, you can go back and find things you changed or lost or simply want to look at again. Be sure to name them in a way that you can figure out what they are—the easiest way is to number them or add the day's date to their name.

STEP 6: EDIT THE INTRO USING HARD CUTS

Next, you're going to add the material from the *Non-sync* folder. At this point, you want to start cutting to the beat of the music. For this tutorial, try to cut the video using hard cuts, rather than dissolves. Hard cuts will make a nice contrast with the prettiness of the footage. You can use dissolves later if you wish.

Use markers to help you cut to the beat of the song. Play the song and tap the m key on every beat as it runs in real time. You might miss a few, but don't worry about it—they're just intended to be a rough guide (Figure 9.25). Turn on the snapping feature if it isn't already on by typing "n". Now when you drag-and-drop edit, your cursor will snap to markers and, therefore, to the beat of the music. Sometimes you'll find you need to turn snapping off if you want to drag a shot to a precise place.

The shots called *02 woods*, *04 woods*, and *05 woods* were designed to cover the intro to the song. Use JKL editing to find in- and out-points of the non-sync shots in the Source viewer. Leave the V1 track locked, and use tracks V2–V4 to add non-sync footage without losing the master edit you created. Use the beat of the music to help you make hard cuts.

Markers

FIGURE *The timeline filled with markers indicating the beat of the music.*
9.25

Continue to fill out the piece with the other shots in the non-sync material bin. Try to vary the footage, even though there's not much of it: try cutting from wide to tight to wide, try cutting from shots that move to the left to shots that move to the right, and so on.

STEP 7: CHEATING SYNC

A key skill is editing in learning to look at the material flexibly. The last shot of Kim dancing on the mountain is nice, but it would be nicer if the end built to a climax. Since she's singing the chorus of the song, you can take footage from the earlier choruses and add them here.

The shot called *26 hotel* is an easy one to cheat, because you can't see her mouth very well. As long as you're within a frame or two of sync, it should look fine. You already synched this shot to the soundtrack and saved it in the Sync sequence. You can now use the Sync sequence to help cheat the shot at the end of the song. Open the Sync sequence, and navigate to the start of the *26 hotel* shot. Find the beginning of the chorus and set an in-point; then set an out-point after the camera moves off of the singer. Now go to your Rough cut 2 sequence and find a point toward the end that has the same lyrics. Add two audio tracks to the sequence, target the video from the Sync sequence to V2 and the audio from the Sync sequence to A3 and A4, and perform an overwrite edit.

Now listen and watch that section of the rough cut. Can you hear the music on A3 and A4 echo the music on A1 and A2? You can use the music to sync the *26 hotel* shot. Select View > Waveform, and compare the waveform of the audio tracks in your sequence. If they're out of sync, they'll look something like Figure 9.26a. Move the audio from A3 and A4, along with the *26 hotel* shot left or right until it looks in sync, as shown in Figure 9.26b. Now watch the footage. When you're satisfied that it looks in sync, you can delete the audio from A3 and A4.

The chorus of this song has an almost gospel-like feel to it—try to bring out the joyousness of the ending by energizing it with more short cuts that have lots of movement.

STEP 8: FINISHING TOUCHES

Continue to work with the edit until you're satisfied, and then go back and add some dissolves wherever they seem appropriate. Select Show Transitions from the Window menu, then select Cross Dissolve from the Dissolve folder, and drag it to the desired cut in the timeline. Drag the edges of the dissolve to make it longer or shorter. Try experimenting with very long dissolves and short dissolves (Figure 9.27).

Finally, unlock the soundtracks and get rid of the empty space, about 40 seconds, at the beginning of the cut, so that it starts right away. Add a dissolve to fade up from black at the beginning and at the end.

A.

Out of sync

B.

In sync

FIGURE **9.26** *The portion of the song on A3 and A4 is out of sync (A), but by simply dragging it two frames earlier in time, you can see from the waveform that it's in sync (B).*

FIGURE **9.27** *The dissolve icon appears at the transition between two shots, and can be dragged to shorten or lengthen the dissolve.*

STEP 9: REVIEW YOUR WORK

ON THE CD/DVD

A rough cut of the *Sweet Sound* music video is included on the CD/DVD. It has all of the sync material edited and a rough pass on the non-sync footage. It's in the folder called *Final Movies* and is called *Sweet.mov*. The real final version of the video is available for viewing on the Web—links are provided at www.dvhandbook.com/nlebook/links. These versions use additional footage that couldn't be provided for the tutorial due to disk space limitations.

BECOMING A FAST EDITOR

The union rate for an editor is about $2,100 a week. Right on! Well, actually, there's a big downside. Because editors are so expensive, everyone wants an editor who can edit fast. So, how do you become a fast editor? Every editor you'll talk with will have a different way of working, but here are some general suggestions for becoming a fast editor:

- **Get to know your editing application.** If you know the software inside and out, you won't waste time looking for that certain menu item or effect, or worse yet, have to search through the manual. This sort of knowledge only comes with time and use.
- **Customize your editing application.** If you can, map the keyboard to serve your needs. Do you use lots of effects? Are you left-handed? You may find that you'll want to adjust the keyboard for different projects as well. The needs for a project with lots of effects are very different from the needs of a cuts-only documentary.
- **Avoid the mouse.** A keystroke is always faster than dragging a mouse and clicking. Using the keyboard also helps you work by rote, just like typing. If you can learn to work by rote, you won't need to think about how to make an edit or where to drag the mouse. This really speeds things up. Unless you're a person who can't type very well, the keyboard is the fastest way to go.
- **Be sure you've got the right hardware.** A slow editing system can and will slow everything else down, and possibly ruin your working rhythm if you have to wait for playback or rendering. If you have a system that relies on rendering, consider getting a cheaper workstation for rendering only. Make sure you have the right amount of RAM for real-time playback and enough storage to minimize media management chores.
- **Watching your edit can be a luxury.** That might sound crazy, but if you're editing an hour-long special, that means it will take an hour to watch it. If you're really under the gun, you won't have time to sit and watch the whole thing on a daily basis. Manage your time carefully, and

multitask by watching the project as you make an output. Also, avoid obsessively watching a scene over and over again. You need to be able to cut a scene, watch it, tweak it, watch it one more time, and move on. You can always come back to it later when you've worked your way through all the scenes.

- **Avoid unnecessary renders.** Rendering eats up a lot of time, so try to avoid rendering until you're approaching the end of an edit session and are feeling fairly confident about the cut. It's a bit of a Catch-22; after all, if you don't render, how can you watch it and know that it works? Well, you can't. However, if you're editing on a system that has cuts-only real-time playback, but requires you to render every dissolve, save the dissolves for the end. If it works with cuts-only, chances are the dissolves will work, too. You should also make sure that there's enough footage before or after the cut where you plan to add the dissolve. That way, you can rest assured that you won't find flash frames in your dissolves after you render.

- **Decide on a length for the project early on.** Many projects have a predetermined length—30 seconds for a commercial, 1 hour for a televised documentary special, etc. Whatever the length of your project, try to keep your rough cuts as close to that length as possible. Having to add 5 minutes or lose even as little as 20 seconds can be a nightmare when you're coming up on the deadline.

Weekly System Maintenance

Editing is a resource-intensive process for your computer. Do the following on a weekly basis if you're spending many hours editing:

1. **Throw out old render files.** Don't let unnecessary or forgotten media clog up your system.
2. **Optimize your hard drives.** Lots of copying, deleting, and capturing can result in fragmented hard drives. However, make sure defragmenting is approved by your editing software manufacturer first.
3. **Rebuild the desktop.** Heavy use can result in a desktop file that needs to be refreshed for Mac users and IBM users with an Active Desktop. Follow your computer manufacturer's instructions, and rebuild the desktop file on a weekly basis.
4. **Back up your project.** You should be backing up daily onto your hard drive, but you should also do a weekly backup in case of an emergency. Save your project file to a disk and store it in a different location.

THE NEXT STEP

If you've completed the work in this chapter, you should be feeling more comfortable using your non-linear editing application. You've learned how to create a sequence, add tracks, set in- and out-points, make a three-point edit, and use advanced editing techniques such as staying in sync and creating a basic sound mix. The next chapter builds on this skill set, moving on from the basics of rhythm, pacing, and synchronization, to the more complex skills associated with story structure and longer format projects.

CHAPTER

10

Creating Story Structure

IN THIS CHAPTER

- Three-Act Structure
- Working with Unstructured Material
- Creating a Rough Cut
- Documentary Projects
- Tutorial: Editing a Documentary Scene
- Making Cuts Work
- Editing Dialogue
- Continuity: Matching Action, Emotion, and Tone
- Dramatic Projects
- Tutorial: Editing a Dramatic Scene

Insert edit Overwrite edit

Many people think that storytelling is strictly the domain of the screenwriter, when in fact, all the key players who work on a film—from the director to the actors to the cinematographer to the editor—play important roles in the telling of the story. If you've ever shot your own film or worked on a set, you know how much the actual footage can differ from the script. Perhaps it rained on a day when a carefree walk in the park was scheduled. Maybe an actor bailed out at the last minute, and the new actor plays the character in a completely different light. Perhaps there just wasn't enough time to shoot all of the shots needed to make a scene work the way it was written. Whatever the case, there are always new things that arise during a shoot—both good and bad.

The editor's task is to take that footage and cut it together, minimizing technical problems and making the story as good as it can be. Usually, this means using the script as a guide, but sometimes it means throwing out the script and starting from scratch with the materials at hand. And sometimes, particularly for documentaries, there is no script. In a way, the editing process is a continuation of the writing process—the writer created a story based on possible footage, and the editor must recreate that story based on what actually exists.

THREE-ACT STRUCTURE

Every good project has a structure, whether it's a music video, an industrial documentary, a narrative feature film, or a good montage of your favorite home movies—and the most basic type of structure is called *three-act structure*. Three-act structure, to put it simply, means that there is always a beginning, middle, and end (Figure 10.1).



Act One: 25-30 minutes
First act break

Act Two: 30-90 minutes
2nd act break

Act Three: 90-120 minutes
Conclusion



FIGURE *Diagram of a three-act structure.*
10.1

For a feature film, the beginning, or first act, is approximately 30 minutes long. It consists of a 5- to 10-minute opening sequence where a problem is introduced: an innocent man is sent to jail for murder (*The Fugitive*), a crime occurs (*The Usual Suspects*), a single woman is invited to the wedding of a man she thought she might marry herself (*My Best Friend's Wedding*). Each of these problems is resolved by the end of the movie: the innocent man is vindicated, the crime is resolved, and the woman realizes that she was never in love with the man. The rest of the first act is spent introducing the characters and the situation, all of which culminate at the end of the first act, where a big event, known as the first *act break* changes the direction of the story. The washed-up actors in *Galaxy Quest* pretend to be their TV characters and go to outer space with the aliens. The depressed suburban father in *American Beauty* decides to change his life. The cross-dressing girl in *Boys Don't Cry* falls in love with a girl who thinks she's really a guy.

This first act break is what many consider the real jumping-off point for the story, which plays out in the second act. Now that you have all the backstory and setup and character introductions out of the way, you get to watch what the movie's really about. The second act is typically the longest act, anywhere from 45 to 60 minutes. In *Almost Famous*, it's the part of the movie where the boy is on tour with the rock band. In *High Fidelity*, it's the part of the movie where the main character deals with the breakup of a long-term relationship by looking up all of his ex-girlfriends. In *Thelma and Louise*, it's the part of the movie when the two women are on the run.

Feature films also have one or more subplots, and a good portion of the second act is dedicated to subplots. One of the subplots is often about a romance, like that between the daughter and the next-door neighbor in *American Beauty*, and also between the teenage groupie and the rock star in *Almost Famous*. The romance between the main character's girlfriend and her new boyfriend is also a subplot in *High Fidelity*, and the main character's changing career from dead-beat record storeowner to music manager is another subplot.

At the end of the second act, another big event happens that results in the third act of the movie, where all of the plots and subplots are resolved. The third act is usually anywhere from 20 to 30 minutes long. In *High Fidelity*, the death of the girlfriend's father causes the couple to get back together, which forces the main character to resolve his commitment issues with both his girlfriend(s) and his career. In *American Beauty*, it's the point where the paranoid man next door mistakenly thinks that the father is gay and has seduced his son. The father's quest to break "out of the box" results in his demise, but he doesn't regret it. In *Thelma and Louise*, it's when Thelma robs a liquor store and is caught on tape. The FBI now has an idea about their whereabouts and can track them down.

APPLYING THREE-ACT STRUCTURE

If you think of three-act structure as simply a beginning, a middle, and an end—or as a setup, an action, and a payoff—then you can apply it to any type of project. For example, the setup of a 30-second commercial could be a woman cleaning a kitchen. The action occurs when a mouse runs out and she screams and jumps on a chair. The payoff is the tag line "Johnson's multipurpose chairs." You can also apply three-act structure to each scene within a film and each sequence of scenes within a film.

Many people consider three-act structure one of the golden rules of Hollywood, but that doesn't mean that a project with three-act structure has to be formulaic. Following the rules laid out by Hollywood films isn't important, but it *is* important to introduce a problem or situation in the beginning so that the viewer is intrigued to keep watching; to expand upon the subject or story so as to provide content and new information for the viewer; and to reach a conclusion at the end to provide a sense of closure. Movies and other projects that fail to achieve these things are often perceived of as boring (poor first act), lacking in substance (poor second act), or pointless (poor third act).

OTHER TYPES OF STRUCTURE

Three-act structure may be dominant, but there are other ways to look at structure. Some people prefer to look at a feature film as 12 sequences that are each about 10 minutes long. Each sequence ends with some sort of revelation that leads the viewer onto the next sequence, eventually building up to a conclusion. Ernest Lehman says he used this concept of structure when he wrote *North by Northwest*. Another sort of structure is the narrative build, or intensity build, where the story gains in intensity as it progresses, much like a musical crescendo (and in fact, often accompanied by one in the soundtrack). This sort of structure is usually not complex enough to sustain a feature-length film, but can be quite successful for a short format piece such as a promo or trailer or music video. One-hour dramatic television shows use a variation of three-act structure, but they are broken into five "acts" to accommodate the commercial breaks.

WORKING WITH UNSTRUCTURED MATERIAL

Whether you're cutting a documentary with hundreds of hours of material, a feature film shot with improvised acting, or simply a montage sequence in the middle of an otherwise scripted film, chances are you'll find yourself faced with the task of editing unstructured material at some point. Although it might seem

daunting it's also an opportunity to be truly creative. Here are some tips for working with unstructured material:

Use chronology to create structure, if appropriate. For example, if you're editing a wedding scene, you can simply manipulate the real chronology of events to create a setup (the bride gets ready, preparations), the action (the wedding ceremony), and the payoff (the reception and the bride and groom depart). Sometimes the chronology is less obvious. Say you have a scene where a bomb explodes in an action movie and there are tons of shots to choose from to show the aftermath—people running, debris flying, car alarms going off, etc. You have more concurrent events and more decisions to make, but again, chronology can help you decipher the footage and build the scene. As long as a scene involves an event or action of some sort, you can use that action to create a structure for the scene.

Use three-act structure to help you figure out each scene. Say you need to edit a scene that shows a mugging victim going to take a first karate lesson to learn self defense. You have a ton of footage of the lesson, but what do you show? You need to serve the story, which is about how the victim is timid at first but then gains confidence. To do that, you need to pick the moments that show this arc in the victim's character. Perhaps a hesitant moment at the door (Act 1), some weak attempts at a karate punch, then stronger (Act 2), then a good solid kick (the second-act break), and a smile of confidence (Act 3). You also have to establish the location with a shot at the beginning, and establish what the class is by adding a short bit of the instructor's introduction, both of which help fill out Act 1. You may also want to improve the payoff in Act 3 by showing cheering reactions of the instructor and the classmates.

Transcripts are a must for any unscripted project of length. Whether it's hours of taped interviews or hours of improvisational dialogue, investing in a transcription will save hours of editing-room time. A transcript notebook provides a handy reference, is available to everyone (not just the editor), and it's simply faster to skim through pages than it is to watch video in real time.

Paper edits are a good way to work toward the first rough cut if there is no script. You can use the transcripts or just your own notes to outline a structure and, basically, create a script before you start to edit the material itself.

CREATING A ROUGH CUT

The first cut of a film is called the *rough cut,* and the goal of a rough cut is to figure out the structure of the film. Just like the official "first draft" of a screenplay is

usually the result of several preliminary drafts, the rough cut of a film is the result of several preliminary edits.

First, a cut of each scene, called a *string-up*, is built. The editor chooses which shots are needed to convey the information contained in each scene, and builds a sequence of all the best takes. Usually, the editor is aided by the director in this selection process. The director chooses which shots were best during the shoot and also during the dailies screening. These circled takes are chosen because the performance and the camerawork seem best. Creating a rough string-up sounds misleadingly simple—think about the fact that a film may have, say, a 10-to-1 shooting ratio. That means the editor has to cut 15 hours of material down to 1½ hours. Simply watching all the footage will take a couple days. Moreover, this is the point where technical problems start to rear their heads— shots that seemed perfect on set may turn out to be unusable.

Next, the editor does another pass on the project, based on the dialogue. This pass is often called a *radio cut*, and the idea is to get all the dialogue and timing right. By refining only the dialogue, the editor is able to focus on the story and the structure, rather than the success of each individual shot. The editor uses the radio cut to make sure that the project is working in terms of the big picture. The editor also performs a very rough mix at this point—nothing fancy, just making sure that everything can be heard and there are no distracting audio problems.

Then, a series of passes helps to refine the cut. The editor focuses on the picture, covering jump cuts with reactions or cutaways, establishing each scene, making sure each edit works, making good transitions from one scene to another, and aiming for a rhythm and pace that's on track with the content of the project.

The result of all this work is the first rough cut. It might not sound all that rough after all those passes, and it probably isn't—it's supposed to be a watchable version of the film that is ready to be screened and reviewed.

This chapter features two tutorials: creating a rough cut of a documentary scene, and creating a rough cut of a dramatic scene. Together, these tutorials work through the process we just described. We'll also talk about editing dialogue, maintaining continuity and techniques for making edits work in order to end up with a polished final cut.

DOCUMENTARY PROJECTS

Many different types of projects fall under the umbrella term *documentary*. What they have in common is a subject that is nonfiction. What they don't have in common is a lot more:

Traditional documentaries are usually one-hour long or feature length. They consist of voice-over narration, interviews, coverage of a subject and/or event, and clips from other media resources. For many traditional

documentaries, there is no writer; rather, the director and editor work together to create narration that tells the story they created with the footage at hand in the editing room.

Clip shows are usually one-hour long, and the content is dominated by clips of other movies and TV shows. For example, a special on monster movies or the life and work of filmmaker Frank Capra would be considered a clip show, since the structure of the project is built around showing video clips.

Reality shows vary in length and format, depending on the subject. The raw footage tends to consist of one to three cameras following the subjects around as they go about their business, and for the editor, this means lots of unstructured material to cut. Luckily, the chronology of events usually provides a spine for the story structure.

Segment shows feature a host or anchor and a series of pre-edited packages, or segments, on different subjects.

Talk shows usually involve a three-camera studio shoot. A technical director creates a line cut during the shoot, and later, an editor builds the show from the line cut, precut segments or clips, and graphic elements.

Industrial and educational videos run the gamut, but are more like traditional documentaries in that they consist of voice-over narration, interviews, and video coverage of the subject or an event. In addition, they tend to use more graphics and titles than a typical documentary.

Working with Low-Res Footage

If your project has a lot of media associated with it, you may have chosen to capture at a low-quality resolution, and recapture later at a high-quality, or uncompressed, resolution. (If you have a FireWire-only DV system, this is unlikely, since they usually only offer one high-quality resolution.)

If so, there are a few things to be aware of as you edit:

- Many low-quality capture resolutions save space by capturing only a single field of video for each frame. That means you're seeing half the video that was recorded onto tape. Although video captured with a *single-field resolution* might look okay, you may find that the "real" footage on videotape has some flaws that weren't noticeable when viewed at the single field resolution, like dropouts and flash fields.
- Other low-quality capture resolutions save space by using more compression, but keep both fields intact. *Two-field resolutions* are preferable, but if they are highly compressed, it may be a distraction when screening your cuts.

In either case, if you're concerned about the quality of a particular shot, it's worth checking the tape to make sure the original looks good. However, there's one caveat: If you're ultimately transferring video to film, avoid unnecessary use of the camera originals. Don't shuttle back and forth on the tapes, avoid pause, slow-motion advance, and single-frame advance modes.

TUTORIAL

EDITING A DOCUMENTARY SCENE

In this tutorial, you'll cut a short documentary scene covering a unique performance by a San Francisco-based band called Tin Hat Trio. They created a musical score to go with some rare, early stop-motion animated films by Ladislaw Starewicz, a Russian filmmaker who was a contemporary of Sergei Eisenstein and Dziga Vertov. The footage includes a backstage interview with the performers, footage of the performance, and clips from the animated films by Starewicz. This scene is part of a larger documentary project about the band. The challenge of this scene lies in the balance between showing the talented musicians and showing how their score enhances the animation.

This tutorial covers:

- Determining a structure
- Creating a radio cut
- Ripple delete edits
- Insert edits
- Ripple and roll
- Split edits (aka L-cuts or overlap edits)
- Adding b-roll
- Slip and slide
- Adding bars, tone, and a slate

WHAT YOU NEED

ON THE CD/DVD

You need non-linear editing software installed on a computer with a CD or DVD-ROM drive, and the companion CD/DVD from this book. See Appendix C for specifics about the media provided for this tutorial. You also need an external NTSC video monitor and headphones or speakers.

This tutorial will be edited using Final Cut Pro 2.0. If you're using a different application, you may want to keep the user manual ready for quick reference.

This tutorial assumes you know the basics of editing in an NLE—setting up a project, importing footage, setting in- and out-points, and performing three-point edits. If not, you might want to go back to some of the tutorials earlier in this book, or refer to the software manufacturer's documentation.

STEP 1: SET UP THE PROJECT

Drag the file called *Documentary tutorial media* to your hard drive. Launch your editing software, and create a new project called *Tin Hat Trio*. Be sure your project settings are appropriate for the media as described in Appendix C (Figure 10.2). Import the footage from the *Documentary tutorial media* folder into the project. There are three subfolders: *Interviews, Performance footage,* and *Animation footage* (Figure 10.3).

FIGURE *Project settings.*
10.2

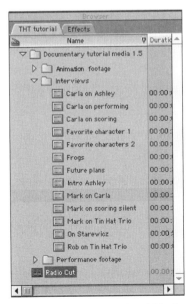

FIGURE *Your browser should look*
10.3 *this.*

 How'd It Get Here?
This footage was shot on NTSC miniDV with a Canon GL1, captured via FireWire, and compressed with the Sorenson Video Codec.

STEP 2: GET ACQUAINTED WITH THE MATERIAL

Watch the footage—there's no script, so think about what's interesting to you. You don't need transcripts with this small amount of footage, but it might be a good idea to note which shots you like. You can use markers in the editing application to set reference points as you watch the material.

STEP 3: DETERMINE THE STRUCTURE

Now that you've watched all the footage, try to organize it in terms of content. Start thinking about how you want to structure the material so that it has a beginning, middle, and end.

Forget about the concert footage and the animations for now, and think about what's being said in the interviews. You'll use this audio to create a spine for the scene. If it helps, organize your ideas on paper.

In the interviews, the band talks about several different things: the history of the Starewicz animations, the process of scoring the animations, and performing together. They introduce Ashley, the foley artist, and they talk about their favorite characters in the animations.

The first step in structuring this material is to decide how the scene will start. You need to set up the basic information—this is a band called Tin Hat Trio and they are performing a live score to some animations by Ladislaw Starewicz. If you don't get this information across in the beginning, viewers will find this scene confusing.

Next, you need to determine what will make up the middle; in other words, the main content of the scene. In this case, the background of the animations, the performance itself, and how they worked to score the animations, is what the body of this piece is all about. You'll also want to introduce the foley artist at some point, to explain her presence.

Finally, how will you end the scene? The conversation about their favorite characters is a funny note on which to end. As a last beat, the comments on their future plans for the performance is the obvious choice.

You don't have to follow this structure if you have a different idea for creating the scene, but this is the basic structure this tutorial will use (Figure 10.4).

STEP 4: BUILD A RADIO CUT

Now it's time to build a cut using the structure you determined from watching the footage. Start with information about the animation in the clip called *On*

Act One: 1-2 minutes
Introduce animations

Act Two: 2-4 minutes
How Tin Hat Trio
created and performed
the score

Act Three: 1-2 minutes
Future plans for
the project

FIGURE *Three-act structure of the Tin Hat Trio*
10.4 *scene.*

Starewicz. In this shot, Mark describes how Starewicz invented stop-motion an-
imation. Find the lines you want, and edit them into a new sequence. Call the
sequence *Radio Cut*. For the next sound bite, Mark introduces the fact that
Tin Hat Trio created a score for the animations in the clip called *Mark on
scoring silent*. Use this to get into the clips about how the group worked to-
gether to score and perform the animations: *Carla on scoring, Mark on Tin Hat
Trio, Carla on performing, Rob on Tin Hat Trio*. This is the meat of the piece,
and later you'll add moments from the performance and the animations to il-
lustrate these comments. Next, introduce the presence of Ashley, the foley artist
who did the live sound effects during the performance, using the *Intro Ashley*
clip.

Some funny observations on the animations themselves are found in *Favorite
character 1*, *Favorite character 2*, and *Frogs*. End the radio cut with Mark's sum-
mation of the band's *Future plans*.

Don't worry about how the picture looks, and don't worry about getting
rid of pauses and awkward moments yet. Just concentrate on the basic infor-
mation in the interviews and the order of them in the sequence. Watch the
clips in order, and try rearranging them until it seems to flow well and make
sense. Your *Radio Cut* sequence should look something like the one in Fig-
ure 10.5.

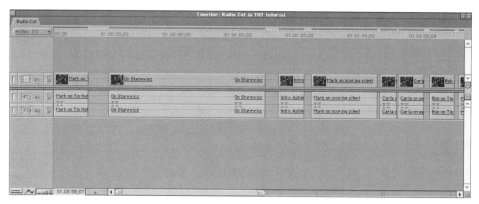

FIGURE *A timeline showing a rough radio cut.*
10.5

Organize Your Sound Tracks

When editing, it's a good idea to determine which tracks will hold what sorts of sound before you start. A typical documentary might have voice-over and interview dialogue on tracks 1 and 2, production sound on 3 and 4, effects and ambience on 5 and 6, and stereo music on 7 and 8. A feature will usually have one track for each actor, a couple tracks for ambience and effects, and a pair of stereo tracks for music. Whatever the needs of your project, if you edit the sounds onto the right tracks from the beginning, you'll save yourself or your assistant editor or a sound editor a lot of time later.

STEP 5: TIGHTEN UP THE SOUND BITES

Now that you have a rough radio cut of the sound bites, it's time to go back in and get rid of hesitations, pauses, and unnecessary dialogue. Make a copy of your sequence and call it *Radio Cut Tightened*. Starting with the first sound bite, *On Starewicz*, play it through and listen for any "fat" that you can cut out. The most obvious thing to get rid of is the interviewer's voice saying "Live insects?" You can also try to get rid of places where he hesitates or says "um." This is called a *pull-up*, and even though you may only cut out a second or less, pulling up the pauses can really affect the pacing of a piece.

Use the Razor tool to create a splice on each side of the media you want to delete, then select it with the Arrow tool, and press Shift+Delete to perform a *ripple delete*. This will remove the unwanted material and close the gap at the same time. Try using this method to pull up some of the hesitation at the beginning of the clip. Be sure to use audio scrubbing to help you find the best place to make a splice. Again, don't worry about jump cuts—you'll cover those later.

After tightening, the *On Starewicz* clip might go like this: "The story goes that Starewicz . . . was an entomologist who tried to make what would have been the first insect documentaries . . . with live insects . . . When he tried to film crickets and some with more delicate shells, he actually ended up cooking them under the lights . . . It was a . . . story of necessity being the mother of invention... he decided to . . . figure out ways to . . . wire up their skeletons so that he could animate them, and this is really how stop-motion animation was born" (Figure 10.6). This edited sound bite is about half as long as the original, but hasn't really lost any information.

Work your way through the entire cut until you've distilled what the interviewees are saying into concise, clear sound bites. This process will take awhile.

Pull-ups

FIGURE *Most sound bites have many places where you can pull up hesitations and*
10.6 *unnecessary sound.*

STEP 6: ADD NATURAL SOUND CLIPS WITH INSERT EDITS

Now it's time to illustrate the sound bites by adding sync sound moments from the animations and the performance. This type of material is sometimes referred to as *nat*, short for natural sound. Create a copy of the *Radio Cut Tightened* sequence and call it *Rough Cut 1*.

As you add the nat sound moments, you should try to think about the structure you developed in Step 2. What's the best way to start the scene? Should you start with Mark on camera talking about Starewicz, or should you start with a clip from a Starewicz animation? By starting with the clip called *Open animation* in the *Animation footage* folder, you'll introduce the Starewicz animation visually. The animation is interesting enough on its own to intrigue the viewer. Load *Open animation* into the Viewer, and set in- and out-points. This clip can be

fairly long—about 20 or 30 seconds—to let the viewers really get a sense of the animation. Later clips can be shorter—about 5–10 seconds.

In the Canvas, set an in-point before the *On Starewicz* interview bite begins. Press F9 to perform an *insert edit*. Insert edits place the new source material into the timeline and push everything else down, so that nothing is copied over (Figure 10.7).

Insert edit **Overwrite edit**

FIGURE **10.7** *Using the insert Edit command lets you add a clip to the start of the sequence without copying over anything.*

Next, a short nat sound shot after Mark says that "he ended up cooking them under the lights" is a natural place for a pause in his comments. Short nat sound breaks such as this are often called *sound-ups*. Ideally, the shot should help illustrate what the interviewee is saying. Since he's talking about the difficulties of filming bugs, a good shot of the *Dancing bugs*, or the *Fighting bugs*, will work nicely here.

Continue to work your way through the scene, adding moments that help tell the story. Think about what you'd like to see as the interviewees talk. After Mark says that Starewicz basically invented stop-motion animation, it would be nice to see another good shot of the animated films. Next, the interviewees will be talking about the scoring of the films and the performance, so a shot of the performance will provide a good segue into this section. Look for clips in the

Performance footage folder that illustrate how the musicians work with the animation, and how they work with each other. When Ashley, the foley artist, is introduced, show a shot of Ashley creating sound effects. Later, when they discuss their favorite characters, go back to the animations to show those characters in motion. Finally, after the sound bite about the group's future plans, end the piece with the two shots in the *Performance footage* bin of the group finishing the performance, bowing, and leaving the stage. This will feel like a natural conclusion to end the scene.

Adding these shots will involve a lot of work and a lot of decision making. Rather than walk you through the process of adding this footage step by step, it's best if you figure it out yourself. This is where some of the hardest work of editing comes into play. You can always look at the finished scene called *THT-textless.mov* in the *Final movies* folder for guidance.

STEP 7: USE RIPPLE TO TRIM OR EXTEND THE INSERTED FOOTAGE

You now have a solid rough string-up of the scene. It's time to refine the cut using *Ripple*, a powerful tool for tweaking an existing edit. Make a copy of your sequence, and call it *Rough Cut 2*.

First, let's refine the end-point of the *Open animation* clip. By using the Ripple tool, you can make the clip longer or shorter without affecting any of the other shots in your sequence. Select the Ripple tool from the Tool palette (Figure 10.8), and then click on the transition between the *Open animation* clip and the first *On Starewicz* clip.

Selection tool

Advanced selection tools

Track selection tool

Ripple and Roll tools

Slip and Slide tools

Razor tools

Zoom in, zoom out

Crop

Pen

FIGURE *The Ripple tool in the Final Cut Pro Tool palette.*
10.8

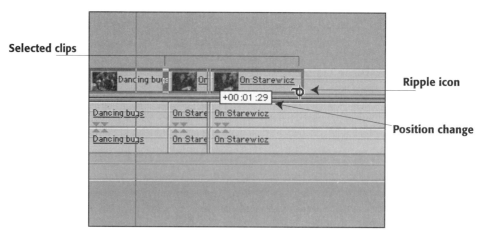

FIGURE *Performing a Ripple edit in the timeline .*
10.9

Position the cursor, which should display the Ripple tool, to the left of the transition over the Open animation clip. The "tail" of the Ripple icon should point toward the Open animation clip (Figure 10.9). Traditionally, the clip to the left of the transition is called the *A-side* of the edit, and the clip to the right is called the *B-side*. With the A-side of the transition selected, you can drag the transition backward in time, making the A-side clip shorter; or you can drag it forward in time, making the A-side clip longer. The length of the B-side clip is unaffected, and is either pushed down the timeline, or pulled up along the timeline automatically to fill the gap between the two shots. Ripple edits are an easy way to trim or extend a shot without losing sync or changing the other shots around it. Work your way through the rest of the sequence using Ripple to trim or extend shots that seem like they need tweaking.

STEP 8: USE THE ROLL TOOL TO REFINE THE ROUGH CUT

Rolling edits are similar to Rippling edits, except that they change both the A-side of the edit and the B-side at the same time. The most common use for the Roll tool is to create a *split edit*, also known as an *L-cut* or an *overlap edit*. In the case of a documentary, split edits are often used to extend the video from the nat sound clips over the interview bites to cover up some of the jump cuts.

Navigate to the second nat clip in the sequence, the *Dancing bugs* shot you placed in the middle of the *On Starewicz* sound bite. Using the Roll tool, you'll extend the video to cover the beginning of the next interview line. First, you'll have to unlock the sync so that you can move the video of the *Dancing bugs* clip separately from the audio. Select the *Dancing bugs* clip with the Arrow tool, and from the Modify menu, select Link. Now you can highlight the video of the

Dancing bugs clip in the timeline without highlighting the audio. Select the Roll tool from the Tool palette, and click on the video track transition between the *Dancing bugs* clip and the *On Starewicz* sound bite that follows it. Drag the transition to the right until you get past several of the jump cuts—about 5 seconds forward in time (Figure 10.10). Go through the rest of your cut and find places to extend the video and cover up small jump cuts. Don't worry about covering all the jump cuts—you'll do that in the next step.

Start position **End position**

FIGURE *The Roll tool lets you easily cover jump cuts with an L-cut.*
10.10

STEP 9: ADD B-ROLL

Now your sequence should be starting to shape up and resemble an edited documentary scene. Make a copy of it, and call it *Rough Cut 2*.

B-roll is used to illustrate the sound bites and drive home points in the story, but it can also serve as a sort of Band-Aid to cover up the jump cuts in your edited sequence. Be careful, though; b-roll looks "cheesy" when its only purpose is to cover jump cuts.

Use cutaways from the Performance footage and Animation footage bins to cover edits in the sound bites. Since the sound associated with the b-roll clip isn't as important as the interview sound bites, target tracks A3 and A4 for the audio. You may have to add tracks to your sequence to do this. Use three-point editing to add these cutaways to the sequence with an overwrite edit (F10). Be sure that you don't target tracks A1 and A2, or you'll end up overwriting your sound bites as well (Figure 10.11).

Mix the audio as you go by adjusting the level of the b-roll audio on A3 and A4, so that it doesn't overpower the sound bites. Double-click on the b-roll audio in the timeline to open the Audio tab in the Viewer. Use the level slider to decrease the volume so that you can hear the music quietly playing under the

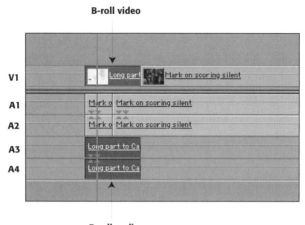

FIGURE **10.11** *Use a three-point overwrite edit to add a b-roll shot to the sequence.*

sound bite audio (Figure 10.12). See the "Basic Mixing" sidebar in Chapter 9 for more on creating a mix as you go.

FIGURE **10.12** *Set the audio levels for the b-roll as you edit to create a basic mix.*

STEP 10: USE SLIP AND SLIDE TO FINE-TUNE THE B-ROLL

Slip and *slide* are powerful tools for refining a shot, and are particularly useful for adjusting b-roll shots. In your sequence, find a b-roll shot that needs adjustment. From the Tool palette, select the Slip tool. In the timeline, position the Slip tool over the b-roll shot, and drag to the left or to the right. By slipping the shot, you are changing the source starting point of the shot without changing its length or position in the sequence or any of the shots around it (Figure 10.13). This is extremely useful for making small adjustments to a b-roll shot so that it times out better.

Slip icon

Selected shot

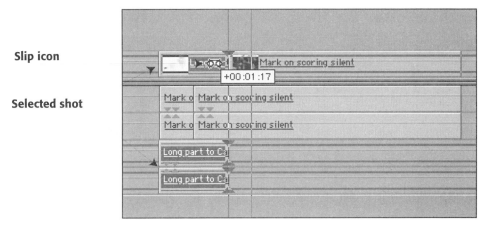

FIGURE *Slipping a shot in the timeline.*
10.13

Sliding a shot has the opposite effect. Select the Slide tool, select the same shot in the timeline, and drag it to the left. The contents of the b-roll shot stay exactly the same, but the position of the shot within the sequence changes. As you drag left, the shot to the left is shortened and the shot to the right is lengthened to make up for the change in position. This is also a valuable tool for adjusting b-roll shots to match what the interviewee is saying (Figure 10.14).

Work your way through the sequence using Slip and Slide to refine the b-roll shots you added.

STEP 11: SMOOTH OUT THE AUDIO TRACKS

The cut of this scene should be looking pretty good by now, but the soundtrack probably leaves a lot to be desired. You need to extend the music and add dissolves to smooth things out. To do this, use Roll to extend the audio from the performance footage so that the music tapers out smoothly. This is a variation on the split edits described in Step 8. Select a b-roll shot that has music in the

Slide icon

FIGURE *Sliding a shot in the timeline.*
10.14

Starting **Ending**
position **position**

timeline, and select Link from the Modify menu to separate the audio and video tracks. Then select the Roll tool and lengthen the sound to create a more natural ending (Figure 10.15).

Fade the music out by highlighting the end of the piece of audio in the timeline and selecting Effects > Audio > Cross-fade (0 dB) (Figure 10.16a). The Cross

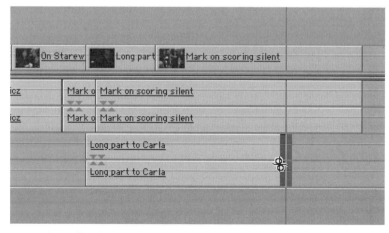

FIGURE *Use the Roll tool to create a split edit in the audio tracks to extend the music.*
10.15

FIGURE *Highlight the transition (A), add a Cross Fade effect (B), and drag the Cross Fade*
10.16 *effect in the timeline to extend it (C).*

Fade appears in the timeline (Figure 10.16b). Drag the Cross Fade to make it longer so that the song sneaks out unnoticeably under the interview sound bite (Figure 10.16c).

Work your way through the edited sequence, smoothing out rough sound edits, adding or extending music where appropriate, and adjusting the levels so that the interview bites are easy to understand.

You'll find it helpful to put some of the sound from the b-roll shots on tracks A5 and A6, so that you can fade out music from one shot on A3 and A4, while fading in music from another shot on A5 and A6. This is called a *cross-dissolve*. By having the elements on separate tracks, you have more control over the fades.

STEP 12: CREATE A LEADER WITH BARS, TONE, AND SLATE

Last, but not least, prepare the sequence for delivery. You need to add bars and tone, and a slate to ensure that whoever receives a copy of your scene will know how to set the audio volume, what they are watching, and that it's in sync.

To add bars and tone, click on the Generator icon in the Viewer (Figure 10.17), and then select NTSC bars and tone. Insert about 30 seconds of bars and tone at the start of the sequence. Be sure to target all the tracks before you perform the edit, or you could lose sync.

Now create a slate by clicking on the Generator again and selecting text. Activate the Controls tab in the Viewer to type in the information you wish to add to the sequence. Typically, a slate includes the title of the project, the version of the cut, the total run time (TRT), the date, the editor's name, the producer's

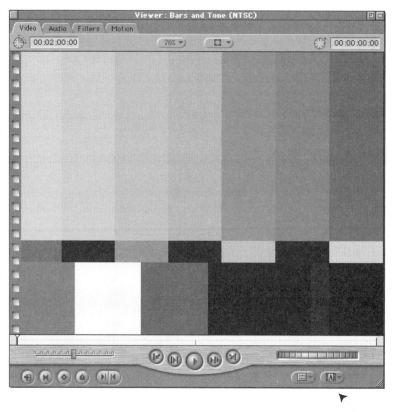

Generator

FIGURE *Use the Generator to create bars and tone.*
10.17

name, and possibly the name of the production company. Insert about 10 seconds of the slate into the sequence after the bars and tone (Figure 10.18).

In Final Cut, you can also add bars and tone and a slate in the Print to Video dialog box before you output. However, it's better to add it to the sequence itself, as described in this step. That way, it will be there every time you send it out, whether it's to videotape, to a QuickTime file, or whatever.

Last, add a quick fade in, about 1-second long, at the beginning of the first shot, and a quick fade out at the end of the last shot in the piece.

STEP 13: REVIEW YOUR WORK

Watch your final cut. Be sure to look at it critically in terms of structure. Does it seem long or boring? Does it seem too short or lacking in information? There are many ways to edit together the footage in this tutorial. Look at *THTtextless.mov*

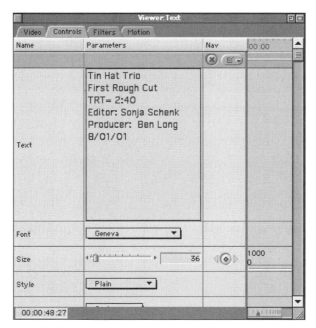

FIGURE *Use the Controls tab to add text information to the slate.*
10.18

ON THE CD/DVD
in the Final Movies folder on the CD/DVD for one possible final cut. If you can, export your final edit as a QuickTime movie and set it aside—you can use it later for the Titling tutorial in Chapter 11.

MAKING CUTS WORK

Once you have the structural spine of a project in place, it's time to focus on the individual cuts themselves. A scene that is in good shape structurally can still seem poorly edited if the cuts within the scene aren't working.

MOTIVATED EDITS

Just as actors ask themselves "What's my motivation?" you can also ask this question when you're cutting from one shot to another. If the answer is "because I need to cover that dialogue edit," you should also try to think about the cut in terms of story. A better answer is "because I want to see how the other person is reacting to what the main character just said." If you can serve both technique and story, you can rest assured that the edit is sufficiently motivated.

A cut can be motivated by many different things, but dialogue, action, and emotional content are some of the primary reasons to cut from one shot to

another. If you are editing a scene showing a gunfight in a western bar, cutting to a shot of the bottles behind the bar during the height of the action to cover a jump cut is unmotivated, and therefore a bad cut. Cutting to the bottles right after the bad guy fires off a random shot that breaks the bottles, is motivated by the action and adds to the scene. If it also serves to cover a jump in time or otherwise rocky cut, even better.

In a dialogue scene between two characters, much like the scene you'll be editing in the next tutorial, your choices in cutting will be fairly limited, even if there are several camera angles of the scene. That's because once you get into the "meat" of the scene, you'll probably just be cutting back and forth between two close-ups. And once you're into those close-ups, it will seem strange if you cut back to a wider shot unless it's motivated by an action. In this case, you're limited by the two close-ups, but there's still a lot of room for manipulation. Imagine you have a scene where a man professes his love for a woman and proposes to her. She says "Yes." If you mostly show the shots of the man as he talks, the scene will seem to be more about him—his fears, courage, whatever. However, if you cut the scene with more shots of her, even though she only says one line, it will play as a scene about her emotions, reactions, and so forth, rather than his. In this case, cutaways to her reactions are very motivated.

You can't avoid cutting around technical problems—an out of focus shot, an actor flubbing his or her line, and so forth—but beware of too many edits, motivated or not. A scene that is overly edited is called *cutty*. Too many unmotivated edits or too many cutaways to hide the fact that the dialogue has been chopped to bits and rearranged are the trademarks of cutty editing. Unless you're achieving a stylistic look (and succeeding at it), avoid over-editing. The line between fast cutting and looking cutty can be a fine one.

CONTINUITY

Editing to maintain continuity straddles the line between creative and technical cutting. *Continuity* simply means that elements within a scene, or film, match from one shot to the next. This can mean anything from making sure the actor's wearing the same clothes, to maintaining the emotional tone of the performance, to matching the movement in a fight scene.

> **Matching action** means that the movement within a scene flows naturally from one shot to the next. For example, you have a wide shot of an actor opening a door, and a close-up of his hand on the doorknob. To cut from the wide to the tight, you have to time it so that the action of opening the door seems continuous. Often, if you're cutting from a wide shot to a tight shot, cutting to match the frame from one shot to the other doesn't work. Instead, you'll need to skip part of the full motion to make the flow seem natural. Similarly, if you're cutting from a tight shot to a wide, you may

have to almost double up some of the motion to make it seem natural. This sounds strange, but the reason behind it has to do with how big the motion is across the frame. The motion of a hand opening a door in a close-up is a very big motion covering half the frame; the same motion in a wide shot is very small. As a result, a cut that matches the motion exactly, although it should look perfect, often doesn't "feel" right (Figure 10.19).

FIGURE *Matching action between a wide shot and a tight shot can be challenging.*
10.19

Matching eyelines is crucial for any scene where the actors are in separate shots looking at each other. It's a rather abstract concept, but if you draw a line from the gaze of an actor out from the frame, and do the same for the other actor in the second shot, the two lines should intersect somewhere between the two shots (Figure 10.20a). If they don't intersect, then they won't appear to be looking at each other (Figure 10.20b). As editor, there's not much you can do if the eyelines don't match, except to try using a filter effect to flip the shot.

Matching performance almost goes without saying. Generally, the performances shot on the same day tend to match. The problems usually occur when parts of the scene are shot later, especially as pick-ups. Pick-ups may be shot months after the principal shoot is over. It can be very hard for the actors and director to get the same emotional tone as in the original shoots.

FIGURE *Matching eyelines (A) and unmatching eyelines (B).*
10.20

EDITING DIALOGUE

You might think that editing dialogue is the sole domain of the sound editor, but you're wrong. It's true that the sound (or dialogue) editor will refine the dialogue after the picture's been cut, but all editors need to be able to edit dialogue in terms of story, pacing, and the emotional tone of the scene. If a scene includes dialogue, whether it's narrative or documentary, editing the dialogue is part and parcel of editing the picture.

Conveying information. At it's most basic level, dialogue conveys information about a story or a subject. The first priority in editing dialogue is to make sure all the necessary information gets in the scene.

Tightening dialogue. Getting rid of all the ums, breaths, and other hesitations can be very important to the successful pacing of a scene. Obviously, if the speaker is on camera, you're going to be stuck with whatever

he or she said, but if he or she is covered up with a cutaway or b-roll, you can *pull up* any unnecessary pauses and get rid of partial sentences and so forth so that the actor speaks concisely.

Overlapping dialogue. You can make a conversation between two people sound more natural by overlapping the dialogue, especially during more intense moments. In real life, people don't always wait for the other person to finish talking—they interrupt, talk over them, and so forth. Conversely, if a scene was shot with overlapping dialogue in it, you may have less freedom to edit the scene as you wish. You'll be locked into the pacing of the overlapping dialogue as it was recorded.

Expanding a moment. Adding pauses, or *beats*, in a conversation is an important tool for intensifying a moment. In a scene where a man asks a woman to marry him and she says "Yes," a carefully placed pause can change the meaning entirely. With no pauses, it plays as a happy agreement. A pause before he speaks plays up his nervousness. A pause before she answers builds suspense if the shot stays on him, and implies hesitation if the shot is on her.

Starting late and getting out early. Sometimes dialogue scenes, as scripted and shot, are much longer than they need to be. The characters enter the scene, greet each other, have a conversation, make plans, and exit. It may help the overall pace to start the scene in the middle, or get out of it early and hard cut to a new scene. Sometimes long stretches of dialogue can seem boring or like too much information—it's often the case with dialogue that "less is more."

Fixing and cheating dialogue. Sometimes dialogue has problems—a messed up line, etc.—and if you can't fix it, the shot, or even the entire scene, is unusable. Sometimes you can cheat a word or phrase from another take. You might be able to save the scene by starting the dialogue under an establishing shot or otherwise getting around it. These sorts of issues are unique to each project, but keeping an open mind and thinking flexibly about how to build a problem scene can result in the sort of "save" at which good editors excel.

DRAMATIC PROJECTS

Whether comedic or serious, dramatic projects are what most of us understand the best. They usually rely on three-act structure and employ all of the elements of the language of film to enhance the story.

- **Feature films**. Feature films run anywhere from 90 to 180 minutes. They are traditionally shot with a single camera, although big-money action scenes will often use several cameras.

- **Movies of the week**. TV movies differ from feature films in content more than in structure.
- **Episodic television**. Episodic television shows are one-hour in length and consist of five acts to accommodate commercial breaks. They may or may not use multiple cameras.
- **Sitcoms**. Sitcoms are 30 minutes in length and usually use more than one camera.
- **Short films**. Short films are usually 10 minutes or less and are usually a sort of miniature feature film, using a similar style and story structure.

EDITING A DRAMATIC SCENE

TUTORIAL

ON THE CD/DVD

The scene you will be editing in this tutorial is a famous one—it's the scene from Shakespeare's *Richard III* where Richard seduces Anne. A text file containing a cut-down version of the scene is included with the tutorial media on the CD/DVD. You might also find it helpful to read the play or watch a movie version, like the recent one featuring Ian McKellan.

For this tutorial, the scene has been modernized. Richard is a corrupt politician, and Anne is the wife of a murdered political activist. At the outset of the scene, she is inside the funeral home, hanging a poster that she hopes will be a call to action for the masses that will attend the funeral of her husband.

A word to the wise: This tutorial assumes you've worked your way through the other tutorials in this book and are somewhat familiar with the standard set of tools in a non-linear editing application. Each step in this tutorial covers a very broad part of the process of editing a dramatic scene, and working your way through it could take a while. This tutorial focuses on the storytelling skills needed in editing, rather than technical how-tos.

This tutorial covers:

- Using a lined script
- Choosing performances
- Matching emotion and tone
- Editing dialogue
- Matching eyelines
- Dramatic pacing
- Maintaining continuity
- Matching action
- Trimming

WHAT YOU NEED

ON THE CD/DVD

You need non-linear editing software installed on a computer with a CD or DVD-ROM drive, and the companion CD/DVD from this book. Be sure your project settings are appropriate for the media (see Appendix C). You also need an external NTSC video monitor and headphones or speakers.

This tutorial will be edited using Avid Xpress DV 2.0. If you're using a different application, you may want to keep the user manual ready for quick reference.

This tutorial assumes you know the basics of editing in an NLE: setting up a project, importing footage, setting in- and out-points, and performing three-point edits. If not, you might want to go back to some of the tutorials earlier in this book, or refer to the software manufacturer's documentation.

STEP 1: SET UP THE PROJECT

Drag the file called *Dramatic tutorial media* to your hard drive. Launch your editing software, and create a new project called *RichardIII*. Be sure your project settings are appropriate for the media—NTSC DV video with 48-kHz audio. Create a bin called *Richard coverage*, and import the footage from the *Richard coverage* folder into the project (Figure 10.21). Create another bin called *Cuts*.

FIGURE *The Avid Xpress DV project.*

How'd It Get Here?
This footage was shot on NTSC miniDV with a Canon GL1, cap-
tured by a FireWire-based DV Raptor board, and compressed
using the Sorenson Video Codec.

First, to make things easier, double-click on any shot in the *Richard coverage*
bin to open a Source clip monitor. Open the pop-up menu in the upper-left cor-
ner (Figure 10.22), and the tool bar appears. Without releasing the mouse, drag
the tool bar onto the desktop near the timeline for easy access.

FIGURE *Drag the tool bar from the pop-up menu onto the desktop for easy access .*
10.22

STEP 2: GET ACQUAINTED WITH THE MATERIAL

First, read the script. A text file called *Richard.txt* is located in the *Dramatic tu-
torial media* folder. The scene has been significantly cut down from the original
play. As such, the final edit will still be about 5 minutes long.

Next, watch the footage. Take note of which performances you like best. For
feature films, the editor is given a lined script and a shot list with the best takes
circled on the set by the director. Figure 10.23 shows a lined version of this
scene as it was shot.

If you're unfamiliar with lined scripts, they represent notes taken by the script
supervisor during the shoot. As the film is shot, the script supervisor takes note
of each take, and draws a line through the script representing the dialogue cov-

```
SCENE 2.

London. Funeral home.
                                        1.
Enter LADY ANNE being the mourner.

          2.              ANNE
          O, cursèd be the hand that made
          these holes! Cursèd the heart that
          had the heart to do it! Cursèd the
          blood that let this blood from
          hence!

Enter RICHARD, DUKE OF GLOUCESTER.
          3.              GLOUCESTER  6.
          Sweet saint, for charity, be not so
          curst.

                          ANNE.
          What black magician conjures up
          this fiend. Foul devil, for God's
          sake, hence and trouble us not.

          4.   5.         GLOUCESTER.  7.
          Lady, you know no rules of charity,
          Which renders good for bad,
          blessings for curses.

                          ANNE.
          Villain, thou knowest nor law of
          God nor man: No beast so fierce but
          knows some touch of pity.

                          GLOUCESTER.
          But I know none, and therefore am
          no beast.

                          ANNE.
          O wonderful, when devils tell the
          truth!

                          GLOUCESTER.  10.
          More wonderful when angels are so
          angry. Vouchsafe, divine perfection
          of a woman, I did not kill your
          husband.                         8
                          ANNE.         11. 12.
          Why, then he is alive.
```

Shots:
1. Poster -tk 3
2. Anne open cu - tk 3
3. 2-shot- tk 2a
4. 2-shot tk 2b
5. 2-shot tk 1
6. Anne cu tk1a
7. Anne cu tk 1b
8. Anne cu tk 1c
9. Richard cu tk 4
10. Richard cu tk 5a
11. Richard cu tk 5b

FIGURE *A lined script showing the first page of the scene you'll be editing in this tutorial.*
10.23

ered in the take, which is usually identified by the scene number and take number. This gives the editor crucial information about how many shots were filmed to "cover" the scene, and where each shot starts and ends. Often, additional notes regarding continuity will be added to the script as well.

The lined script in Figure 10.23 shows the 12 setups covering the first page of the script. The shots in the *Richard coverage* bin correspond to those in the shot list in Figure 10.23. Print out the text file of the script and, as you look through the footage, mark it with lines to reflect the coverage with which you have to work.

Steps 3–7 will walk you through the process of building a rough string-up as you select the shots you like and cut them together.

STEP 3: GETTING INTO THE SCENE

The very beginning of this scene has only two shots covering it: a shot of the poster showing the dead body of Anne's husband, *Poster—take 3*; and the reverse close-up of Anne as she puts up the poster, *Anne open cu—take 3*. In other words, there aren't too many decisions to be made here; just the challenge of cutting these two shots together in a way that works.

Start with the dialogue; double-click on *Anne open cu—take 3* in the bin to open the clip Source window. Avid Xpress DV, unlike Avid Media Composer, opens a different Source window for each clip. Play the shot, and use the I and O keys to set in- and out-points at the beginning and end of Anne's lines in the script. Click on the red Overwrite Edit button, or type the letter "B," to perform an edit (Figure 10.24). You'll be prompted to select a bin—choose *Cuts*. A new untitled sequence is automatically created in the Composer window. Rename it *Rough string-up*.

Next, add the *Poster—take 3* shot. It's fairly clear that you're going to want to overlap Anne's first few lines with the poster shot. First, set in- and out-points on

A. Source monitor **C. Composer monitor**

B. Overwrite edit

FIGURE *After setting in- and out-points in the Source window (A), click on the red Overwrite*
10.24 *Edit button (B) to perform the edit and automatically open a new sequence in the Composer monitor (C).*

the poster shot. The second pan down works well, because it starts on a static shot of the top of the poster, framing the word *murdered*, and then follows Anne's hand down the poster to reveal the image. By starting on the word *murdered*, you immediately set up the fact that this scene is about the aftermath of a murder. Next, decide what part of Anne's lines you wish to cover, and at what point you want to see Anne on camera. Set an out-point there. Next, target only the V1 track by deselecting the purple track indicators to the right of the timeline (Figure 10.24). Perform an overwrite edit.

Now watch the two shots. Matching the action between them will be a challenge. The problem is that the action in the poster shot shows Anne's hand going down and her head looking down. The close-up of Anne, however, starts out somewhat static, then moves up, and doesn't move down until the end of the shot. You can either try to cut from the end of the hand moving down and settling to the start of Anne's lines—two fairly static moments in each respective shot—or you can try for an intentionally jarring cut—from the movement down on the poster to a particularly intense line or Anne's hand moving across the frame.

Use Undo to remove the first edit you made, and try it in a different position. From the Edit menu, select Undo/Redo List to see a list of the actions that are available to undo or redo. Play around with the two shots until you feel like they work.

STEP 4: CUTTING THE SET UP TO THE SCENE

The next several lines of dialogue set up the scene. Anne, the wife of the recently murdered Edward, is horrified to run into Richard, who she thinks is the murderer. This part of the scene is really about Anne and her reaction to encountering Richard. As you look at the coverage for this part of the scene, think about how you can cut the shots together to enhance Anne's reaction.

On a technical level, there is the need to get Richard into the scene and show the actors' changing positions as they move from the area near the poster into a tighter two-shot. There's only one shot that shows Richard's entrance, *2 shot open—take 2a*. The transition from the shot of Anne talking to the poster to the wide shot is a bit startling, and a perfect example of the sort of transitional moment that can be helped by the soundtrack later in the editing process. On the positive side, the shot is wide enough to establish the scene. Although there is no hard-and-fast rule, if you don't show a somewhat wide shot early, the scene will feel claustrophobic and ungrounded.

Much of the later parts of the scene will involve cutting between two close-ups, so it might be a good idea to avoid doing that at this stage. Instead, if you use only Anne's close-ups and cut to the wide 2-shot for Richard's lines and reactions, you'll achieve two things: the close-ups of Anne, *Anne cu 1a* and *Anne cu 1b*, will serve to draw the attention to her point of view, rather than Richard's. The use of the wide 2-shot for Richard's lines allows you to cover the geography of the scene—Anne's movement away from Richard, and Richard's

movement toward her. It is important to show these moments so that viewers don't get "lost" in the layout of the scene. There are two takes of the wide 2-shot, *2-shot open—take 1*, and *2-shot open—take 2b*. Beware that the movement of the actors is slightly different in these two takes.

This part of the scene ends with Richard's statement that he did not kill her husband, at the end of the first page of the script. At this point, the coverage will move into two close-ups. To ease this transition, you need to make sure Richard seems like he's standing very close to Anne. The over-the-shoulder shot, *Anne Richard OS 4a*, can help facilitate this.

With these tips in mind, use three-point editing to build this scene, and don't worry about jump cuts, cutaways, and so forth. The goal is to figure out which shots you want to use and when, and build a very rough cut this way (Figure 10.25). Later, you'll go back and fine-tune the awkward spots.

Drag-and-Drop in the Timeline

TIP

If you want to rearrange the order of the shots in your sequence, drag-and-drop editing in the timeline is the easiest way to accomplish this. In Avid Xpress DV, highlight the yellow arrow at the bottom of the timeline, and then click on the shot you want to move, including the audio tracks. It will appear highlighted in pink, and you can drag it around the timeline. Holding the Command or Control key will snap to edits. The yellow arrow is the equivalent of an insert edit, and will close the gap where the clip originally was and push other shots down the timeline after the insertion point. The red arrow is similar to an overwrite edit and will leave a hole where the shot was, and cover up anything on the timeline after the insertion point.

Timeline								
	V2							
V1	V1		Anne cu 1	2 shot open x2	Anne cu 1	2 shot open x2	Anne	
A1	A1		Anne cu 1	2 shot open x2	Anne cu 1	2 shot open x2	Anne	
A2	A2		Anne cu 1	2 shot open x2	Anne cu 1	2 shot open x2	Anne	
	A3							
	A4							
	TC1	0	01;00;40;00		01;00;50;00		01;01;00;02	

FIGURE **10.25** *Build the rough string-up in broad strokes—don't worry about seamless dialogue edits or cutaways yet.*

STEP 5: USE CLOSE-UPS TO COVER BANTERING DIALOGUE

The next part of the scene is a bit of snappy banter—short lines thrown back and forth quickly as Richard vows that he did not kill Anne's husband and she calls him a liar. This section ends when Richard tells Anne that her scorn "kills me with a living death" and Anne reacts with disbelief.

At this point, there's really no reason to show anything but close-ups. Think about what you'd want to see if you were the viewer. When Richard says he didn't kill Anne's husband, you want to see Anne's response; when Anne says "In thy foul throat, thou liest," you want to see Richard's reaction. The new information in this part of the scene lies in the actors' faces, not in their movement or anything that a wider shot would reveal. Too much cutting back and forth can resemble a Ping-Pong match, but for this sort of confrontational scene, cutting between two close-ups is an appropriate choice.

The shots that cover this part of the scene are *Anne cu 1c-g*, *Richard cu 4a*, *Richard cu 5b-d*, and *Richard cu 6a*.

There's a lot of coverage, but beware of eyelines that don't match, performances that don't match, and camera framing that doesn't match. Figure10.26 shows two camera angles that don't quite match.

A B

FIGURE *These camera angles don't quite match, because B is much tighter than A.*
10.26

STEP 6: CUT THE KNIFE SEQUENCE

When Anne reacts with disbelief to Richard's claim that he's miserable without her, he resorts to a desperate act, pulling a knife on her and then offering to let her kill him. This intense exchange leads to a new direction for Anne, who then accepts the ring he offers her, albeit warily. This exchange has more action and movement than the previous parts of the scene—Richard pulls the knife, he goes down on one knee, Anne takes the knife, she throws it on the ground, Richard picks it up and holds it at his own throat, and then puts it away.

When building this part of the rough string-up, pay careful attention to covering the action and matching the action. In this section of the scene, the action and reactions are as important as the dialogue itself. You'll need to use a wider shot—*2 shot 7a* and *2 shot 8a*—to show Richard pulling the knife, Anne taking the knife from him, Richard going down on one knee, and Richard putting away the knife. These moments will serve as a spine to keep the viewer oriented as to how the action is playing out. For the dialogue in between, close-ups are again a natural choice, as this is an intense moment for both characters. Unlike the bantering dialogue in the part of the scene preceding this, this section can play out with more pauses and moments of deliberation.

For Anne, the shot called *Anne knife cu & ring tk 1* covers this portion of the script. For Richard, *Richard cu 5e-f* provides close-up coverage.

Try matching the action between the wide shot and the close-up as Richard goes down on one knee. Start his motion with the wide—*2 shot 7*—and then cut into the middle of it with the close-up—*Richard cu 5e*. The cameraperson missed the beginning of his movement, but got the second half of it. You can also try using the close-up of Anne as her head follows his motion to help the moment.

This part of the scene includes the key turning point for Anne's character—the moment she throws the knife down. Here she has the chance to avenge her husband's murder and she realizes she can't do it. She also realizes that, if Richard is to be believed, he killed her husband in order to win her. From this point on, she loses her will and submits to Richard's manipulation of her. It's important not to let this moment pass too quickly. Show a close-up of Anne before she throws the knife, to let us know that she's struck deeply by Richard's words and actions. There's also a cutaway of the knife hitting the floor—*Knife dropped*. Try to see how you can manipulate the moment by using parts of the performance that do not contain dialogue (Figure 10.27).

FIGURE *Use parts of the performance that do not contain dialogue to milk the moment when Anne throws* **10.27** *down the knife.*

STEP 7: GETTING OUT OF THE SCENE

The end of the scene is a radical shift in tone. Richard is now in control, and Anne is cautious, yet essentially submissive. The moment when Richard puts the knife away, the performance in *2 shot 8a* is a good acknowledgment of this shift. As he snaps the knife shut, the melodrama is gone, and he is authoritarian and businesslike.

Richard offers Anne a ring, which she warily accepts. This is another moment that can be maximized using reactions and the cutaway to the ring slipping onto Anne's finger—*Ring cu.tk1*. Be aware of matching the action from the wide to the tight shot as you cut this together.

The last part, where Richard guides Anne toward the door, is the most problem fraught in terms of coverage. It's necessary to show Anne crossing frame as she goes to leave, because the rest of the scene plays out with Richard to screen left and Anne to screen right. However, there's no good shot of Anne crossing frame. There are many ways to cut this transition, and finding the right one is a bit like solving a logic puzzle. Getting it to work will call for a little ingeniousness and imagination, and perhaps a little cheating. If you want to see one possible solution, look at the *RichardIII.mov* file in the *Final Movies* folder.

The shots that can cover this part of the scene are *Anne knife cu & ring tk 1*, *Richard cu 5f-j*, *Ring cu.tk 1*, *Anne end cu 4*, *Ann end cu 6*, *End reverse wide 2a*, *Richard end med 1*, and *Richard end cu 1*.

Now that you've made your way through the entire scene once, go back and watch it. Does it seem to work, despite its roughness? Do you want to rearrange some of the shots? Editing a scene like this is a lot of work, but if you've gotten this far, you're done with the hardest part.

STEP 8: CLEAN UP AND SEPARATE THE AUDIO

The rough string-up might sound terrible to you, but simply cleaning up the audio can work wonders. First, open the audio level meters by selecting Tools > Audio Tool, and the audio mixing interface by selecting Tool > Audio Mix Tool (Figure 10.28). As you go through the sound in the scene, keep an eye on the levels. If you notice anything too loud, use the level sliders in the Audio Mix Tool to decrease the volume. This scene was shot with a single microphone, so the wider the shot, the lower the levels. If the audio sounds too soft, increase the levels.

Next, go through the cut and get rid of double lines. Set an in- and an out-point in the timeline, and then use a Lift edit by typing the letter "Z" on the keyboard to remove the unwanted audio without messing up the sync. Be sure that you select only target tracks A1 and A2.

If they're not already there, add some audio tracks to the sequence, for a total of eight audio tracks. To add a track, select New Audio Track from the Clip

FIGURE *The Audio Tool and Audio Mix Tool in Avid Xpress DV.*
10.28

menu. As you work on the sound, you'll designate certain tracks for certain types of sounds. This will help make editing the sound easier later. For this scene, A1 and A2 will be reserved for Anne's lines, A3 and A4 will be for Richard, A5 and A6 will be for room tone and sound effects, and A7 and A8 will be used for music (Figure 10.29).

Next, fill these holes you're creating with room tone. The scene was set in a very large room, and as a result, the sound is very echo-y. Find a shot where there isn't much dialogue and use it for room tone. The poster shot is a good choice. Find a good section of room tone and set an in-point at the beginning of it. Now, set in- and out-points around the gap that you want to fill in A1 and A2 by targeting those two tracks and positioning the blue cursor in the gap, and mark the clip by typing the letter "T." Next, target tracks A5 and A6 by patching the audio from the poster source clip to tracks A5 and A6 in the sequence (Figure 10.29), and perform an overwrite edit.

Separate Anne and Richard's dialogue by moving Richard's lines to tracks A3 and A4. Use Add Edit to create a splice within a cut (type the letter "P"), and then shift select the audio tracks and drag them down while holding the Command or Control key. This ensures that the shot you're dragging doesn't slip out of sync. When you're done, your tracks will resemble a *checkerboard*, which is another term for splitting the sound up in this manner (Figure 10.29).

Patching

Checkboarded tracks

FIGURE *The Richard III scene, with the audio split across eight tracks .*
10.29

STEP 9: USE TRIM MODE TO FINE-TUNE THE PICTURE

Now you need to work through the scene again and fine-tune the picture. If you always cut from one actor saying a line to the other actor saying a line, it may make the performances look weak. Overlap edits, or L-cuts, can help break up the rhythm and give the viewers a chance to see some reactions.

Find an edit that you think would be helped with an L-cut. Create the L-cut by placing the blue cursor bar near the edit in the timeline (Figure 10.30a), and then click the Trim Mode button (Figure 10.30b). The Composer monitor switches to Trim Mode (Figure 10.30c), and pink roller bars appear on the edit in the V1 track in the timeline (Figure 10.30d).

Make sure that there are two pink rollers in the timeline. This means that you'll be performing a Rolling edit, where both the A-side and the B-side of the edit move together. The buttons in the Trim window let you roll the edit in 1-frame or 10-frame increments (Figure 10.30). As you roll the edit, watch how the edit moves in the timeline. When you think it's at the right spot, press the Play Loop button at the bottom of the Trim window (Figure 10.30). If you don't think it works, continue adjusting the edit until you are happy with it.

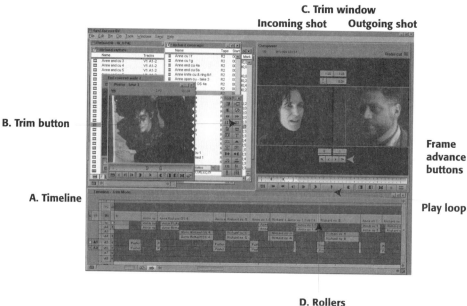

FIGURE *Place the blue cursor bar near the edit in the timeline (A), and click the Trim Mode*
10.30 *button (B). The Composer window switches to Trim Mode (C), and pink roller bars*
appear in the timeline (D).

STEP 10: LOOK AT THE OVERALL PACING

Watch the entire scene with an eye toward pacing. Is there enough variety?
Does it seem boring? Use Trim Mode to add beats where the scene seems to
need more emotional power, and to remove beats when the pacing seems dull.
For this scene, you want to save the emotional beats for the sections with the
knife and the ring, and keep the pacing snappy during the earlier confronta-
tional dialogue.

STEP 11: ADD CUTAWAYS

Now you can cover any jump cuts with cutaways. In this scene, the cutaways
consist primarily of the reaction shot of the other actors. Try to make sure the
cutaways serve the story, as well as the need to cover up a jump cut. Look for
moments when the actor responds to what the other person is saying. Be sure
not to overuse cutaways—the scene will look jumpy and poorly constructed.

STEP 12: ADD MUSIC

Many films use music to transition from one scene to another, and also as a
"bed" underneath part of the scene to enhance the mood. You'll have to resort
to your own CD collection to find a music track to add here. It's actually very

common for editors to bring in CDs from home for use as a temporary score while they edit the rough cut. Later, the composer will use this music as a guide.

A somber piece of music with strong percussive hits is a good choice for the opening of the scene. You can edit the music so that the hits fall on the cut from the poster to Anne, and on the cut from Anne to the wide shot when Richard enters. This will help make those edits seem motivated.

You may or may not wish to add a music bed under the entire scene, but you should definitely add some music as the end of the scene approaches. You can start it when Richard guides Anne across frame toward the door. Again, try to use music to ease any awkward moments in this part of the scene, and to enhance the emotional tone as well.

STEP 13: WATCH YOUR CUT

How do you like the scene? Does the pacing work? Are the story points clear? How about matching action and continuity? Did you use the shot called *End wide reverse 2a*? This shot has a continuity problem: the actor is wearing his glasses. How did you solve the problem of getting Anne to cross the frame before she leaves? Using the close-ups of the actors' hands after Richard places the ring on her finger is one of the few solutions available. It works because Richard grabs her hand tightly and doesn't release when she tries to pull it away. This serves as a story point, highlighting Richard's controlling nature. If it weren't for that, the shot probably wouldn't work. One possible edit of the scene is in the *Final Movies* folder and is called *RichardIII*.

LOCKING PICTURE

Whether it's picking the right take for the performance, or deciding which shots will make the most interesting montage, or deciding to leave a scene on the cutting room floor, editing can be a time-consuming process.

Having spent days, weeks, or months editing the story, it's time to stop working on it; in other words, to *lock picture*. Locking picture means that you won't make any further changes to the story—especially to the timing.

It's time to take your cut to the next level by fixing image problems, adding titles and special effects, and completing the sound track.

11

Polishing the Final Cut

IN THIS CHAPTER

- Titles
- Tutorial: Basic Titling
- Color Correction
- Tutorial Color Correction and Film-look Effect
- Fixing Video Dropouts
- Advanced Effects: Compositing and Mattes
- Tutorial: Basic Bluescreen
- Fixing Audio Problems
- Sound Design
- Sound Mixes

Polishing the final cut of any project can be a huge undertaking in and of itself. Traditionally, special effects editors, title animators, sound editors, and many others each take a certain part of the film and polish it. However, these varied jobs often fall into the lap of the main editor. As technology advances, this is becoming more and more the case, and not just for ultra-low budget productions. However, the tools available on the average non-linear editing system are simply not as sophisticated as the dedicated workstations that special effects and sound editors use.

With that in mind, this chapter will take you through the process of polishing the final cut with the toolset available on the typical non-linear editing workstation. You'll add titles to the documentary scene from Chapter 10, "Creating Story Structure," you'll learn to fix a video dropout using Adobe Photoshop, you'll apply a color correction treatment to a shot from the dramatic scene you edited in Chapter 10, you'll composite a bluescreen shot that can be added to the promo editing tutorial from Chapter 9, "Editing Basics." If that sounds like a lot, it is. However, thanks to modern non-linear technology, it's nothing out of the ordinary for a typical non-linear project these days.

The second half of this chapter is about polishing the soundtrack. Big-budget movies dedicate several weeks to the construction of soundtracks, but most lower-budget projects can only afford to spend a week, or less, on the sound. The sound workflow presented in this book assumes a lower-budget production in which the primary editor does the majority of the sound editing. That means that by the time the picture is locked, a rough soundtrack already exists. In Chapter 8, you learned how to maintain, or improve, audio quality as you capture it, Chapter 9 described how to perform a basic sound mix, and this chapter will help you add the finishing touches and troubleshoot problems.

TITLES

Every project has titles of some sort. Luckily, the titling capabilities of the average non-linear editing system are up to all but the highest quality tasks (see the sidebar, "Titles and Effects for Film").

- **Opening titles** can vary from white text on a black background to complicated visual effects sequences created by A-list designers.
- **End credits** usually consist of rolling titles to save time. Many non-linear editing applications are able to automatically generate a credit roll.
- **Lower thirds** refer to the titles that identify a subject in a documentary project, so named because they are constrained to the lower third of the screen.

Title safe

Action safe

FIGURE *The title safe boundary for NTSC television.*
11.1

Because most projects end up being viewed on a television monitor at some point, titles are constrained to a part of the screen that's called *TV safe* or *title safe* (Figure 11.1). This ensures that the titles will be visible on any television set, despite discrepancies from set to set.

Titles and Effects for Film

For projects destined for projected theatrical release, the quality of the internal titling tools of most non-linear editing applications is not sufficient. The image will be projected at several hundred times the size of what you see in the computer monitor, and it will look terrible if it's not of very high resolution. Instead, you need to create high-resolution titles in programs such as Adobe Photoshop and/or Adobe After Effects, and then have the files printed directly to film stock—a process called a *film out*. The standard resolution for film titles is about 2000 pixels, or 2K, in width, which adds up quickly. However, resolutions vary depending on the project and the requirements of the transfer house, so be sure to do your homework before you start creating film titles.

Save a Textless Master

It's standard procedure to create a final master of each project with no titles. This is called the textless master *and can be used later if the project is translated into another language, and as a resource for promotional clips. After you add titles and graphics, the new master is called the* texted master.

TIP

BASIC TITLES

TUTORIAL

In this tutorial, you're going to add some basic titles to the Tin Hat Trio documentary scene that you cut in Chapter 10, "Creating Story Structure." The scene needs an opening title and some lower thirds to identify the subjects.

This tutorial covers:

* Using the title tool
* TV safe boundaries
* Creating lower thirds
* Making sure titles are visible
* Fading titles in and out
* Creating a credit roll

WHAT YOU NEED

You need non-linear editing software installed on a computer with a CD or DVD-ROM drive, and the companion CD/DVD in this book. Refer to Appendix C for details about the footage used for this tutorial. You also need an external NTSC monitor.

ON THE CD/DVD

You will edit this tutorial using Adobe Premiere 6.0. You can install the demo software on the CD/DVD, or use your own editing application. If you're using a different application, you may want to keep the user manual ready for quick reference.

ON THE CD/DVD

You have the choice of using the cut you created in Chapter 10, or you can use a precut version provided on the CD/DVD.

STEP 1: SET UP THE PROJECT

ON THE CD/DVD

Launch Adobe Premiere and create a new project called *THT titles*. Import the file called *THTtextless.mov* from the *Title tutorial* folder on the CD/DVD, or import the file you created at the end of the documentary editing tutorial in Chapter 10.

STEP 2: OPEN THE TITLE WINDOW

From the File menu, select New>Title to open the title window.

STEP 3: ADD A LOWER-THIRD TITLE

The first title you'll add is a lower third to identify Mark Orton, the member of Tin Hat Trio who introduces the animations.

Use the Title pull-down menu and choose a font. The titles in this tutorial use the font Formata Medium. Next, set the font size to 48. Be sure the Title tool is active in the tool palette, place the cursor in the work area, and type "Mark Orton" (Figure 11.2).

Use the color selector below the tool palette to choose a color (Figure 11.2a). This title is going to be superimposed over the video image, which is quite dark, so choose a color that will stand out against a dark background. A pale yellow is very close to white and seems to stand out nicely. Make the background in the Title window black by typing "B" so that you can see the title better.

Next, from the Title menu, select Shadow > Soft. Most superimposed video titles use some sort of shadow to help the text stand out from the background.

Position the text in the lower third of the screen, but make sure it's within the title safe boundary. (Figure 11.2b). Look at the video image and try to place it somewhere where it will be visible.

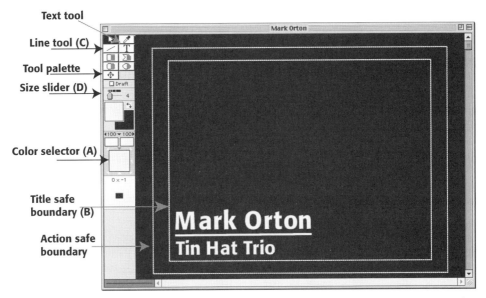

FIGURE *The Title window in Adobe Premiere lets you select a color (A), position the text with*
11.2 *the title safe boundaries (B), add a rule (C), and use the slide to adjust the size of the rule (D).*

Next, add another line of text that says "Tin Hat Trio," and place it below Mark's name. Use a slightly smaller font. Finally, add a line, or *rule*, under Mark's name to set it off from the other text. Use the Line tool, and set the size slider to 4 (Figures 11.2c and d).

STEP 4: ADD THE TITLE TO THE SEQUENCE

Exit the Title window; you'll be prompted to save the title you just created. Call it *Mark lower third*. You'll see it appear in the Project folder. Drag it to the time-line and place it over the appropriate part of the sequence. You'll have to render a Preview in order to view the title. Drag the yellow preview bar in the timeline so that it only covers the area with the title (Figure 11.3). This tells Premiere to only render this section of the sequence. Now look at the placement of the title (Figure 11.4 and Color Plate 4). Is it readable? Is it too big or too small? Does it extend past the title safe boundary or fill more than the lower third of the screen?

Once you're happy with the lower third, refine it by making sure it's on screen long enough to read it and accommodate any dissolves, if necessary. The standard rule of thumb is that a title is up long enough if you can read it two times aloud, slowly—usually about five seconds.

As for fading the title on and off, there's another standard rule. If the title starts at the same time as the shot, you don't need to fade it up. Rather, it can appear at the same time as the picture. The same is true with the end. If it starts later than the picture or ends earlier, then you should add a short dissolve so that it fades on and off smoothly—a 30-frame dissolve is the usual (Figure 11.5).

Place the title so that it starts at the same frame as the shot with "Mark" starts. This title needs a fade out. Open the track by clicking on the triangle icon. You'll see a red line in the track that indicates the transparency. Set keyframes

FIGURE *Set the yellow bar before rendering a Preview.*
11.3

(A) Centered text **(B) Left-justified text**

FIGURE
11.4
Watch the Preview to see if your title looks good. The title placed to the left (B) is easier to read than the title placed in the center (A) (see also Color Plate 4).

(A) No fades

(B) Fade out

(C) Fade in and out

FIGURE
11.5
If a title is the same length as a shot (A), it does not need a fade. However, if it ends before the shot does, it needs a fade out (B); if it starts after the shot, it needs a fade in, too (C).

Drag keyframe

Open track

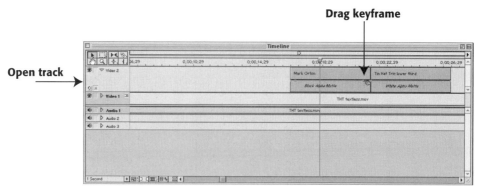

FIGURE *Open the track by clicking on the triangle icon, add keyframes, and drag the*
11.6 *transparency line down to add a fade out.*

by clicking on the red line and dragging it down to decrease the transparency
(Figure 11.6).

Add the other lower thirds: Carla Kihlstedt, Tin Hat Trio (the violist); Mark
Burger, Tin Hat Trio (piano and accordion); Ashley Adams, Foley Artist. You can
also add a different lower third to identify the animations. The animation is
called "The Insect's Christmas," by Ladislaw Starewicz, 1913.

STEP 5: ADD A CREDIT ROLL

Automatic credit rolls are becoming standard in NLE title tools. To create a credit
roll for this project, go to the File menu and select New > Title. In the Title
menu, select the Rolling Title tool (Figure 11.7a). Draw a box to cover the area
in which you'll place the rolling title. The box should go all the way from the
top to the bottom of the frame (Figure 11.7b); a new set of scroll bars will ap-
pear at the edge of the box, and a cursor will appear inside the box.

Type in the text you wish to add for the credit roll. You'll need to add several
blank lines at the beginning of the text and several more at the end, so that the
text rolls up from the bottom at the start and then clears frame at the end. You
can see a rough preview by moving the slider at the lower left of the Title win-
dow (11.7c). When you're done adjusting the text, close the Title tool and save
the title as "Credit Roll."

A new clip called Credit Roll appears in the Project folder. Highlight the clip,
and select Duration from the Clip menu. Change the duration to 30 seconds,
place it at the end of the sequence, and render a Preview to check it out (Figure
11.8).

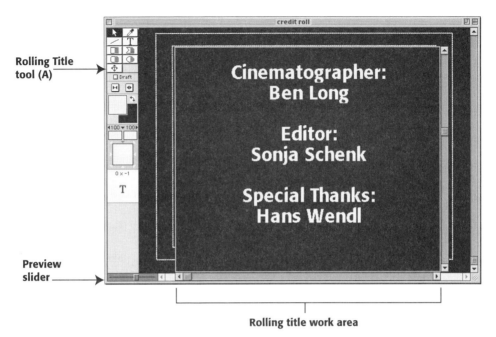

FIGURE *In Adobe Premiere 6.0, you can automatically create a credit roll by using the Rolling*
11.7 *Title tool (A) to define an area for the rolling text (B) and preview your work (C).*

FIGURE *Adjust the duration of the title and place it at the end of the sequence in the timeline.*
11.8

Compression and Recompression

All digital files are compressed. When you save your media or export it to a different format, you are compressing it again, a process that could introduce compression artifacts. Ideally, you should stick to the same type of compression throughout your workflow, and be very careful about accidentally recompressing it.

CORRECTING AND ENHANCING THE IMAGE

If your system can handle more than one layer of real-time effects, you're lucky. You can add filters that correct overall problems as you edit, much the same way you do a sound mix as you edit. However, whatever your system's capabilities, it's usually best to wait until the final stage before adding these sorts of special effects. The reason for this is that as you make changes, you'll have to rerender areas where you changed the images or added new footage. Rendering

Adobe After Effects

Sometimes non-linear editing applications seem to offer more filters and transition effects than you know what to do with, and there's a good reason for this: those special effects are often too generic to be useful. For example, you might think the chrome title effect looks cool, but your project needs titles that look more like banged-up rusted metal. An effect with a lot of visual impact often needs to be created for the specific situation at hand, and the way to do that is with Adobe After Effects.

Adobe After Effects is the most popular choice for creating 2D effects, and is a welcome addition to any editing system. Offering a sophisticated set of tools and extensive support from third-party developers, After Effects is used to create all sorts of motion graphics, from flying text and color correction, to bluescreen composites and custom traveling mattes. Think of it as Photoshop with movement.

Render settings in After Effects have always catered to the broadcast and film industry professional, with options for motion blur, field rendering, and variable frame rates, including 24fps. It supports high-resolution media for film-quality outputs. Many who work with After Effects extensively add some serious hardware, including a capture board, like one of the Targa models by Pinnacle, or the SDI-based Digital VooDoo boards for uncompressed digital capture and output.

can be a very time-intensive process, especially if you're rendering something like a color correction filter that is applied to your entire project. Therefore, waiting until the picture is locked can save lots of time and trouble. If you have problem footage and you're worried about whether the problem is reparable, do some tests on a single shot and save them in a separate bin or on videotape so that you can easily reference them later.

Color correction is used to change the overall color cast of an image. It's not uncommon to get video footage that looks kind of green or red, especially if it was shot under low lighting conditions. One of the primary goals of color correction is to enhance skin tones of the subjects, and the amount of adjustment to the overall color cast is usually limited by that factor. If there are no people in the footage, you'll have much more latitude in terms of manipulating the color balance.

Good color correction filters let you adjust the red, green, and blue color channels in the image, and also let you check the results on a vectorscope to make sure that they are *NTSC legal* (Figure 11.9). If you increase the saturation or contrast too much, you may exceed the capacity of NTSC, or PAL, video, which is more limited than the color capacity of a computer screen. The only way to avoid this is to check your color-treated video on a waveform monitor and vectorscope, as described in Chapter 8, "Getting Media into your Computer." At the very least, always view effects and titles on a video monitor to see how they "really" look. If your final goal is film, the Web, or multimedia, the color restrictions of video do not apply.

Contrast adjustment is another feature that can help enhance the overall image. Often, the contrast controls are part of the color correction filter. A good

FIGURE *The color correction filter lets you adjust the red, green, and blue channels in a video*
11.9 *image.*

FIGURE *Contrast adjustment.*
11.10

video image has blacks that are truly black (or 7.5 IRE in NTSC-speak), and whites that look clear and bright, anywhere from 75 to 100 IRE. Video shot under low lighting conditions often exhibits a poor contrast range between black and white (Figure 11.10).

Film-look effects are achieved by using a cocktail of image adjustment filters, particularly color and contrast adjustments. Some special film-look filters add noise to replicate the look of film grain, but this is unadvisable. Video noise is much more noticeable and annoying than film grain is, and the result might not look like film at all. If your project is destined for a video-to-film transfer, do not add these filters—they'll just degrade the image. Instead, wait until the film transfer is completed, and adjust colors and contrast during the *color timing* process.

Fixing a Single-Field Dropout

The video dropout is one of the most ubiquitous problems for projects that finish on videotape (Figure 11.12). Fixing them can be a little tricky, but not as hard as you might think. Depending on the dropout, it can probably be fixed in your non-linear editing application or in an image-editing application like Adobe Photoshop.

Most dropouts occur on a single field of video. In order to get rid of them, the good field needs to be copied and pasted over the problem field. As long as there isn't a lot of movement in the shot, particularly camera movement, the double field should be invisible.

The first trick is to find the problem field. If the dropout is on the dominant field, you can find it by stepping through frame by frame. However, if the dropout is on the other field, you will only see it when the image plays, not when you're parked on a frame. Nonetheless, you should be able to narrow it

down to the frame where the dropout occurs. With Avid Media Composer, you can step through the video field by field by using a special Field Advance button in the active Command Palette.

If the dropout is not on the dominant frame, you can fix it in most NLEs by creating a freeze frame using the duplicate field option (as opposed to interlaced or interpolated). By doing this, you'll create a freeze that consists of the clean, dominant field over and over. Simply paste one frame of the freeze over the problem frame in the sequence, and you'll cover the second field with a copy of the first field.

ON THE CD/DVD If the dropout is on the dominant field, the best fix for this problem is to export the problem frame as a still image and open it in Adobe Photoshop. (There is a demo version of Photoshop on the companion CD/DVD). Be sure to export an uncompressed format. Next, from the Filters menu, select Video > De-interlace, choose the appropriate field, and duplicate from the dialog box that appears (Figure 11.11). Then, reimport the corrected image and paste it over the problem frame.

FIGURE **11.11** *Use the de-interlace filter in Adobe Photoshop to remove a field containing a dropout.*

FIGURE *Digital dropout.*
11.12

Film Output

TIP

If your digital video project is going to be transferred to film, be extra careful when applying filters to your footage. You may degrade the image quality, and what looks better on video might look worse on film. Don't bother with adding a film-look effect, because simply transferring your footage to film will make it look like film. It's safest to have the lab do any color correction and image enhancement necessary for the film output after you've done the tape-to-film transfer.

COLOR CORRECTION

TUTORIAL

Despite the advances in digital video technology, everyone (mostly) still wants their project to look like film. It's a common opinion that film makes the real world look better than it is, and video makes it look worse. Whatever your opinion, this simple tutorial will show you how to create a film look for the video footage in the Richard III scene.

This footage was shot under insufficient lighting conditions; consequently, it needs some color correction. There's one important thing to notice about this footage: even though the shooting conditions were less than ideal, an attempt was made during the shoot to use film-style lighting. There's no way to fake this after the fact.

The challenge in creating a film look lies more in having a good eye than in the technology used. For this tutorial, you'll use Adobe After Effects 4.1 to manipulate a shot of Anne from the Richard III scene. If you're really motivated, you can go back to the media in the dramatic scene tutorial and do the entire scene, or try using your favorite NLE application instead of After Effects.

This tutorial covers:

- Creating a project in After Effects
- Interpreting the footage
- Adjusting brightness and contrast
- Changing the color balance
- Adjusting the color saturation
- Enhancing skin tones
- Maintaining rich blacks
- Checking for NTSC safe colors

WHAT YOU NEED

ON THE CD/DVD

You need compositing software installed on a computer with a CD or DVD-ROM drive, and the companion CD/DVD from this book. Refer to Appendix C for details about the footage used for this tutorial.

This tutorial uses Adobe After Effects 4.1. You can either install the demo software on the CD/DVD, or use another application such as Commotion or a film-look plug-in like CineLook. If you're using a different application, you may want to keep the user manual ready for quick reference.

STEP 1: SET UP THE PROJECT

Launch After Effects, and create a new project called *Film look*. Import the file in the *Film look tutorial* folder: *Reg last line.mov*. From the File menu, select Preferences > Time and make sure the time base is set to 29.97 fps. The footage for this project is in the NTSC format. From the Composition menu, select New Composition. The dialog box shown in Figure 11.13 appears. Call the composition *Anne film look*, and select NTSC DV, 720x480 for the Frame Size. The Pixel Aspect Ratio is D1/DV NTSC; the Frame Rate is 29.97; the Resolution is Full; and the Duration is 8 seconds.

FIGURE *Your settings in the New Composition*
11.13 *dialog box should look like this.*

STEP 2: INTERPRET THE FOOTAGE AND BUILD A SEQUENCE

In order for After Effects to work properly, you need to go through a special process to de-interlace the video footage. From the File menu, select Interpret footage > Main. The dialog box shown in Figure 11.14 will appear. Separate Fields should be set to Lower, and Motion Detect should be checked.

FIGURE *Interpreting the footage helps After Effects*
11.14 *create a better quality final output if the*
footage you're working with contains fields.

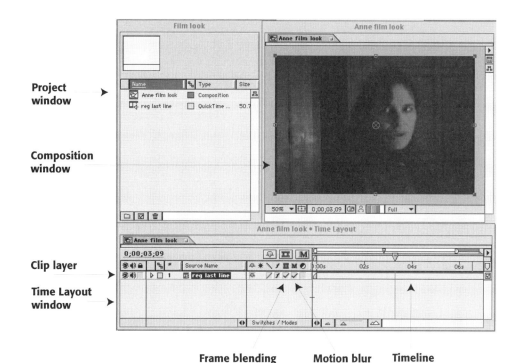

Frame blending Motion blur Timeline

FIGURE *The After Effects interface is similar to a non-linear editing application interface.*
11.15

Drag the file called *Reg last line* into the Time Layout window first. Your time-line should look like Figure 11.15, and the shot should be visible in the Composition window. Check the boxes for Frame Blending and Motion Blur to the right of the clip in the Time Layout window (Figure 11.15).

STEP 3: ADJUST THE BRIGHTNESS AND CONTRAST

Highlight the *Reg last line* shot in the Time Layout window, and then, from the Effect menu select Adjust > Brightness and Contrast. The Effect Controls window opens (Figure 11.16). The footage is quite dark, so start by increasing the bright-ness by dragging the brightness slider in the Effect Controls window. Be careful; if you drag it too far, you'll introduce noise into the image. As you increase the brightness, the image starts to look a little faded. Correct this by adjusting the contrast slider. A brightness setting of 50 and contrast of about 37 seems to im-prove the image without overdoing it. Color Plate 12 shows the different steps of this tutorial in color.

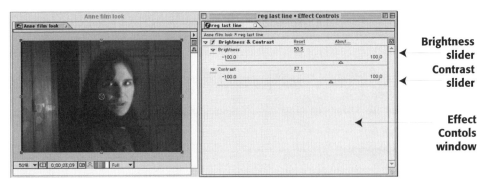

FIGURE *Use the sliders in the Effect Controls window to adjust the brightness and contrast (see* **11.16** *also Color Plate 12).*

STEP 4: ADJUST THE COLOR BALANCE

Next, add a color balance filter by selecting Effects > Adjust > Color Balance. This filter is added to the Effect Controls window below the Brightness and Contrast filter you added in the last step. The Color Balance filter lets you make many fine adjustments in the color of the scene. This is the part where using your own judgment comes in. Play around to see what looks best. Notice that the background looks rather greenish when compared to her face. Boost the Shadow Red Balance to 35 to warm up the image. Now, even though her face looks a little too red, the overall color cast is consistent across the scene (Figure 11.17).

FIGURE *Adjust the Color Balance to make the background match the foreground.*
11.17

STEP 5: DECREASE THE COLOR SATURATION

The reason the actor's face looks reddish is due to the low light conditions under which the footage was shot. The camera compensated for the dim light, and the result is a somewhat oversaturated image. You can desaturate the image by selecting Effect > Adjust > Hue and Saturation. Decrease the saturation by dragging the slider in the Effect Control window to about –30.

FIGURE *Decrease the saturation to reduce the red tones in the actor's face.*
11.18

STEP 6: ADJUST THE BLACK LEVELS

Now the image is looking quite a bit better than the original. To make the image look more film-like, make sure that the blacks are dark and rich, not gray or de-saturated. Add another Brightness and Contrast filter, and decrease the Bright-ness a little—say, –10—to bring the blacks down a bit. You may have to adjust the contrast as well (Figure 11.19).

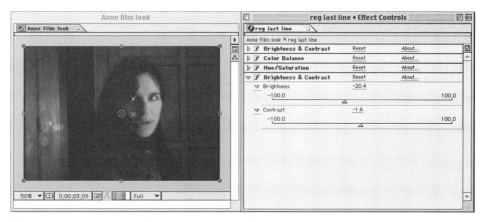

FIGURE *Apply another Brightness and Contrast filter, and darken the images so that the*
11.19 *blacks look dark and rich.*

STEP 7: MAKE SURE THE IMAGE IS NTSC SAFE

From the Effects menu, select Video > Broadcast Colors. You can use this filter to make sure the adjusted video is still NTSC safe. From the Effect Controls window, select the How to Make Color Safe pop-up menu, and then select Key Out Safe. The image should turn completely white, indicating that the entire image is NTSC safe (Figure 11.20). If not, go back and adjust some of the filters you added earlier until you get an image that's NTSC safe.

Check for non-NTSC colors here

FIGURE *Use the Broadcast Colors filter to make sure the adjustments you made are NTSC safe.*
11.20

STEP 8: RENDER AND COMPARE

Render the adjusted shot by selecting Add to Render Queue from the Composition menu. Then select Window > Render Queue (Figure 11.21). Select Output Module and set the compression to the Animation compressor (Figure 11.22). Confirm that the Render Settings match the ones shown in Figure 11.23—particularly that the Field Render box is set to Lower. In the Render Queue window,

Check box

Render settings

Output module

FIGURE *The Render Queue window.*
11.21

FIGURE *The Output Module and Compression Settings set to Animation.*
11.22

select an Output destination, make sure you check the small box next to the *Anne film look* listing, and then click the Render button (Figure 11.21). The file is only 8 seconds long, so it shouldn't take more than 5–10 minutes to render.

FIGURE *Your Render Settings should look like this.*
11.23

FIGURE *If you don't render the fields properly, you'll get artifacts like this.*
11.24

Watch the results. How does the key look? Are there any distracting artifacts? Color Plate 12 shows each step of the color correction process used in this tutorial in color. Check out a possible final render in the *Final Movies* folder called *Anne film look.mov.*

If you notice small horizontal line artifacts like the ones in Figure 11.24, check the field render settings and make sure they're not set to Upper.

ADVANCED EFFECTS

The most impressive special effects shots these days involve *composites*—images that are a combination of one or more layers. The simplest form of composite is the superimposition of one full-frame image over another. *Keys* take compositing to the next level, letting you choose to make one image partially transparent. There are several different types of keys: luma keys, chroma keys, and matte keys (Figure 11.25 and Color Plates 8–11).

Luma keys make a user-specified range of brightness transparent. Usually, a luma key is used to key out the black parts of an image or the white parts (Figure 11.25c and Color Plate 9b).

A. Background source B. Foreground source

C. Chroma key D. Superimposition

E. Luma key F. Matte source

G. Matte foreground composite H. Matte key full composite

FIGURE *Two images (A and B) chroma keyed (C), superimposed (D),*
11.25 *luma keyed (E), and matte keyed (H) (see also Color Plates 8-11.*

Chroma keys make a particular color transparent, and *matte keys* define a transparent area by shape. Footage shot for use with a chroma key filter is usually shot against a bluescreen or a greenscreen background. The blue or green areas are then keyed out and replaced with a background image (Figure 11.25c and Color Plate 10a).

Matte keys define a transparent area by shape (Figure 11.25h and Color Plate 10b). If you're familiar with still-image editing programs like Adobe Photoshop, a matte key is basically the same thing as an alpha channel. A simple matte key might use a circle shape to key out part of the image. A more complex matte key might key out a window, or an object in a scene. For the most part, if you're working with motion footage, you'll need to use an animated *traveling matte*, one that moves with the subject (Figure 11.26).

FIGURE *A still frame sequence from a traveling matte.*
11.26

TUTORIAL

BLUESCREEN COMPOSITING

Bluescreen compositing is one of the most powerful tools for creating special effects. For this short tutorial, you'll take a shot of an actor that was recorded against a bluescreen background, and create a composite shot with a background. This shot is from the Knights series, and when it's composited, it will match some of the shots that you used in the promo editing tutorial in Chapter 9, "Editing Basics."

This tutorial covers:

- Creating a project in Adobe After Effects
- Using the chroma key effect
- Using multiple layers of effects
- Blending foreground and background elements

WHAT YOU NEED

ON THE CD/DVD

You need compositing software installed on a computer with a CD or DVD-ROM drive, and the accompanying CD/DVD from this book. Refer to Appendix C for details about the footage used for this tutorial.

This tutorial uses Adobe After Effects 4.1. You can either install the demo software on the CD/DVD, or use another application like Commotion or a compositing plug-in like Ultimatte. If you're using a different application, you may want to keep the user manual ready for quick reference.

STEP 1: SET UP THE PROJECT

Launch After Effects and create a new project called *Knights bluescreen*. Import the two files in the *Knights bluescreen tutorial* folder: *El Cid.mov* and *Background.mov*. From the File menu, select Preferences > Time, and change the time base to 25 fps. The footage for this project is in the PAL format. From the Composition menu, select New Composition. The dialog box shown in Figure 11.27 appears. Call the composition *El Cid composite*, and select PAL D1/DV square pixels, 768 × 576 for the Frame Size. The Pixel Aspect Ratio is square, the Frame Rate is 25, the Resolution is Full, and the Duration is 6 seconds.

FIGURE *Your settings in the New Composition dialog box should look like this.*
11.27

STEP 2: BUILD A SEQUENCE

Drag the file called *Background.mov* into the Time Layout window first, and then the file called *El Cid.mov*. Your timeline should look like Figure 11.28, and the *El Cid* shot should be visible in the Composition window.

FIGURE *Note the gradations in the bluescreen background; these can make it*
11.28 *harder to create a matte (see also Color Plate 5).*

STEP 3: ADD A CHROMA KEY EFFECT

Highlight the *El Cid* shot in the Time Layout window, and then from the Effect
menu, select Keying > Color Key. The Effect Controls window automatically
opens up (Figure 11.29). As you might notice, the bluescreen is not evenly lit,
and gets quite dark toward the top of the image. (Color Plate 5). This can make
creating a clean matte somewhat difficult. Use the Eyedropper to select a part of
the lightest blue background near the actor's clothing in the Composition win-
dow. From the Effect Controls window, drag the Color Tolerance slider. Play
around until you find a setting where as much of the blue background as possi-
ble is keyed out, without keying out part of the actor (Color Plate 6). A setting
around 57 seems to work well.

STEP 4: ADD A SECOND CHROMA KEY EFFECT

Highlight the *El Cid* shot in the Time Layout window again, and select Keying >
Color Key from the Effect menu. A second Color Key effect appears in the Effect
Controls window. This time, use the Eyedropper to select a part of the darker
blue background near the top of the screen. Drag the Color Tolerance slider.
This time, you should be able to get rid of most of the blue background. A set-

Color
Tolerance
slider

FIGURE *The Effect Controls window.*
11.29

FIGURE *Add a second Color Key effect to key out the darker blue areas (see also Color Plate 7).*
11.30

ting around 33 seems to work well. Use the Edge Feather slider to make the area around the hair look smoother (Figure 11.30 and Color Plate 7).

STEP 5: ADD SOME TRANSPARENCY TO THE FOREGROUND

You can't always get away with this, but for this shot, you can integrate the foreground and the background by making the foreground a little transparent. If you look at the *Knights* promo in the *Final Movies* folder, you'll see that in the com-

posite shots of the other actors in the promo, the foreground elements are somewhat transparent.

To do this, go to the Time Layout window and open the *El Cid.mov* track by clicking on the triangle icon next to the track. Here you'll see three more layers called Masks, Effects, and Transform. If you click on the triangle next to the Effects layer, you see the two Color Key effects you added inside. Click on the Transform layer and scroll down to Opacity (Figure 11.31). Click to the right of the word *Opacity*, where it says "100," and a dialog box appears (Figure 11.31). Type in "75" to change the opacity to 75%.

Color Key layer 1

Color Key layer 2

Opacity layer

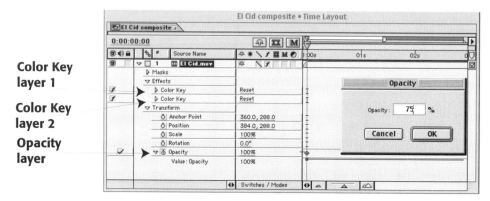

FIGURE *Open the El Cid track and change the opacity to 75%.*
11.31

STEP 6: RENDER AND WATCH THE RESULTS

That's it. Highlight the *El Cid composite* file in the Program window and select Composition > Add to Render Queue. Then select Window > Render Queue. Confirm that the Render Settings match the ones shown in Figure 11.32—particularly that the Field Render box is set to Lower. Check the Output Module and make sure the Compression is set to the Animation compressor. In the Render Queue window, select an Output destination, make sure you checked the small box next to the *El Cid composite* listing, and then click the Render button (Figure 11.33). The file is only 6 seconds long, so it shouldn't take too long to render.

Watch the results. How does the key look? Are there any distracting artifacts? The area behind his head is hard to key successfully, because it's so dark that it can hardly be considered blue. Do you think you can get away with this area, or does it need more work? Check out a possible final render in the *Final Movies* folder called *El Cid Blue.mov*.

ON THE CD/DVD

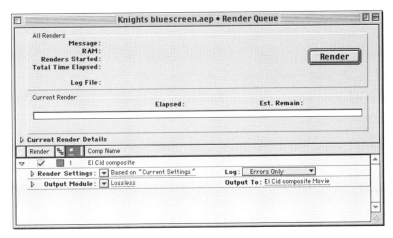

FIGURE *Render settings.*
11.32

FIGURE *The Render Queue window.*
11.33

Adobe Photoshop

You might not think that a still-image program like Adobe Photoshop would be that useful for a film or video project, but depending on your project, Photoshop can very extremely useful.

Most non-linear editing applications offer a very limited, scaled-down graphics editing interface for creating titles akin to a simple Paint program. You'll get much better-looking titles if you create each still title page in Photoshop at a high resolution. Photoshop also has better anti-aliasing and more sophisticated tools for blending and manipulating graphics.

Another reason that Photoshop can work so well for creating titles is the presence of *alpha channels*. An alpha channel is a transparency layer, or matte, that defines which part of the image is transparent. Using alpha channels, you can create titles in Photoshop that will be superimposed over video; you can define the transparency in Photoshop. If you aren't dealing with a lot of motion, you can use Photoshop to create a custom matte key to import into your NLE for a customized composite.

You can use batch processing to apply a set of filters to an image sequence exported from your project, and you can use Photoshop to fix video dropouts, as described in the sidebar earlier in this chapter.

SOUND SOLUTIONS

Sound editing is a subject that could merit an entire book in its own right. However, the amount of work that the editor does on the soundtrack before locking picture should not be underrated. By the time picture is locked, the editor has built the basic tracks, synchronized audio and picture if necessary, created a rough mix, added a temporary music score, and tried to fix any distracting problem with the audio. The next step is threefold: organize the soundtracks in preparation for the final mix(es), remove and/or replace any problem audio, and create additional tracks to refine the sound design.

SEPARATING TRACKS

Hopefully, you've been working with the soundtracks organized somewhat in terms of content. Now it's time to go through your audio tracks and make sure they're consistent. The idea here is to separate out different types of sound so that you can apply global effects, and so that you can easily find a particular piece of sound in your project when working. Even if you're planning to take your sound to a professional sound editor for a sweetening session and a mix, it's a good idea to organize and separate the tracks before you hand them off to the other editor. If you're mixing the sound using a non-linear editing application, it's probably a good idea to limit the number of tracks to eight. Usually, this is the number of tracks an editing application can play back, or monitor, in real time. If you're working on a dedicated sound-editing application, like ProTools

or Peak, you can probably add as many tracks as you want, depending on the hardware associated with your system.

MONO VS. STEREO

When you plan your track layout, you will need to dedicate one track for *mono* sounds and two tracks for *stereo* sounds.

Mono sounds are those that only have one channel of audio. If you have the audio from the male lead in your movie recorded on channel one, and the female lead on channel two, those are both examples of mono sound. Most production audio is mono. Don't be confused if you have audio from a camera mic on two channels. Although technically this isn't mono sound, if you only used one of the two channels that were recorded, you probably wouldn't lose anything. So, practically speaking, you can treat that audio as mono sound.

Stereo audio consists of two channels of sound. Channel one is usually balanced, or *panned*, slightly to the right, and channel two is panned slightly to the left. The effect is a richer, more complex sound that doesn't seem to come from one place. Music is usually stereo, and so are some special effects available on CD.

TYPICAL TRACK CONFIGURATIONS

Most soundtracks consist of some variation of the following: dialogue, effects, and music. Ideally, you should give each actor or voice a separate track. When you're mixing, you can then apply global volume adjustments or equalization to the entire track. Depending on the project, you'll need 2–4 tracks for dialog, voice-over, production sound and ambience; 2–4 tracks for effects; and 2–4 tracks for music.

Checkerboarding

If you're not handing the sound off to someone else to finish, the next step is to checkerboard, *or* A/B roll, *the audio. This is a continuation of the process of separating the tracks to make mixing easier. The second tutorial in Chapter 10 includes checkerboarding dialog.*

SYSTEM LIMITATIONS

Even the best non-linear editing systems can usually only monitor eight tracks of sound. That means you'll have to render, or mix down your audio in order to hear it properly if you have more than 8 tracks. The professional term for this is *pre-mixing*; for example, if you have a soundtrack that has four actors each on a separate radio microphone. If you dedicate a track to each actor, that's four tracks right there. You'll only have four more to use for effects and music.

Instead, you can build a complicated set of effects tracks and then premix them into two stereo tracks to monitor them. You can also use *nested sequences* to simplify a complicated mix.

DAMAGE CONTROL

Unfortunately, a primary task of the sound editor is to remove problems in the soundtrack. Production audio tends to be problematic in one way or another, and sound editors often spend most of their time cleaning up the sound.

SNAP, CRACKLE, AND POP

Video and film images are divided into frames, and most editing applications are designed to consider one frame the smallest increment of time. However, digital audio is not limited by frames—one minute is one minute, whether it corresponds to 25-fps video or 30-fps video. A tiny sample from the soundtrack may get split in two when you make an edit on an even frame, and the result will be an audible pop or click at the edit. There are a few ways to get rid of these. First, you can simply try to move the edit one frame forward or backward in time. Usually, this shift won't be audible and will get rid of the pop. If your non-linear editing system allows for subframe audio editing, you can move the edit by a tiny increment forward or backward in time to get rid of the pop. Another solution is to add a two-frame dissolve at the edit. This dissolve won't be audible to the listener, but should remove the pop.

CLEANING UP DIALOGUE

The first goal when dealing with dialogue is to make sure it's intelligible. Remember that someone who's hearing the dialogue for the first time might have more trouble understanding it. The next job in cleaning up dialogue is to go through the entire project, separating the tracks and making sure each piece of dialogue is clean, not clipped. If your NLE offers subframe audio editing, it will be useful during this process.

ADR

Sometimes, dialogue audio is so problematic that it's unusable. There may have been a problem with the microphone, or too much ambient noise, or maybe the sound wasn't recorded in the first place. Whatever the reason, sometimes the only solution is to rerecord the dialogue, a process called *ADR*, short for *automatic dialogue replacement*, or also called *looping*. Don't be fooled by the term *automatic*, however, because ADR is far from a simple automatic process.

Certain types of shots are better suited to ADR than others. As a rule of thumb, the shorter the lines you need to replace, the more likely they'll be successfully replaced with ADR. Also, the more clearly you can see the actor's

mouth, the harder it is to get away with ADR. A Shakespearean monologue de-livered in a close-up directly to camera is a worst-case scenario. A wide shot of two actors on a busy street is a good candidate for successful ADR.

The standard procedure for ADR is done at a professional postproduction fa-cility in a special recording room. The video or film is played on a large screen while the actor stands in a booth and tries to mimic his or her performance, in terms of lip sync, energy, and emotion. This is a notoriously difficult task to per-form. The video or film clip is played over and over until the actor and sound engineer get it right. The do-it-yourself version involves the same process in the editing room using a mic and a video monitor. You can probably get away with the do-it-yourself ADR for something like the aforementioned wide shot of two actors on a busy street. For a whole scene with close-ups, you'll need all the professional help you can afford.

EQUALIZATION

Equalization is an important tool for anyone who's serious about his or her soundtrack, but it does require a good ear (and some good headphones or speakers) and a light touch. Overdoing it can make your sounds worse than they originally were. The equalizing tools in many NLEs are very rudimentary, and in some cases consist of simply preset EQ filters such as *bass boost, hiss re-duction*, and so on. If this is the case, you'll do better to equalize your audio on input, as described in Chapter 8. If your NLE does in fact offer a decent equal-izer, the standard interface is a window with several sliders, each representing a different sound frequency (Figure 11.34).

FIGURE *Equalizing audio in Avid Xpress DV.*
11.34

Boosting the low and midrange frequencies can add richness to a voice; raising the midrange frequencies can make voices more intelligible; wind and microphone noise can be diminished by reducing the low frequencies; and tape hiss can be removed by diminishing high frequencies. However, if a problem sound falls into the frequencies used by the human voice (which vary according to the voice), removing those frequencies to get rid of, say, a hum, will reduce the actor's voice as well, making it sound tinny or muddy.

USING SOUNDS TO FIX BAD EDITS

Sounds can help an awkward edit seem motivated. For example, you might have a scene where an actor turns his head and yells. This action might not be believable unless you have a sound that indicates an action that happened off camera to motivate the behavior—a horn honk, or barking dog, or another person yelling. A hard sound can mask a hard or jumpy cut. A music cue can also make an awkward cut seem appropriate. In general, if there's a cut that you couldn't fix when you were editing the picture, you should try experimenting with sound effects and music to make it work, or simply mask it.

SOUND DESIGN

Good sound design is a creative art. Much of the media that we see on a regular basis—sitcoms, comedic film, etc.—do not have interesting sound design. They put dialogue above all else. If you remember a movie because of its striking mood, it's likely that sound design played an important role, whether it's a big action movie like *Gladiator* or an evocative TV show like the *X-Files*.

Sound effects can make or break a moment. They can cast a tone on an event that's humorous or serious. The key is to avoid the unintentionally humorous. There are many excellent sound effects libraries available on CD for a price, but don't be afraid to create your own. The skill is in finding something that sounds like what you need, even if it has nothing to do with the real source of the sound. A crunching potato chip might work as the sound of a bone breaking if you boost the levels a bit.

Ambience, at its most basic level, comes in the form of room tone, but it can be anything from the standard nighttime crickets to howling wind to laughter from a nearby playground. The choice of ambient sound can have a powerful effect on the mood of a scene.

Music usually comes in two flavors, underscore and stings. Underscore is the music that we think of when we think of the soundtrack. Stings are music hits, such as a low ominous tone or a percussive sound that is used to

highlight a moment, especially in television or in action scenes. Most film soundtracks are created by a composer, based on temporary music scores cut into the piece by an editor or sound editor. Lower-budget projects often use CD library music to create a score.

Transitions can be a variation, or combination, of sound effects, ambience, and music. They serve to create a shift in tone to let the viewers know that they're in a new scene, or that there's been a significant change in the story.

MIXES

It's important to know a little about mixing in order to determine the type of final mix you need. It used to be that mixes were a one-time event done in real time. That means that as the sounds played, a sound engineer used a mixing board to set the levels and equalization as it was laid off to tape. When mixing in real time, it's very important to have all the different sounds on different tracks so that the mixer can quickly make adjustments on-the-fly.

Today, mixers use non-linear sound editing applications to set the levels and EQ for each piece of audio in a project. These settings are adjusted throughout the editing process and saved as part of the project. After the picture is finished, the editor does a few passes on the project to adjust the levels and the EQ. Once these settings are determined, the sound is laid off to tape. In other words, the "mix" is an ongoing process that starts when you capture your sound, and ends when you deliver your final project.

TIP

Mix a Copy
If you have all your sound tracks ready to perform the final mix, save a copy of the split-track sequence as a backup in case you need to create a different mix later.

TYPES OF MIXES
There are several standard types of mixes:

- **Mono mixes** distill all the sound down to a single track. Today, mono mixes are rarely used professionally, but are sufficient for simple viewing copies of your work in progress.
- **Stereo mixes** are what we're all familiar with—audio CDs and television are examples of sound that has been mixed in stereo. To create a stereo mix, the audio is mixed down to two channels, the left, or channel one, and the right, or channel two. True stereo audio means that the left channel is panned slightly to the left, and the right channel is panned slightly to

the right. However, in most projects, the only true stereo sound is in the music tracks. In this case, you'd mix all the audio and the left channel of the music to track one, and all the audio plus the right channel of the music to track two to get a stereo mix.

- **DM&E mixes** use four channels, with one channel dedicated to dialogue (D), two channels dedicated to stereo music (M), and the fourth channel dedicated to effects (E). By keeping these elements separate, you can use the DM&E mix as a source to remix the sound in your project for dubbing in a foreign language.

- **Surround sound mixes** are becoming increasingly popular, and with the advent of HDTV may soon become the norm. There are several different types of surround-sound systems, and they involve different numbers of tracks and track configurations. In general, they have 3–5 channels balanced for the left, right, and center of the theatrical screen; left and right channels in the rear of the theatre; and a subwoofer channel. In general, the rear channels are only used occasionally.

LAST, BUT NOT LEAST...

Your cut is perfect, the sound is finished, and all the special effects are done. It's time to get it out of your computer to wherever it's going—theatres, VCRs, DVD players, a Web browser, or maybe all of the above. Whatever your goals, the next chapter will help you get it done.

Outputs

12

IN THIS CHAPTER

- Videotape Outputs
- Audio Outputs
- Film Outputs
- Web Delivery
- Digital Media Outputs
- Archiving Your Project

A. This locked sequence would result in a "dirty" list.

B. The same sequence, collapsed onto a single video track and stripped of all effects, non-standard transitions and audio.

As editing technology improves, the task of doing final outputs becomes easier and easier. However, that doesn't mean that there isn't any work involved. A word of advice: set aside enough time for your outputs. If there's a real time factor involved, as for a videotape output, make sure you budget enough time to set up the output and do it twice in real time. It's not uncommon that you'll find you forgot something and need to start over half-way through. If your output is digital and requires rendering or compressing files, it could take even longer. If you include the prep work in your plans, you can avoid the panic mode that often sets in at the end.

VIDEO OUTPUTS

At the present, most projects will need to make a videotape output at some point or other, whether it's a viewing copy or the real deal.

Videotape outputs are relatively simple, as long as you have the right equipment. Hopefully, you performed the testing recommended in the tutorial in Chapter 7, "Setting Up and Managing a Project." If so, you can count on a trouble-free output.

OUTPUTTING FROM YOUR NON-LINEAR EDITING SYSTEM

The quality of the outputs you make from a non-linear editing system is dependent on three things: the quality of the camera original footage, the quality level at which it was captured, and the videotape format to which you are outputting. In other words, if you shot the film with your Dad's old VHS camcorder, but then captured at an uncompressed resolution and output to Digital Betacam, the footage is still going to look like VHS. Maintaining image quality as you capture is discussed in detail in Chapter 8, "Getting Media into Your Computer." As for the quality of the output format, that depends on the purpose of the output—for viewing copies, VHS is usually the best choice. For a final master, a high-quality digital format is the ideal. Whatever your needs, there are three ways to get your digital media onto videotape:

- **Hard records**. If you don't have a system with deck control, you can still output to tape by sending the video and audio signals out of the computer and into the videotape deck, and then pressing Play and Record (or just Record on some decks). In the professional world, this is called a *hard record*. With a hard record, the deck records over all the tracks, including the control track.
- **Assemble edits**. Assemble edits are a more sophisticated version of a hard record. Using the interface in your NLE and deck control, an assemble edit

records onto all the tracks of the videotape, including the control track (Figure 12.1). With assemble edits, you can usually record to a deck at a specific timecode, providing that the first few minutes of the tape have been black and coded.

- **Insert edits**. Insert edits are the most sophisticated of all. They let you record to a tape at a specific timecode and choose which tracks you wish to record (Figure 12.1). In order to perform an insert edit, you need a tape that's been black-and-coded. Insert edits are useful if you need to make a change to a small portion of the master after you've already done the output. If you want to replace a shot, you can set in- and out-points, and *punch in* only the track you need. You'll need a high-end deck—DVCAM or better—that supports insert edits.

Assemble edit

Insert edit (V1, A1 and A2)

FIGURE *Assemble edits record over all the tracks on the tape (A); insert edits record over the* **12.1** *tracks you select (B).*

Up-Res-It Yourself

If you've been working at a low resolution and it's time to recapture the footage at a high resolution, you should try to avoid recapturing the audio. This will save you the hassle of having to remix the tracks. If you're working with a QuickTime native editing system, the video and audio are stored as part of the same file. However, you can extract the audio tracks, with timecode, in QuickTime Pro. Be sure to save them as QuickTime movies, not AIFF or WAV files, or you'll lose the timecode information.

HEAD SLATES

It's standard procedure to start all final masters at hour one exactly, or 1:00:00:00. If you send your master to a duplication facility or to a network for broadcast, they will assume that the first frame of your project starts at hour one. (If you can only create a videotape output using a hard record, you won't be able to do this.) Most master tapes have timecode that starts at around 00:58:30:00. This gives a minute and a half for color bars and head slates, prior to the one-hour mark. There's a good reason for this: the first minute or so of a videotape is the area most prone to damage. By starting the program a little later, there's less risk of dropouts at the head of the master. The minute and a half of tape prior to hour one is used to record one minute of bars and tone, then 10 seconds of black, then a 10-second slate identifying the content of the tape, and then either 10 more seconds of black, or if the tape is destined for broadcast, a 10-second countdown. The slate usually includes the following information: project name, total run time (TRT), date of the output, production company's name, name of the producer or director, name of the editor, and which version it is—first rough cut, final master, textless master, and so forth.

Protect Yourself

Today, most video projects are mastered on to a digital tape format. After the master is created, a digital clone is made to reserve as a protection copy.

MOVING YOUR PROJECT TO AN ONLINE EDITING SYSTEM

If you used your NLE as an offline editing system and are now ready to move to an online editing system, you'll have to move your media from the offline sys-

tem to an online system. The method that works best for you will depend on your project needs.

- **Move the drives containing the media and the project file** if the online system is compatible with the project file you created on the offline system. This method is useful if you are simply moving to an online editing system for color correction, or some other form of image enhancement that doesn't require recapturing the media.
- **Deliver an EDL and the source tapes** for recapturing. EDLs contain a very limited amount of information when it comes to special effects, so you may find that you have to rebuild effects from scratch if you go with this method. See the EDL section on page 335 for more on effects and EDLs.
- **Deliver the project file and the source tapes** if the online system is compatible with the offline system. This way, the online editor will have the project file as a resource, including special effects information that can't be included in an EDL.

PREPARING TO CREATE AN EDL

If you are creating an EDL from your edited sequence, you need to do a little prep work first. Make a copy of your final edited sequence as a backup, and then do the following (Figure 12.2):

- Collapse all the video onto a single track.
- Remove nested sequences. You'll need to paste the contents of the nested sequence into the primary video track in the timeline.
- Remove temporary items, such as titles and effects.
- Remove/replace anything that doesn't have timecode.
- Remove nonstandard effects. EDLs can only provide information about standard SMPTE digital video effects (DVEs). Typically, you'll be limited to dissolves, 20 standard wipes, and a static superimposition track.
- Make a guide output on videotape with mixed audio and matching timecode, preferably burn-in.
- Be sure to export the right format EDL. In general, the standard EDL format is CMX-3600, but there are other formats such as Sony, GVG, Axial, and others.
- If you have more than 800 picture edits in your project, break the project into two parts and create two EDLs. There's usually a limit to the number of lines you can have in a standard EDL.
- Make sure frame rates used in motion effects are supported by the online system hardware. If you have a motion effect with a frame rate of, say, 52.97%, it's likely that it's not supported.

A. This locked sequence would result in a "dirty" list.

B. The same sequence, collapsed onto a single video track and stripped of all effects, non-standard transitions and audio.

FIGURE *The original sequence, and the same after preparing to create an EDL.*
12.2

TIP

Reel IDs for DV Tapes

Long projects shot on miniDV pose a special problem. Since you cannot define the timecode on a miniDV tape, all the source tapes will start at 00:00:00:00. In addition, if the camera was turned off during the shoot, the tape might have two or more sections that start at 00:00:00:00. This can wreak havoc on an EDL, so be sure to take note of tapes that have more than one timecode start, and assign each section of the tape a different reel ID.

WHAT'S IN AN EDL?

Technologically speaking, EDLs are old news; they've been around since the 1970s, and the information they contain is very simple and very specific. EDLs are nothing more than tab-delimited text files—a standard way of organizing digital information. When you export an EDL, you'll have to tell the software what to include (Figure 12.3). The options can consist of the following:

- **Header**. Contains information about the name of the project, whether it's dropframe or non-dropframe, and other basics.
- **Event number**. Each edit is considered an "event," and each event has a number.
- **Reel ID**. Each source tape is identified by a nine-character reel ID.
- **Tracks**. The tracks involved in the edit: V for video, A1 for audio track one, A2 for audio track two, and AA for both audio tracks. You can also have a second video track, V2, for superimpositions.
- **Type of edit**. C stands for a straight cut, D for dissolve, W for a wipe, and K for a key effect.

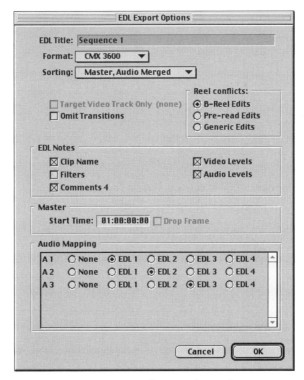

FIGURE *Exporting an EDL from Apple Final Cut Pro 2.0.*
12.3

- **Source timecode**. In and out—identifies the start and end of each shot on the source reel.
- **Master timecode**. In and out—identifies where the shot is placed in the master edit.
- **Sort mode**. The edits in your EDL can be arranged in different ways. An *A-mode* list is sorted by master timecode in, or from start to finish on the master. A *C-mode* list is sorted by tape number and source timecode. This can be a faster way to assemble an online edit, because there's less time spent cueing source tapes. There are also B, D, and E modes that are not commonly used. Figure 12.4 shows an EDL in A-mode and C-mode.
- **Comments**. Comments can be added to most EDLs, letting you add notes to the online editor about special circumstances and so on.
- **Prereading and b-reels**. If you want to dissolve between two shots on the same source tape in a linear editing, this will be accomplished either using prereads or a b-reel. To create a dissolve, linear editing systems need to be able to play the a-side of the dissolve and the b-side simultaneously. If the a-side and the b-side are on the same source tape, this poses a problem. High-end decks can preread, or store frames in memory, to create the dissolve. If the equipment you're working with can preread, you'll need to create a "b-reel," a new source reel with all the b-sides of the dissolves that occur on the same source tapes.

Event	Tape I.D.			Source In	Source Out	Master In	Master Out

```
001  005285  V  C  17:09:22:20  17:09:23:14  01:05:11:10  01:05:12:04
002  005287  V  C  19:22:55:18  19:23:00:29  01:05:12:04  01:05:17:13
003  005286  V  C  18:23:50:17  18:23:58:17  01:05:17:13  01:05:25:13
004  005285  V  C  17:28:50:16  17:28:51:15  01:05:25:13  01:05:25:12
```

A-mode EDL Tracks selected (in this case video only)

```
001  005285  V  C  17:09:22:20  17:09:23:14  01:05:11:10  01:05:12:04
002  005285  V  C  17:28:50:16  17:28:51:15  01:05:25:13  01:05:25:12
003  005286  V  C  18:23:50:17  18:23:58:17  01:05:17:13  01:05:25:13
004  005287  V  C  19:22:55:18  19:23:00:29  01:05:12:04  01:05:17:13
```

C-mode EDL

FIGURE *A portion of a sample EDL sorted in A-mode and C-mode.*
12.4

TIP

RT11 Disks

Many linear online editing systems can only read EDLs that are saved on a special disk format, called RT11. To format an RT11 disk, you need a standard floppy disk and software that can create that format, like Avid Media Composer. Focal Point Systems, makers of Film Logic, have an application called EDL Access that will let you format an RT11 disk.

AUDIO OUTPUTS

If you used your non-linear editing system to create a final master and record it onto videotape, you probably recorded the audio at the same time. However, there are all kinds of circumstances where you might need to output the audio separately:

- **Laying back to videotape**. If your videotape master was created at an online facility or went through a color correction process, you might need to add the audio to the master tape later, a process known as a *lay back*. To do a lay back, you'll need to be able to perform an insert edit of just the audio tracks. See the section on insert edits earlier in this chapter.

- **Multitrack outputs**. Multi-track outputs are the best way to back up your soundtracks, in case you want to remix later, whether it's to create a foreign language dubbed version of your project, or to create a different mix for another format—say, a DVD. To do a multitrack output, you'll send each track of audio in your project out to a different channel on audio tape. The Tascam DA88 is a great tool for this job, since it records eight tracks, plus timecode. You can also send two tracks at a time to a videotape format like DVCAM. If you have 24 tracks, you'll need 12 DVCAM tapes. You'll need to use hardware that can perform an insert or an assemble edit, so that you can make sure all the tapes have matching timecode.

MOVING AUDIO TO ANOTHER WORKSTATION

It's also very common to move audio from one workstation to another, whether to complete the mix or to create different media, such as DVDs. Just as with video, there are several ways to move audio media around:

- **OMF export**. The OMF format lets you export audio files, timecode, edited timeline, and handles in a self-contained file. This is exceptionally useful when exporting an already-edited sound sequence to an audio editing workstation for sweetening.

FIGURE *Exporting an OMF from Apple Final Cut Pro 2.0.*
12.5

- **EDLs**. EDLs can also be used to recreate audio edits on a digital audio workstation. Most EDL formats can handle four tracks of audio. Remember, if your media doesn't have timecode—say, a song off CD for instance—useful information about it won't end up in the EDL. This is a good way to go if your sound editor is planning to recapture the audio using higher-quality equipment.
- **AIFF and WAV files**. AIFF (Mac) and WAV (IBM) files are both digital audio file formats. You can export to these formats from almost any NLE. One drawback is that these formats do not save timecode information.
- **QuickTime**. If you need timecode associated with your digital audio files, you can export audio and timecode to an audio-only QuickTime movie. The downside is that many sound-editing applications cannot work with QuickTime audio files.

FILM OUTPUTS

Film outputs are intrinsically different from video outputs. There are two basic categories: film outputs for projects that originated on film, or cut lists; and film outputs for projects that originated on video, or video-to-film transfers.

CUT LISTS

When a project that originated on film is finished, it's necessary to generate a cut list to give to the negative cutter in order to conform the negative. Cut lists are the film equivalent of EDLs, and include the original keycode numbers on the film stock, timecode for the video guide output, and film reel IDs.

Just as you need to prepare your sequence to export an EDL, you also need to prepare your sequence if you're exporting a cut list. For film original projects, checking for duplicate footage is a must. Since there's only one negative, you

can't use the same piece of footage twice unless you create a dupe reel. Film-oriented software—like Avid Film Composer, Lightworks, and Film Logic—will find duplicates and create a list for the dupe reel for you. The next step is to replace any temporary elements, or *opticals*, that include titles and special effects shots. As with EDLs, you'll need to remove any nested sequences, collapse the video onto one track, and remove temporary effects.

Once you generate the cut list, it's a good idea to output a guide videotape with window burn-in master timecode, in addition to the already burned-in source timecode and keycode on each shot. This will help the negative cutter in case there are any questions when conforming the negative. Be aware that if you cut the film in a 24-fps project and then create a 29.97-fps NTSC videotape output, or 25-fps PAL output, the timecode on the tape won't match the timecode in the cut list. You can use After Effects to convert your final sequence from 24 fps to 29.97 or 25 fps, although this will require a long rendering session.

Remember that when you export the sound to send to a mixer for a film original project, you may have to compensate for pulldown (see Chapter 8 for more about film and sound). The cut list is the tip of the iceberg when it comes to finishing a film.

VIDEO-TO-FILM TRANSFERS

If you're planning on a videotape-to-film transfer, you should be in regular contact with the company that's going to do the transfer. They'll have suggestions as to how to shoot the video in a way that best suits their transfers, and also things you can do while capturing and editing to ensure the best quality final master. Some companies like to get a totally finished final master and transfer it directly to film; others want a master that has no dissolves or other effects; and others need tapes that are A/B rolled. It's also likely that you'll have to break longer projects into 20- or 40-minute reels. Since the methods of transferring video to film differ from one company to another, it's important to decide on a transfer house early on and stick with their advice.

Currently, there are three popular methods for doing a tape-to-film transfer:

- **Digital laser transfer** takes the video file and converts it to an RGB environment. Each frame is then saved as a separate, high-resolution file and is recorded on film with a special laser. This method is considered the best quality, and is the most expensive.
- **Digital CRT transfer** is similar to a digital laser transfer, except a CRT (cathode ray tube) is used instead of a laser. This process is considered very high quality, but not quite as good as a digital laser transfer.

- **Electron beam recording** is the lowest-quality method of transferring video to film. The video image is converted to three RGB channels that are each recorded onto 16mm black-and-white film stock using an electron beam. They are then composited using an optical printer to create a color negative.

DIGITAL DELIVERY

Expect the information in this category to change quickly! Always do your homework before you plan a digital delivery—you never know what might have appeared on the market since you last delivered something.

STREAMING MEDIA

Creating streaming media for the Web involves a series of tradeoffs—image quality and playback versus fast download times and accessibility for a large percentage of viewers. Terran Interactive's Cleaner 5 is the software of choice when it comes to converting video to Web-compatible streaming formats and comes bundled with just about every NLE on the market.

The following formats are used for streaming media:

- **Streaming QuickTime** is one of the two leading formats for Web delivery.
- **RealMedia** is probably the most popular format for Web delivery, and as such, guarantees the largest user base.
- **Flash and Shockwave** were originally designed for streaming animation. Although you can export video to the Flash and Shockwave formats, they might get bogged down with anything more than the shortest, most compressed piece of video. Look for new products on the market designed to convert QuickTime and AVI video to Flash player files.

CD-ROM

Although the hype surrounding DVDs has taken a lot of the spotlight away from CD-ROMs, they're still a viable format for press kits, including music videos on audio CDs, games, interactive projects, and corporate presentations. Another advantage is that recordable CD-ROMs are very cheap when compared to videotape—about $1 each. Unfortunately, the standard CD-ROM can only hold about 650MB, so you'll be limited in terms of length and image quality.

There are two steps to output to a CD-ROM (or CD-RW):

- **Compress the video**. Since CDs are relatively slow and somewhat small, you'll have to compress your video before you send it out to CD. Typically, video on a CD-ROM is resized to 320 x 240 pixels, or one-quarter the size

of full-screen video. For slower CD-ROM drives (2x or 4x), Cinepak is the best codec to use, although the loss in image quality is clearly apparent. Of all the codecs suitable for CD-ROM use, MPEG1 produces the best quality output, but requires a fast computer for playback. You'll need to buy special MPEG1 encoding software to export video in this format. Another good codec is the Sorenson video compressor, which provides a nice balance between quality, file size, and system requirements. Compressing with any codec will take a long time.

- **Arrange the compressed files on your hard drive and burn the CD**. With so many computers coming with preinstalled CD-R drives, this is the easiest part of the process.

TIP

Outputting Overscan
Media captured from videotape includes an overscan area— black edges of the frame that aren't visible on a TV set. If you're outputting to a digital file format, the overscan area will remain visible; to get rid of it, crop the image before outputting.

VCD

Video CDs, or VCDs, are the predecessor to DVDs and are very popular outside North America. The standard VCD format uses MPEG1 compression and holds about 74 minutes of full-screen, full-motion NTSC or PAL video on an ordinary 650MB CD-ROM or CD-RW.

VCDs can be played on special VCD players, on some DVD players, and on most Mac and Windows-based computers.

There are several VCD formats:

- **VCD 1.1** is the original specification developed by Sony and Phillips in 1993.
- **VCD 2.0** can deliver NTSC and PAL video, and provides hi-res, interactive menus similar to DVDs.
- **VCD-ROM** is a hybrid format that supports both computer data and VCD 2.0 on the same disk.
- **VCD-Internet** is a variation of VCD-ROM that includes video as well as links to control online or on-disc content, stored in the form of Web pages. This format also includes drivers that allow the disc to play on any Mac or Windows machine without having to install special software.

Creating a VCD is similar to creating a CD. First, you'll need to compress the video using MPEG1 encoding software, and then you'll need software that can write VCD format, such as Adaptec Toast for Macintosh or Easy CD Creator for Windows.

DVD

DVDs are becoming increasingly popular and it looks like they'll soon replace VHS tape as the standard viewing format of choice. There are a number of DVD authoring products on the market, and the hardware technology for burning DVDs is trickling down fast, having already reached the high end of the consumer desktop market. At the moment, the standard process for mass-producing DVDs is to use DVD authoring software—like DVDit or DVDstudio—to create the interactive content and then export the DVD media to a DLT tape for delivery. If you're not mass-producing DVDs, you can simply create a DVD using a DVD burner the same as you would a CD.

DVDs use MPEG2 encoding, a higher-quality version of the MPEG1 specification used for VCDs. Once you're finished editing, you'll need to convert your final project to MPEG2. Be aware that compressing to MPEG2 takes a long time if you're using software-based compression. DVDs can hold about 10GB of media, which is why the standard medium for delivering DVD media is DLT, a tape format that can hold up to 40GB on a single cartridge.

Audio for mass-produced DVDs is mixed using Dolby Digital A-3 surround-sound technology. You'll have to go to a professional mixer to create this type of mix. If you're not heading for the mass market, a standard stereo mix will suffice. The DVD authoring software you use will convert the OMF or AIFF audio to A-3 for you.

There are basically two types of DVD content: interactive content that includes a film project, ancillary materials, such as director commentaries, featurettes, and so on; and DVDs that simply contain the filmed project itself—in other words, DVDs that act as a replacement for videotape. The former will require quite a bit of work to put the entire package together. The latter simply requires that you compress your footage and burn the DVD.

Whatever your needs, be aware that there are several types of DVD formats, and not all players can read all of them—DVD-Video, DVD-ROM, DVD-RAM, DVD-RW, and DVD+RW.

The bad news is that DVD-Video players are the most likely to be unable to play different format DVDs. The good news is that DVD drives inside most computers can play any of these formats. The even better news is that you can use DVD software to burn DVD material on a standard CD-R, and give it to the director to screen the cut on his or her own computer. The not-so-hot news is that it'll take longer than doing a real-time output to tape.

ARCHIVING YOUR PROJECT

Last but not least, it's important to archive your project. The cheapest way to archive a project is by saving it as an EDL on a CD-ROM (more stable than the

standard floppy disk). You can also back up the project and the media to a large-format tape storage medium such as DLT or DAT. If you think you'll need media again and you captured uncompressed digital video footage, you can output a string-up of all the shots in your project back onto the original digital video format without any loss of quality.

APPENDIX

Videotape Formats

There are two types of videotape formats: analog and digital. Many of the digital specifications listed here cannot be applied to analog formats—it's a case of comparing apples and oranges. Here's a brief summary of the significance of the more obscure specifications listed in this appendix:

Scanning system: Different head systems mean that the data is recording in a different pattern on the tape.

Data rate: For digital formats, the higher the data rate, the higher the image quality.

Color sampling: The "uncompressed" ratio of 4:2:2 is considered ideal.

Color depth: The more bits, the more information, and the better the color representation.

Interlace or progressive scan: Interlaced means two fields; progressive means no fields.

Tape speed: The faster the tape speed, the more space there is to record data, and the better the quality of the recording.

Tape width: Wider tapes are more stable physically.

What follows is a list of most of the existing videotape formats on the market and their specifications.

VHS

(Video Home System)

Introduced: 1976
Developer: JVC

345

Format type: Analog composite
Scanning system: Two-head helical
Data rate: Not applicable
Color sampling: N/A—analog composite
Color depth: N/A
Compression: N/A
Interlace or progressive scan: Interlaced
Square or nonsquare pixels: N/A
Timecode tracks: None
Longest tape length: 8 hours (EP)
Tape speed: SP—1.3 inches per second (ips); LP—.66 ips; EP—.44 ips
Tape width: 1/2"
Video tracks: One
Audio tracks: Two longitudinal; two AFM

S-VHS

(aka Super-VHS)

Introduced: 1987
Developer: JVC
Format type: Analog S-video
Scanning system: Two-head helical
Data rate: N/A
Color sampling: N/A—analog S-video
Color depth: N/A
Compression: N/A
Interlace or progressive scan: Interlaced
Square or nonsquare pixels: N/A
Timecode tracks: None
Longest tape length: 120 minutes
Tape speed: 1.3 ips
Tape width: 1/2"
Video tracks: One
Audio tracks: Two longitudinal; two AFM
Digital audio tracks: Two @ 48 kHz; four 32 @ kHz

HI-8

Introduced: 1989
Developer: Several

Format type: Analog composite
Scanning system: Two-head helical
Data rate: N/A
Color sampling: N/A—analog composite
Color depth: N/A
Compression: N/A
Interlace or progressive scan: Interlaced
Square or nonsquare pixels: N/A
Timecode tracks: Recorded on video tracks
Longest tape length: 120 minutes
Tape speed: .57 in/sec
Tape width: 8mm
Video tracks: One
Audio tracks: Two AFM
Digital audio tracks: Two @ 48 kHz; four 32 @ kHz

DIGITAL 8

Introduced: 1999
Developer: Sony and others
Format type: Digital
Scanning system: Two-head helical
Data rate: 25 Mb/sec
Color sampling: 4:1:1
Compression: DV-based
Interlace or progressive scan: Interlaced
Square or nonsquare pixels: Nonsquare
Timecode tracks: None
Longest tape length: 120 minutes
Tape width: 8mm
Video tracks: One
Audio tracks: Two AFM
Digital audio tracks: Two 32 kHz

DV

(aka DVC)
Introduced: 1996
Developer: EIAJ
Format type: Digital component

Scanning system: Multihead helical
Data rate: 25 Mb/sec
Color sampling: 4:1:1
Color depth: 8 bits
Compression: DCT-based
Interlace or progressive scan: Interlaced
Square or nonsquare pixels: nonsquare
Timecode tracks: Yes
Longest tape length: 210 minutes
Tape speed: 18.831 mm/sec
Tape width: 6.35mm (1/4")
Video tracks: One
Digital audio tracks: Two @ 16 bit / 48 kHz; four @ 12 bit/ 32 kHz

DVCAM

Introduced: 1996
Developer: Sony
Format type: Digital component
Scanning system: Two-head helical
Data rate: 25 Mb/sec
Color sampling: 4:1:1
Color depth: 8 bits
Compression: DCT/DV intraframe
Interlace or progressive scan: Interlaced
Square or nonsquare pixels: Nonsquare
Timecode tracks: Longitudinal and VITC
Longest tape length: 210 minutes
Tape speed: 33.85 mm/sec
Tape width: 6.35mm (1/4")
Video tracks: One
Audio tracks: One longitudinal cue track
Digital audio tracks: Two @ 16 bit / 48 kHz; four @ 12 bit/ 32 kHz

DVCPRO

Introduced: 1995
Developer: Panasonic
Format type: Digital component
Scanning system: Multihead helical

Data rate: 25 Mb/sec
Color sampling: 4:1:1
Color depth: 8 bits
Compression: DCT/DV intraframe
Interlace or progressive scan: Interlaced
Square or nonsquare pixels: Nonsquare
Timecode tracks: Longitudinal and VITC
Longest tape length: 210 minutes
Tape speed: 33.85 mm/sec
Tape width: 6.35mm (1/4")
Video tracks: One
Audio tracks: One longitudinal cue track
Digital audio tracks: Two @ 16 bit / 48 kHz; four @ 12 bit/ 32 kHz

3/4" UMATIC

Introduced: 1971
Developer: Sony/JVC/Matsushita
Format type: Analog
Scanning system: Two-head helical
Data rate: N/A
Color sampling: N/A
Color depth: N/A
Compression: N/A
Interlace or progressive scan: Interlaced
Square or nonsquare pixels: N/A
Timecode tracks: LTC timecode track and VITC
Longest tape length: 60 minutes
Tape speed: 3.75 in/sec
Tape width: 3/4" (19mm)
Video tracks: One
Audio tracks: Two longitudinal
Digital audio tracks: N/A

1" TYPE C

Introduced: 1976
Developer: Ampex/Sony
Format type: Analog
Scanning system: 1-1/Two head helical

Data rate: N/A
Color sampling: N/A
Color depth: N/A
Compression: N/A
Interlace or progressive scan: Interlaced
Square or nonsquare pixels: N/A
Timecode tracks: On third audio channel
Longest tape length: 120 minutes
Tape speed: 9.6 in/sec
Tape width: 1"
Video tracks: One
Audio tracks: Three longitudinal
Digital audio tracks: N/A

BETACAM SP (BETASP)

Introduced: 1986
Developer: Sony
Format type: Analog component
Scanning system: Two-head helical
Data rate: N/A
Color sampling: N/A—analog component
Color depth: N/A
Compression: N/A
Interlace or progressive scan: Interlaced
Square or nonsquare pixels: N/A
Timecode tracks: LTC timecode track and VITC
Longest tape length: 94 minutes
Tape speed: 4.67 ips
Tape width: 1/2"
Video tracks: One
Audio tracks: Two longitudinal; two AFM
Digital audio tracks: Two @ 48 kHz; four 32 @ kHz

BETACAM SX

Introduced: 1996
Developer: Sony
Format type: Digital component
Scanning system: Two-head helical

Data rate: 18 Mb/s
Color sampling: 4:2:2—CCIR 601
Color depth: 10 bits
Compression: MPEG2 p@ml
Interlace or progressive scan: Both
Square or nonsquare pixels: Nonsquare
Timecode tracks: LTC timecode track and VITC
Longest tape length: 180 minutes
Tape speed: 2.345 ips
Tape width: 1/2"
Video tracks: One
Audio tracks: One longitudinal cue track
Digital audio tracks: Four @ 16 bit/48 kHz

DVCPro 50

Introduced: 1995
Developer: Panasonic
Format type: Digital component
Scanning system: Multihead helical
Data rate: 50 Mb/sec
Color sampling: 4:2:2
Color depth: 8 bits
Compression: DCT/DV intraframe
Interlace or progressive scan: Interlaced
Square or nonsquare pixels: Nonsquare
Timecode tracks: Longitudinal and VITC
Longest tape length: 210 minutes
Tape speed: 67.6 mm/sec
Tape width: 6.35mm
Video tracks: One
Audio tracks: One longitudinal cue track
Digital audio tracks: Four @ 16 bit / 48 kHz

Digital Betacam

Introduced: 1993
Developer: Sony
Format type: Digital component
Scanning system: Multihead helical

Data rate: 127.76 Mb/s
Color sampling: 4:2:2—CCIR 601
Color depth: 10 bits
Compression: DCT-based
Interlace or progressive scan: Interlaced
Square or nonsquare pixels: Nonsquare
Timecode tracks: LTC timecode track and VITC
Longest tape length: 124 minutes
Tape speed: 3.8 ips
Tape width: 1/2"
Video tracks: One
Audio tracks: One longitudinal cue track
Digital audio tracks: Four @ 20 bit/48 kHz

D1

Introduced: 1987
Developer: Sony
Format type: Digital component
Scanning system: Multihead helical
Data rate: 112 Mb/sec
Color sampling: 4:2:2—CCIR 601
Color depth: 8 bits
Interlace or progressive scan: Interlaced
Square or nonsquare pixels: Nonsquare
Timecode tracks: LTC timecode track and VITC
Longest tape length: 245 minutes
Tape speed: 11.28 in/sec
Tape width: 19mm (3/4")
Video tracks: One
Audio tracks: One longitudinal track
Digital audio tracks: Four @ 20 bit/48 kHz

D2

Introduced: 1989
Developer: Ampex/Sony
Format type: Digital composite
Scanning system: Multihead helical
Data rate: 60.1 Mb/sec

Color depth: 8 bits
Interlace or progressive scan: Interlaced
Square or nonsquare pixels: Nonsquare
Timecode tracks: LTC timecode track and VITC
Longest tape length: 208 minutes
Tape speed: 5.19 in/sec
Tape width: 19mm (3/4")
Video tracks: One
Audio tracks: One longitudinal track
Digital audio tracks: Four @ 20 bit/48 kHz

D3

Introduced: 1991
Developer: Panasonic
Format type: Digital composite
Scanning system: Multihead helical
Color depth: 8 bits
Interlace or progressive scan: Interlaced
Square or nonsquare pixels: Nonsquare
Timecode tracks: LTC timecode track and VITC
Longest tape length: 245 minutes
Tape speed: 83.88 mm/sec
Tape width: 1/2"
Video tracks: One
Audio tracks: One longitudinal track
Digital audio tracks: Four @ 20 bit/48 kHz

D5

Introduced: 1994
Developer: Panasonic
Format type: Digital component
Scanning system: Multihead helical
Data rate: 288 Mb/s
Color sampling: 4:2:2—CCIR 601
Color depth: 8 or 10 bits
Compression: None
Interlace or progressive scan: Interlaced
Square or nonsquare pixels: Nonsquare

Timecode tracks: LTC timecode track and VITC
Longest tape length: 124 minutes
Tape speed: 167 mm/sec
Tape width: 1/2"
Video tracks: One
Audio tracks: One longitudinal cue track
Digital audio tracks: Four @ 20 bit/48 kHz

D5 HD

Introduced: 1994
Developer: Panasonic
Format type: Digital component
Scanning system: Multihead helical
Data rate: 288 Mb/s
Color sampling: 4:2:2—CCIR 601
Color depth: 10 bits
Compression: None
Interlace or progressive scan: Both
Square or nonsquare pixels: N/A
Timecode tracks: LTC timecode track and VITC
Longest tape length: 124 minutes
Tape speed: 167 mm/sec
Tape width: 1/2"
Video tracks: One
Audio tracks: One longitudinal cue track
Digital audio tracks: Four @ 20 bit/48 kHz

D9

(aka Digital-S)
Introduced: 1996
Developer: JVC
Format type: Digital component
Scanning system: Four-head helical
Data rate: 50 Mb/s
Color sampling: 4:2:2—CCIR 601
Color depth: 10 bits
Compression: DCT-based intraframe
Interlace or progressive scan: Both

Square or nonsquare pixels: Nonsquare
Timecode tracks: LTC timecode track and VITC
Longest tape length: 124 minutes
Tape speed: 2.27 in/sec
Tape width: 1/2"
Video tracks: One
Audio tracks: Two longitudinal cue tracks
Digital audio tracks: Four @ 16 bit/48 kHz

D9 HD

Introduced: 1998
Developer: JVC
Format type: Digital component
Scanning system: Eight-head helical
Data rate: 100 Mb/s
Color sampling: 4:2:2—CCIR 601
Color depth: 10 bits
Compression: DCT-based intraframe
Interlace or progressive scan: 1080i/720p
Square or nonsquare pixels: nonsquare
Timecode tracks: LTC timecode track and VITC
Longest tape length: 60 minutes
Tape speed: 115 mm/sec
Tape width: 1/2"
Video tracks: One
Digital audio tracks: Eight @ uncompressed

HDCAM

Introduced: 1997
Developer: Sony
Format type: Digital component
Scanning system: Helical
Data rate: 140 Mb/s
Color sampling: 3:1:1
Color depth: 8 bits
Compression: DCT-based intraframe
Interlace or progressive scan: Both include 1080P/24 fps
Square or nonsquare pixels: Nonsquare

Timecode tracks: LTC timecode track and VITC
Longest tape length: 124 minutes
Tape speed: 96.7 mm/sec
Tape width: 1/2"
Video tracks: One
Audio tracks: One longitudinal cue track
Digital audio tracks: Four @ 20 bit/48 kHz

DVCPRO 100

Introduced: 1998
Developer: Panasonic
Format type: Digital component
Scanning system: Multihead helical
Data rate: 100 Mb/sec
Color sampling: 4:2:2
Color depth: 8 bits
Compression: DCT/DV intraframe
Interlace or progressive scan: Interlaced
Square or nonsquare pixels: Nonsquare
Timecode tracks: Longitudinal and VITC
Tape width: 6.35mm (1/4")
Video tracks: One
Audio tracks: One longitudinal cue track
Digital audio tracks: Four @ 16 bit / 48 kHz

APPENDIX

Video Standards

There are different standards for broadcast television in different parts of the world. They differ in terms of frame rate, number of scan lines, and the method of scanning, among other things. As a result, transferring from one standard to another can be expensive. NTSC is common in the Americas and Japan, although Japanese NTSC does differ slightly. PAL is the most common standard in the rest of the world, with the exception of France, Russia, and most of Eastern Europe, which use SECAM.

NTSC

(National Television Standards Committee)

Regions: North America, South America, and Japan*
Frame rate: 29.97 fps
Horizontal resolution: 525 scan lines
Scanning method: Interlaced (two fields)

Analog
Field dominance: Variable
Aspect ratio: 4:3

* NTSC from the Americas uses a black level of 7.5 IRE; NTSC from Japan uses a black level of 0 IRE. All other TV standards use a black level of 0 IRE.

PAL

(Phase Alternate by Line)

Regions: Europe (except France)
Frame rate: 25 fps
Horizontal resolution: 625 scan lines
Scanning method: Interlaced (two fields)

Analog
Field dominance: Upper
Aspect ratio: 4:3

SECAM

(Sequence Couleur a Memoire)

Regions: Asia, Russia, and France
Frame rate: 25 fps
Horizontal line resolution: 625 lines
Scanning method: Interlaced (two fields)

Analog
Aspect ratio: 4:3

DTV

(Digital Television)

The Digital Television Standard has yet to be implemented in the United States and is actually a set of standards that include SDTV and several variations of HDTV.

SDTV
(Standard Definition Television)**

Frame rate: 60P, 60I, 30P, 24P***
Pixels per line: 640
Horizontal line resolution: 480
Scanning method: Interlaced (two fields) or progressive scan

Digital**
Aspect ratio: 4:3

**SDTV is the digital equivalent of NTSC, and was developed to ease the transition from analog to digital television transmission.

***I stands for Interlaced; P for Progressive scan.

HDTV
(High Definition Television)

Frame rate: 60I, 30P, 24P
Horizontal line resolution: 1080
Pixels per line: 1920
Scanning method: Interlaced (two fields) or progressive scan

Digital
Aspect ratio: 16:9
Frame rate: 60P, 30P, 24P
Horizontal line resolution: 720
Pixels per line: 1280
Scanning method: Progressive scan

Digital
Aspect ratio: 16:9
Frame rate: 60P, 60I, 30P, 24P
Horizontal line resolution: 480
Pixels per line: 704
Scanning method: Interlaced (two fields) or progressive scan

Digital
Aspect ratio: 16:9 and 4:3

APPENDIX

C About the CD/DVD

The CD/DVD contain files to assist you in your editing endeavors. There are three main folders: Demos, Tutorials, and Extras. The Demos folder contains software useful for editing and special effects. The Tutorials folder contains media needed for some of the tutorials in this book. The Extras folder contains extra items you may need when editing.

The contents of the CD and DVD are basically the same; however, the tutorial media on the CD is highly compressed due to storage constraints. In addition, in the case of some of the tutorials, there is more media available with which to edit on the DVD. The specific contents of the CD and DVD are listed next. Refer to the system requirements in this appendix to ensure that your system is ready to work with these files.

To use the items in the CD/DVD, you should select the folder you wish to use, and then select the appropriate file or folder. For the tutorial media, it is highly recommended that you drag the folder to your hard drive, rather than working directly from the CD/DVD.

ABOUT THE CD

The CD contains the following:

DEMOS

The demo files have been archived to allow for more space on the CD. Mac users must unstuff the macdemos.sea file to open the demo

archive, and Windows users must unzip the windemos.zip file (see system requirements).

Macintosh Demos

- Adobe Premiere 6
- Adobe Photoshop 6
- Adobe After Effects 4.1
- Digital Origin EditDV Unplugged
- Boris Red
- Trakker Technologies Slingshot

Windows Demos

- Adobe Premiere 6
- Adobe Photoshop 6
- Adobe After Effects 4.1
- Digital Origin FreeDV
- Boris FX
- in:sync Speed Razor 2000
- Ulead Media Studio Pro 6
- Trakker Technologies Slingshot

TUTORIALS

You will need 350MB of disk space to save the tutorials media from the CD onto your computer.

- **Knights Promo tutorial and Knights Bluescreen tutorial**. The footage for these tutorials is 720 × 576, 25 fps, PAL video that uses Sorenson Video compression. The audio is 22 kHz, 16-bit stereo.
- **All other tutorials**. The footage for all of the other tutorials is 720 × 480, 29.97 fps, NTSC video that uses Sorenson Video compression. The audio is 22 kHz, 16-bit stereo.
- **Final Movies**. The Final Movies folder contains final edited versions of the tutorials in this book.

EXTRAS

- **Audio reference tone**. In both AIFF format for Macintosh and WAV format for Windows, 60 Hz tone is used to calibrate audio, a process also described in Chapter 8.

- **Test patterns**. Still images of NTSC and PAL color bars can be used to calibrate the video signal, as described in Chapter 8. In both AIFF format for Macintosh and WAV format for Windows, 60 Hz tone is used to calibrate audio, a process also described in Chapter 8.

The Sorenson Codec and Native DV Editing

TIP

If you are editing in a DV-native environment, such as Final Cut Pro, EditDV, or Avid Xpress DV, the media on the CD/DVD compressed with the Sorenson codec will need to be rendered before you can play it back in real time. It's a good idea to drag all of the Sorenson-compressed media clips into a sequencer, render it, and then record it onto DV videotape and recapture it. That way, you'll be working with DV footage and won't need to do any additional rendering.

ABOUT THE DVD

The DVD contains the following:

DEMOS
Macintosh Demos

- Adobe Premiere 6
- Adobe Photoshop 6
- Adobe After Effects 4.1
- Digital Origin EditDV Unplugged
- Boris Red
- Trakker Technologies Slingshot

Windows Demos

- Adobe Premiere 6
- Adobe Photoshop 6
- Adobe After Effects 4.1
- Digital Origin FreeDV
- Boris FX
- in:sync Speed Razor 2000
- Ulead Media Studio Pro 6
- Trakker Technologies Slingshot

TUTORIALS

- **Venice Montage tutorial** (Chapter 2). The Venice Montage tutorial footage is 720 × 480 pixel resolution, 29.97 fps, NTSC video that uses Sorenson Video compression. The audio is 22 kHz, 16-bit mono. You'll need 720MB of disk space to save this media on your computer.
- **Knights Promo tutorial** (Chapter 9). The Knights Promo tutorial footage is 720 × 576 resolution, 25 fps, PAL video that uses Avid ABVB NuVista compression. You will need to install the Avid codecs in the Extras folder to play this footage on your computer. The audio is 48 kHz 16-bit stereo. You'll need 1.3GB of disk space to save this media on your computer.
- **Music Video tutorial** (Chapter 9). The footage for the Music Video tutorial is 720 × 480 resolution, 29.97 fps, NTSC video that uses Sorenson Video compression. The music track is 48 kHz 16-bit stereo audio. You'll need 795MB of disk space to save this media on your computer.
- **Documentary tutorial** (Chapter 10). The footage for the Documentary tutorial is 720 × 480 resolution, 29.97 fps, NTSC video that uses Sorenson Video compression. The audio is 48 kHz 16-bit stereo. You'll need 755MB of disk space to save this media on your computer.
- **Dramatic tutorial** (Chapter 10). The Dramatic tutorial footage is 720 × 480 resolution, 29.97 fps, NTSC video that uses DV compression. The audio is 48 kHz, 16-bit stereo. You'll need 4GB of disk space to save this media on your computer.
- **Knights Bluescreen tutorial** (Chapter 11). The media for this tutorial is 720 × 576 resolution, 25 fps, PAL video that uses Avid ABVB NuVista compression. You will need to install the Avid codecs in the Extras folder to play this footage on your computer. There is no audio in this tutorial. You'll need 80MB of disk space to save this media on your computer.
- **Film Look tutorial** (Chapter 11). The Film Look tutorial footage is 720 × 480 resolution, 29.97 fps, NTSC video that uses DV compression. The audio is 48 kHz, 16-bit stereo. You'll need 51MB of disk space to save this media on your computer.
- **Final Movies**. The Final Movies folder contains final edited versions of the tutorials in this book.

EXTRAS

- **Audio reference tone**. In both AIFF format for Macintosh and WAV format for Windows, 60 Hz tone is used to calibrate audio, a process also described in Chapter 8.

- **Test patterns**. Still images of NTSC and PAL color bars can be used to calibrate the video signal, as described in Chapter 8. In both AIFF format for Macintosh and WAV format for Windows, 60 Hz tone is used to calibrate audio, a process also described in Chapter 8.

SYSTEM REQUIREMENTS

MAC

- 300 MHz G3 or better
- 128MB of RAM
- 650MB+ of available hard disk space
- 24-bit or greater video display card (recommended)
- QuickTime 5.0 or higher
- Stuffit Deluxe to unstuff the archive folders on the CD

WINDOWS

- Intel Pentium processor, Pentium II, or multiprocessor system recommended
- Win 98 (32MB RAM), or WIN NT 4.0 or later (65MB RAM)
- 650+MB of available hard disk space
- 24-bit or greater video display card (recommended)
- QuickTime 5
- ZipIt to unstuff the archive folders on the CD

Glossary

2-pop A sync at the end of a countdown leader. After the "2" (as in "5, 4, 3, 2, 1"), there is a one-frame beep of 60 Hz audio reference tone that occurs at the "2" (the "1" is a frame of black). The "2-pop" is used for syncing audio and video when shooting non-sync sound.

3/4" A popular videotape format developed in the 1960s that used to be the standard for broadcast quality.

3:2 pulldown A method for transferring 24-fps film to 29.97-fps NTSC video. The film is slowed down by .1%. The first film frame is recorded on the first two fields of video, the second frame is recorded on the next three fields of video, and so on.

3-point editing *See* **three-point editing**.

A/B rolling *See* **checkerboard**.

A/V Audio/video.

accelerator cards Custom hardware that can accelerate certain features such as 3D rendering, rendering of plug-in filters, or display of complex video.

action safe The area of your image that will most likely be visible on any video monitor. Essential action should be kept within the action safe area, as action that falls outside this area may be lost due to *overscan*.

address A frame of video as identified by timecode information.

AES/EBU An acronym for the Audio Engineering Society and the European Broadcaster's Union; also a standard for professional digital audio that specifies the transmission of audio data in a stream that encodes stereo audio signals along with optional information.

aliasing The "jaggies," those stair-stepping patterns that occur on a diagonal or curved line on a computer or video display. Can be smoothed or corrected through *anti-aliasing* processes.

alpha channel An 8-bit color channel (*see* **channels**) that is used to specify the transparency of each pixel in an image. An alpha channel works like a sophisticated stencil, and is the digital equivalent of a matte.

alternate data rates When streaming QuickTime files from a Web site, it is possible to specify several copies of the same movie, each optimized for a different data rate. The server will then decide which movie is best for the speed of the user's connection.

A-mode EDL An EDL sorted in order of master record-in timecode.

amp Short for *ampere*, a unit that measures the voltage of an electrical power source.

analog Information represented electronically as a continuous, varying signal. *See also* **digital**.

animation compressor A lossless QuickTime codec.

answer print The final print of a film after color-timing.

anti-aliasing The process of eliminating "jagged" edges on computer-generated text and graphics. Anti-aliased graphics have their edges slightly blurred and mixed with background colors to eliminate the jagged, stair-stepping patterns that can occur on diagonal or curved lines.

array *See* **RAID**.

aspect ratio The ratio of the width of the picture to the height. Aspect ratios can be expressed as ratios, such as 4:3, or as numbers, such as 1.33.

assemble edit An edit onto a videotape that records over the entire tape, including the video track, the audio tracks, and the control track.

ATA A type of hard drive interface. Not as fast as SCSI, but fast enough for DV.

ATSC Advanced Television Systems Committee—established to set the technical standards for DTV, including HDTV.

attenuator A circuit that lowers the strength of an electronic signal.

audio compressor A filter (or piece of hardware) that reduces the dynamic range of a sound to accommodate loud peaks.

audio guide track A mixed audio track from the offline final cut that is placed onto one of the audio tracks of the online master to serve as a guide during the online editing session.

audio mixer A piece of hardware that takes several audio signals and mixes them together, allowing for the mixing of different sources. Mixers usually include some sort of equalization control.

audio sampling rate The number of samples per second that are used to digitize a particular sound. Most DV cameras can record at several audio sampling rates. Higher rates yield better results. Measured in kilohertz, 44.1 kHz is considered audio CD quality, and 48 kHz is considered DAT quality.

AVR Avid Video Resolution, a series of low and high-resolution codecs included with the Avid family of editing systems. Some Avid products offer uncompressed resolutions as well.

Axial One of several linear hardware-based online editing systems.

balanced audio A type of microphone connector that provides extra power. Sometimes needed if you want to have microphone cable lengths of 25 feet or longer.

bandwidth The amount of digital information that can be passed through a connection at a given time. High bandwidth is needed for high-quality images.

bars and tone A combination of *color bars* and *60-Hz audio reference tone*, usually recorded onto the head of each videotape. Used for calibrating video and audio levels.

Betacam SP A high-quality, analog videotape format popular for broadcast applications.

bin A film-editing term that refers to the place where the shots for a scene are stored. In software editing systems, bins can also be referred to as folders, galleries, or libraries.

binary A system for encoded digital information using two components: 0 and 1.

BITC Acronym for burn-in timecode (pronounced "bitsy"); also know as *vis code* or *window burn* timecode.

black-and-coded tape A "blank" tape that has been *striped* with a combination of a black video signal and timecode.

black burst A composite video signal with a totally black picture. Used to synchronize professional video equipment. Black burst supplies video equipment with vertical sync, horizontal sync, and chroma burst timing.

black burst generator A piece of video hardware that generates a black composite video signal, or black burst, used to sync professional video equipment and to *black-and-code* tapes.

black level The black level defines the darkest a video image is allowed to get. Improperly set black levels can result in dull, grayish blacks.

blue spill A bluish light that is cast onto the back of a foreground subject due to a reflection from a bluescreen.

bluescreen A special screen, usually composed of blue cloth or backdrops painted with special blue paint, that is placed behind a foreground element. Bluescreen shots are those shots that you intend to later composite with other elements through the use of a chroma key function. Blue is used because most living animals have little naturally occuring blue colors.

BNC connector A connector used to carry composite video, component video, timecode, and AES/EBU audio signals.

break-out box A box that has connectors and ports for attaching video and audio peripherals. Usually provided with complex video digitizing systems.

broadcast colors Your computer monitor can display many more colors than can NTSC video. Broadcast colors are those colors that are safe—that is, they will display properly—for use in broadcast video. Many programs, such as

Adobe Photoshop and Adobe After Effects, include special filters that will convert the colors in an image to their nearest broadcast safe equivalent. *See also* **NTSC legal**.

broadcast quality A somewhat vague term, referring to the minimum quality considered acceptable for broadcast television. Until the 1980s, 3/4" Umatic tape was considered broadcast quality; then Betacam SP was introduced and became the standard for broadcast quality. Today, Hi8 and MiniDV are often considered broadcast quality because the final master is usually Digital Betacam.

BT. 601 A document that defines the specifications for professional, interlaced video standards as the following: 720 × 480 (59.94 Hz), 960 × 480 (59.94 Hz), 720 × 576 (50 Hz), and 960 × 576 (50 Hz) 4:2:2 YCbCr. Also called CCIR 601 and ITU-R 601.

bumping up The process of transferring a videotape from a lower-quality format to a higher-quality format; e.g., bumping up miniDV tapes to DVCPro.

byte A unit of computer storage. How much one byte equates to depends on what you are storing. If you're just storing text, then a single byte can hold one character. For video or audio, what a byte holds depends on how your video is compressed and stored.

camera negative After film stock is exposed in the camera and is processed, the result is the negative, also called the camera negative, which is usually transferred to video using a *telecine* process, and then, after editing, is used to strike the final print.

capturing The process of moving video data from a DV camera into a computer. Because the camera has already digitized the data, the computer does not have to perform any digitizing.

CCIR 601 *See* **BT. 601**.

CDR A special type of compact disc that can be recorded by the end user using a special drive. Standard audio or data formats are supported by most recording programs, along with Video CD, a special format that can store 70 minutes of full-screen, full-motion MPEG1-compressed video.

CG Character generator. A special machine for creating titles and other text characters for inclusion in a video. Most editing packages include CG features.

CGI Computer-generated imagery. Used to refer to any effect that is created digitally, be it a composite, or a fully digital image such as a walking dinosaur. CGI is often used as a noun: "we'll fill that spot with some CGI of a duck."

channel The color in an RGB image is divided into channels, one each for the red, green, and blue information in the image. When these channels are combined, a full-color image results. Certain effects are easier to achieve by manipulating individual color channels. Additional *alpha channels* can also be added for specifying transparency and selections. *See* **alpha channel**.

checkerboard A way to arrange each piece of sound across a group of audio tracks, so that no piece of sound is directly "touching" any other piece of sound, resulting in a checkerboard-like appearance. Also called *A/B rolling*.

chroma key A special key function that will render a specific color in a layer transparent. For example, if you shoot someone in front of an evenly lit blue-screen, you can use a chroma key function to render the blue completely transparent, thus revealing underlying video layers.

chroma The part of the video signal that contains the color information.

chromatic aberration Color shifts and color artifacts in an image caused by faults in a lens, or by the camera's inability to register all three channels of color information. Single-chip video cameras are especially prone to chromatic aberration.

chrominance The *saturation* and *hue* of a video signal. Although slightly different in meaning, this term is often used interchangeably with the term *chroma* to refer to color.

Chyron A title identifying a speaker in a documentary that runs along the bottom of the screen, named after the Chyron character-generator popular in many post facilities. These I.D. titles are also known as *lower thirds*.

Cinepak A QuickTime codec. Very *lossy*, but ideal for delivery mediums with low data rates such as CD-ROM or the Web.

clipping In digital media, an electronic limit that is imposed on the audio and/or video portion of the signal in order to avoid audio that is too loud and video that is too bright, too saturated, or too dark. *Clipped blacks* are any blacks in an image that are darker than the set black level, or 7.5 IRE. *Clipped whites* are any whites that are brighter than the set white level, or 100 IRE. *Clipped audio* is any sound that goes into the red area on a VU meter. Clipped media is indicated by a flat line in a waveform view of the signal.

clip A digitized piece of media, consisting of video, audio, or both.

close-up A shot where the subject fills the majority of the frame. If the subject is a person, the shot will consist primarily of his or her head and shoulders.

C-Mode EDL An EDL sorted nonsequentially by source tape number and ascending source timecode.

CMX A hardware-based linear online editing system. CMX-format EDLs are often the default for other editing systems.

codec COmpressor/DECompressor, an algorithm for compressing and decompressing video and audio.

color bars A test pattern used to check whether a video system is calibrated correctly. A waveform monitor and vectorscope are used, in conjunction with color bars, to check the brightness, hue, and saturation.

color correction A process of improving the color balance of motion footage.

color depth The number of colors that a given video system can be displayed. The greater the number of bits-per-pixel that are used to store color, the higher the color depth.

color sampling ratio In component digital video, the ratio of luminance (Y) to each color difference component (Cb and Cr). 4:2:2 means that for every four samples of luminance, there are two samples of chroma minus blue and chroma minus red. 4:2:2:4 indicates an additional four samples of the alpha channel or keying information.

color timing The process of setting the red, green, and blue lights when creating a film print. Usually, the color settings are timed to change with each significant scene or lighting change in the film.

color-correction A postproduction process to correct the overall color of a videotape master in order to get the best quality image, with an emphasis on enhancing skin tones.

component video A video signal consisting of three separate color signals (or components), usually RGB (red, green, blue), YCbCr (Luminance, Chroma minus Blue, and Chroma minus Red), or Y, R-Y, B-Y (Luminance, Red minus Luminance, Blue minus Luminance).

composite video A video signal that contains all the luminance, chroma, and timing (or sync) information in one composite signal.

compositing The process of layering media on top of each other to create collages or special effects.

conforming The process of meticulously recreating an offline edit using, usually, higher-quality footage with the aid of an EDL or cut list.

continuity During a shoot, the process of keeping track of dialogue changes, actors' positions, wardrobe, and props so that the footage from shot to shot and day to day will cut together. Usually, the person in charge of continuity makes notes on a copy of the script and takes Polaroids of the set.

control track A part of the video signal that contains the timing, or synchronization, information used to regulate the motion of the tape itself as it plays through a VTR.

co-processors Extra processors that are used to speed up a computer, or to perform special functions. *See* **accelerator cards**.

coverage Shooting all of the footage that will be needed to properly *cover* an event or scene.

CPU Central processing unit. The box that contains the motherboard, peripheral cards, and some storage drives. Also used to refer to the main processing chip that the system uses.

cross-platform Programs or hardware that come in different versions for different platforms. Ideally, the program's interface and features are identical from one platform to the next.

CRT monitor The monitor attached to your computer. Short for cathode ray tube.

cut list A list of all the edits in a film that is given to the negative cutter to conform the negative.

cutaway A shot of something other than the main action or dialogue in a scene that is used to build the story and smooth rough edits.

D/A Digital/Analog.

dailies The footage that was shot in one day (also called *rushes*).

daisy chain A group of storage devices that have been chained together so that each can be accessed independently.

DAT Digital Audio Tape, an audio tape format developed by Sony that records audio using a sampling rate of 48 kHz and is capable of recording SMPTE timecode information.

data rate The amount of data that a particular connection can sustain over time. Usually measured in bytes/second.

DaVinci A professional digital color correction system.

daylight Daylight is the combination of sunlight and skylight.

dBm *See* **decibel milliwatt**.

dBSPL *See* **decibel sound pressure loudness**.

decibel The standard unit for measuring sound. A subjective scale where one unit equals one increment of "loudness."

decibel milliwatt A unit for measuring sound as electrical power.

decibel sound pressure loudness A measure of the acoustic power of a sound.

degauss To completely erase all the information on a magnetic video or audio tape, using a demagnetizing device.

depth of field A measure of how much, and what depth, of the image is in focus.

destination monitor The monitor or window that displays an edited sequence as it plays, as opposed to the source monitor, which plays unedited source footage. Also called the *record monitor*.

destructive editing Any form of editing (either video or audio) that physically alters the original source material.

device control The ability of a piece of hardware, such as an edit controller or a CPU, to control a peripheral device, such as a VTR, via a remote control cable.

digital Information recorded electronically as a series of discrete pulses, or *samples*, usually using a *binary* system.

digitizing The process of taking analog video information from a camera or deck and turning it into digital information that can be used by a computer.

dissolve A transition in which the first shot is partially or completely replaced by gradually superimposing the next shot.

DLT (Digital Linear Tape) An optical tape backup system, DLT tapes typically hold about 20GB of media.

DM&E Acronym for dialogue, music, and effects; a four-channel, split audio mix that allows for easy remixing in case the audio needs to be dubbed to a foreign language.

drag-and-drop editing A two-step editing method where the user selects a shot and drags it from one position and drops it in another position; for example, from a bin to the timeline, or from one position in the timeline to another.

drive chassis A box, mount, or rack for holding hard drives. Usually separate from the CPU.

dropouts A weak portion of the video signal that results in a problem in playback. *Hits* are small dropouts that are only one or two horizontal lines in size; *glitches* are larger, where 5% or more of the image drops out. Large analog dropouts can result in a few rolling video frames, and large digital dropouts can result in random "holes" across the screen.

DTV Acronym for Digital Television, the new digital television broadcast standard that will be adopted in the United States by 2006. DTV is an umbrella term that includes several subgroups, including HDTV and SDTV.

dual-stream processing The ability to handle up to two video signals at a time.

dub A copy of a videotape, also known as a *dupe*.

DVD Digital video disc (sometimes called "digital versatile disc"). An optical storage medium that is the same physical size as a compact disc. There are several different DVD standards and formats ranging from DVD-RAM (a rewritable format), DVD-ROM (a read-only format), and DVD-video (the format that is used for video releases).

DVE An acronym for *digital video effects*. The term comes from the professional linear video-editing world and applies to what has become a fairly standard set of effects: wipes, dissolves, picture-in-picture, barn doors, and split screen, to name a few. Based on a trade name for a system sold by NEC.

edit controller A piece of hardware used in linear editing systems to control and synchronize multiple video decks.

Edit Decision List A list of all the edits in a project, identified by a chronological *event* number, source name, source in-point timecode, source out-point timecode, master in-point timecode, and master out-point timecode.

EDL *See* **Edit Decision List**.

EIDE A type of hard drive interface. Not as fast as SCSI, but fast enough for DV.

EISA slots A type of expansion slot used in Windows-based computers.

EQ *See* **equalization**.

equalization The process of adjusting the volume of individual *frequency* ranges within a sound. Equalization can be used to correct problems in a sound, or to "sweeten" or enhance the sound to bring out particular qualities.

Ethernet A standard networking protocol for connecting computers together through one of several types of networking cable.

Exabyte A digital, optical tape-based storage system, used for backing up projects with large amounts of data.

fade out A dissolve from full video to black video, or from audio to silence.

field dominance Hardware and software that play the field of video containing the odd-numbered scan lines first are known as *field-one dominant*. Those that play the field of video containing the even-numbered scan lines first are known as *field-two dominant*.

fields Each frame of interlaced video consists of two fields: one field contains the odd-numbered scan lines, and the other field contains the even-numbered scan lines. In NTSC video, each field has 262.5 horizontal lines.

film grain Images are recorded on film by exposing the film's light-sensitive emulsion. Composed of chemical particles, the film's emulsion has a visible grain when projected. Many video producers try to mimic this grainy look to produce an image that looks more film-like.

film recorder *See* **film recordist**.

film recordist The person responsible for transferring (or recording) video to film.

filters Special effects that are applied to an entire piece of media in an edited sequence, as opposed to the transition between two pieces of media. For example, a color effect or a luma keyed effect.

FireWire Apple's name for the IEEE-1394 specification.

Foley The process of creating and recording ambient sound effects in real-time while watching the attendant video or film. Foley work is usually performed on a Foley stage equipped with special surfaces and props. Named for Jack Foley, the originator of the technique.

fps Fps, or frames per second, is used to describe the speed at which film and video play. Film plays at 24fps; PAL video at 25fps; and NTSC video at 29.97 fps.

fragmentation When a hard drive has had many files deleted and replaced, it can become fragmented, which can slow its performance. At this point, it may need to be defragmented, or optimized.

frame One complete film or video picture, each frame of video contains two fields. Moving images need at least 18 frames per second to appear as full motion, and 24 fps to allow for sync sound. NTSC video plays at 29.97 fps, and PAL video at 25 fps.

frame accuracy The ability for a device, particularly a VTR, to accurately perform edits on a predesignated frame. Nonframe accurate VTRs may miss the mark by one or more frames.

frame rate When speaking of video or film recording, the number of frames per second that are recorded (and then played back).

frequency An audio signal is made up of different frequencies, or wavelengths, that yield the high (or treble), mid, and low (or bass) tones. The human voice resides mostly in the mid-tones.

gain The strength (or amplitude) of an audio or video signal.

gain boost A method of electronically increasing the strength, or amplitude, of an audio or video signal, resulting in a higher *signal-to-noise ratio*. In video, the image gets brighter, but has more visible noise.

garbage matte A special matte used to knock out extraneous objects in a compositing shot. Garbage mattes are usually applied to a bluescreen shot before chroma keying. They can be used to eliminate props, mic booms, and other objects that can't be eliminated through keying.

gate A special type of audio filter that only allows a specific range of frequencies to pass.

generation A duplication of a videotape (as opposed to a clone) is considered the second generation. A duplicate of a duplicate is yet another generation.

generation loss For analog videotape, each consecutive generation (or duplicate) results in a loss in quality, known as generation loss.

green spill The same as blue-spill, except that it occurs with a greenscreen as a backdrop, rather than a bluescreen.

greenscreen Same as bluescreen, but used for those occasions where you need to have blue elements in your foreground.

handheld microphone The typical handheld mic that is used by rock stars, comedians, and wandering talk show hosts. Usually an omnidirectional, dynamic microphone.

handles Extra footage at the head and tail of each shot to allow the editor room to add dissolves and manipulate the pacing of a scene.

hard cut An edit from one shot to another without any sort of transition in between, such as a dissolve.

HDTV High-definition television, a subgroup of the new DTV digital television broadcast standard that has a 16:9 aspect ratio; a resolution of either 1280 × 720 or 1920 × 1080; a frame rate of 23.96, 24, 29.97, 30, 59.95 or 60 fps; and either interlaced or progressive scanning.

horizontal blanking interval The part of the composite video signal between the end of the image information on one horizontal scan line and the start of the image information on the next horizontal scan line.

horizontal delay A display feature available on professional video monitors that shows the video signal offset horizontally so as to allow the editor to analyze the horizontal sync pulses. *See also* **vertical delay**.

horizontal line resolution The number of vertical lines in the visible portion of the video signal.

horizontal sync The sync pulses in the video signal that regulate the movement and position of the electron beam as it draws each horizontal scan line across the video monitor.

hot-swapping Replacing a peripheral without shutting off the computer's power. Note: not all peripherals are hot-swappable!

HSB Just as colors can be defined by specifying RGB (red, green, and blue) values, colors can also be defined by specifying Hue, Saturation, and Brightness. Many color pickers allow you to switch to an HSB mode. For some operations, selecting a color is easier in one mode than in another.

hue The shade of a color.

I/O Input/Output.

IDE drives Hard drives that adhere to the IDE interface specification.

IE1394 *See* **FireWire**.

IEEE-1394 A high-speed serial interface that can be used to attach DV cameras, storage devices, printers, or networks to a computer.

I-frame A video compression term. An intermediate frame between two keyframes. I-frames store only the data that has changed from the previous frame.

iLink Sony's name for the IEEE-1394 specification.

inbetweening The process of calculation (or interpolation) that is required to generate all of the frames between two *keyframes* in an animation.

in-point The starting point of an edit.

insert edit An edit onto videotape that does not replace the control track and allows for the separate editing of video, audio, and timecode.

insert mode In most NLEs, a method of editing in the timeline that allows the placement of a shot between two shots without covering up what's already there. Instead, the second shot (and all the shots following it) move down to accommodate the new shot. *See also* **overwrite mode**.

intensity (of light) The strength of a light source, measured in candelas.

interface The controls and windows that you use to operate a program.

interlace scan The process of scanning a frame of video in which one field containing half the horizontal lines is scanned, followed by another field that contains the other half of the horizontal lines, adding up to a complete frame of video.

interlaced *See* **interlace scan**.

interleaving The process of alternating data across multiple discs, as in an array.

internegative An intermediary step sometimes necessary in film processing. The camera negative is printed, and a new negative, the internegative, is made (or struck) from that print. The internegative (or IN) is then used to create more prints.

interpositive An intermediary step sometimes necessary in film processing. The camera negative is printed, and this print, called the interpositive (IP), is used to create a new negative. The release prints are then struck from that negative.

IRQ Special addressing information used by peripherals attached to a Windows-based computer. Each peripheral must have its own IRQ.

ISA slots A type of expansion slot used in Windows-based computers.

ISO-9660 A format for writing CD-ROMs. Can be read by either Mac or Windows-based computers.

ITU-R 601 *See* **BT. 601**.

JKL A way of editing using the J, K, and L keys on a computer keyboard specifically programmed to allow for fast shuttling through clips in an NLE.

key effect Different types of "keys" can be used to remove the background from a video clip to expose underlying video. *See* **chroma key** and **luminance key**.

keycode numbers Numbers that identify each frame of film.

keyframe interval When compressing video, the frequency at which a keyframe will occur.

keyframe When animating, you will explicitly define the parameters of an animated element by creating a keyframe. The computer will automatically calculate the changes that occur between keyframes. See **inbetweening**.

kinescope A method of making a film copy of a video image by recording the image off a video monitor.

LANC (or Control-L) A device control protocol most commonly found on consumer equipment and incapable of frame accuracy. *See also* **RS-422** and **RS-232**.

latitude The size of the gray scale ranging from darkest black to brightest white. The human eye sees more latitude than can be recorded on film or video.

Lavalier A small clip-on mic. Usually an omnidirectional, condensor microphone.

layback The process of transferring the finished audio back onto the master videotape after *sweetening*.

LCD Liquid crystal display. The type of display used as a viewfinder on most cameras. In terms of cameras, LCD usually refers to a small, flip-out screen, as opposed to the optical viewfinder.

lens Usually a series of separate glass lenses, the lens on a camera is what focuses light onto the *focal plane* to create an image.

letterboxing The process of putting black bars at the top and bottom of the screen to change a 4:3 aspect ratio image to a wider aspect ratio image.

linear editing Editing using linear media—i.e. tape to tape—as opposed to using random access media stored on a computer hard drive. All tape is linear, so linear media can be either digital or analog.

locking picture The process of formally finalizing the editing of a film for story, so that the sound editors can start working without having to deal with any changes in timing.

logging The process of recording the contents of each field tape using time-code, shot names, and descriptions. The first step in the editing process.

long shot A shot that plays out over a long period of time.

looping The process of re-recording dialog in a studio. Called "looping" because the actor sometimes watches a continuous loop of the scene that is being re-recorded. Also known as *ADR*, for automatic dialogue replacement.

lossless Used to denote a form of compression that does not degrade the quality of the image being compressed.

lossy Used to denote a form of compression that degrades the quality of the image being compressed.

Lower thirds *See* **Chryon**.

LTC An acronym for longitudinal timecode, a type of timecode that is recorded onto a linear track on a videotape.

luma clamping *See* **luminance clamping**.

luma key *See* **luminance key**.

luminance clamping The process of clamping (or clipping, or scaling) the luminance value in a video signal. In video that has been luma clamped, luminance values over 235 are eliminated, frequently resulting in video with bright areas that look like solid blobs of white.

luminance key A special key function that will use the luminance values in a layer to determine the transparency of that layer. For example, a luminance key could be set to render the darkest areas of the layer transparent.

luminance The strength (or amplitude) of the *gray scale* (or brightness) portion of a video signal.

master shot A wide shot that contains all the action in particular scene. Used as the basis for building the scene.

M-JPEG A lossy, high-quality codec that can deliver full-motion, full-frame video. Almost always requires special compression hardware.

montage In editing, the process of juxtaposing two shots against each other to arrive at an effect different from what each shot would imply on its own.

motherboard The main circuit board inside a computer.

motion blur When an object moves quickly, it will look blurrier. Individual frames of video or film should show a certain amount of blur around moving objects. Motion blur is usually the result of average shutter speeds ($1/60^{th}$ to $1/125^{th}$ of a second). Faster shutter speeds will result in less motion blur; slower shutter speeds will result in more. A lack of motion blur will result in stuttery, stroboscopic motion.

MPEG A lossy, high-quality codec. Comes in several flavors. MPEG1 is used for the VCD format; MPEG2 is used for DVD format video. Both flavors are suitable for distribution of full-motion, full-frame video.

N.A.B. The National Association of Broadcasters.

negative cutter The person who physically cuts the film negative to conform to the final cut.

NLE *See* **non-linear editing system**.

nondestructive editing Any form of editing (either video or audio) that leaves your original source material unaltered.

non-linear editing system A digital editing system that uses a software interface and digitized audio and video stored on a hard drive, which allows for random access, non-linearity, and nondestructive editing.

Notch A special type of audio filter that can eliminate a specific, defined frequency of sound.

NTSC An acronym for National Television Standards Committee, NTSC is the broadcast video standard for North America and Japan, with a frame rate of 29.97 fps and 525 horizontal scan lines.

NTSC legal Refers to colors that fit within the NTSC guidelines for broadcast television. A vectorscope is used to determine if an image is within the NTSC legal color boundaries.

NTSC monitor *See* **NTSC/PAL monitor**.

NTSC/PAL monitor The monitor attached to a camera, video deck, or the video output signal from a non-linear editing system. Used to display the video.

offline clip An offline clip is one that has been logged, but does not have any audio or video media attached to it, whether that is because it hasn't been captured yet or because the media has been deleted.

offline editing Offline editing means working in a draft mode with the intention to eventually take the project to a better resolution and possibly, better videotape format, in order to do a final pass that will improve its look, quality, and polish.

one-light print A one-light print is a film print created from the film negative that uses a single, constant, optimized light setting (i.e., one light) for the red, green, and blue lights used to create the print.

onion-skinning Some animation programs can display semi-opaque overlays of previous frames. These "onion-skin" frames can be used as a reference for drawing or retouching the current frame.

online editing Creation of the final master videotape, whatever the means or format involved, usually conformed from the original production footage using an EDL.

operating system The low-level program that controls the communication between all of the subsystems (storage, memory, video, peripherals, etc.) in your computer.

opticals Special effects that are traditionally added by an "optical" department. Usually, these are effects that are added through a separate optical printing pass. Lightning bolts, light flares, glows, and halos are all traditional optical effects that can now be performed through rotoscoping, or with the application of custom filters.

OS Operating system.

out-point The end point of an edit.

overexposure Overexposure refers to video or film that was shot with too much light or the wrong camera settings, resulting in a whitish, washed-out, faded-looking image.

overlapping edit An edit where the picture ends before or after the sound ends. Also called an *L-cut* or a *split-edit*.

overscan All video formats scan more image than they need, to compensate for the fact that not all monitors and televisions display images at exactly the same size. To keep your action and titles within the visible area, you'll want to pay attention to the *action* and *title safe* areas of the screen.

overwrite mode In most NLEs, a method of editing that allows the placement of a shot in the timeline that covers up anything that was previously occupying that space. *See also* **insert mode**.

PAL An acronym for Phase Alternate by Line, a television standard used in most of Europe and Asia, with a frame rate of 25 fps and 625 horizontal scan lines, resulting in somewhat higher quality video than NTSC.

PAL Monitor *See* **NTSC/PAL monitor**.

pan To rotate the camera left and right around the camera's vertical axis.

partitions Logical divisions in a hard drive that make the drive appear to be more than a single drive.

patch bay A rack of video and audio input and output connectors that makes it easier to reconfigure the hardware in an editing system.

phono connector A medium-sized single-prong connector used primarily for analog audio, especially headphones. Also known as *1/4" connector*.

pistol-grip tripod A tripod with a head that is controlled by a single pistol-grip mechanism. Such heads can be freely rotated around all axes simultaneously, making it very difficult to perform a smooth motion along a single axis.

pixel Short for *pic*ture *element*. A single point on your screen.

platform The computer hardware/OS combination that you have chosen to work on.

plug-ins Special effects and add-ons that can be added to a host application. *See* **filters**.

post house *See* **post-production facility**.

post-production facility A service bureau that provides editing and other post-production equipment and services.

pre-roll The process of rewinding the videotape to a cue point several seconds before the in-point so that playback of the tape is stabilized and up to full speed when the tape reaches the in-point.

prime lens A lens with fixed focal length.

production board A hard-backed set of spreadsheets designed specifically for organizing film production.

production designer The designer who is responsible for the look of the entire production. He or she will supervise the set decorators, costumes, and other visual artists.

production strip A removable color-coded paper strip that fits into the spreadsheet layout of the production board and allows for easy reorganization.

progressive scan A type of video display where each horizontal line is scanned consecutively from top to bottom, resulting in a full frame of video without the need for *fields* (compare to *interlaced scan*).

proxy A placeholder. Usually used in editing programs to take the place of video that has yet to be shot, or that has yet to be digitized at the highest quality.

QuickTime A software architecture for displaying and manipulating time-based data (such as video and audio) on a computer.

rack focus A rack focus is a shot where the focus is set on an object in the background, and then the focus is pulled, or racked, to an object in the foreground (or vice versa). Exemplified by a shot of a billiard ball; then a rack focus to reveal the person holding the cue stick.

radio cut An edit of a scene based on dialogue only, disregarding whether the picture works or not. The idea being that the result should play like an old-fashioned radio show.

RAID Redundant Array of Independent Discs. A group of hard drives arranged to act like a single, very fast storage device.

RAM Random access memory. The electronic memory inside your computer used to hold programs and data when working.

RCA connector A small, single-prong connector most commonly used to carry composite video and unbalanced audio signals.

reaction A shot of a person in a scene as he or she reacts to the dialogue or action of the scene.

RealMedia A special streaming video and audio architecture created by Real, Inc.

real time A function, such as playback or recording, that occurs immediately and in real time, without the need for rendering and without any speeding up of the process, such as 4x (quadruple speed) recording.

real-time editing Editing that can happen in real time. That is, effects and edits do not have to be calculated or rendered before they can be seen.

reflective light Light coming from an indirect source, such as a bounce card, the sky (but not the sun), etc.

reflector A shiny board or fabric used to redirect a bright light source, such as the sun.

RGB color space The range of colors that can be displayed and recorded by your computer.

room tone The sound of the room in which a scene was recorded. During a shoot, the sound recorder will record roughly a minute's worth of the quieted location to create an "empty" sound with the right atmosphere. This sound will be used by the sound editor to correct audio problems.

rotoscoping The process of painting over existing frames of video or film. In DV production, rotoscoping is used for everything from painting in special effects, to painting custom-made mattes for compositing.

rough cut An early edit of a project, as opposed to the final cut.

router An electronic patching system for audio and video equipment.

RS-232 A serial device control protocol that allows computers to control video decks and other hardware. RS-232 is most commonly used for low-end professional and consumer equipment.

RS-422 A serial device control protocol that allows computers to control video decks and other hardware. RS-422 is the standard for professional equipment, uses SMPTE timecode, and is capable of frame accuracy.

RT11 A floppy disk format used by high-end linear online editing equipment to store EDLs.

SAG Acronym for the Screen Actors' Guild.

saturated colors The technical term for bright, bold colors is *saturated*. For example, a true red is saturated, while pink and maroon are *desaturated* reds.

saturation The amount of color in the video signal.

screen correction shot A shot of a bluescreen or greenscreen stage that has no actors in it and is used by compositing software to help create the matte.

scrim A lighting accessory used to tone down the brightness of a light. Single scrims dim the light by 1/2 f-stop, and double scrims dim the light by a full f-stop. Half scrims are a half-moon shape, to allow for further manipulation of the light.

SCSI IDs When using SCSI devices, each device on the SCSI chain must have its own unique SCSI ID. A SCSI port can support up to seven devices.

SCSI Small Computer Systems Interface. An interface standard for connecting hard drives and other peripherals. Comes in many different flavors, including SCSI-2, Ultra-SCSI, and Ultrawide-SCSI.

SDI An acronym for Serial Digital Interface, SDI is the professional digital video standard I/O protocol with a data rate of either 270Mbps or 360Mbps. *See also* **FireWire**.

SDTV An acronym for Standard Definition Television, a subgroup of the DTV digital television broadcast standard designed to replace the current NTSC standard.

Seamless edit A style of editing where the edits appear natural and do not call attention to themselves. A traditional Hollywood movie dialogue scene is usually seamlessly edited.

SECAM An acronym for *Sequential Colour a Memoire*, SECAM is the broadcast television standard for France, Russia, and much of eastern Europe.

sequence An assembly of shots edited together.

sharpening In a video camera, a special algorithm that is applied to the video image to make it sharper. With too much sharpening, strange artifacts will appear in the image.

shooting ratio The ratio of the length of footage shot to the length of the final film. For example, a project with a 5:1 ratio would have shot five hours of footage for a one-hour final project.

shot list A list of the shots a director plans to shoot on a particular day of filming or taping. Usually, a shot list is derived by carefully going over the script, the storyboard, and blocking the scene with the actors in rehearsals.

shotgun A very directional mic that is often affixed to the front of the camera or to a boom or fishpole.

shutter In a camera, the shutter opens and closes to control how long the focal plane is exposed to light. There is no physical shutter in a video camera; instead, the camera's CCD samples light for an appropriate length of time, and then shuts off.

shutter speed The speed of the rotation of the *shutter* inside the lens, measured in rotations per second.

sides A dialogue-only version of a script used to make readings easier for actors.

signal Electronic information (video or audio) that is passed from one device to another.

single-chip A camera that uses a single CCD to gather all three (red, green, and blue) of the signals that will be used to create a full-color image.

single-field resolution Some low-resolution codecs cut down the size of the captured video files by discarding one field for each frame of video. The resulting single-field video plays fairly well, but contains half the information of two-field video.

sixty-cycle tone (60 Hz) Sixty-cycle tone, or 60 Hz tone, is used as an audio reference to calibrate the audio levels on editing equipment and speakers. Typically, the 60 Hz tone should fall at 0dB on a VU meter and at either −14dB or −20dB on a digital level meter.

skylight The ambient light from the sky, which consists of the reflected light of the sun. On a cloudy day, there is no sunlight, but there is still skylight.

slating When recording the sound separately from the video or film, the process of holding a slate in front of the camera. On the slate are written the scene and take numbers. The top of the slate can be clapped to produce a distinct sound that will be used for syncing the audio and video.

slow reveal A moving shot, often a pan or dolly, that reveals something slowly, such as a slow pan of a bathroom that reveals a dead person in the bathtub.

slow-motion A shot that plays at a slower speed than full-motion film or video. Usually described as a percentage of full motion.

SLR camera A *single lens reflex* camera. Unlike a camera with a separate viewfinder, in a SLR camera, you actually look through the lens at your subject. A 35mm still camera with removable lenses is typically an SLR.

slugline The first line of a scene in a screenplay that identifies whether the scene is interior or exterior, the location, and the time of day, all in uppercase letters.

SMPTE The Society of Motion Picture and Television Engineers, a professional organization that sets the technical standards for broadcast television in the United States.

SMPTE timecode The timecode standard developed by the SMPTE organization, considered the broadcast standard in North America.

snow The image of a video signal that has no control track; also known as *noise*.

soft light Light from a diffuse, often indirect light source.

SoftDV The DV codec provided by Media100 for their EditDV line of video editing products.

Sorenson compressor A lossy QuickTime codec with very good quality.

source monitor The monitor or window that displays the unedited source footage, as opposed to the destination (or record) monitor, which plays the edited sequence.

SP-DIF Short for Sony/Phillips Digital Interface, a digital audio format used for consumer equipment.

Spin rate Measured in revolutions per minute, the speed at which a hard drive spins.

split-track dialogue Dialogue that is spread across several separate tracks, rather than mixed onto a single track. Usually, split track dialogue has one track dedicated to each actor, or if the dialogue is *checkerboarded*, two tracks dedicated to each actor.

spotting Watching a locked-picture edit of your project with the intent of identifying all of the sound effect and music cues that will be needed.

steadicam A special camera mount that provides hydraulic, gimbaled support for a camera. Allows steady, fluid motion of the camera.

storage Nonvolatile storage that is used for long-term holding of programs and data. Usually magnetic or optical.

streaming video Video that is downloaded, on demand, interactively to the viewer's computer.

striped drives Hard drives that have been indexed with special information so that they can be used as an array.

strobing The odd, stuttery motion caused by fast shutter speeds. Strobing appears because of a lack of motion blur.

sunlight The light from the sun.

super To superimpose. Usually used to refer to the process of superimposing a title over an image.

supercardioid A very narrow cardioid pattern that indicates that a mic is very directional.

S-video *See* **Y/C video**.

S-Video connector A proprietary cable that is used to carry the Y/C video signal.

sweetening The process of polishing the audio on a project by adding effects, equalizing, and fine-tuning edits.

switcher *See* **router**.

sync Short for *synchronization*, the electronic pulses used to coordinate the operation of several interconnected pieces of video hardware. Also, the electronic pulses used to regulate the playback of the videotape in the VTR. *See also* **sync sound**.

sync sound Recording sound and video that are synchronized together, whether onto the same tape or by two or more separate recording devices.

TBC Abbreviation for *time base corrector*, an electronic device used to correct video signal instability during videotape playback. Most modern professional VTRs have internal TBCs.

telecine The process of transferring film to videotape.

telephoto lens A lens with a very narrow field of view (and, therefore, a long focal length). Telephoto lenses magnify objects in their field of view. Typically, lenses with focal lengths greater than 70 mm (equivalent to a 35mm film camera) are considered wide angle.

termination The last device in a SCSI chain must have a terminator, a connector that signifies the end of the chain. Bad termination can result in the entire SCSI chain malfunctioning.

textless master A videotape master that has no titles or any other text in it. Used for foreign language versions.

three-point editing A method of editing where each edit is performed using an in- and an out-point on both the source footage and the edited sequence. Once the editor enters three of the four in- and out-points, the NLE or edit controller will automatically calculate the fourth in- or out-point.

three-point lighting The standard way to light a person using a strong directed key light, a diffuse, less intense fill light, and a strong backlight.

throughput A measure of the speed at which data can be moved through a computer or storage system.

timecode Timecode is a numbering system encoded in the video tape itself. It measures time in the following format: hh:mm:ss:ff, where h = hours, m = minutes, s = seconds, and f = frames.

timeline A chronological display of an edited sequence in a non-linear editing system.

title safe Another guide similar to the action safe area, the title safe area is slightly smaller. To ensure that your titles are visible on any monitor, always make certain that they fall within the title safe area.

transcoder A device that changes the video signal from one format to another, such as from component to composite, or from analog to digital.

transfer mode The type of calculation that will be used to determine how layers that are stacked on top of one another will combine.

travelling matte A matte that changes over time to follow the action of a moving element. Travelling mattes are used to composite a moving element into a scene. In the digital world, an animated alpha channel serves the same function as a travelling matte.

trim mode The process of adjusting, or fine-tuning, an existing edit in an NLE.

turnkey system A video editing system that is preconfigured and assembled, and provides everything you need to start working.

tweening *See* **inbetweening**.

UltraATA A type of hard drive interface. Not as fast as SCSI, but fast enough for DV.

ultraviolet The area beyond violet on the color spectrum, beyond the range of visible light.

Umatic *See* **3/4"**.

uncompressed video Video that has not had any compression applied to it, either by the camera or by a computer.

underscan A display feature available on professional video monitors that allows the viewer to see the complete video signal, including the sync pulses.

unidirectional A mic that picks up sounds from a particular direction.

USB Universal Serial Bus. A standard for attaching serial devices such as keyboards, disk drives, and some types of storage. At the time of this writing, USB video capture devices were just becoming available.

UV filter A filter that can be attached to the front of the lens. Filters out excess ultraviolet light, and serves to protect the lens from scratching and breaking.

vacuum tubes Before the invention of the CCD, video cameras used vacuum tubes to convert light into electronic signals.

VCD Video compact disc. A format for storing 70 minutes of full-frame, full-motion, MPEG1 compressed video on a normal compact disc or recordable compact disc.

vectorscope A special monitor for calibrating the hue, or color information, in a video signal.

vertical banding Bright vertical smears that can occur in some video cameras when the camera is pointed at a very bright source.

vertical blanking interval The period during which the video image goes blank as the electron beam returns from scanning one field of interlaced video to start scanning the next field. This "empty" space in the video signal is sometimes used to store VITC timecode, closed-captioning, and other information.

vertical delay A display feature available on professional video monitors that shows the video signal offset vertically, so as to allow the editor to see and analyze the vertical sync pulses. *See also* **horizontal delay**.

vertical line resolution The number of horizontal lines in a frame of video.

vertical sync The sync pulses in the video signal that control the field-by-field scanning of each frame of interlaced video.

VGA monitor The monitor attached to your computer.

Video for Windows A software architecture for displaying and manipulating time-based data (such as video and audio) on a computer.

virtual memory A process by which the disk space can be used as a substitute for RAM.

vis code *See* **window burn**.

VITC Vertical Interleave Timecode; timecode that is encoded in the vertical blanking interval of the video signal.

VTR *Video tape recorder*, the professional term for VCR, usually indicating a professional-quality video deck.

VU meter Volume unit meter. The volume meters on a sound recording device. VU meters help you gauge whether you are recording acceptable audio levels.

wattage A measurement of the amount of electrical power used by a light, which determines the light's intensity.

waveform monitor A special monitor for calibrating the brightness, or luminance, of a video signal. Waveform monitors are used to set the proper white and black levels.

white level The peak level of the luminance (or gray scale) of the video signal; i.e., the brightest part of the image, usually set at 100 IRE.

wide angle lens A lens with a very wide field of view (and, therefore, a short focal length). Typically, the smaller the angle of the lens (measured in millimeters), the wider the angle.

widescreen A video image with an aspect ratio of 16:9, as opposed to the standard 4:3. Widescreen footage can be recorded using an anamorphic mode or by letterboxing a normal image.

wild sounds Non-sync sounds recorded by hand "in the wild" using a portable recording system.

window burn Timecode that is displayed as part of the video image.

wipe A type of transition where one image is wiped over another.

work print A low-quality print of the film negative used to create a rough cut.

work tape A duplicate or clone of the camera original source tape used for logging and viewing to protect the quality of the original.

XLR cable *See* **XLR connector**.

XLR connectors Three-pronged, balanced audio connectors for connecting mics and other recording equipment.

Y/C video Also called S-video (short for "separate video"), Y/C video has separate luma (Y) and chroma (C) video signals. *See also* **component video** and **composite video**.

YUV color space The range of colors that can be displayed and recorded on digital video.

Index

This book is to be returned on or before
the last date stamped below.
Fine 50c per day 2X

DVD + CDROM